CERAMIC
ART OF THE ITALIAN
RENAISSANCE

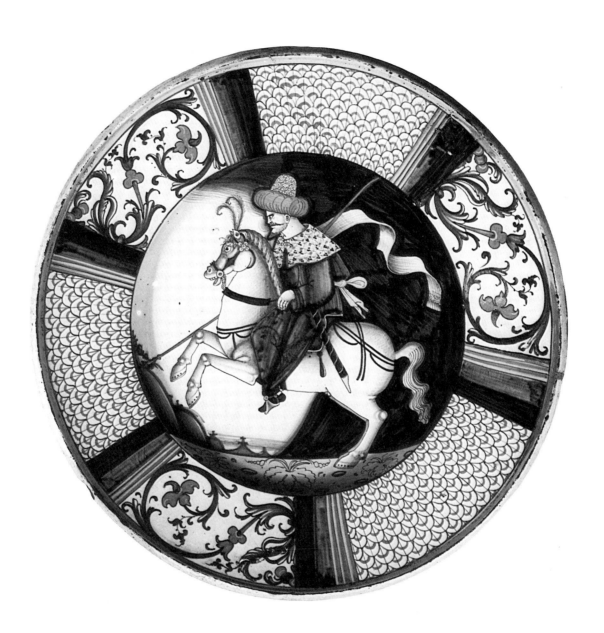

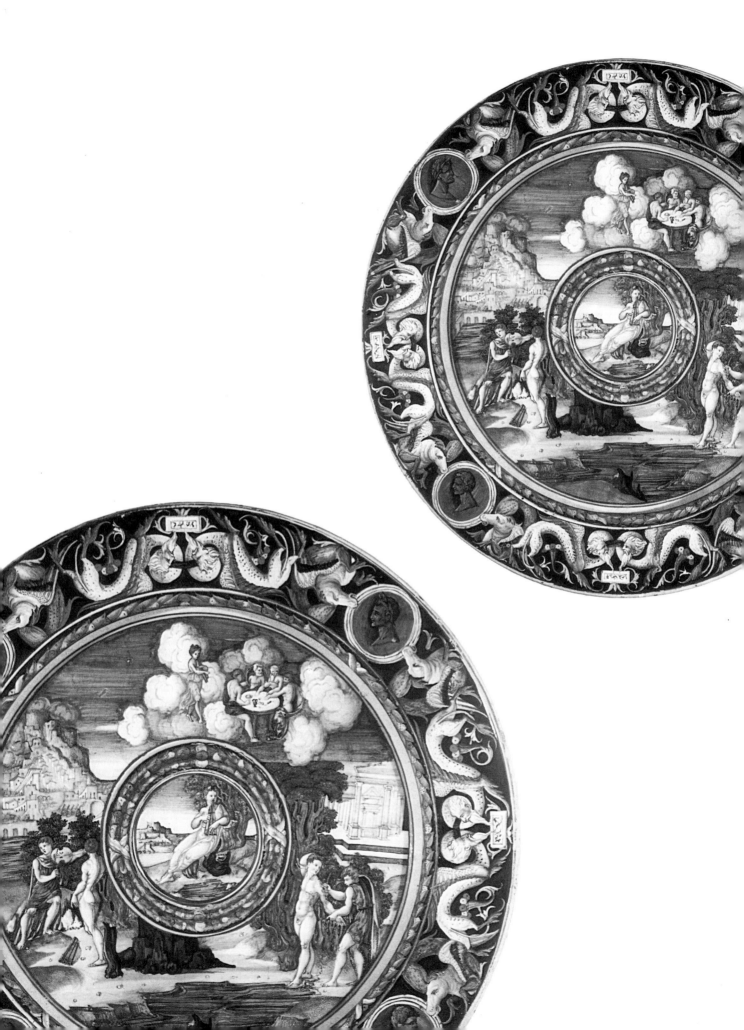

CERAMIC ART OF THE ITALIAN RENAISSANCE

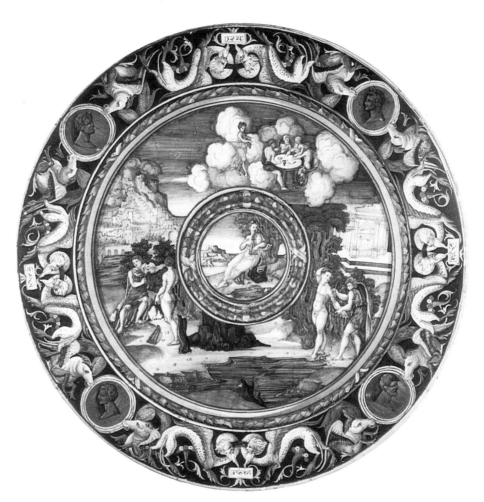

TIMOTHY WILSON

with the collaboration of Patricia Collins, and an essay by Hugo Blake

Published for the Trustees of the British Museum by
BRITISH MUSEUM PUBLICATIONS

The Trustees of the British
Museum acknowledge with
gratitude generous
assistance towards the
production of this book
from EniChem (UK) Ltd

EniChem

© 1987 The Trustees of the British Museum

Published by British Museum Publications Ltd
46 Bloomsbury Street, London WC1B 3QQ

Reprinted 1987

Cover **131.** Dish: a subject after Dürer. Attributed
to the 'Vulcan painter', probably Tuscany,
c. 1510–35.

Page 1 **158.** Dish: a horseman in 'Turkish'
costume. Deruta, *c.* 1530–60.

Previous page **60.** Dish: the story of Apollo and
Marsyas. Circle of Nicola da Urbino, Urbino,
c. 1525–30.

This page **108.** Vases of fruit, flowers and
vegetables. Della Robbia workshop, Florence,
c. 1490–1520.

British Library Cataloguing in Publication Data
Wilson, Timothy
 Ceramic art of the Italian Renaissance.
 1. Majolica, Italian—Catalogs
 I. Title II. Collins, Patricia
 III. Blake, Hugo IV. British Museum
 738.37 NK4315
 ISBN 0-7141-0541-4

Designed by Roger Davies

Typeset in Monophoto Garamond
and printed in Great Britain by
BAS Printers Limited, Over Wallop, Hampshire

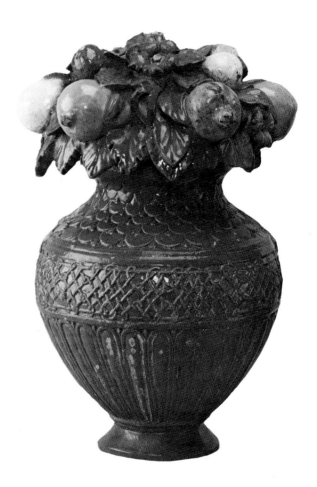

CONTENTS

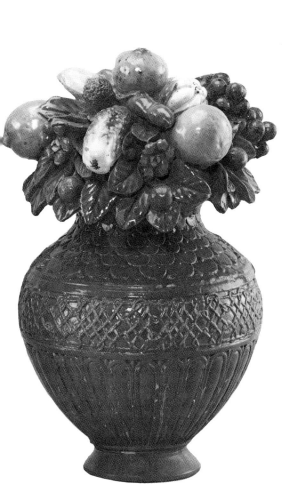

Preface

THE British Museum has the first-born of the great English maiolica collections (London, Cambridge and Oxford boast between them the best concentration of fine maiolica in the world), for Hans Sloane already owned maiolica. In the Victorian period Franks and his circle built up for the Museum superlative collections of Renaissance 'minor arts', with maiolica in the forefront of their interests; they bought in a historical spirit, seeking to do for Renaissance Italy what the collections already did for the cultures of the ancient world. Tim Wilson cites in his introduction (pp. 17–18) the clear-cut distinction which held at the time of the Bernal Sale in 1855 as between the collecting policies of the British Museum and of the institution which was to become the Victoria & Albert Museum. That distinction still largely holds good, and this exhibition will introduce the public for the first time for many years to one of our most important historical collections.

It may seem paradoxical to talk of pottery as if it was an archive, but in fact a cultural history of Renaissance Italy can be written through its painted pottery. This has been recognised from time to time by maiolica specialists, but much less within the traditional syllabus of Art History as taught in our universities, where maiolica measured against the highest aesthetic criteria of *disegno* is excluded as 'derivative', in fact brushed off as provincial, a footnote here and there. But the succession of local exhibitions in recent years in Italy, for instance that in Urbino in 1983 on the artistic *ambiente* of Raphael, is demonstration enough that the notion of the great single masterpiece, the great formative artist, leaves yawning voids in our understanding of what made the Italian Renaissance. At every turn throughout the sixteenth century Italian artists were in some sense involved with painted pottery, either directly or at one remove; patrons, often the richest and most discriminating, from the Medici to Isabella d'Este to Francesco Guicciardini, admired it in 'cabinets' or on tables, and ordered sets with their arms; the taste for classical myth and history found expression in its most ambitious products, and one does not need to be deeply versed in Ovid's *Metamorphoses* or classical history to appreciate these vivid images, for maiolica has one overriding advantage: it has not been cleaned, scrubbed and cleaned again, like many of the famous pictures of the period; its palette is as fresh as on the day it came from the kiln.

This book is designed for a non-specialist public, with catalogue entries kept concise. Catalogues of the British Museum collections both of post-classical Italian pottery and of Hispano-Moresque pottery are planned over the next few years, so that what Tim Wilson has given us here, with the help of Patricia Collins, is 'Work in Progress' towards larger tomes; the Trustees of the British Museum are still fully committed to the publication of the big, learned, scholarly catalogue, even in this time of shrinking means.

Since the Second World War most of the Renaissance and Later collections have not been on permanent exhibition, simply for lack of gallery space. That state of affairs will soon come to an end. A major gallery is being planned to display the collections covering the period from the Renaissance to Neo-Classicism, and a new centre for the housing and study of the rest of the European ceramic and glass collections is being constructed, so that one of the world's crucial study collections will at last be made easily available on a day-to-day basis.

It remains for me to thank EniChem, to whose enlightened sponsorship this exhibition and catalogue are much indebted. Several loans have added appreciably to the importance of the exhibition, where a piece of maiolica was required to fill out the Museum's collection or focus on a particular artist. With the help of these loans we have been able to present one of the fullest panoramas of this branch of Renaissance art ever put together, and I would like here to thank William Beare, Bruno Schroder, the Ashmolean Museum, the Courtauld Institute Galleries, the Fitzwilliam Museum, the Louvre, the Henry Reitlinger Bequest, the Rijksmuseum, the Royal Museum of Scotland, and the Victoria & Albert Museum.

Finally, with my colleague Tim Wilson, I wish to acknowledge the following, who have helped to create the exhibition: Simon Muirhead and his colleagues, who designed it, Ray Higgs and the Department's Museum Assistants who installed it and took care of the thousand and one details of its presentation, and Nigel Williams and his team of ceramic conservators, particularly Kirsty Norman, whose work on the maiolica collections has been highly skilled.

NEIL STRATFORD
KEEPER OF MEDIEVAL & LATER ANTIQUITIES

Acknowledgements

This book owes an unusual amount to other people. Patricia Collins, Special Assistant in the Department, has been involved in every stage of the book, especially the iconographical research. My other overriding debt is to John Mallet for years of encouragement and guidance. I also wish to thank the following for generous help and advice: in Britain, Mavis Bimson, Hugo Blake, Sheridan Bowman, Frank Britten, Jenny Chattington, John Cherry, Cecil Clough, Michael Cowell, Celia Curnow, Elizabeth Diaz Barreiro, Rudolf Drey, Anne Farrer, Silvia Ferino Pagden, John Gere, Peter Gidlow-Jackson, Antony Griffiths, J. P. Hudson, Karen Hughes, Michael Hughes, Jean Michel Massing, Jennifer Montagu, Hugo Morley-Fletcher, Stella Newton, Julia Poole, Ines Rawe, Dennis Rhodes, Michael Rogers, Ruth Rubinstein, Hugh Tait, Michael Tite, Nicholas Turner, Rachel Ward, Ann Wayne; in Germany, Tjark Hausmann, Johanna Lessmann, and the late, sadly missed Jörg Rasmussen; in France, Pierre Ennès and Catherine Join-Dieterle; in Italy, Sandro Alinari, Paride Berardi, Graziella Berti, Grazia Biscontini Ugolini, Gian Carlo Bojani, Luigi Borgia, Giulio Busti, Angela Caròla Perotti, Guido Donatone, Angiolo Fanfani, Guido Farris, Carola Fiocco, Riccardo Francovich, Gabriella Gherardi, Floriano Grimaldi, Mario Luccarelli, Tiziano Mannoni, Otto Mazzucato, Michelangelo Munarini, Sergio Nepoti, Carmen Ravanelli Guidotti, Giocondo Ricciarelli, Sandro Sebastianelli, Giovambattista Siviero, Marco Spallanzani, and Guido Vannini; in New Zealand, Alison Holcroft; and in America, Lois Katz, Jessie McNab, Wendy Watson, and David Whitehouse. Many other friends, too many to list, have shown me kindness, answered questions, or allowed me to see their collections. In 1984 I had the incomparable privilege of a fellowship at the Harvard Center for Renaissance Studies at I Tatti, near Florence, for which I am deeply grateful.

THW

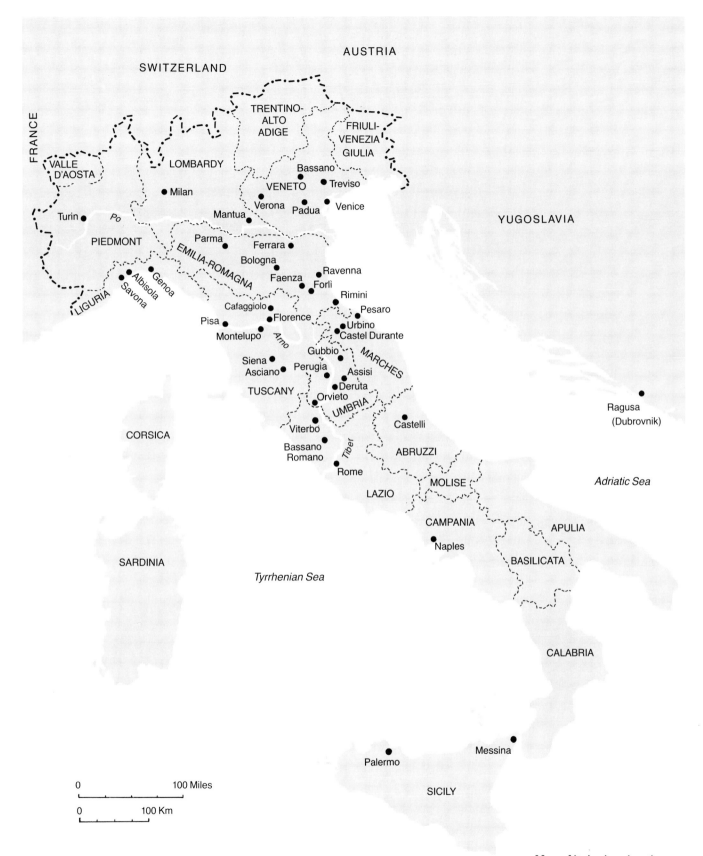

AUSTRIA

SWITZERLAND

FRANCE

TRENTINO-
ALTO
ADIGE

FRIULI-
VENEZIA
GIULIA

VALLE
D'AOSTA

LOMBARDY

• Milan

VENETO

• Bassano

• Treviso

Verona • Padua • Venice

Turin •

Po

PIEDMONT

Mantua •

YUGOSLAVIA

Parma •

Ferrara •

EMILIA-ROMAGNA

Bologna •

Ravenna

Genoa •

Faenza • Forlì

LIGURIA

Albisola •

Savona •

Cafaggiolo •

Rimini

Pisa •

Florence •

Pesaro

Montelupo •

Arno

Urbino
Castel Durante

Siena •

Gubbio •

MARCHES

Asciano •

Perugia •

Assisi

TUSCANY

Deruta •

Ragusa
(Dubrovnik)

Orvieto •

UMBRIA

Castelli •

Viterbo •

Tiber

CORSICA

Bassano
Romano •

Rome •

ABRUZZI

Adriatic Sea

LAZIO

MOLISE

CAMPANIA

APULIA

Naples •

BASILICATA

SARDINIA

Tyrrhenian Sea

CALABRIA

0 100 Miles

0 100 Km

Messina

Palermo •

SICILY

**Map of Italy showing the
main Renaissance pottery
centres, and modern regional
boundaries.**

Introduction

Maiolica and the Italian Renaissance

IT should be impossible to be interested in the outburst of artistic energy that we call the Italian Renaissance without being interested in its painted pottery. As painting, maiolica is the principal branch of Renaissance art which has consistently preserved all the vividness of its original colouring; as an index of taste, it offers an incomparable corpus of non-religious subject matter; and as a form of ceramics, this so-called 'minor art' came perhaps closer to the 'major arts' than at any other point in the long history of world ceramics.

In a microcosm of the broader cultural history of the period, the maiolica of Renaissance Italy absorbed into the Italian tradition elements from the Islamic world and from the rediscovered culture of ancient Rome, and developed them into something entirely new, which was then passed on to the rest of Europe. The technique of white tin glaze, with the pictorial effects it made possible, was mastered in Islam centuries before it was known in Europe. Inspired by Islamic achievements, fifteenth-century Italian potters developed a range of colours to add to modest medieval green and manganese, and created a new ornamental language which was unambiguously Italian. By 1500 two other overwhelming influences were brought to bear – ornament and subject matter from ancient Rome, and the new technologies of printing, woodcut, and engraving. The outcome was the extraordinary phenomenon of pottery treated as a form of pure painting, and the creation by 1510 of a fully narrative style. Unlike some forms of Renaissance art, *istoriato* ('story-painted') pottery had no precedent in Greece or Rome, as Vasari pointed out:

As far as we know, the Romans were not aware of this type of painting on pottery. The vessels from those days that have been found filled with the ashes of their dead are covered with figures incised and washed in with one colour in any given area, sometimes in black, red, or white, but never with the brilliance of glaze nor the charm and variety of painting which has been seen in our day . . .

Sixteenth-century *istoriato* pottery was an up-market product, not as expensive as silver or Chinese porcelain, but unequivocally seen as an art form. The finest *istoriato* pieces were collectors' items, and for actual use only exceptionally. Sets like the one painted by Nicola da Urbino for Isabella d'Este show, even now, little scratching or chipping of the glaze, as would be inevitable had they ever been much used at table. Before long maiolica sets were being specially designed by major artists and commissioned by, or presented to, some of the most powerful men in Europe, including the King of Spain, the Grand Maître of France, and the Duke of Bavaria.

Under these circumstances some maiolica painters began to think of themselves as fully fledged artists in the Renaissance manner, and to sign and date their work. A famous Cafaggiolo plate of about 1510 shows a maiolica painter at work on a dish, with two aristocratic clients watching; his dress is no less elegant than theirs. The Urbino artist Francesco Xanto Avelli wrote poetry, put literary tags on his dishes, painted elaborate moral and political allegories of his own invention, and described himself grandly as 'painter'. Such aspirations belied the reality of the pottery industry: *istoriato* work was exceptional, and most workshops depended on the bread-and-butter production of more utilitarian objects.

No general economic history of maiolica has yet been written,

although a great deal of material is available in the form of contracts, inventories and accounts. Certainly, in the late fifteenth and sixteenth centuries production became more 'industrial' in scale, markets became wider, and middle-men came to play a crucial role in marketing. But some fascinating questions remain difficult to answer: how expensive, relatively, were the finest maiolica services? How much more expensive were lustred wares than unlustred? How much could a good painter earn? Parallel to these are questions about workshop organisation: what was the normal relationship between a journeyman painter and the head of a workshop? Did maiolica painters also turn their hands to other kinds of painting? How widespread was collaboration between skilled painters and assistants?

Maiolica scholarship has tended to neglect issues like these in favour of intensive studies of the production of particular areas. Local attribution is fraught with difficulties, partly because of the well-documented itinerant habits of craftsmen, partly because it has to start from marked pieces, which may be unrepresentative. For instance, there is documentary evidence of high-quality maiolica production in Ferrara; but in the absence of marked pieces none has been identified. A single surviving piece is evidence of *istoriato* manufacture in Fabriano; if this piece had happened not to survive, this production could hardly have been suspected.

Nor are attributions to particular painters, in the strict art-critical manner, straightforward: a painter's style could vary radically depending on what model he was following, what workshop he was working in, or how fast he had to work. Furthermore, some pieces are undoubtedly the result of collaboration between painters. Even apparent artists' signatures can be deceptive: in some cases what appears to be the artist's name or initials proves to be that of an owner; in others, it is uncertain

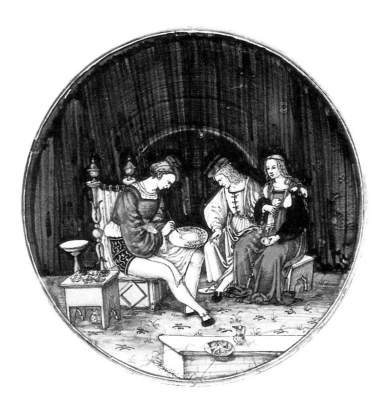

Fig. i. A maiolica painter at work; Cafaggiolo, *c.* 1510. Victoria & Albert Museum.

whether the 'signature' is that of the painter or the owner of the workshop. The handwriting of inscriptions may be helpful; but inscriptions were on occasion written by someone other than the painter.

The artistic geography of Renaissance maiolica is distinctly different from that of the other arts. This is partly due to the fact that through much of northern Italy incised slipwares were more commonly made than tin glaze, and partly to the Renaissance development of specialist pottery villages like Deruta, Montelupo, and Castelli. Some major art centres, like Rome, Bologna, and Milan, seem not to have been significant producers of 'artistic' maiolica at all. The heartlands of Renaissance maiolica were Tuscany, Umbria, and above all the tract of eastern Italy between Ferrara and Ancona. Pottery was not necessarily an urban art, and the contribution of major centres like Florence, Faenza, and Urbino, as compared to outlying workshops, can be difficult to assess.

Among the arts of the Renaissance, maiolica is a 'middle-brow' art. Classical subject matter is abundant, but it is an unintellectual classicism, derived from paraphrases of Ovid and collections of stories from Roman history. Echoes of the great painters are everywhere, but maiolica painters rarely show any profound understanding of contemporary art; commonly the inspiration is work of an earlier generation, mediated through engravings. Artists of real originality, like Nicola da Urbino, are exceptional. For this very reason maiolica gives unique insight into what the Renaissance meant to Italians outside the scholarly and artistic *avant garde*. It is this that makes its pottery not only one of the most vivid, but also one of the most characteristic arts of the Renaissance.

LITERATURE (GENERAL WORKS) Fortnum 1896; Ballardini 1938; G. Liverani 1958A; Giacomotti 1961; Rackham 1963; Scott-Taggart 1972; Mallé n.d.; Conti 1980; Watson 1986.

Technique

Most of the objects in this book are what in modern Italian is called *maiolica* – tin-glazed earthenware. Information on the techniques used in sixteenth-century Italy is abundant, thanks to the *Three Books of the Potter's Art*, a treatise by Cipriano Piccolpasso of Castel Durante, written around 1557. The manuscript, now in the Victoria & Albert Museum, contains careful drawings of maiolica manufacture, as well as detailed descriptions of techniques, and glaze and pigment recipes; it is an incomparable source for Renaissance ceramic technology. However, what Piccolpasso wrote was what one amateur potter was able to find out about the technology of his time. Clays, recipes, kilns, and methods varied from workshop to workshop and from region to region, and generalisations about the techniques of Renaissance maiolica have to be made cautiously.

The technique for fine maiolica described by Piccolpasso is as follows. Clay was dug mainly from river beds and purified; the clays for most 'artistic' Renaissance maiolica fired to a colour varying from pale buff to pink. The dish or vessel was made on a wheel, or by the use of plaster moulds, and given a first firing to a temperature of about 1000°C. The kilns in Piccolpasso's drawings were wood-fired up-draft kilns built of brick, with the fuel under the kiln floor. The ware was then dipped in a tin-opacified lead glaze of which the main ingredients were potash (made from burning the lees out of wine barrels), sand, and oxides of lead and tin, the mixture being ground and mixed with water; the tin

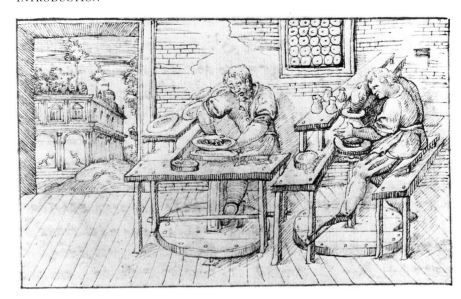

Fig. ii. Potters at the wheel; from the Piccolpasso manuscript, *c.* 1557. Victoria & Albert Museum.

oxide remained suspended in the glaze and had the effect of turning it white. In some workshops, especially in Tuscany and when red clays were being used, a layer of slip was applied beneath the tin glaze for a whiter effect.

When the tin glaze was dry it was painted on the powdery surface. Piccolpasso remarks: 'Painting on pottery is different from painting on walls, since painters on walls for the most part stand up, and pottery painters sit all the time'. The best brushes (which had to be very soft), he adds, were made from the hair of goats and the mane of asses, with mouse whiskers sometimes added.

In range and subtlety of colours, Renaissance *istoriato* has rarely been equalled. The main pigments used were blue from cobalt, green from copper, yellow from antimony, orange from antimony and iron, and purple and brown from manganese. The opaque white used for highlights was based on tin. The colour that gave most difficulty was red: a red derived from an iron-rich clay called 'Armenian bole' was sometimes used, but even the factories that mastered it (mainly at Faenza and in Tuscany) tended to use it in small quantities.

Tin glazes are basically white, but can be tinted. The most common coloured glaze used in the Renaissance was a bluish or lilac-grey, achieved by adding cobalt or manganese to the glaze. Blue (*berettino*) glazes were particularly used in Faenza and the Veneto.

After painting, according to Piccolpasso, the ware was dipped in, or sprinkled with, a clear glaze. It was then stacked in the kiln. Dishes were placed on small pointed spurs, or on pegs, inside protective saggars, usually face downwards. Most Renaissance maiolica dishes, even the most lovingly painted, have three or more marks on the front where they rested on these supports, and little attempt seems to have been made to avoid scarring the painted surface. The second firing was to about 950°C, and the pottery emerged in its finished state.

A few centres, the most important being Deruta and Gubbio, used the additional process of metallic lustre, a technique learnt from Islamic and Hispano-Moresque pottery. Compounds containing silver or copper were painted on the twice-fired pottery, which was then refired

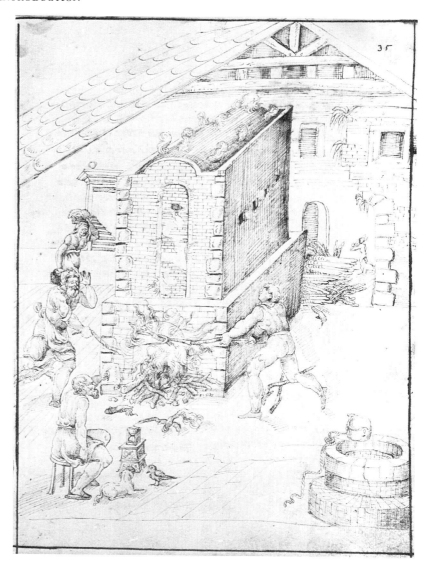

Fig. iii. Firing a kiln; from the Piccolpasso manuscript, *c.* 1557. Victoria & Albert Museum.

in a smaller kiln at a lower temperature. Towards the end of this firing the fuel was changed to brushwood, which filled the kiln with smoke; carbon monoxide combined with the oxygen in the metal oxides, causing a thin layer of pure metal to be formed on the surface; when cleaned, this produced a much-admired iridescent effect. In general, yellow and golden lustres were made from silver, and red lustre from copper, but the final colour varied according to firing conditions. Lustre was always a specialist skill, only made in a few workshops.

There is little direct information on the size and organisation of maiolica workshops. Potteries varied from tiny 'one-man-and-a-dog' operations to complex businesses with several premises and a high degree of specialisation between painters, kiln-stackers, turners, and so on. Most of the 'artistic' maiolica in this book was probably made in relatively large workshops and painted by specialist painters, some of whom were independent journeymen working on a piece-work basis. Sometimes the head of a workshop was its best painter; sometimes, on the other hand, he may have been an entrepreneur with only managerial control of the actual production.

LITERATURE Caiger-Smith 1973; Piccolpasso 1980

Archaeology and maiolica

by HUGO BLAKE
University of Lancaster

Fig. iv. Part of the thirteenth-century façade of the Church of San Lanfranco, Pavia – one of the earliest contexts for archaic maiolica in northern Italy. *Bacini* survive on the outside of many medieval Italian churches, particularly in Pisa, Pavia, and Rome.

Archaeology is the study of material culture as a social phenomenon. Archaeologists are interested not only in the things men and women made – for instance, pots and houses – but also in environmental data which reveal the conditions in which people lived and how they exploited their surroundings. Since the 1960s archaeologists in Italy have expanded their field of study from prehistory and antiquity almost to the present day. In the last decade techniques suitable for reconstructing social history have been adopted and developed, with such results that the country can now boast some of the finest research programmes.

Pottery is particularly important to archaeologists as it tends to survive underground. Fired clay is rarely subject to chemical decay, and broken pottery cannot be recycled like metal and glass. A lot of energy has therefore been devoted by archaeologists to classifying pottery, even though other substances such as wood were probably more commonly employed.

Archaeologists usually date a pottery type by its contexts: it may have been discovered with a coin or in association with a dated building. The chronological brackets archaeology can propose are thus rather wide, and they cannot compare with the precision of a date inscribed on a pot or a signature of a known artist or a written contract – all evidence available in the Renaissance. This sort of evidence rarely exists for the Middle Ages, and excavated contexts have been of some use in charting the medieval origins of maiolica; but even here the study of the pottery used to decorate Italian churches, which are more precisely datable by inscriptions, documents or architectural criteria, has so far provided more information about the finer tablewares. It now seems that Italian potters were stimulated around AD 1200 by imports from Islamic north-west Africa to make the first tin-glazed pottery. In north-central Italy the technique was applied to traditional forms with European decoration. At Rome the first extensive and complete stratified sequence, excavated recently in the Crypta Balbi area, suggests that local painted glazed pottery, both lead- and tin-glazed, took its inspiration from southern Italian imports. Archaeological excavation has also thrown light on the dating of the blue decoration characteristic of fifteenth-century maiolica: work in the 1970s at Tuscania to the north of Rome, and around Florence, has put back its introduction to the end of the fourteenth century, some thirty to forty years earlier than previously thought.

The greatest contribution archaeology could make to the study of Renaissance maiolica would be through the excavation of a pottery workshop. The sites of some Renaissance kilns are known, at Cafaggiolo for instance; elsewhere they could be located by applying electrical and magnetic prospecting techniques in fields with promising names recorded on old estate maps. A second best has been the careful recording of potters' waste heaps at places like Genoa. A remarkable dump at Montelupo has yielded examples of every stage of manufacture, revealing in what sequence the decoration was applied, and even a trial piece imitating Spanish lustre.

Great advances have been made in the last decade in establishing the geological origins of clays by examining their mineralogical and chemical constituents. In this way may be established not only the likely place of manufacture of a type but also, by plotting where it has been

found, how far afield it was traded. There was, for example, considerable regional specialisation in glazed tablewares from the thirteenth century: central Liguria (between Genoa and Savona) dominated the nearby coastal and southern French markets with incised slipware (later superseded by Pisan maiolica). Production and distribution inland were more localised, and here specialised pottery centres supplying markets outside their local area did not develop before the second half of the fourteenth century.

As pottery turns up on almost every later medieval site in peninsular Italy, archaeologists are well placed to document consumption. Pots are rarely found exactly where they were used. Normally we must make do with the rubbish, which, before centralised disposal was introduced in towns, was discarded near the place of use. The role of tin-glazed pottery in the later Middle Ages and the Renaissance can be shown by plotting the proportions of different types of pottery in relation to the economic and social status of sites (recorded in written sources, or deduced from the quality of housing and from the consumption of other artefacts or food). Both the exotic raw materials and the skills required made tin-glazed pottery a relatively expensive commodity. The earliest Islamic imports graced only aristocratic tables; the first local maiolica probably did not reach lower than the new mercantile class; only in the fifteenth century did ordinary urban craftsmen and hospital refectories regularly acquire the simpler decorated types; and perhaps not before the following century was this glaze applied to more utilitarian forms. Distinctions can also be seen in the forms that were tin-glazed. In south Italy and along the coasts, areas more susceptible to Mediterranean influence, bowls were commoner, whereas inland the transalpine European jug tradition predominated. Only towards the end of the Middle Ages did tin-glazed bowls become commoner in north-central Italy. The wide variety of vessel shapes found in museum collections reflects the curatorial wish to have at least one of everything rather than the proportions used by medieval Italians.

So far archaeology has told us most about the role, technology and origins of maiolica. Until a workshop is unearthed, the finer Renaissance wares can still best be studied by examining the specimens preserved above ground in relation to the written and artistic record. Archaeologists appear recently to have made medieval maiolica their exclusive preserve, but a case could be made for applying to it the art-historical approach: it would be illuminating to consider the ornament, which archaeologists only classify, date and locate, in the context of other arts and as an incomparable source of secular taste. On the other hand, the rigour of the archaeological method and description has much to teach art-historians working on Renaissance fine wares. The Renaissance maiolica in this book is an élite product; archaeology offers, by contrast, contact with objects of everyday use and, by its emphasis on context, the possibility of extracting from them detailed information about social and economic history.

LITERATURE In addition to the works listed on p. 24, the following have been referred to in this essay: Mannoni 1969; Whitehouse 1972; Mannoni & Mannoni 1975; Vannini 1977; Francovich et al. 1978; Antiche maioliche di Deruta 1980.

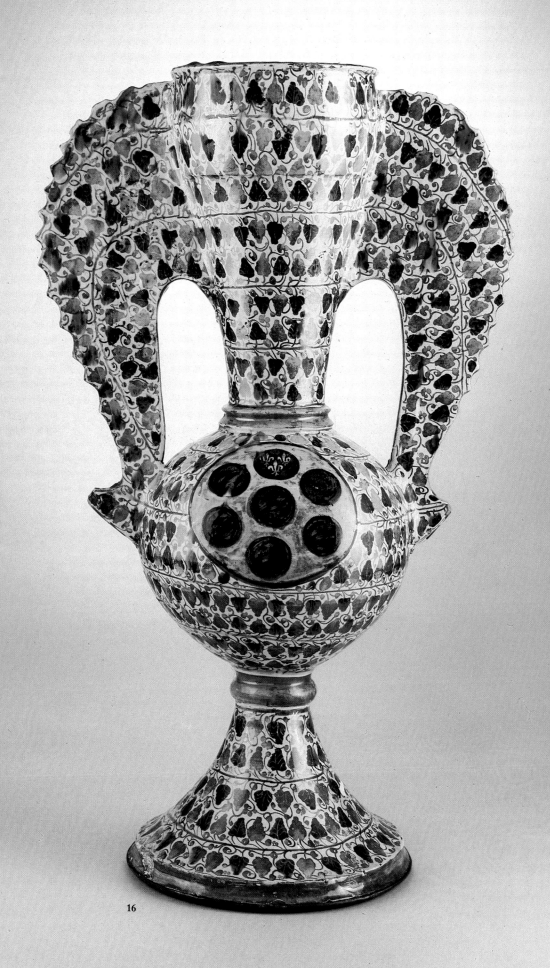

16

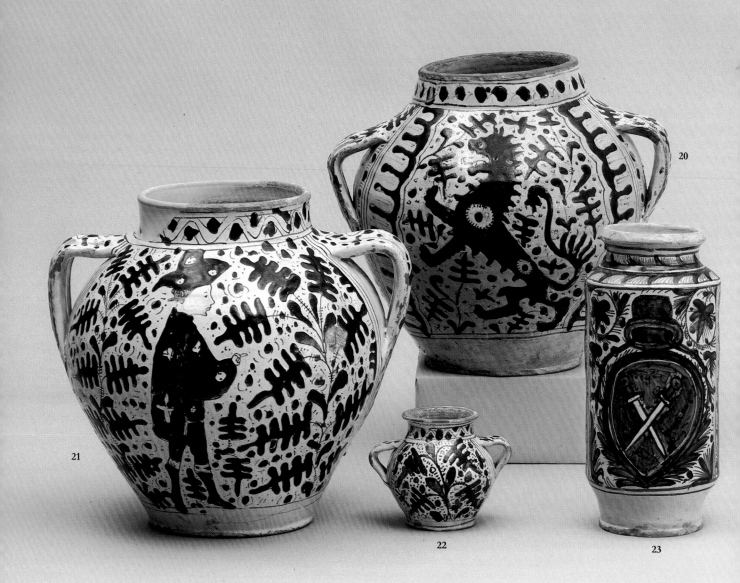

20

21

22

23

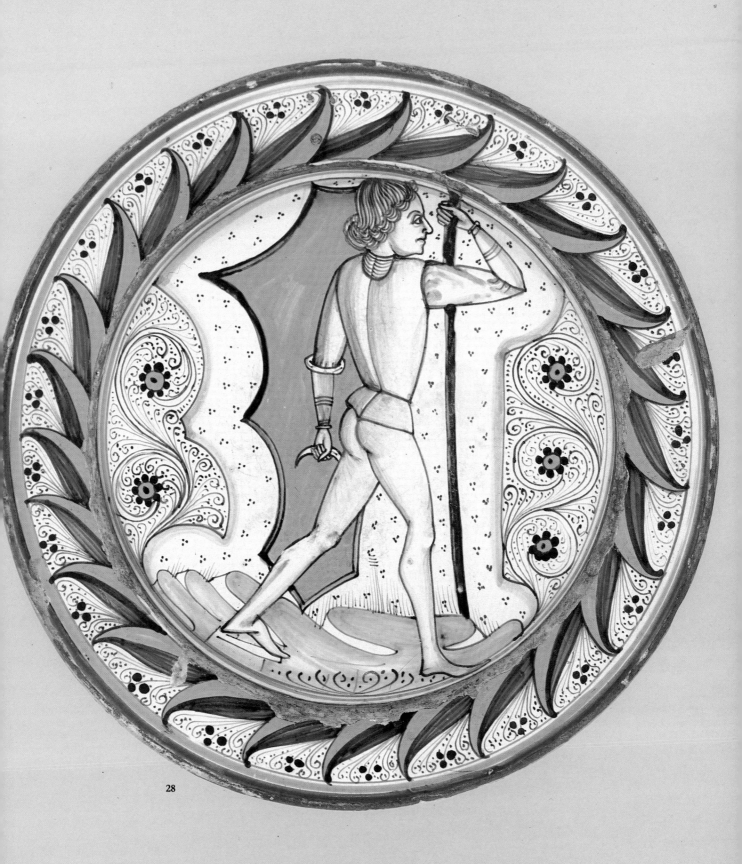

28

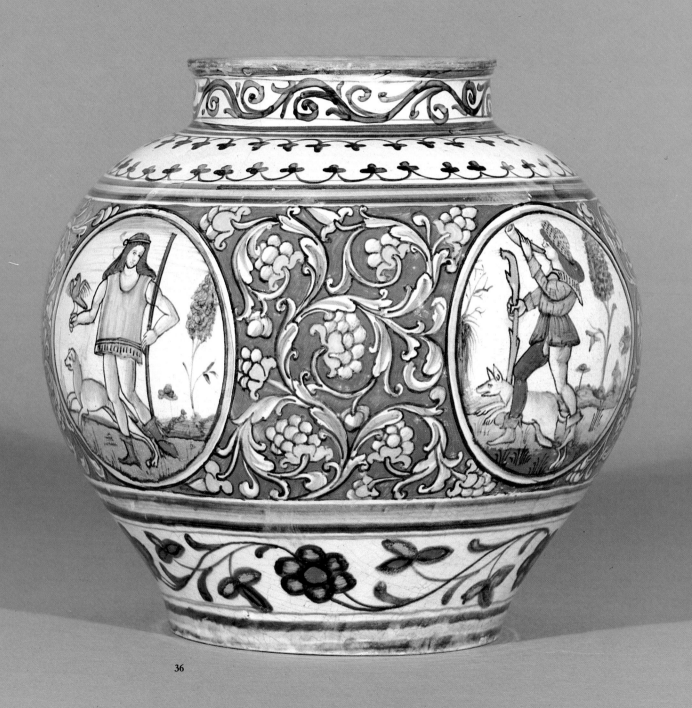

36

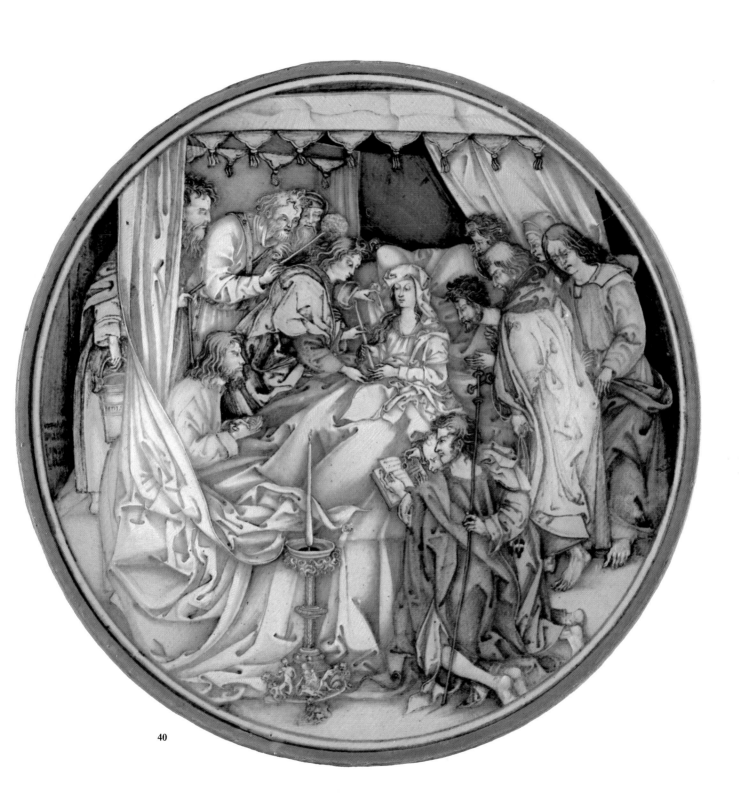

40

41

42

45

202

53

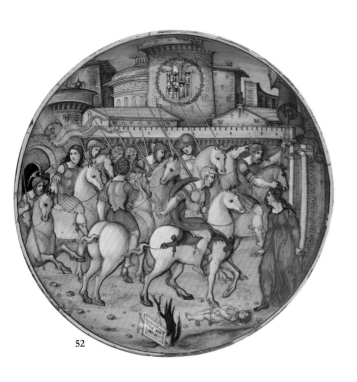

52

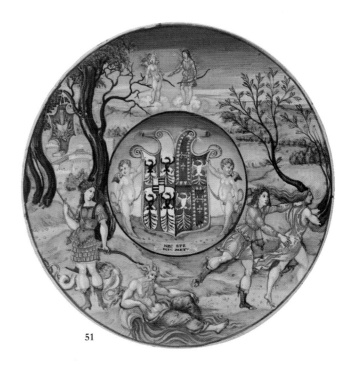

51

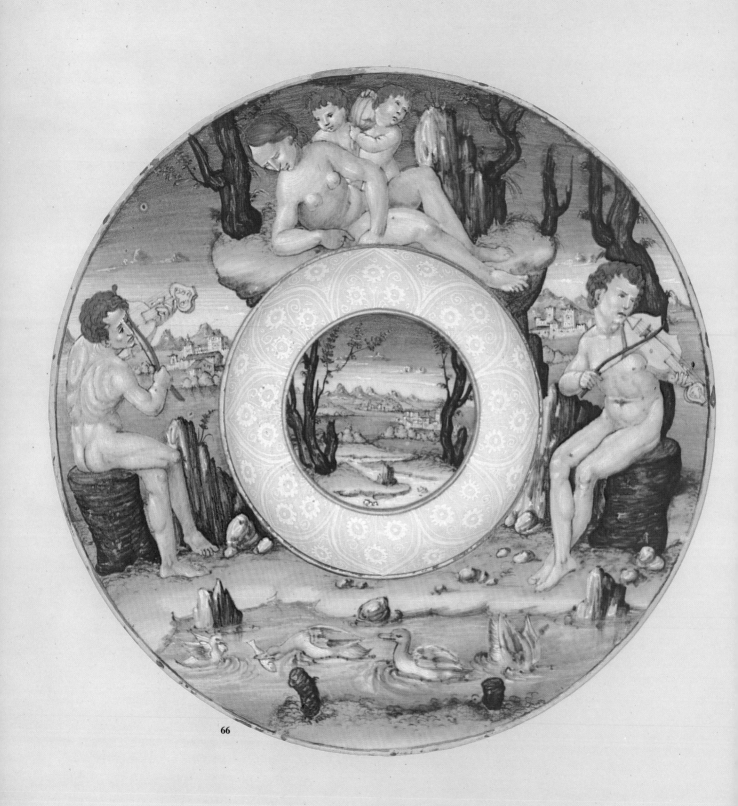

66

The British Museum collection

In 1873 C.D.E. Fortnum wrote: 'The choicest collection of Italian pottery in England, and perhaps in the world is that in the British Museum; although not extensive . . . it is remarkable for the artistic excellence of the specimens, the many pieces signed by the painters, and the illustration of almost every period and fabrique of the art'. This collection was, and is, a monument to Victorian connoisseurship; above all it is the creation of Sir Augustus Wollaston Franks (1826–97), who joined the staff of the British Museum in 1851.

The British Museum is founded on the vast miscellaneous collection accumulated by Sir Hans Sloane and purchased for the nation after his death in 1753. Among his 'curiosities' were a few pieces of sixteenth- to eighteenth-century maiolica. The most imposing of these is 245; the fact that the date on this had already been altered when Sloane acquired it is an alarming reminder that faking maiolica is not new.

In the first half of the nineteenth century the collecting policy of the British Museum focused on books, and the archaeology of ancient civilisations. When Franks arrived to take charge of 'British and Medieval' antiquities, no maiolica had been added to the collection in the ninety-eight years since Sloane's death, and there was no significant collection of Renaissance antiquities in any public museum in Great Britain. That the British Museum began to collect the 'applied arts' of the Middle Ages and Renaissance was entirely due to Franks's energy. He had an excellent collector's eye (it was he who first established the personality of Nicola da Urbino) and the generosity to spend his personal wealth for the benefit of the Museum. Within a few months of his arrival the Museum bought part of the collection made in Rome by the 'Abbé' James Hamilton, including twelve dated pieces from the workshop of Maestro Giorgio. Among pieces bought the following year was the famous 'Orsini-Colonna' jar (219); and in 1853 purchases from the collection of the great Gothic-revival architect A. W. N. Pugin included a handsome Deruta plate (155, illustrated overleaf).

The British Museum was not alone in the field for long. Following the Great Exhibition in the Crystal Palace in 1851, the Board of Trade created in 1852 a 'Museum of Ornamental Art' in Marlborough House; its brief was to provide a repository of good design to improve public taste, to inspire craftsmen and designers, and to help British industry compete with the acknowledged superiority of French design. It was the ancestor of the world's most comprehensive museum of art and design, the Victoria & Albert Museum. Renaissance pottery was valued as inspiration for the English pottery industry, and in 1853 and 1854 a good deal of maiolica was bought for Marlborough House.

In August 1854 died one of the most discriminating collectors of all time, Ralph Bernal. Henry Cole, director of Marlborough House, tried to induce the British government to buy the whole of Bernal's huge collection of medieval and Renaissance arts. They failed, and the collection was put up for auction at Christie's in March 1855. The British Museum and Marlborough House both applied to the Treasury for special grants to bid. Franks's letter to his Trustees stressed the historical importance of the maiolica:

In these collections there are a number of specimens which are of peculiar value to any public museum. Mr Bernal appears to have selected such objects as are not only good of their kind, but which have on them a date, the name of the artist or some

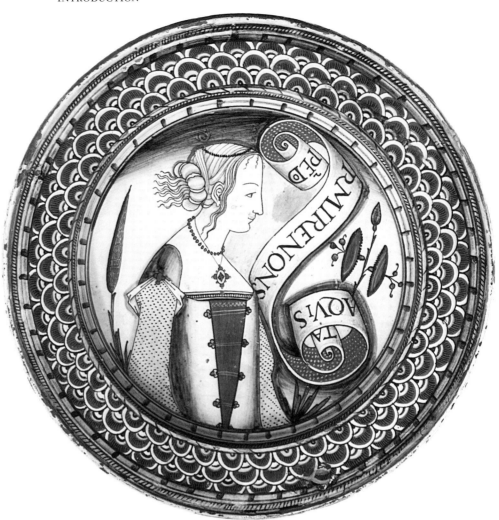

155. A Deruta dish, bought by the Museum in 1853 at the sale of A. W. N. Pugin.

interesting historical association. They are in fact a collection of documents on the several branches of art to which they belong. The Collection of Majolica is, as far as I am aware, unrivalled in any Museum excepting that of Brunswick. It is certainly superior to the one in the Louvre unless the latter collection has been increased very recently. This interesting ware bears much the same relation to the pictorial art of the 15th and 16th centuries that Greek vases do to Greek Art. At both periods we find the ramifications of art very extensive and showing themselves in objects of all kinds and purposes. It is well known that several of the great Masters made designs to be executed in Majolica and are even said to have painted on the earthenware themselves . . .

The criteria stated by Marlborough House were quite different:

The articles . . . have been selected on the following grounds: — First and mainly, on account of the suggestions they are calculated to afford for improving manufactures; beauty and excellence of style as decorative works, and for skilful workmanship; as illustrations of technical processes, both from an artistic and scientific point of view; and lastly for their interest as historical specimens of manufacture and ornament. Although some of the specimens possess considerable archaeological value, that consideration, and still less mere rarity or fashion . . . have not been admitted as reasons for selection.

At the sale, which saw some dramatically high prices, the British Museum bought 72 pieces classified in the catalogue as 'Faenza and Raffaelle ware', Marlborough House bought 133. Most of the British Museum's purchases from the Bernal Sale are marked or dated, or are

armorial, and they established for all time the documentary emphasis of the collection.

Shortly before the Bernal Sale, apparently as a device to induce the Trustees to take positive action over it, Franks presented some of his own collection. This was one of the earliest in a stupendous series of gifts made by Franks over nearly fifty years; he is the most important benefactor in the entire history of the Museum. Within five years of Franks's arrival the British Museum had thus acquired a collection of Renaissance maiolica of some importance. In 1856, however, the growth of the collection suffered an ironic setback by the appointment as Principal Librarian (Director) of an Italian, Antonio Panizzi, the formidable creator of the present Reading Room. Panizzi did not want the British Museum to collect post-classical artefacts; before a Parliamentary committee in 1860 he spoke with approval of the time when 'the British Museum was a collection only of classical antiquities; its object was the spreading of good taste and assisting scholars in respect to classical art and learning'. Under Panizzi, Franks was unable to buy major maiolica, which became more expensive as collectors competed with increasing frenzy in the London and Paris sale-rooms. Franks compensated by encouraging wealthy friends to form art collections which in due course were given or bequeathed to the Museum. Among them was John Henderson, who died in 1878, leaving to the Museum a wide-ranging collection including over a hundred pieces of maiolica. Henderson's maiolica was uneven in quality, but the bequest greatly extended the range of the Museum's holdings and contained a few of the finest pieces in the whole collection; it also included excellent Hispano-Moresque. Another friend of Franks was C. D. E. Fortnum, author of the pioneering South Kensington catalogue of 1873; his collection eventually went to Oxford, but not before he had given the British Museum two pieces of Medici porcelain and a fundamental piece of documentary Pesaro maiolica (96).

In 1884 one of the most historic collections of maiolica in Europe, formed by Sir Andrew Fountaine in Italy early in the eighteenth century, and increased by successive members of his family, was dispersed in a spectacular sale at Christie's. Franks applied all his political skill to extract a government grant for the sale, but Treasury meanness was insurmountable, and he succeeded in purchasing only a few pieces for the Museum. In 1898, however, the Museum received a great benefaction, when Baron Ferdinand Rothschild bequeathed a lavish collection of Renaissance and other objects from Waddesdon Manor. This included sumptuous maiolica of late Renaissance Urbino, an area in which the collection had hitherto been thin. The 'Waddesdon Bequest' forms the nearest equivalent to a Renaissance princely *Schatzkammer* that any English museum can show.

Alongside Italian maiolica, the British Museum acquired in the 1850s some notable Spanish lustreware, including important armorial examples. Meanwhile, a Trustee of the Museum, Frederick Du Cane Godman, began to build up an incomparable private collection of Valencian and Islamic pottery. In 1983, under the generous wills of Godman's daughters, this collection passed to the Museum.

By 1900 a change in fashion was taking place, as museums and collectors turned their attention to pre-Renaissance Italian pottery. Franks's

generation had been primarily interested in the refined craftsmanship of *istoriato* and its relationship with the 'major arts' of the High Renaissance. Under his successor, Hercules Read, the Museum acquired earlier pottery, largely thanks to Henry Wallis (1830–1916), a member of the Pre-Raphaelite circle of painters. Wallis's love of ceramics took him all over Europe and the Islamic world in search of specimens and information; and long before medieval archaeology existed as an academic discipline, he appreciated the importance of excavated fragments. From 1897 he published a series of elegant privately printed volumes on pre-Renaissance maiolica. Wallis acted as a sort of agent for the British Museum, attempting to pressurise Franks and Read into collecting early maiolica. In 1892 he wrote to Franks: 'It would be worthwhile securing just now a collection of the early Italian wares that have been lately found in Italy . . . the things could be got now for a trifling sum, whereas they are certain to go up shortly in price . . .'; and four years later, to Read: 'At present our knowledge is but limited from the scanty number of pieces, but if you start the nucleus of a collection . . . you are likely to receive other examples and eventually an adequate representation of the art. And then your splendid collection of Maiolica will not have the appearance of having started its existence in full bloom, having neither buds, stalks or roots'. In 1897 he wrote again from Naples: 'This country is being carefully searched as by a small tooth comb for the last remnants of the *quattrocento* wares. Paris, Berlin and Vienna are ready buyers, so I think you ought to make a special effort in that direction or the opportunity will be lost . . .' With Wallis's help the British Museum acquired a fair collection of medieval and *quattrocento* maiolica, although Wallis often lost out to two dynamic Continental curators, Wilhelm Bode of Berlin, and Emile Molinier of the Louvre.

In 1908 Wallis wrote to Read from Rome: 'Among the places I visited was Orvieto, where they have recently had a find of *quattrocento* maiolica and where also they are forging the same, as I was told'. Read did not take the opportunity to buy through Wallis, but later bought pottery from Orvieto through two rather disreputable dealers, Domenico Fuschini (in 1910) and Camillo Visconti (in 1913 and 1920). He would have done better to trust Wallis, since among the 1913 purchases were several pieces that owed a good deal to the restorer, and one out-and-out fake (276).

Between the two World Wars maiolica fell out of fashion with collectors. Prices dropped, and bargains were available at the sales in London of collections like the Oppenheimer, Damiron, and Pringsheim, but there was little money and no-one on the Museum staff with the enthusiasm to make major purchases possible. Between 1925 and 1958 the Museum bought not a single piece of Italian pottery. In fact, the collection was reduced when, in 1941, incendiary bombs destroyed the provisional display mounted in one of the galleries. The greatest treasures had been removed to safety, but among the pieces destroyed were some twenty pieces of maiolica. The saddest loss was a large dish with the Triumph of Galatea, attributed to Nicola da Urbino but, according to Fortnum, 'grander and more powerful than the usual works of the artist'.

In the last thirty years it has been possible to renew in a modest way the tradition of bringing together pieces of historic and scholarly

importance, but prices for high-quality maiolica have risen sharply since the 1960s and the British Museum is increasingly incapable of competing for pieces worthy of its tradition. Any continued growth of the collection seems likely to depend on private generosity.

LITERATURE Marryat 1857; Miller 1973; Norman 1976; D. Wilson 1984; T. Wilson 1985A; Sutton 1985.

11. An early fifteenth-century Tuscan jar, acquired by the Museum in 1898 through Henry Wallis.

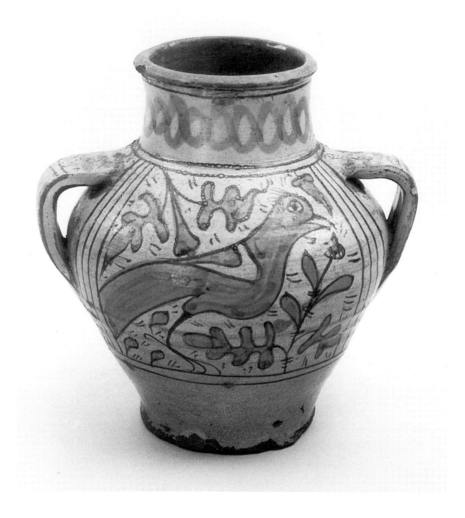

Museum collections of maiolica

Great Britain The principal collections of maiolica in Great Britain belong to the Victoria & Albert Museum, the British Museum, the Wallace Collection, the Fitzwilliam Museum in Cambridge, and the Ashmolean Museum in Oxford. Interesting smaller collections are in the Royal Museum of Scotland in Edinburgh, the city museums of Glasgow, Manchester, and Stoke-on-Trent, the Courtauld Institute Galleries (London University), and Polesden Lacey and Waddesdon Manor (both National Trust).

Italy The most wide-ranging collection is the Museo Internazionale delle Ceramiche, Faenza, which has recovered heroically from almost total destruction in the Second World War. Other fine-quality collections include: Bargello, Florence; Museo Civico Medievale, Bologna; Museo Correr, Venice; Museo Civico, Arezzo; Museo Civico, Pesaro; Castello Sforzesco Museum, Milan; Museo Civico, Turin; Museo di Capodimonte, Naples.

France Louvre; Musée National de la Renaissance, Ecouen; Musée National de Céramique, Sèvres; Musée de Céramique, Rouen; Musée des Beaux-Arts and Musée des Arts Décoratifs, Lyons.

Germany One of the world's greatest collections, in the Schlossmuseum in Berlin, was severely damaged by bombing in the Second World War; most of what remains is now in the Kunstgewerbemuseum in West Berlin. Other notable collections are in Brunswick, Hamburg, Cologne, Stuttgart, Frankfurt, and Munich.

Austria Museum of Applied Art, Vienna.

Netherlands Rijksmuseum, Amsterdam; Boymans–van Beuningen Museum, Rotterdam.

Soviet Union Hermitage, Leningrad.

United States The collection at the Metropolitan Museum in New York has been superbly supplemented by the Robert Lehman collection. There are interesting collections in Washington D.C. and Baltimore, and notable pieces in Boston, Chicago, Detroit, Los Angeles, the Getty Museum in Malibu, and Philadelphia.

Canada George R. Gardiner Museum, Toronto.

THE CATALOGUE

NOTES TO THE CATALOGUE

The primary purpose of this book is to present the artistic achievement of Renaissance pottery to people interested in the culture of the Renaissance, not to provide a substitute for the projected *Catalogue of Post-Classical Italian pottery in the BM*. The catalogue entries are summary and include only essential notes on technique and condition. Sources of purchases and collecting history have been included only if of particular interest. Unless otherwise stated, dishes and plates are covered on the front and back with an opaque white glaze. Bibliographies are limited to works felt to make a positive contribution to knowledge. The opinions of an author have normally been cited once only: C. D. E. Fortnum's South Kensington *Catalogue* of 1873 has been cited in preference to his 1896 *Maiolica*; and Bernard Rackham's 1940 V&A *Catalogue* has been cited rather than his 1933 *Guide*. The word 'district' has been used loosely: 'Urbino district' includes Pesaro and Castel Durante; 'Florence district' includes Montelupo.

Unless otherwise stated, objects are the property of the British Museum (abbreviated BM), Department of Medieval & Later Antiquities (MLA). References to Adam Bartsch, *Le peintre-graveur* (1808-54) are abbreviated B.

1 Medieval pottery

The pottery made between 1200 and 1450 in Italy has been the object of a great deal of interest from archaeologists in the last twenty years. This section presents a selection from the British Museum collection to illustrate the kind of green- and manganese-decorated pottery made in the area of Italy that was to become the heartland of Renaissance 'art pottery'. Neither the British Museum nor any other museum outside Italy has a representative collection of Italian medieval pottery; all are biased towards tin-glazed pottery from north-central Italy, and most have a misleading stress on finds from Orvieto, because the medieval pits at Orvieto happened to be the object of intensive pillage before the First World War. The distinct tradition of pottery painted in various colours (so-called 'Proto-Maiolica') which flourished in Sicily and Southern Italy is not included here.

The pottery in this section differs from the rest in this book in two fundamental ways. Firstly, it has mostly been thrown away and excavated much later, whereas the rest of the catalogue consists largely of pieces that have been preserved in collections above ground. Secondly, it was made to be used; the only kinds of medieval pottery intended solely for decoration were *bacini*, dishes set into the brickwork of churches and other buildings. Tin-glazed pottery was at the upper end of the pottery market; tin had to be imported, mainly from Devon and Cornwall, and was not cheap. Vannoccio Biringuccio in his *Pirotechnia* (1540), noted: 'I have heard from people who know that the largest quantities and best tin found in Europe is what is mined in England; I have heard that it is also found in parts of Flanders, and in Bohemia and the Duchy of Bavaria, but the bizarre place names are too difficult for me'. However, by 1400 tin-glazed jugs were not too expensive to be found on the tables of the modestly prosperous, in taverns, or on the refectory tables of religious houses.

The date of the earliest Italian tin-glazed pottery is uncertain, but the technique of painting on a tin-opacified glaze rather than beneath a transparent one was widely known in northern Italy by 1250. Distinctive regional shapes and styles developed, and enough has been excavated for it to be possible to 'place'

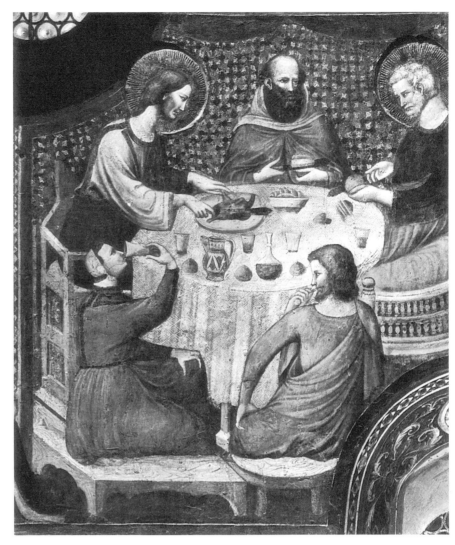

Fig. v. *The Marriage Feast at Cana*; part of a fresco in the Sanctuary of San Nicola, Tolentino, the Marches, *c.* 1340–50, showing contemporary wooden, glass, and pottery vessels at table.

most jugs to a particular region. Chronology is more difficult, and most medieval pottery is only approximately datable. Old museum collections are of little use in furthering the study of medieval pottery: they were never acquired through excavations carried out to scientific standards; many pieces have no find-spots recorded; and those given in museum records, having been filtered through dealers anxious to give the foreign buyer what they thought he wanted, have to be treated sceptically.

LITERATURE There is an enormous modern literature on the medieval pottery of Italy, much of it in *Archeologia Medievale*, the annual *Convegni internazionali della ceramica* at Albisola, and two recent conferences

(*Valbonne* 1980, and *Siena/Faenza* 1986). Some other relevant works are: Wallis 1897, 1901; Bode 1911; G. Liverani 1960, 1961; Whitehouse 1967, 1978, 1980; Cora 1973; Mannoni 1975; Mazzucato 1976; Blake 1978, 1980; *Ceramiche medioevali dell'Umbria* 1981; Francovich 1982; Mazza 1983; *La ceramica orvietana del medioevo* 1983, 1985.

1 Jug

Lazio, *c.* 1200–50

Painted in manganese and green beneath a lead glaze: trellis pattern on each side. Part of spout missing. H 19.3 cm
MLA 1897, 5–11, 5; bought from H. Wallis

An example of so-called *ceramica laziale*; the applied flaring spout is characteristic

1

3

of the Rome district (Mazzucato 1976, 1980; Whitehouse 1976, 1978; Manacorda *et al.* 1986). This type of jug was in use at the time of the introduction of tin glazes *c.* 1200–50; there are tin-glazed examples of the same form.

2 Jug

Tuscany, 14th century

Red fabric; painted in manganese and green: a human-headed bird between pointed leaves; interior and foot lead-glazed. Glaze decayed. H 21.7 cm

MLA 1908, 5–12, 2; bought from S. Bardini

This jug was stated to have been dug up beneath the dealer Stefano Bardini's house in Florence; parallels from Siena

and Montalcino (Francovich 1982, fig. 11, pp. 121–3) suggest it may have been made further south.

3 Jug

Probably the Marches, 14th century

Painted in manganese and green: an unidentified coat-of-arms; geometric decoration. Lower part and interior lead-glazed. Glaze decayed; part of rim missing. H 22.5 cm

MLA 1897, 5–11, 1; bought from H. Wallis
Bibl. Wallis 1897, fig 3; 1901, fig. 37; Rackham 1963, pl. 1B; Berardi 1984, p. 108, note 29.

The shape is characteristic of Romagna and the Marches.

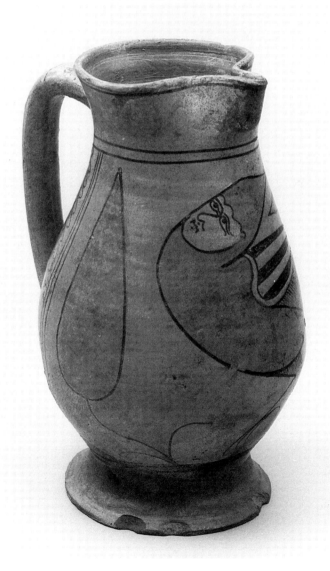

2

4 Fragments of Jug

Orvieto district, 14th century

Part of a jug, reconstructed from fragments;
painted in manganese and green: applied
female bust set in stylised tree branches;
another relief, probably a 'pine-cone',
detached from one side. Lower part and
interior lead-glazed. H (max) 17.9 cm

MLA 1910, 2–14, 28; bought from
D. Fuschini; purportedly dug up in Orvieto

Jugs with heads and 'pine-cones' in
relief have been found mainly in
Orvieto; cf. *Ceramiche medioevali
dell'Umbria* 1981, pl. 93. The
arrangement here recalls a 'Tree of
Jesse'.

From around 1905 quantities of
medieval pottery were dug up in
Orvieto and avidly acquired by
collectors and museums; cf. p. 20, and
La ceramica orvietana del medioevo 1985,
pp. 18–32.

5 Jug

Orvieto district, c. 1300–1420

Painted in manganese: beneath the lip, *S*.
Lower part and interior lead-glazed.
Reconstructed from fragments; some infill.
H 15.5 cm

MLA 1910, 2–14, 12; bought from
D. Fuschini; purportedly dug up in Orvieto

S may stand for the owner. Comparable
jugs in the BM have an asterisk, a
crossbow, a rudimentary shield of arms,
and other letters of the alphabet.

6 Jug

Orvieto district, c. 1250–1400

Painted in manganese and green: a
vigorously splayed cross beneath the lip.
Lower part and interior lead-glazed.
Restorations. H (max) 21.2 cm

MLA 1910, 2–14, 18; bought from
D. Fuschini; purportedly dug up in Orvieto

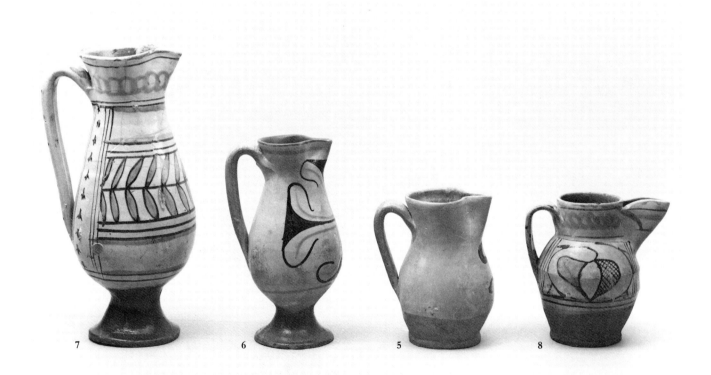

5, 6, 7, 8

7 Jug

Orvieto district, 14th century

Painted in manganese and green: foliate, cable, and arrowhead patterns in panels. Interior and foot lead-glazed. Reconstructed from fragments; some infill. H 30.5 cm

MLA 1910, 2–14, 17; bought from D. Fuschini; purportedly dug up in Orvieto

8 Jug

Orvieto district, *c*. 1300–1420

Painted in manganese and green: on either side, a leaf and stalk in a panel. Lower part and interior lead-glazed. Reconstructed from fragments; some infill. H 15 cm

MLA 1910, 2–14, 9; bought from D. Fuschini; purportedly dug up in Orvieto

9 Two-handled bowl

Perhaps Umbria, *c*. 1350–1450

Painted in manganese and green: a foliate spray, the sides cross-hatched. Exterior and part of base lead-glazed. The colours have run and the bowl warped in firing. Reconstructed from fragments; some infill. DIAM (average) 24 cm

MLA 1935, 7–23, 1; given by H. Reitlinger

10 Pharmacy/storage jar

Tuscany, *c*. 1380–1420

Painted in purple and turquoise: on each side, a diagonal band with running foliage. Interior lead-glazed. H 34.3 cm

MLA 1905, 10–12, 1; given by the National Art-Collections Fund

Bibl. Boy Sale 1905, lot 48 (as Valencian); NA-CF 2nd Annual Report 1905, pp. 18–19; Solon 1907, col. pl. 1; Bode 1911, pl. IX; Cora 1973, pl. 12; Sutton 1985, p. 119.

11 Pharmacy/storage jar

Probably Tuscany, *c*. 1400–40

Painted in manganese and turquoise: on each side, a bird among leaf sprays. Interior lead-glazed. H 21.5 cm

MLA 1898, 5–23, 7; bought from H. Wallis

Bibl. Wallis 1903, pl. 47; Bode 1911, p. 19; Rackham 1963, pl. 7C; Cora 1973, pl. 51A.

Illustrated on p. 21.

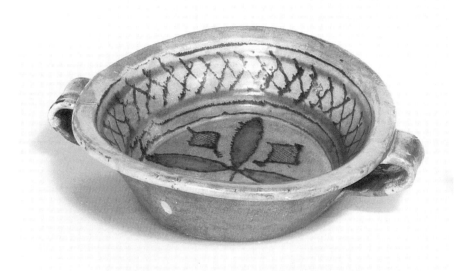

9

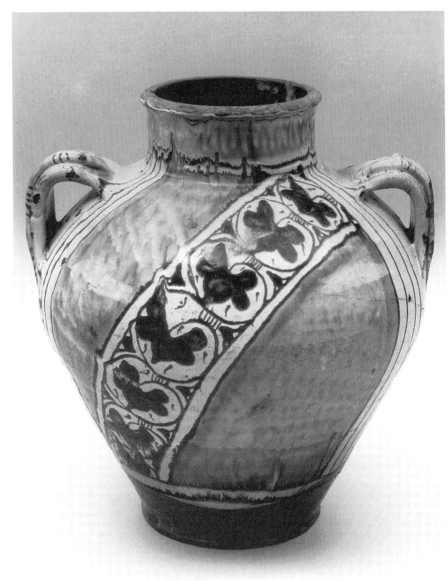

10

2 Hispano-Moresque pottery for Italian clients

The notion of earthenware as a luxury item, for display rather than use, was introduced into medieval Europe from Islam. In the fourteenth century lustred pottery of great technical and artistic quality was produced in Malaga, in Islamic southern Spain. By 1400 the centre of production had shifted to the region around the flourishing Christian port of Valencia, and Valencian lustreware became the most widely diffused luxury pottery of fifteenth-century Europe. Quantities have been found in excavations in medieval ports of southern England, such as Bristol, Southampton, and London, and it was also popular in the Low Countries; but the best customers of the Valencian potteries in the fifteenth century were the Italians, in particular the wealthy families of Tuscany, which were linked to Valencia by common involvement in the trade of the western Mediterranean. Several Florentine merchant-banking houses had branches in Valencia, and it was presumably through them that Florentine families commissioned lustreware with their arms. Pieces of this sort, made to order, were the 'top of the market': excavations in Tuscany, Liguria, and elsewhere show that a lot of less ambitious Valencian pottery was also imported.

This section illustrates the range and quality of Spanish lustreware identifiable heraldically as made for Italian clients. The earlier examples bear the arms of Florentine families. From the late fifteenth century Rome, linked to Spain by the presence of Spanish churchmen at the papal court, also became prominent in the patronage of Spanish potteries.

Imported lustrewares were known in Italy as *maiolica*. The immediate reason for this was the importance in the trading network of Majorca (*Maiolica* in medieval Italian), which lay in a pivotal position between Spain and Italy; there may also have been some confusion with the Spanish phrase *obra de melica* (Malaga work), a common term for lustreware even after Malaga had yielded to Valencia as the main production centre. Just as the word 'china' in English referred originally to blue-and-white porcelain made in China, then to English imitations, then broadened to

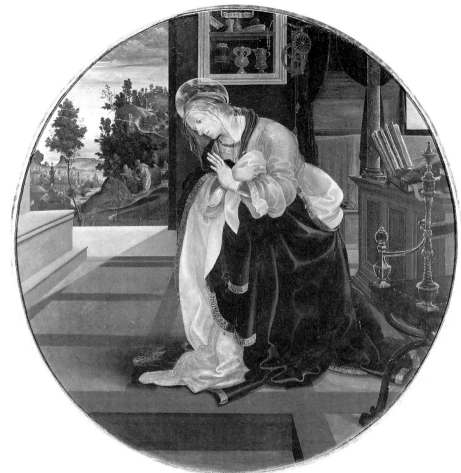

Fig. vi. The Virgin Annunciate, by the Florentine artist Filippino Lippi, 1483–4. Imported Hispano-Moresque wares are depicted in the cupboard. Pinacoteca Civica, San Gimignano.

become a general term for ceramics, so *maiolica* in Italian at first referred to Hispano-Moresque lustrewares, then to lustrewares made in Italy, and eventually broadened to include all tin-glazed pottery.

The chronology of Valencian lustrewares is uncertain, and patterns continued in use through much of the fifteenth century. It is hazardous to attribute lustrewares to particular centres in the Valencia region: Manises was the main centre for the production of high-quality export ware, but there are no marked pieces, and not enough archaeological work has been published to enable the productions of Manises definitely to be distinguished from those of Paterna and other nearby centres.

LITERATURE *Valencian lustreware*: Van de Put 1904, 1911, 1938; Frothingham 1936, 1951; González Martí 1944; Ainaud de Lasarte 1952; Husband 1970; Lerma *et al.* 1986.
On the export trade: González Martí 1948; Frothingham 1953; Blake 1972; Hurst 1977; Spallanzani 1978A; Hurst & Neal 1982;

Vince 1982; Francovich & Gelichi 1984; G. Berti & Tongiorgi 1985.

12 Dish

Probably Manises, *c.* 1420–80

Painted in blue and purple; golden-brown lustre: floral decoration; arms, *or, seven torteaux, on the middle one a cross argent*. Reverse: blue and lustre foliate and flower tendrils. DIAM 46.5 cm
BM, Godman Bequest, 1983, G 569
Bibl. New Gallery 1896, no. 478; *Godman Collection* 1901, cat. 45, no. 397, p. 33, pl. XXV.

The arms were used by descendants of Vieri de' Medici (d. 1395), who was granted the right to place a cross, emblem of the people of Florence, in the Medici arms (Litta *et al.* 1819–1923, *s.v.* Medici).

13 Dish

Probably Manises, *c.* 1420–80

Painted in blue; golden-brown lustre: floral decoration; arms of Arrighi of Florence.

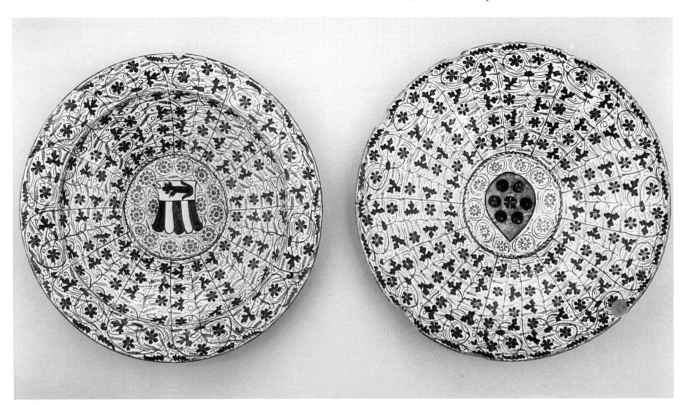

13, 12

Reverse: blue and lustre fern and flower
tendrils. Two suspension holes near edge.
DIAM 45 cm
BM, Godman Bequest, 1983, G 571
Bibl. New Gallery 1896, no. 479; *Godman
Collection* 1901, cat. 46, no. 395, p. 33,
pl. XXV; Van de Put 1904, pp. 75–6, pl. XVII.

14 Drinking vessel

Probably Manises, *c*. 1420–80

Four spouts on the body; false spout on a
handle over the top. Painted in blue; golden-
brown lustre: floral decoration; on either
side, a shield of arms. H 33.2 cm
MLA 1852, 6–30, 1
Bibl. Marryat 1857, fig. 7; González Martí
1944, pp. 276, 284, fig. 368; Frothingham
1951, pp. 181–2, fig. 150; Charleston 1968,
p. 141, fig. 397.

The arms seem to be intended as *per fess
or and azure, a lion counterchanged*. These
arms occur on some pieces with leaf
decoration (González Martí 1944,
pl. XVIII; Frothingham 1936, p. 167);
they were used by several Italian
families, including Salvi of Siena and,
with black for blue, Nori of Florence. It
has been suggested that they are here
intended, the tinctures being
accidentally reversed, for Gentili of
Florence, *per fess azure and or, a lion
counterchanged*; a dish in similar style

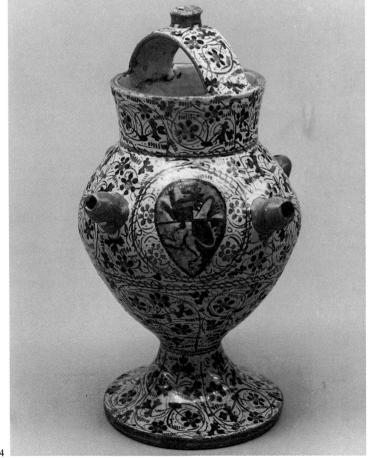

14

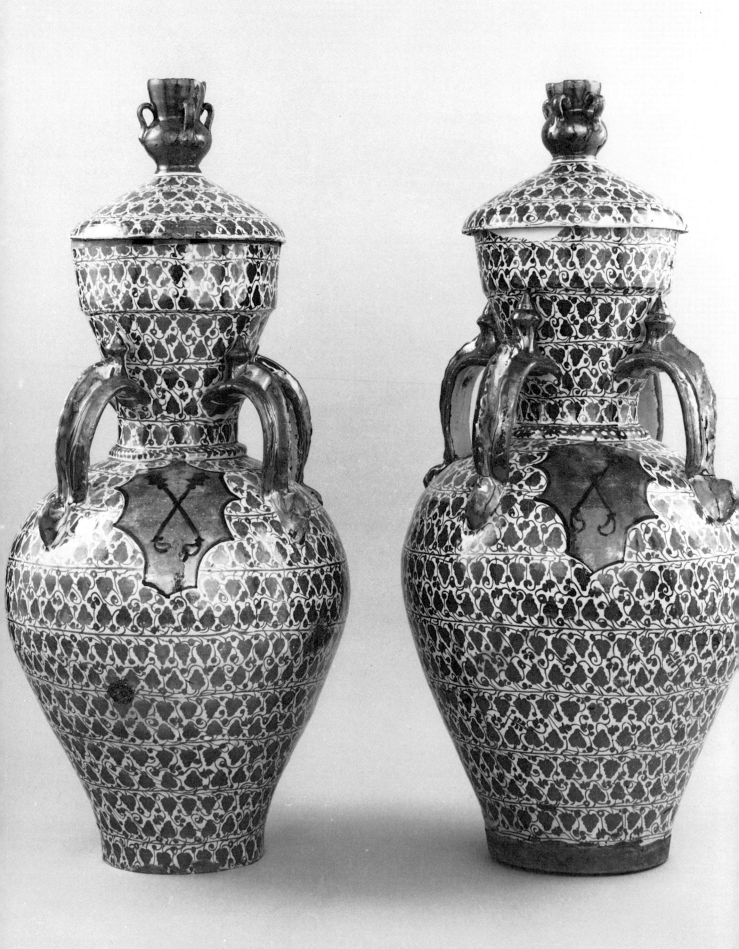

(Van de Put & Rackham 1916, no. 618) has these arms. A simple coat-of-arms like this can usually not be tied down to a particular family.

15 Two four-handled jars, with covers formed as miniature jars

Probably Manises, c. 1450–1500

On either side of each, the arms of Gondi of Florence, in blue and lustre; the rest of the surface has leaf decoration in lustre. The rims have had slots cut in, and the rims and bases have been ground down, apparently to enable the jars to be used as lamps. Part of one lid broken away. H (overall) approx. 54 cm

BM Godman Bequest, 1983, G 552–3, 554–5
Bibl. Godman Collection 1901, cat. 43, nos 246, 248, p. 33, pl. XLII; Frothingham 1951, p. 190.

Probably made for Giuliano Gondi (1421–1501), one of the leading citizens of fifteenth-century Florence. Dishes with the same arms are in the V & A (Van de Put 1904, pl. XXVII), Musée de Cluny, and Fitzwilliam Museum.

16 Jar with wing handles

Probably Manises, after 1465

Jar on high foot; wing handles with serrated edges, the upper serrations pierced with shallow holes. Painted in blue, yellow, purple; yellowish-golden lustre: leaf decoration; on each side a roundel, one with a coat-of-arms, *or, 6 torteaux and in chief a hurt charged with three fleurs de lis or*, the other blue with a yellow ring containing a pointed stone; through the ring curl two feathers, yellow and purple. The manganese has in places fired badly. H 57 cm

BM Godman Bequest, 1983, G 619; formerly Horace Walpole collection, Strawberry Hill
Bibl. Walpole 1784, p. 55 ('a large vase of Florentine fayence with the arms of the great duke'); Strawberry Hill Sale 1842, 23rd day, lot 51; Magniac Sale, Christie's, 2–15 July 1892, lot 968; *Godman Collection* 1901, cat. 36, no. 441, p. 32, pl. XL; Van de Put 1904, p. 88, pl. XXVI; Frothingham 1951, p. 128, fig. 88; T. Wilson 1984, p. 433, pl. CXLIV.

The arms are for Piero 'the Gouty' de' Medici (d. 1469) or his son Lorenzo the Magnificent. The lilies in the uppermost roundel were an augmentation granted to Piero in 1465 by Louis XI of France. The diamond ring and feathers was a Medici *impresa*.
Illustrated in colour

⬅15

17

18

17 Broad-rimmed bowl

Valencia district, after 1458

Painted in blue and purple-black; golden lustre: continuous interlinking pattern; arms, Piccolomini impaling Spannocchi, both of Siena. Reverse: lustre tendrils and fern motifs. DIAM 22.8 cm

MLA 1857, 8–4, 32; bought from T. A. Trollope
Bibl. Van de Put 1904, pp. 95–6, pl. XXXI; González Martí 1944, p. 504, fig. 621.

These arms were adopted by the Spannocchi family after Ambrogio di Nanni Spannocchi served as Treasurer to Pius II (Piccolomini), Pope from 1458 to 1464. Cf. González Martí 1944, p. 514, fig. 627. Sienese arms are less frequent than Florentine on Valencian lustreware: Van de Put (1904, p. 22) lists two other examples.

18 Two tiles

Probably Valencia region, after 1513

Moulded in relief with a linking strapwork design, and the arms of Medici, surmounted by the papal tiara and crossed keys; the strapwork picked out in pale-golden lustre, the arms painted in purple and blue. Chipped and worn. Each tile 14 cm square

MLA 1883, 11–6, 8 & 9; given by A. W. Franks
Bibl. Wallis 1902, p. xxiv; Papini 1914, pp. 69–71; Lane 1939, p. 29, pl. IXC; 1960, p. 71; Rackham 1940A, pp. 179–80; Gonzáles Martí 1952, p. 654.

These tiles formed part of the pavement in the Chapel of Pope Leo X (the first of the Medici Popes, 1513–21) inside the papal fortress in Rome, the Castel Sant'Angelo. The relief decoration is a Spanish technique; it has been argued (Mazzucato 1985) that these Castel Sant'Angelo tiles are imitations made in Liguria, but recent analysis of the clays suggests they are Spanish imports. Pavements for the Vatican had already been ordered from Spain in the 1490s by the Spanish Pope Alexander VI (Borgia).

3 Florentine relief-blue jars

Until the late fourteenth century the colours used by central and north Italian potters were normally limited to green and manganese. A decisive departure before 1400 was the introduction in Tuscany and elsewhere of an overwhelming blue, sometimes verging on black and usually slightly in relief from the surface. The characteristic decorative motif on relief-blue pottery was a stylised 'oak-leaf' spray, among which the painters included human figures, birds, animals and heraldic devices. In pottery from the Florence district this decoration is found mainly on bulbous two-handled storage jars, a form that had already been in use in Tuscany in the fourteenth century. Although jars of this type are not painted with a drug name, some bear devices which can be connected with monastic hospitals, and most were made for hospital pharmacies. The scale of this business was remarkable: a contract made in 1430–1 records an order for something like a thousand jars of various shapes and sizes placed by the Florence hospital of Santa Maria Nuova with the workshop of Giunta di Tugio, in the southern part of the city. Scattered all over the world, a series of relief-blue jars survive painted with the crutch emblem of the hospital, and these may well have been part of this commission; they are marked beneath the handle with an asterisk in manganese, which has been thought to be the workshop mark of Giunta di Tugio. Neither Valencian lustreware nor any of the pottery of medieval Europe has recognisable workshop marks of this sort; in this sense, relief-blue is the earliest 'documentary' pottery in post-classical Europe.

LITERATURE Wallis 1903; Bode 1911; Cora 1973.

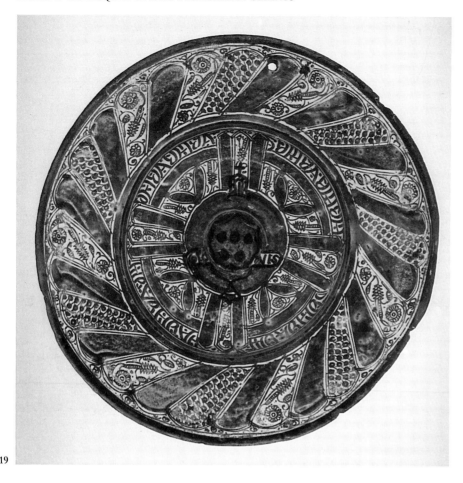

19

19 Dish

Perhaps Valencia region, after 1513

Painted in blue; golden-brown lustre: arms of Medici, surmounted by a papal tiara, and GLOVIS. The decoration includes pseudo-Roman letters and spiral gadrooning following the moulded form of the dish. Reverse: lustred fern scrolls and concentric lines. Suspension hole in rim. DIAM 39.4 cm
MLA 1892, 6–17, 2; given by F. D. Godman
Bibl. Drake Sale, Christie's, 30 June–3 July 1891, lot 544; T. Wilson 1984, p. 436, pl. CILa.

The arms and motto are those of Pope Leo x. A dish in Bologna (Ravanelli Guidotti 1985A, no. 278) and a jug in Arezzo (Francovich & Gelichi 1984, fig. 2) may have formed part of the same set.

GLOVIS was a cryptic *impresa* used by Leo x and by his brother Giuliano de' Medici. According to Paolo Giovio, the explanation was that, backwards, it read *si volg*, 'it turns', referring to the turn of Fortune's wheel; but according to Vasari it stood for *Gloria, Laus, Onor, Virtus, Iustitia, Salus* (Glory, Praise, Honour, Virtue, Justice, Safety).

20 Pharmacy/storage jar

Florence district, *c.* 1420–50; perhaps workshop of Giunta di Tugio

Painted in manganese and relief-blue: on each side a lion rampant amidst 'oak-leaf' sprays. Under one handle, three asterisks. Patches of glaze have run off the body.
H 35.4 cm
MLA 1903, 5–15, 1; bought from H. Wallis
Bibl. Wallis 1903, fig. 21; 1905A, col. pl. I; Bode 1911, pl. XIX; Cora 1973, p. 77, fig. 81b.

The lions rampant are akin to the heraldic beasts on Hispano-Moresque.

Mark: Cora 1973, M222.
Illustrated in colour

21 Pharmacy/storage jar

Florence district, *c.* 1420–50; perhaps workshop of Giunta di Tugio

Painted in manganese and relief-blue: on each side a man in contemporary costume, between 'oak-leaf' sprays. Beneath each handle, an asterisk. On one side the glaze has run. Part of rim broken away. H 36 cm

MLA 1902, 4–24, 1
Bibl. Wallis 1903, figs 10, 11; Solon 1907, col. pl. III; Bode 1911, pp. 16, 18; Cora 1973, figs 56, 57c, p. 75.
Mark: Cora 1973, M226.
Illustrated in colour

22 Pharmacy/storage jar

Florence district, *c.* 1420–60; possibly workshop of Giunta di Tugio

Painted in manganese and relief-blue: 'oak-leaf' sprays. Beneath one handle, an asterisk. Damaged by heat near base. H 12.3 cm

MLA 1898, 5–23, 4; bought from H. Wallis
Mark: cf. Cora 1973, M226.
Illustrated in colour

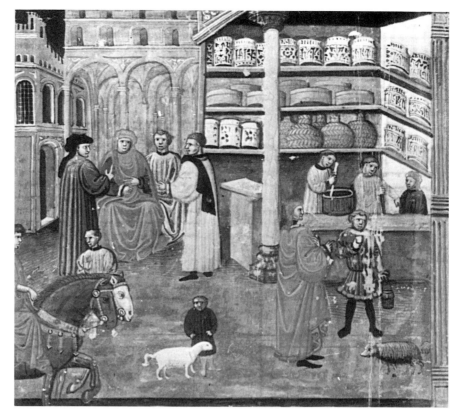

Fig. vii. A fifteenth-century Italian pharmacy. Miniature, *c.* 1440, from a manuscript of the *Canon* of Avicenna. University Library, Bologna.

23 Pharmacy/storage jar

Perhaps Florence district, probably 1448–51

Painted in relief-blue and purple: on one side, a shield of arms beneath a cardinal's hat, *gules two swords crossed in saltire argent the points downwards, the hilts azure*; on the other, a lion rampant. Broken and reconstructed. H 32.8 cm

MLA 1898, 5–23, 1; bought from H. Wallis
Bibl. Wallis 1903, figs 14, 15; Bode 1911, p. 15; Rackham 1963, pl. 2A; Cora 1973, figs 80a, 80c, pp. 77, 79.

The arms are probably for Cardinal Astorgio Agnese of Naples, Archbishop of Benevento and governor of Bologna; he was made cardinal in 1448 and died in 1451. This identification is uncertain, since his tomb (Santa Maria sopra Minerva, Rome) shows his arms with a *bordure indented*, but must be correct if the bizarre hat is a cardinal's. This jar is the only known example of a personal coat-of-arms on pottery of this type, which was usually commissioned by institutions, and is a rare datable example of relief-blue.

The shape of cylindrical storage jar called *albarello* is of Islamic origin. It was made in Italy in the fourteenth century, but most surviving Italian examples date from *c.* 1450 or later; cf. Pesce 1971.
Also illustrated in colour

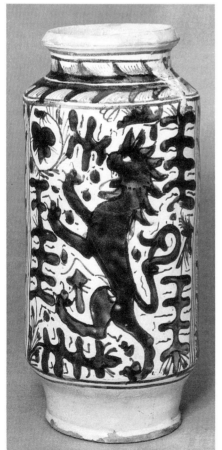

23

4 Early Renaissance decoration

From about 1450 the maiolica workshops of north-central Italy developed a brilliant new decorative language, using a wider range of colours and developing ornamental ideas from abroad. In Tuscany, which more than anywhere else had seen high-quality imports from Valencia, the potters took up the Valencian flower design and, more hesitantly, the leaf pattern. East of the Apennines, Faenza, Pesaro, and other centres developed a rather different style, in which 'peacock feathers' and so-called 'Persian palmettes' are prominent; these motifs distantly echo Oriental patterns and may have been inspired by textiles. Other design elements included pointed leaves gently curving in continuous friezes, or vigorously curling in the style known as 'Gothic'; interlaced strapwork; a delight in profile figure-drawing; the use of groups of dots, hatching, or tight curls to fill empty space; and the effective device known as the 'contour panel', in which a central subject is emphasised by an outline frame that roughly echoes its shape and separates it from a more densely ornamented part of the surface. The style that developed from these various elements spread through north-central Italy and as far south as Naples. The greatest compendium of early Renaissance ornament is the beautiful pavement made by workmen from Faenza for the church of San Petronio in Bologna; it bears the date 1487, and it was in this period that Faenza began to establish itself as the most innovative and technically accomplished of Italian pottery towns. The balance of form and decoration achieved on the best of this later fifteenth-century maiolica is perhaps as pleasing as has ever been achieved by pottery anywhere.

LITERATURE For the traditional classification of styles, based on Faenza, see Ballardini 1938, pp. 20–30; G. Liverani 1958A, pp. 13–19; for Tuscany, Cora 1973; for Naples, Donatone 1970, 1976; for Pesaro, Berardi 1984.

24 Pharmacy/storage jar

Florence district, *c.* 1450–80

Painted in blue, orange, purple, green, black, red: decoration imitating Valencian flower pattern; arms, *or, a griffin rampant sable, overall a bend gules*. Under each handle, *pp* above

Above: **Fig. viii.** Part of the pavement, with the date 1487, in the Vaselli Chapel, Church of San Petronio, Bologna.

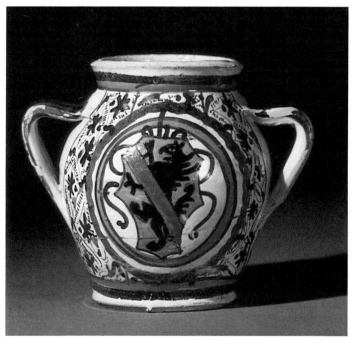

24

short vertical dashes. H 13.3 cm
MLA 1906, 4–18, 2; bought from H. Wallis
Bibl. Wallis 1904, figs 94–5; Cora 1973,
pl. 167a.

The arms are Grifoni of Florence
(Amayden 1910, I, p. 432). From the
same set: BM 1906, 4–18, 3; Rackham
1940A, no. 331. For a comparable set
from the hospital of Santa Fina, in San
Gimignano, cf. Vannini 1981, pp. 64–5,
84–5. For the mark, cf. Cora 1973,
M114–M117.

25 Pharmacy/storage jar

Probably Tuscany, *c.* 1440–80
Painted in blue and manganese: panels
containing leaves; dots, dashes, and
squiggles. The blue has misfired. H 24 cm
MLA 1898, 5–23, 5; bought from H. Wallis
Bibl. Wallis 1904, fig. 4

A ponderous imitation of Hispano-
Moresque. Cf. Cora 1973, group VIIE.

26 Two tiles

Perhaps Viterbo, *c.* 1470
Painted in blue: a profile of a young man;
and a swirling quatrefoil of 'Gothic' foliage.
10.9 cm square (1895, 10–23, 5); 10.6 cm
square (1895, 10–23, 6)
MLA 1895, 10–23, 5 & 6; bought from
H. Wallis
Bibl. Wallis 1902, p. xv, figs 10, 11; Rackham
1940A, pp. 60–1.

Part of the pavement of the Mazzatosta
Chapel in the church of Santa Maria
della Verità in Viterbo: the chapel
frescos are dated 1469. Some of the
figures in the frescos are from life, and
the tiles may be too. It is not certain
whether the tiles were made by local or
itinerant workmen, or imported from a
specialist workshop elsewhere. (Cf. a
similar pavement at Abbadia San
Salvatore in southern Tuscany). Most of
the pavement is still in the church; other
tiles are in the V&A, and Rotterdam.
See Ricci 1888, pp. 28–9, 65; Wallis
1902, pp. xv–xvi; Lane 1960, p. 49;
Kuyken 1964; Mazzucato 1981. The
suggestion that the tiles are by the
Paulus Nicolai whose name appears on
a later pavement in the Viterbo church
of Santa Maria della Peste (*Il
Quattrocento a Viterbo*, Viterbo 1983,
p. 197) seems improbable.

27 Jug

Probably Umbria, *c.* 1450–80
Painted in blue, black, yellow, purple, green:
'Gothic' foliage; under the lip, a contour
panel containing an owner's mark (a crossed
circle with a dot in each quarter, surmounted
by a cross). Interior lead-glazed. The black
has bubbled and the glaze discoloured in
firing. Restoration to lip. H 17 cm
MLA 1898, 5–23, 3; bought from H. Wallis
Bibl. Wallis 1905A, fig. 42

28 Dish

Probably Deruta, *c.* 1470–90
Painted in blue, orange, green: in a contour
panel, a young man holding a spear and
shield; around the panel, flowers and
tendrils; pointed leaves on rim. Reverse lead-
glazed; two suspension holes in foot.
DIAM 38 cm
MLA 1899, 6–15, 1; ex-Zschille collection
Bibl. Falke 1899, no. 2; Wallis 1905A, fig. 37;
Faenza 5 (1917), pl. VI; Rackham 1963, p. 15,
pl. 12; Hausmann 1972, p. 145; Giacomotti
1974, pp. 137–8.

Fragments of similar design have been
found at Deruta (cf. Magnini 1934,
pl. XX).
 If the dish were to hang from the
holes in the foot-ring it would hang
askew; curiously, the same is true of
numerous Deruta dishes.
Illustrated in colour

29 Pharmacy/storage jar

Perhaps Naples, *c.* 1465–80
Painted in blue, turquoise, orange, purple: a
crowned shield of arms, Aragon quartering
Hungary, France, Jerusalem. Reverse:
symmetrical 'Gothic' foliage. H 31.4 cm
MLA 1856, 6–12, 1
Bibl. Molinier 1888, p. 73; Wallis 1904,
fig. 32; Donatone 1970, pl. I; 1974A,

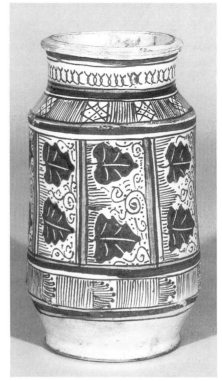

25

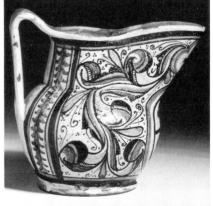

27

26

fig. 253; Giacomotti 1974, p. 30; Berardi 1984, p. 131; Mallet 1986, p. 424.

The arms are those of the Aragonese kings of Naples. A similar jar in the Louvre (Giacomotti 1974, no. 97) bears the arms of Alfonso II of Aragon and Ippolita Sforza, who were married in 1465; this provides a rough date for a series of jars which Donatone has argued were made for a royal pharmacy in Naples. In style they resemble products of north-central Italy and may have been made by immigrants to Naples.

30 Pharmacy/storage jar

Probably Naples, *c.* 1480–1500

Painted in blue, orange, yellow, green, purple: in a garland flanked by 'Gothic' foliage, a man in contemporary costume and *Tulio*[?]. *Roma*; on the reverse, a panther(?). H 32.5 cm

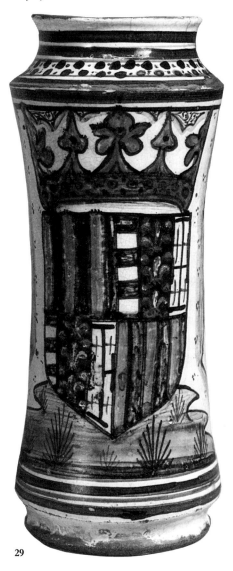

29

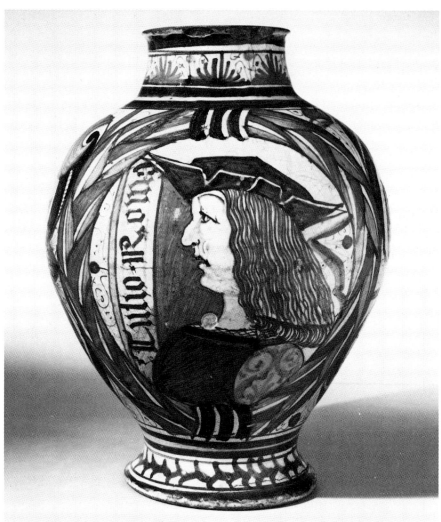

30

MLA 1919, 11–14, 1; bequeathed by E. B. Ede
Bibl. Donatone 1983, pl. 21, figs 9, 10.

The back resembles church pavements in Naples, particularly the Brancacci Chapel in Sant'Angelo a Nilo (Donatone 1981, pl. 2; cf. pl. 34C, 37C, 37D). Some comparable pharmacy jars of the period have identifiable portraits, but Tulio (Julio?) is unidentified.

31 Pharmacy/storage jar

Emilia-Romagna, the Marches, or Umbria, *c.* 1470–1500

Painted in blue, orange, green, purple: decoration including wavy rays, flowers, and 'peacock feathers'; in roundels, a young man, *yhs* (twice), and an unidentified shield of arms, *vert, a bend argent*. H 28.5 cm

MLA 1874, 6–12, 2; given by A. W. Franks
Bibl. Wallis 1904, fig. 40.

The ornament is paralleled on pieces attributed by Berardi (1984) to Pesaro.

32 Broad-rimmed bowl

Faenza, *c.* 1480–1510

Painted in blue, orange, yellow, purple, green, white: profile of a young man; on the rim, roundels with 'Persian palmettes'. Reverse: blue and purple rings and a blue spiral. DIAM 21.7 cm

MLA 1878, 12–30, 412; Henderson Bequest
Bibl. Henderson 1868, pl. VII; Wallis 1905A, fig. 26.

33 Bottle

Probably Faenza, *c.* 1480–1510

Painted in blue, green, orange, yellow: bands of decoration incorporating rays, rosettes, flowers, and tendrils; on one side, a blank scroll. Restoration to rim. H 25.7 cm

MLA 1898, 5–23, 10; bought from H. Wallis

The scroll is blank for the contents to be added by the user. A similar jar (Bojani *et al.* 1985, no. 77) has the drug name painted on. The rosettes are akin to the 'Persian palmette' (32).

34 Pharmacy jar

Probably Pesaro, *c.* 1470–90

Painted in blue, yellow, green, and orange: a monk and a nun; between them, on a scroll, *HUMILITAS ALTA PETIT* (Humility aspires to the heights). Reverse: a young man and woman facing each other. The figures are in contour panels; the background decorated with flowers and tendrils. Around the base, *.sy.de.fumoterre* (syrup of fumitory). H 37.3 cm

MLA 1885, 5–8, 21; given by A. W. Franks
Bibl. Berardi 1984, p. 130, fig. 34.

This jar and 35 are probably from the same set as two at Ecouen (Giacomotti 1974, nos 94, 95). Their authenticity has been doubted (Rasmussen 1984, p. 62), but scientific analysis supports their genuineness. The motifs are paralleled by fragments from Pesaro (Berardi 1984, figs 31, 37, 44, 72). The strongly characterised faces, especially of the men, suggest they are drawn from life.

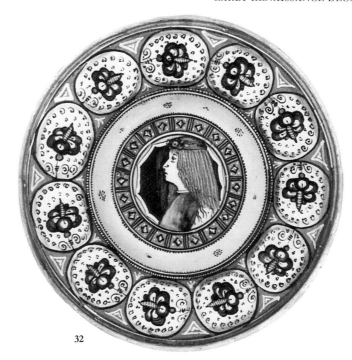

32

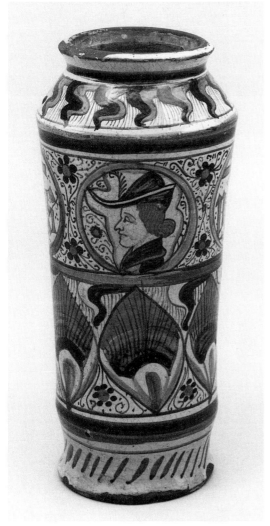

31

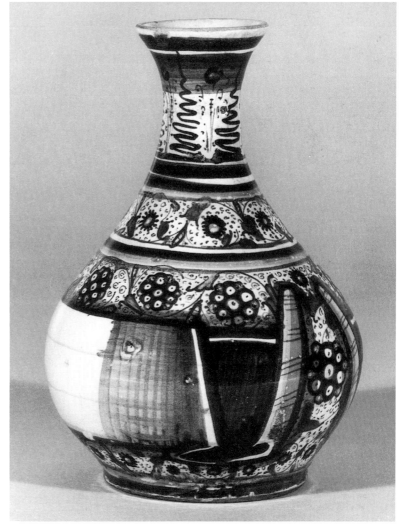

33

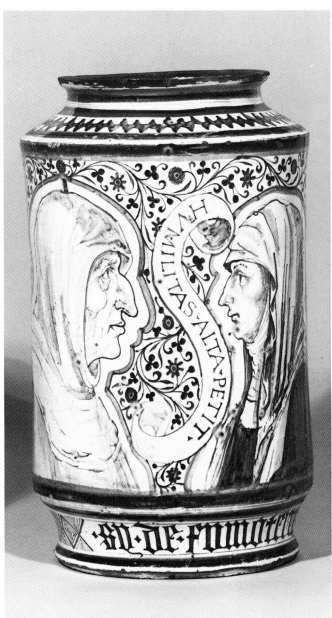

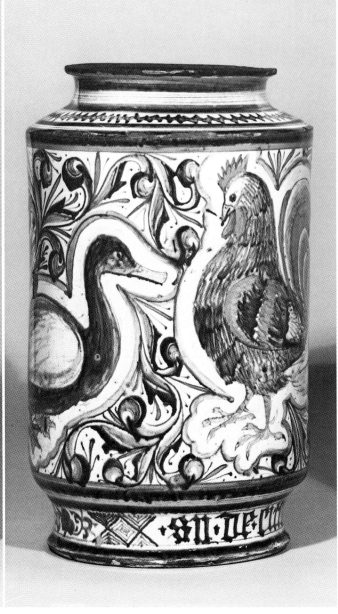

34

35

35 Pharmacy jar

Probably Pesaro, *c.* 1470–90

Painted in blue, orange, purple, yellow: a cock, a duck, a peacock clutching an egg, and a goose, in contour panels against 'Gothic' leaves. Around the base, *.sy.de.citro* (lemon syrup). H 36.6 cm

MLA 1885, 5–8, 22; given by A. W. Franks

*Bibl.*Berardi 1984, p. 130, fig. 33.

36 Pharmacy/storage jar

Probably the Marches, *c.* 1480–1500

Painted in blue, orange, yellow, green: bands of decoration, incorporating four roundels with contemporary hunting scenes.
H 28.4 cm

MLA 1855, 12–1, 60

Bibl. Bernal Sale 1855, lot 1843; Borenius 1930, p. 25; Rackham 1940A, pp. 44–5.

Berardi (1984) suggests this type was made in Pesaro; cf. Vydrová 1973, nos 7, 8.
Illustrated in colour

5 *Istoriato* maiolica: the first phase

By about 1500 technical control of colour and increasing drawing skill in maiolica workshops made possible the development of a new kind of 'art pottery', in which the whole surface was treated like a canvas for painting. By about 1515 *istoriato* ('story-painted') pottery was being made in Emilia-Romagna, the Marches, Umbria, and Tuscany. It was at this point in its development that Italian maiolica for the first time aspired to the condition of 'fine art'; the superb achievements of the early *istoriato* painters were up-market products intended unequivocally for display rather than use. Factory-marks and dates are found increasingly frequently (though individual artists' signatures are unusual before 1520). For this reason scholarly research into High Renaissance maiolica begins to focus less on archaeology (*istoriato* was never more than a tiny part of the production of any factory, and fragments are excessively rare in excavations) and more on art-historical method, attempting to reconstruct the work of particular workshops and painters on stylistic criteria: in this section for the first time the reader will find attributions to individual painters.

Although some of the earliest *istoriato* painting cannot be attributed to particular towns, the most dynamic centre from 1500 to 1520 was Faenza; this section is dominated by pieces made there. Some are painted on the bluish (*berettino*) glaze particularly favoured by Faenza potters; nearly all of them have blue as their keynote colour, in contrast to the heavier use of orange and brown in the *istoriato* of the following generation.

37 Panel

Origin uncertain, 1493

Painted in blue, green, orange, purple: the Virgin and Child. On the unglazed reverse: GIORGIO . LOMBARᴰ *1493*. 26 × 26.5 cm
MLA 1884, 7–26, 1; given by J. C. Robinson; from the wall of a house in Treviso
Bibl. Robinson in Fountaine Sale 1884, supplement, p. 23 (*The Times*, 2 June 1884); Wallis 1897, fig. 32; 1905A, fig. 5; Ballardini 1933–8, I, no. 14, figs 13, 234.

One of the earliest dated pieces of *istoriato* maiolica; 'Giorgio of

37

Lombardy' may be the artist, but nothing is known of him.

38 Pharmacy jar

Deruta, 1501

Painted in blue, orange, yellow, green, black: within a wreath, soldiers fighting; in medallions, a monogram (*P*,*A*, and perhaps *M*,*Q*) incorporating a double cross, and a moor's head. Reverse: ribbons and *1501*.
H 38 cm
MLA 1855, 12–1, 61
Bibl. Bernal Sale 1855, lot 1845; Rackham 1915, p. 34, pl. 1G; Falke 1914–23, I, Introduction; Ballardini 1933–8, I, no. 23, fig. 21; Fiocco & Gherardi 1983, pp. 91–2.

This jar, 139, and 150 formed part of an imposing series made for an unidentified ecclesiastical pharmacy (similar *albarelli* dated 1501: Rackham 1940A, no. 390; Ballardini 1933–8, I, no. 24; Shinn 1982, no. 12; Chompret 1949, no. 870). Numerous smaller *albarelli* with the same emblems exist. This is the largest, the only one with an *istoriato* scene, and the only one without a drug name.

The scene may be based on a woodcut.

39 Plaque

Origin uncertain, 1506

Painted in black, blue, yellow, orange, purple, green: the dead Christ supported by angels. Inscribed . . . *M. 19. ZO 1506 pax vobis* (. . . M. 19 June(?) 1506. Peace be with you).
15.6 × 12.5 cm
MLA 1904, 4–18, 1
Bibl. Marryat 1850, p. 15, fig. 4; Marryat Sale 1867, lot 860; Ballardini 1933–8, I, no. 36, fig. 29.

Probably a 'pax', to be kissed by participants in the Mass. The composition echoes engravings by Nicoletto da Modena (B XIII, p. 267, no. 21, or *Ill. Bartsch*, 25, Commentary, p. 218, no. 068).

40 Plate

Perhaps Faenza, *c*. 1510–20

Painted in blue-grey, yellow, purple, orange, green, brown, white: the Death of the Virgin. Reverse: polychrome foliate ornament and refined scale pattern.
DIAM 26.3 cm
MLA 1878, 12–30, 407; Henderson Bequest

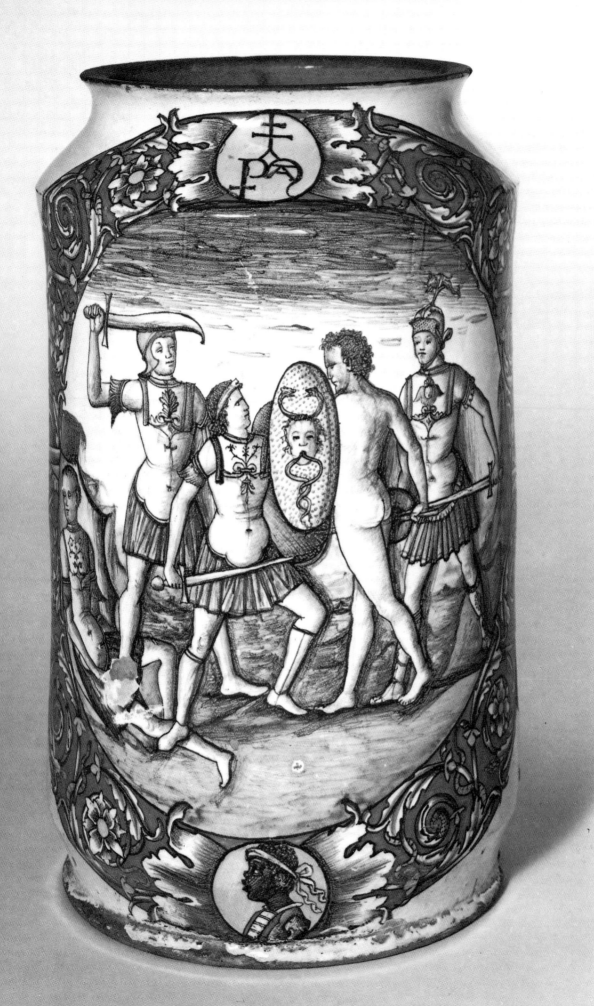

38

Bibl. Henderson 1868, pl. VIII; Fortnum 1896, pp. 256–7; Falke 1907, p. 108; Sauerlandt 1929, pp. 78–9, pl. VII; Rackham 1930A, pl. XXXIA, p. 146; 1940A, p. 86; G. Liverani 1958A, p. 26, fig. XVIII; Fourest 1983, pl. 39.

The subject is from the engraving by Israel Van Meckenem (B VI, p. 223, no. 50) after Martin Schongauer. Different scholars have attributed different pieces to this painter (the 'Master of the Death of the Virgin'), but none of these attributions seems fully convincing.

Also illustrated in colour

41 Bowl

Faenza, *c*. 1515–25

Painted in blue, yellow, green, red, orange, white, purple: Christ manhandled by soldiers in an architectural setting; grotesques incorporating *putti*, masks, moons, and winged faces. Reverse: blue and orange hatched arches and IN FAENCA.

DIAM 19.1 cm

MLA 1878, 12–30, 405; Henderson Bequest

Bibl. Delange 1853, pp. 103, 111; Fould Sale 1860, lot 2107; Robinson 1862, no. 5168; Fortnum 1873, p. 490; Rackham 1930B, p. 79; 1940A, p. 86; Ballardini 1938, p. 31; G. Liverani 1958A, p. 26; Mallet 1974, p. 11, pl. XII; Ravanelli Guidotti 1985A, p. 72.

The figures are extracted from the woodcut *Christ before Annas* (John 18)

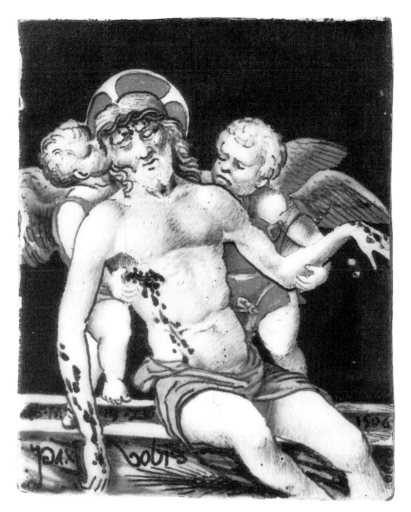

39

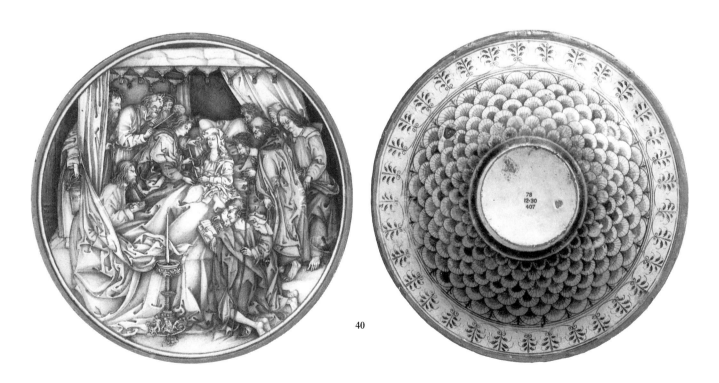

40

by Dürer, *c.* 1509 (B VII, p. 120, no. 28), or one of the early copies.

Rackham's attribution of this bowl to the painter of 40 is questionable; cf. 42. *Illustrated in colour*

42 Bowl

Faenza, *c.* 1515–25

Painted in blue, green, yellow, orange, brown, white: Christ in the tomb showing his wounds, the shaft of the cross behind him; grotesques incorporating winged monsters and children's heads. Reverse: blue and orange hatched ornament; in the centre, three concentric circles, crossed, with four tangent loops. DIAM 19.4 cm

MLA 1855, 12–1, 111

Bibl. Bernal Sale 1855, lot 2086; Fortnum 1873, p. 490; Solon 1907, fig. 13; Rackham 1940A, p. 81.

The border resembles 41, and the bowls are probably products of the same workshop, perhaps both by the same artist as 184. The mark resembles Argnani 1898, pl. XL, no. xxxiv. *Illustrated in colour*

43 Bowl

Origin uncertain, *c.* 1510–20

Painted in blue, yellow, green, orange, brown, white: St Jerome in a landscape; round the sides, flowers and trophies of arms on a ground alternating blue and yellow, divided by cornucopias. Reverse: blue and orange hatched circles; in the centre, DO in monogram. DIAM 20.2 cm

MLA 1878, 12–30, 406; Henderson Bequest
Bibl. Castellani Sale 1871, lot 68; Fortnum 1873, p. 504; Guasti 1902, p. 56.

The delicate painting has affinities with pieces attributed to Faenza, Deruta, and Siena.

43

44 Dish on low foot

Probably Faenza, *c.* 1520–35

Blue-grey glaze; painted in blue, green, yellow, orange, purple, white: a young man and woman quarrelling; an old man and Cupid behind them; musical instruments scattered in the foreground. Reverse: blue floral sprays and interlace. DIAM 20.2 cm

MLA 1855, 12–1, 90

Bibl. Bernal Sale 1855, lot 1983.

45 Dish

Attributed to the 'Master of the Bergantini bowl', Faenza, 1525

Greyish-blue glaze; painted in blue, brown, green, yellow, orange, red, white: the battle of Lapiths and Centaurs; arms: Guicciardini impaling Salviati; at the bottom, an upturned jug lettered .VIC. and .I. Reverse: scale pattern; within the cut-away foot, a yellow wreath, *1525*, and a mark resembling an inflatable ball. Shattered and reconstructed. DIAM 29.3 cm

MLA 1855, 12–1, 65

Bibl. Bernal Sale 1855, lot 1872; Fortnum 1873, p. 478; Solon 1907, col. pl. VI; Ballardini 1933–8, I, no. 161, figs 152, 303R; 1940, pp. 3–9, pl. I; Verlet 1937, p. 184; G. Liverani 1939A, pp. 6–7, pl. III(b); Rackham 1940A, p. 100; 1951, p. 110.

From a set made for Francesco Guicciardini and his wife Maria Salviati; see 202. The story (Ovid, *Metamorphoses* 12) is the fight between the Lapiths, a people of Thessaly, and the Centaurs, half-man half-horse, after the Centaurs drank too much at a Lapith wedding. VIC. I. is unexplained. The painting seems to be by the same artist as a bowl (Bojani *et al.* 1985, no. 104) marked as made in 1529 in the workshop of Piero Bergantini, who is documented from 1503 to 1537. For other works attributed to this painter, see G. Liverani 1939A, pp. 6–7. The style echoes Luca Signorelli.

The mark of a circle crossed, with a dot or circle in one corner, occurs on much Faenza maiolica of the first half of the sixteenth century. It appears to represent an inflatable ball, with its valve (Norman 1969; Mallet 1974). The old view that it is the mark of the workshop called the Casa Pirota seems untenable. *Illustrated in colour*

44

46 Panel

Attributed to the 'Master of the Bergantini bowl', Faenza, 1527

Greyish-blue glaze; painted in blue, white, green, yellow, orange, purple, brown, red, black: the Adoration of the Magi; on a tablet, *1527* and a mark resembling an inflatable ball. On the unglazed reverse, a yellow disc with .B., F, B, *1527* F. 44 × 34.6 cm

MLA 1855, 12–1, 78

Bibl. Bernal Sale 1855, lot 1934; Fortnum 1873, p. 478; Ballardini 1933–8, I, no. 203, fig. 188; G. Liverani 1939A, p. 6; Rackham 1940A, pp. 99–100; 1951, p. 110.

Two plaques with the same subject similarly treated are dated 1525 and 1528 (Ballardini 1933–8, I, nos 160, 216); a similar one (*ibid.*, no. 234) is marked F *1529* F.

47 Panel

Perhaps by the 'Master of the Bergantini bowl', Faenza, *c.* 1525–30

Greyish-blue glaze; painted in blue, white, green, yellow, orange, brown, black: the Virgin, Child, and infant St John, with Catherine of Alexandria and other saints; in roundels, the Angel Gabriel and the Virgin, and St Francis and St Dominic; background of grotesques. 42.2 × 34.7 cm

MLA 1855, 12–1, 77

Bibl. Dodd Sale, Christie's, 2 March 1846, lot 23; Bernal Sale 1855, lot 1933; Fortnum 1873, p. 478.

46

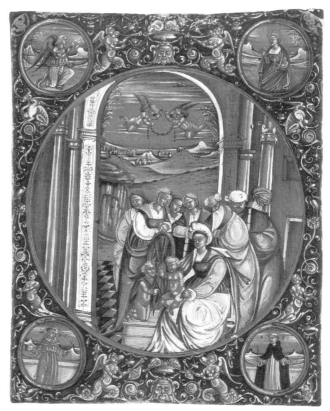

47

48 Dish on low foot

Probably Faenza, *c.* 1525–30

Painted in blue, yellow, orange, brown, white, green: Ananias writhing in his death agony before St Peter. Reverse: blue and orange hatched arches and a rosette.

DIAM 27.3 cm

MLA 1855, 3–13, 8; given by A. W. Franks

Bibl. Ravanelli Guidotti 1985A, p. 76.

Based on an engraving (B XIV, p. 47, no. 42) after Raphael's design for the Sistine Chapel tapestries. According to Acts 5, Ananias sold some land and gave only part of the proceeds to the Apostles; he was accused of deceit by St Peter and fell dead.

48

6 Nicola da Urbino

The painter who signed 'Nicola da Urbino' is the Raphael of maiolica painting. His early work, which dates from about 1520 and is the earliest identified *istoriato* from the Urbino region, has an incomparable lyricism, touched with gaucheness; within ten years, with the help of Marcantonio-school engravings, he had, more than anyone else, created the classic style of High Renaissance maiolica.

Some confusion was caused in the past by the assumption that Nicola da Urbino was the same man as Nicola Pellipario of Castel Durante, the father of the Urbino potter Guido Durantino. Recent research in Urbino archives, however, has demonstrated that Nicolò da Urbino was almost certainly a man called Nicola di Gabriele Sbraga (or Sbraghe), who is recorded in Urbino from 1520 and died in 1537/8. The documents give us additional information: that Nicola was already called *maestro* in 1520; that he had a workshop of his own; and that he had regular business contacts with Guido Durantino.

The study of Nicola's work starts from five signed pieces. A central group of three is made up of a fragment in the Louvre (59) with a monogram of *NICOLA* and *da Vrbino*; a plate in Florence with a similar monogram *NICHOL[A]*, marked as made in 1528 in the workshop of Guido Durantino; and a remarkable recent discovery, the plate in Novellara signed 'I, Nichola, painted it' (62). Two other plates are apparently signed by him: a dish in Leningrad with *NICOL* in monogram and *1521*; and 63, which has *Nicola da .V.* on the back. From the marked pieces it is possible to attribute to Nicola two splendid armorial sets – one, which must have been the most prestigious commission in Urbino in the 1520s, for Isabella d'Este, Marchioness of Mantua; the other for a member of the Calini family of Brescia. Unquestionably by the same painter, and to all appearances rather earlier, are some exquisite plates in Venice, a series to which no. 49 may originally have belonged. In these services, graceful figures move in an idyllic landscape and among pure Renaissance buildings, with a poetic quality never achieved on maiolica before or since.

Nicola in this phase was one of the most inventive of maiolica painters.

62

Many pieces of the Correr, Este, and Calini sets have subjects from Ovid's *Metamorphoses* and compositions suggested by the primitive woodcuts in the Venice edition of 1497; but Nicola had an effortless talent for arranging figures in a landscape to fit the awkward spaces on maiolica plates, and his figures take on a grace and energy quite foreign to the woodcuts. Nicola often repeated subjects: for instance, the story of Midas, Pan and Apollo occurs on all three sets; in each case the debt to the Ovid woodcut is apparent, but each composition is freshly conceived. Nicola stands, in this, in impressive contrast to Francesco Xanto Avelli, who tended, once he had devised a composition for a subject, to use it with little variation over and over again.

By 1530 some of the imaginative quality had gone from Nicola's work. The impressive signed plate in the Bargello and 62 are based on Marcantonio engravings, which left less scope for creative imagination than the humble Ovid woodcuts. At the same time a change in colouring came over

his work, from the blue-dominated pastel tones of the early period to the browner colouring characteristic of the 1530s (a development that affected other Urbino painters too). Most critics have felt a relative tiredness in some of the work of this period, but the issue is confused by uncertainty in distinguishing Nicola's later work from that of followers. The issue focuses round 63, which some have felt to be too mediocre to be by Nicola; yet the mannerisms and the handwriting on the

reverse are certainly his. The solution may be that artistic responsibility in a maiolica workshop where the workshop head was himself a painter was more confused than modern art-historians find convenient.

LITERATURE Fortnum 1873, pp. 323–7; Wallis 1905B; Falke 1917; Rackham 1922, 1928; G. Liverani 1939B; Polidori 1962; Wallen 1968; Rasmussen 1972; Mallet 1981; Negroni 1986.

49 Broad-rimmed bowl

By Nicola da Urbino, Urbino, *c.* 1520

Painted in blue, yellow, green, grey, brown, orange, white: the Calumny of Apelles; in the well, a bull with a quill (the emblem of St Luke the Evangelist) and *bianco sopra bianco* roundels on the sides. DIAM 27.9 cm

Ashmolean Museum, Oxford (Fortnum Bequest)

Bibl. Pourtalès Sale 1865, lot 1718; Fortnum 1873, p. 485; 1896, p. 194, pl. XIV; 1897, pp. 72–3, C474; Solon 1907, col. pl. XX; Rackham 1922, pp. 127–8, pl. IIB; 1963, pl. 68; Hausmann 1972, p. 232; Mallet 1976, p. 17, fig. 7; 1978, p. 400, pl. II; Massing, forthcoming.

This plate is similar to a set of seventeen plates in the Correr Museum, Venice, and has an identical *bianco sopra bianco* pattern to some of them; it and a plate in Berlin (Hausmann 1972, no. 170) may come from the same set.

This and 50 treat the same subject, known as the Calumny of Apelles. The Greek writer Lucian gave a description of an ancient painting by Apelles, an allegory of the power of slander. On the right is a judge with long ears 'which might be taken for those of Midas'; before him Calumny, a young woman, accuses an innocent prisoner; at the back, naked Truth. Other figures, according to Lucian, represent Ignorance, Suspicion, Envy, Deceit, etc. Lucian's description was taken up by Alberti in his influential treatise on painting, and various Renaissance artists produced versions of the subject, the most famous being Botticelli's in the Uffizi. Massing has shown that Nicola's ultimate source in his treatments of the subject was Signorelli's (lost) fresco in the Palazzo Petrucci, Siena. It may be that the design was provided for Nicola by one of Signorelli's collaborators, Girolamo Genga (cf. pp. 113; Verlet 1937; Rackham 1951).

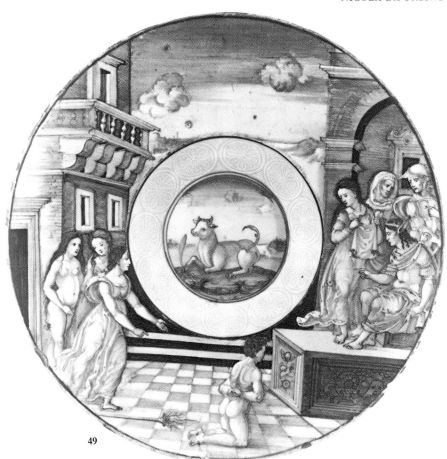

49

50 Dish

Attributed to Nicola da Urbino, Urbino, *c.* 1520–5

Painted in blue, green, yellow, orange, brown, black, purple, white: the Calumny of Apelles; *bianco sopra bianco* on the sides of the well; on the rim, grotesques incorporating masks, scrollwork, dolphins, a shield of arms (Ridolfi of Florence), and tablets with indecipherable lettering. DIAM 53 cm

Rijksmuseum, Amsterdam; from the Royal Cabinet of Curiosities at The Hague; bought in Lucca in 1826 by J. E. Humbert

Bibl. Förster 1894, p. 28; Falke 1914–23, II, fig. 1; Rackham 1922, p. 127; Heukensfeldt-Jansen 1961, no. 19; Hausmann 1972, p. 232; Massing, forthcoming.

A reworking of the theme of 49.

51 Broad-rimmed bowl

By Nicola da Urbino, Urbino, *c.* 1525

Painted in blue, green, yellow, brown, orange, purple, white: left, Apollo and the dead Python; top, Cupid kindling Apollo's love for Daphne; right, Apollo pursuing Daphne, who is being changed into a tree; bottom, the river-god Peneus, Daphne's father; in the well, a shield of arms, Gonzaga impaling Este, supported by *putti*; on a

scroll, NEC SPE NEC METV (without hope and without fear); hanging from a tree, a shield with gold bars heated in a crucible. Reverse: yellow rings. H 27.1 cm

MLA 1855, 12–1, 103

Bibl. Bernal Sale 1855, lot 2049; Fortnum 1873, pp. 324–5; Solon 1907, col. pl. XXI; Rackham 1922, p. 128, pl. IID; 1930A, p. 149, pl. XXXV; G. Liverani 1939B, p. 8; Chompret 1949, fig. 118; Jestaz 1972–3, part I, note 33; Chambers & Martineau 1981, no. 131.

The arms and motto are those of Isabella d'Este (1474–1539), one of the most discriminating art-collectors of the Renaissance. The gold bars were an *impresa* of her husband Francesco Gonzaga, Marquess of Mantua, indicating tried and proven integrity.

Twenty-one pieces (two large dishes, the rest roughly this size) of this set survive, all painted by Nicola. All, except two Biblical subjects, have scenes from ancient mythology, mainly Ovid's *Metamorphoses*. Cf. G. Liverani 1937A, 1938, 1939B; Wallen 1968; Hausmann 1972, pp. 232–5; Mallet 1981; Rasmussen 1984, pp. 158–62.

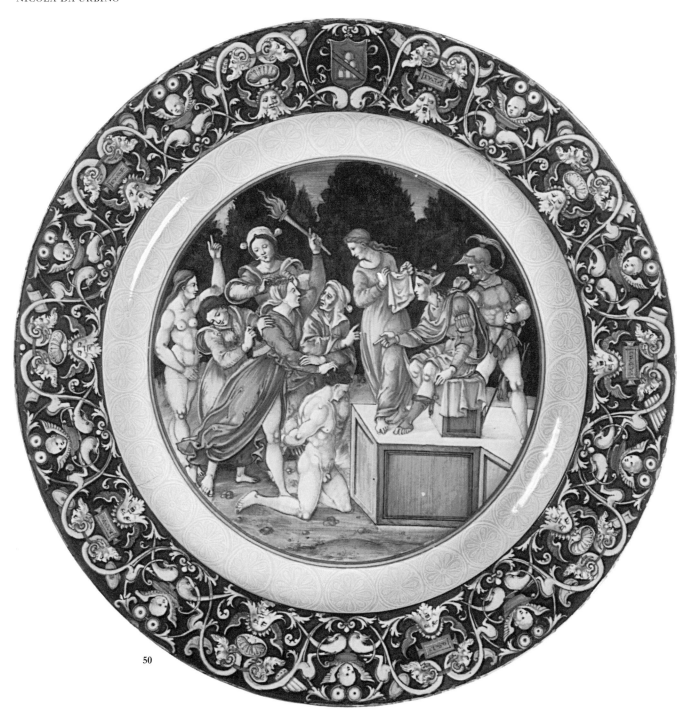

50

The stories of how Apollo killed the monster Python, and how Daphne was rescued from Apollo's amorous intentions by being turned into a laurel tree, are from Ovid, *Metamorphoses* 1. The combination of the stories and outline composition are derived from the woodcut in the 1497 Italian Ovid, fol. VIIr. Peneus, an addition of Nicola's, is ultimately based on the ancient statue in Rome known as 'Marforio', which had long been known but only recently recognised as a river-

god (Haskell & Penny 1981, no. 57; Rubinstein 1984).
Illustrated in colour

52 Dish on low foot

By Nicola da Urbino, Urbino, *c.* 1525
Painted in green, grey, blue, yellow, orange, brown, black, white: Trajan stops outside Rome to hear a petition for justice; on a tower, a wreathed shield of arms, Gonzaga impaling Este; on a tree stump, a tablet with NEC SPE NEC METV. Reverse: yellow rings.
DIAM 26.9 cm

MLA 1855, 12–1, 96
Bibl. Bernal Sale 1855, lot 2015; Fortnum 1873, p. 324; Chambers & Martineau 1981, no. 137.

From the same set as 51.
 The subject is the medieval legend of how the Emperor Trajan turned back his army to see justice done to a woman whose son had been killed. Dante imagined a sculptural frieze with the story, and Nicola's scene looks like an illustration to *Purgatory*, X, 77–81:

'There was at Trajan's bridle a widow in an attitude of tearful grief. Round about him was a trampling throng of horsemen, and above them the eagles of gold seemed to move in the wind'. The figure of Trajan, like countless other Renaissance horsemen, is ultimately derived from the ancient statue of Marcus Aurelius in Rome.
Illustrated in colour

53 Dish

By Nicola da Urbino, Urbino, *c.* 1525

Painted in blue, yellow, green, brown, orange, black, white: the arms of Calini supported by *putti*; on the sides, *bianco sopra bianco*; on the rim, left to right, Apollo with his lyre, Tmolus, Pan playing his pipes, Pan defeated, Midas, Tmolus, Apollo playing a *lira da braccio*. Reverse: yellow rings.
DIAM 41.6 cm
MLA 1855, 12–1, 73
Bibl. Bernal Sale 1855, lot 1910; Rackham 1922, p. 27; 1928, pp. 230–6, pl.IIIA; 1945, p. 148, pl. IIB; Polidori 1962, p. 350; Giacomotti 1974, p. 250; T. Wilson 1985A, p. 79, pl. XXIX.

The story of the music competition between Apollo and Pan is from Ovid, *Metamorphoses* 2. The judge, the mountain-god Tmolus, awarded the prize to Apollo; King Midas was given ass's ears for disagreeing. The figures are inspired by the woodcut in the 1497 Ovid, fol. LXXXXIIIIr.

A large plate with the companion subject of Marsyas flayed by Apollo (Getty 1985, no. 175), 54–58, and four other plates (Giacomotti 1974, no. 820; Rackham 1928, pl. IIID; Watson 1986, no. 45; Damiron Sale 1938, lot 57) also survive from a service made by Nicola for one of the Calini family of Brescia, perhaps the lawyer Luigi Calini (cf. a plate with a ladder in a shield and LC, Bernardi 1980, no. 85). The set resembles the probably rather larger one made for Isabella d'Este, but is not quite its equal in quality. In neither set is there any demonstrable unifying theme, though more than half the subjects in both are from the *Metamorphoses*. Nicola also treated the subject of Apollo, Pan, and Midas in the Correr and Este sets; each of the three compositions is different.

Nicola has given the right-hand Apollo a Renaissance (bowed) *lira da braccio*, as in the woodcut; on the left he holds a classicising (plucked) lyre; the Italian word *lira* included both

instruments (Winternitz 1967, pp. 90, 155).
Illustrated in colour

54 Broad-rimmed bowl

By Nicola da Urbino, Urbino, *c.* 1525

Painted in brown, orange, green, blue, yellow, black, white: Phalaris watching Perillus being roasted alive in the bull; in the centre, the arms of Calini, supported by *putti*. On the column bases, NERQ . . . and SPQR with IS in monogram. Reverse: yellow rings. DIAM 27 cm
Royal Museum of Scotland, Edinburgh, 1897. 327a (Dundas Bequest)
Bibl. Rackham 1928, pp. 230–5, pl. IA.

The subject is the classical story of Phalaris, the brutal tyrant of Agrigentum, who commissioned from Perillus a bronze bull in which to roast his enemies alive; when it was finished Phalaris made the inventor its first victim.

SPQR (Senatus Populusque Romanus) is comprehensible, but NERQ and IS are examples of an irritating habit of Nicola's of putting inexplicable letters on architectural details. The figure of Phalaris resembles the judge in 49 and 50.

55 Broad-rimmed bowl

By Nicola da Urbino, Urbino, *c.* 1525

Painted in blue, brown, orange, yellow, green, white, black: Cycnus changed into a swan by Neptune; centre, the arms of Calini, supported by *putti*. Reverse: yellow rings. DIAM 27 cm
Royal Museum of Scotland, 1897. 327b (Dundas Bequest)
Bibl. Rackham 1928, p. 235, pl. IB; 1945, p. 148, pl. IID.

Cycnus, son of Neptune, was invulnerable to weapons; he was strangled by Achilles, but changed at the last moment into a swan (Ovid, *Metamorphoses* 12).

The circular temple, like the one on 53, is an exercise in Renaissance fantasy architecture characteristic of Nicola. Rackham suggested that they were directly influenced by Bramante's 1502 *tempietto* at San Pietro in Montorio, Rome. Laurana's Ducal Palace in Urbino (fig. xxxii) was an incomparable source of architectural ideas; cf. Watson 1986, p. 114; Bernardi 1980.

56 Broad-rimmed bowl

By Nicola da Urbino, Urbino, *c.* 1525

Painted in blue, green, brown, yellow, orange, black, white: left, Perseus flying to rescue Andromeda from the monster; right, Perseus holding the head of Medusa, with Pegasus behind; centre, the arms of Calini, supported by *putti*. Reverse: yellow rings.
DIAM 26.8 cm
Royal Museum of Scotland, 1897. 327c (Dundas Bequest)
Bibl. Rackham 1928, p. 235, pl. IC.

Perseus, son of Jupiter and Danae, had winged sandals, a gift from Mercury. He killed the Gorgon Medusa, whose head turned into stone anyone who looked at it; from her blood was born the winged horse Pegasus. Perseus then saved the princess Andromeda from a sea-monster (Ovid, *Metamorphoses* 4). The composition echoes the woodcut in the 1497 Ovid, fol. XXXIIIIv. A different version of the subject by Nicola is in the V&A (Rackham 1940A, no. 549); another from the Este service is in Boston.

57 Plate

By Nicola da Urbino, Urbino, *c.* 1525

Painted in green, blue, black, brown, grey, orange, yellow, white: right, a man carrying a dead hare; left, dogs attacking hares, and a man blowing a horn; on a hillside, a shepherd; on a tree, a shield of arms of Calini. Reverse: yellow rings. DIAM 26.4 cm
Royal Museum of Scotland, 1897. 327d (Dundas Bequest)
Bibl. Rackham 1928, p. 235, pl. IIB; 1963, pl. 70A.

The subject is unidentified.

58 Plate

By Nicola da Urbino, Urbino, *c.* 1525

Painted in blue, green, brown, yellow, orange, black, white: St George attacking the dragon; the maiden runs away; in the background, a fortified town; on a tree, a shield of arms of Calini. Reverse: a yellow ring. DIAM 26.2 cm
Royal Museum of Scotland, 1897. 327e (Dundas Bequest)
Bibl. Rackham 1928, p. 235, pl. IIA.

59 Fragment

By Nicola da Urbino, Urbino, *c.* 1525–8

Centre of a plate, cut down, the foot cut away. Painted in blue, green, yellow, orange, brown, white: Apollo with his lyre, and seven of the nine Muses. Reverse: *Elmonto de*

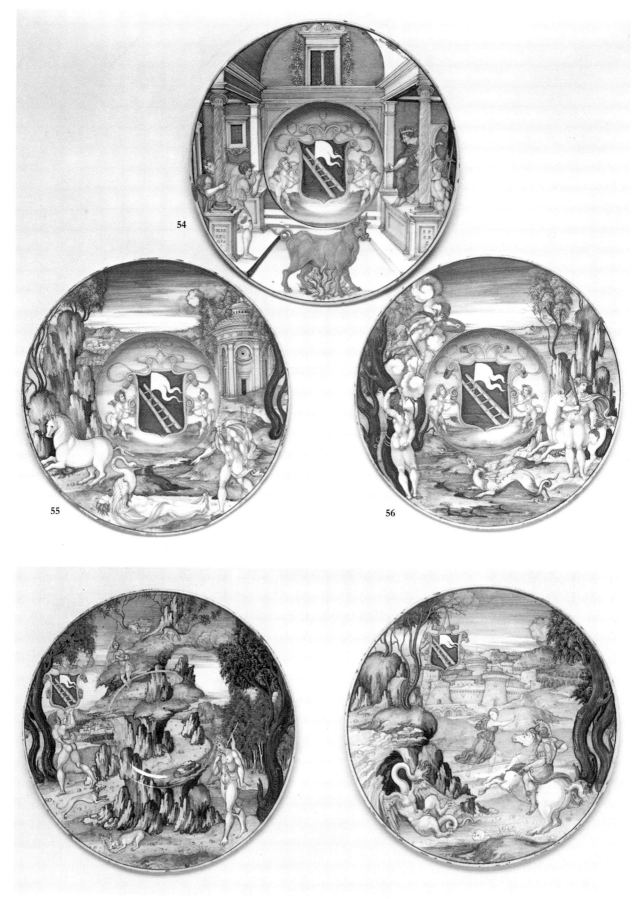

54

55

56

57, 58

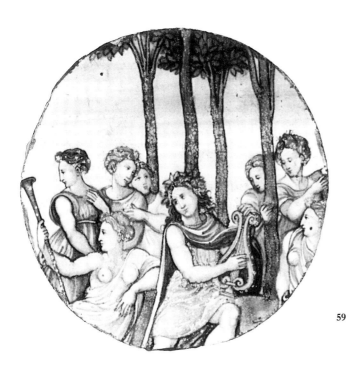

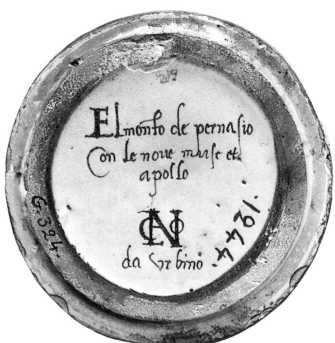

59

pernasio Con le noue muse et apollo (Mount Parnassus with the nine Muses and Apollo) *NICOLA* (in monogram) *da Vrbino*.
DIAM 14 cm
Musée du Louvre, Paris, OA 1244
Bibl. Darcel 1864, G324; Darcel & Delange 1869, pl. 100; Fortnum 1873, p. 324; Wallen 1968, pp. 95–6, figs 2–3; Giacomotti 1974, no. 829.

After the engraving by Marcantonio (B XIV, p. 200, no. 247), after Raphael's design for the Vatican *Stanze*, of Apollo and the Muses and poets on Mount Parnassus. The earliest example of Nicola's use of Raphael compositions is the 1521 plate in Leningrad (Kube 1976, no. 58). There are no examples in the Calini set, but five in the Este set. This fragment is perhaps the earliest of Nicola's surviving works to describe the subject on the back, a practice which became standard in Urbino workshops.

60 Dish

Circle of Nicola da Urbino, Urbino, *c.* 1525–30
Painted in blue, green, brown, orange, black, purple, white: in the boss, Athene with her pipes; top, Athene playing to the gods; left, Apollo playing a *lira da braccio*, with Marsyas, who has thrown down his pipes; right, Apollo flaying Marsyas. On the border, grotesques, incorporating human- and horse-headed monsters, classicising medallions, and tablets with indecipherable

squiggles. Reverse: yellow rings, and a wreath *alla porcellana*. DIAM 51.2 cm
MLA 1885, 4–20, 1
Bibl. Fortnum 1873, p. 326; Fountaine Sale 1884, lot 59; Rackham 1922, p. 127, pl. IIA; 1935, p. 109; 1940A, p. 182; Norman 1976, p. 99; Mallet 1980, pp. 157–8, pl. XXIX; Moore 1985, no. 24.

The story of Apollo and Marsyas is told briefly in Ovid *Metamorphoses* 6, but in detail in the 1497 Italian paraphrase (fol. XLIXv). At a feast of the gods Pallas Athene played the pipes, but she looked so comical that the gods laughed at her; she came down to earth and, disgusted by her reflection in a pool as she played, threw the pipes away. They were found by Marsyas, who learnt to play them and challenged Apollo to a music competition, on condition that the winner could do what he liked with the loser; Apollo won and flayed Marsyas. The painter has rearranged the figures from the Ovid woodcut.

This plate and two with comparable borders, one in Oxford dated 1526 (Fortnum 1897, C431) and one in the Wallace Collection (Norman 1976, C41), are close in style to Nicola but may be partly or wholly by an associate. For the border, cf. also 50.
Illustrated on the title page

61 Plaque

By Nicola da Urbino, and/or an associate, Urbino, *c.* 1525–30
Painted in blue, brown, grey, green, orange, yellow, purple, white: the Virgin and Child with St Joseph and the infant St John. Damaged lower left. 28 × 22 cm
MLA 1885, 5–8, 28; given by A. W. Franks
Bibl. Robinson 1862, no. 5205.

62 Dish

By Nicola da Urbino, Urbino, *c.* 1530
Painted in blue, green, yellow, orange, brown, black, purple, red, white: the cup found in Benjamin's sack (Genesis 44); on a building, a shield of arms of Manzoli of Bologna, *barry of four argent and sable, a chief gules*. Reverse: yellow rings and *Chom lifrateli de Joseff for gointi a Vna hostaria e fuli trauati inum Sacho de grano Vna taza doro Ioni Chola pinsitt* (how the brothers of Joseph came to an inn and a gold cup was found in a sack of grain. I, Nichola, painted it). Broken and repaired. DIAM 42 cm
Church of Santo Stefano, Novellara
Bibl. Cuppini 1962, pp. 44–7, fig. 3; F. Liverani 1985.

Joseph, sold into slavery, rose to be governor of Egypt. During a famine his brothers came to buy corn in Egypt. To detain his youngest brother Benjamin, Joseph had a silver cup planted in Benjamin's sack. Elements of the composition seem to be derived from an

61

63

engraving (B XV, p. 11, no. 7), perhaps after Raphael.

Unfortunately it has not been possible to include this item in the exhibition; it is illustrated on p. 44.

63 Plate

By Nicola da Urbino, perhaps with assistants, Urbino, *c.* 1535

Painted in blue, grey, yellow, green, orange, brown, black, white: an animal sacrifice. Reverse: yellow rings and *Chome li atiniensi Sagrificharo a la dea diana* (how the Athenians sacrificed to the goddess Diana) *Nicola da .V.* Broken and repaired. DIAM 26 cm

MLA 1855, 3–13, 23; given by A. W. Franks

Bibl. Darcel 1864, p. 181; Fortnum 1873, p. 324; Rackham 1922, p. 27; 1933, pl. 61; G. Liverani, 1939B, p. 12; Wallen 1968, p. 100, note 2, figs 8, 9; Rasmussen 1972, pp. 52–3; Scott-Taggart 1972, p. 53; Mallet 1981, p. 169, note 6; Ravanelli Guidotti 1985A, p. 132; F. Liverani 1985, pp. 392–3; T. Wilson 1985A, p. 71, pl. XXIII.

The composition owes much to an engraving of *The Sacrifice of Noah* by Marco da Ravenna (B XIV, p. 6, no. 4). Nicola had a workshop of his own and probably employed assistants; his name on this plate is not in itself proof that he himself painted it. However, the handwriting is certainly his, and the present writer does not fully share the view that this plate 'to judge by its miserable quality, has more to tell us about workshop practice than about the hand' of Nicola (Mallet 1978, p. 400). Nicola's later work is decidedly uneven in quality.

64 Plate

Attributed to Nicola da Urbino, Urbino, *c.* 1533–5

Painted in blue, green, orange, brown, yellow, grey, black, white: right to left, Venus, Diana, Minerva, Mercury, Apollo, with river-gods, in a landscape with ruins; on a tree, a shield of arms beneath a circlet. Reverse: yellow rings and *del Chonseglio de Apollo .e. minerua* (of the council of Apollo and Minerva). DIAM 27.5 cm

MLA 1855, 12–1, 55

Bibl. Bernal Sale 1855, lot 1809; G. Liverani

1955, p. 12; Norman 1976, p. 191; Chambers
& Martineau 1981, no. 195; Mallet 1981,
pp. 166–9, fig. 5.

The iconography is obscure. The figures
are selected from an engraving by
Caraglio after Rosso of *The Muses and
Pierides* (B XV, p. 89, no. 53). The arms
are those of Federico Gonzaga, Duke of
Mantua (son of Isabella d'Este), and
Margherita Paleologo, who were
married in 1531. Two pieces with the
same arms attributed to Nicola, another
by Xanto dated 1533, and two more
attributed to Nicola with Federico's
impresa of Mount Olympus, may all have
been part of the same set. Cf. Chambers
& Martineau 1981, pp. 198–200; Mallet
1981, pp. 167–9. One of the 'Olympus'
pieces (G. Liverani 1939B, p. 13) has a
companion subject ('the parliament of
Apollo and Minerva') to this plate.

65 Dish on low foot

Castel Durante, 1526

Painted in blue, grey, yellow, green, orange,
brown, purple, black, white: a banquet; on
the right, Ascanius, Dido, and Aeneas.
Reverse: in yellow, *1526 In castel durante*.
Broken and repaired. DIAM 28.3 cm

MLA 1855, 12–1, 97

Bibl. Bernal Sale 1855, lot 2017; Fortnum
1873, p. 299; Ballardini 1933–8, I, no. 186,
figs 181, 322R; Giacomotti 1974, p. 244.

The subject is taken, in reverse, from the
Quos Ego engraving by Marcantonio
(p. 127). Cupid, disguised as Aeneas' son
Ascanius, is embraced by Dido and wins
her heart.

 This artist wrote *In castel durante* on
the back of *istoriato* dishes dated 1524,
1525, and 1526 (Ballardini 1933–8, I,
nos 164–6, 184–9; Chompret 1949,
figs 125–6), and is known as the 'In
Castel Durante* painter' (Mallet 1970–1,
part 2, p. 340; Rasmussen 1984, p. 164).
His work has occasionally been
confused with Nicola's (he was
unflatteringly called 'Pseudopellipario'
by Rackham), but his style is distinct.
His alarming incompetence at
perspective drawing is counterbalanced
by the charm of his colouring.

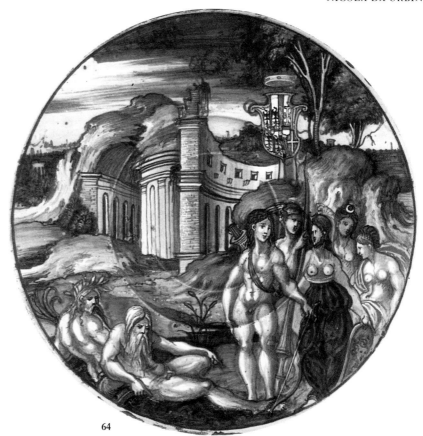

64

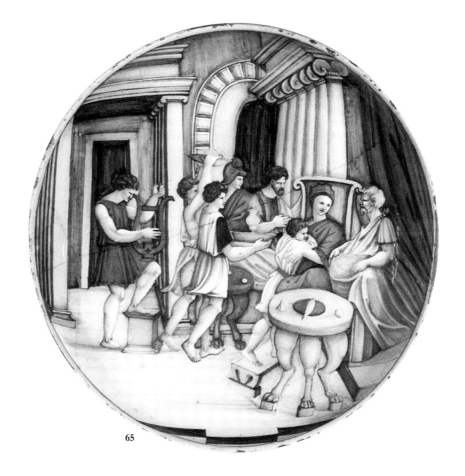

65

7 Francesco Xanto Avelli, 'FLR' and 'FR'

This section deals with the work of the most extraordinary personality in the history of maiolica. Francesco Xanto Avelli of Rovigo made a habit between 1530 and 1542 of signing and dating his work and adding informative notes, from which we can build up a picture of his reading and interests.

Xanto seems to have thought of himself as a man of culture. He was well-read in Italian poetry (particularly Petrarch) and had some knowledge of classical literature. He wrote poetry; 75 illustrates a scene from one of his poems. On other pieces he illustrated contemporary political events or devised elaborate moral allegories. He signed works more regularly than any maiolica painter before (or since). His figure style is grounded in Marcantonio-workshop engravings: sometimes he takes over whole compositions; more often he takes single figures from engravings and reworks them to produce compositions of his own – a technique that degenerates at times into scissors-and-paste pastiche. Xanto is something of a parody of 'Renaissance man'; but it is in his work that maiolica painting reflects most widely the culture of the High Renaissance.

It is known from documentary evidence and signed pieces that from 1530 Xanto worked mainly or entirely in Urbino. A document in the Urbino archives (Negroni 1986, p. 18; cf. Vanzolini 1879, I, p. 337) records an agreement made by five workshop heads in Urbino (Guido Durantino, Nicola di Gabriele, Giovanni Maria di Mariano, Guido di Merlino, and Federico di Giannantonio) to resist claims for an increase in pay made by a group of workmen including Xanto; the 'bosses' agreed not to employ any of the 'trade unionists' without the agreement of the others. It may be somehow as a result of this dispute that Xanto began to sign works in full.

There has been much argument about what work can be attributed to Xanto before his first fully signed work in 1530. Four distinct groups of *istoriato* plates and dishes are involved:

1) Unsigned works with inscriptions ending in words like *fabula, istoria,* or *nota* and a closing diagonal stroke resembling *y* (71, 72, 192).

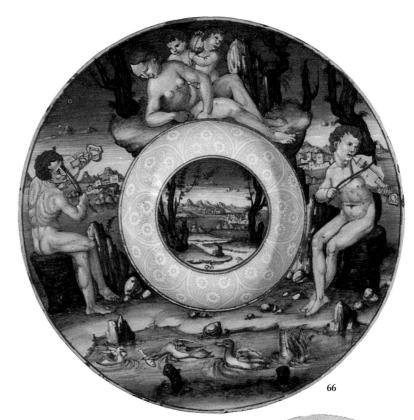

66

2) Dishes signed 'FLR' (70).
3) Pieces signed 'FR' (69).
4) Other pieces dating from the 1520s apparently by 'FR'.

This exhibition offers visitors the opportunity to make up their own minds on the problem. The catalogue entries have been written in the belief that categories 1) and 2) are by Xanto, *c.* 1527–30, and that 3) and 4) *may* represent his early work.

LITERATURE Fortnum 1873, pp. 344–50; Rackham & Ballardini 1933; Prentice von Erdberg 1950–1; Rackham 1957A; Norman 1965; Petruzzellis-Scherer 1980; Mallet 1970–1 (part 3), 1976, 1984; *Dizionario Biografico degli Italiani*, s.v. Avelli.

66 Broad-rimmed bowl

Attributed to the 'Master of the Resurrection Panel', perhaps Urbino district, *c.* 1520

Painted in blue, green, yellow, brown, orange, white, black: a watery landscape with two men, each playing a *lira da braccio*, and a woman with two children, one with a lute; *bianco sopra bianco* on sides of well. Reverse: blue and orange foliate scrolls and interlace; in the centre, T and B in monogram. DIAM 29.1 cm

MLA 1855, 12–1, 54

Bibl. Bernal Sale 1855, lot 1808; Fortnum

1873, pp. 497, 533–4; 1896, p. 255, mark no. 290; Solon 1907, col. pl. XIX; Ballardini 1933A, p. 37, pls Xb, XId; Rackham & Ballardini 1933, pp. 393, 395, fig. 1; Rackham 1930B, p. 78; 1940A, p. 260; 1957A, pp. 99, 102; 1963, pl. 58; G. Liverani 1958A, p. 34; Mallet 1970–1, part 3, p. 170; 1980, p. 158, pl. XXVIII.

The authorship of this plate is controversial. Rackham and Ballardini attributed it to 'FR' at Faenza. The only piece, however, unquestionably by the same painter is a dish in the De Ciccio collection, Capodimonte, Naples, similar in subject and identically decorated on the back. Although it is

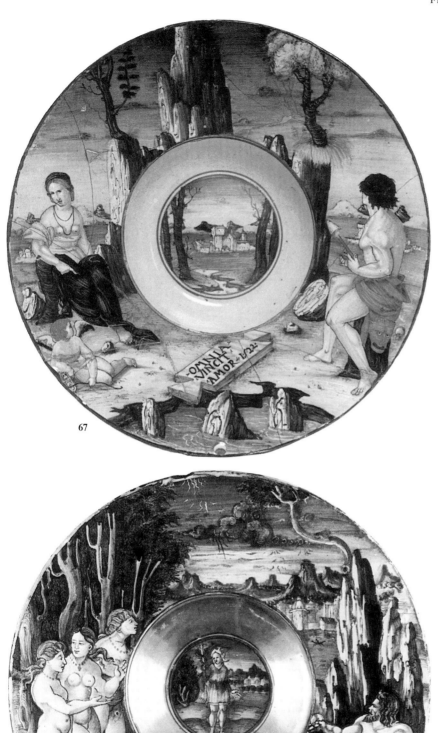

67

68

open to doubt whether the initials on the back refer to the painter or workshop, the writer believes these plates to be by the painter of two panels with a similar monogram, one with the Resurrection (Rackham 1940A, no. 275), the other with the martyrdom of St Sebastian (Conti 1971, no. 185). These panels are usually attributed to Faenza, but the Naples and BM dishes seem more akin to Urbino-region products. The link with works like 67 and a signed 'FR' plate in Melbourne (Mallet 1976) suggests this artist may have worked together with 'FR'.

The figure composition recalls an early engraving of Marcantonio Raimondi's (B XIV, p. 300, no. 398). *Also illustrated in colour*

67 Broad-rimmed bowl

Attributed to 'FR', Urbino district, 1522

Painted in blue, green, orange, yellow, brown, black, purple, white: Hercules, Omphale, and Cupid, in a watery landscape; the sides of the well plain; on a tablet, .*OMNIA..VINCIT..AMOR.* (love conquers all) *1522*. Broken and repaired. DIAM 30 cm
Victoria & Albert Museum, 2542–1856
Bibl. Fortnum 1873, pp. 534; Solon 1907, fig. 38; Rackham 1933, p. 34, pl. 18A; 1940A, no. 793; Rackham & Ballardini 1933, pp. 394–5, fig. 2; Ballardini 1933–8, I, no. 120, fig. 115; Mallet 1976, p. 9; Fourest 1982, pl. 42a.

In one of the classical stories about Hercules the hero was enslaved to and fell in love with Omphale, Queen of Lydia; at her whim they exchanged clothes and he spun wool.

Hercules is perhaps composite from two Marcantonio engravings (B XIV, p. 332, no. 442; p. 345, no. 464); similar figures occur on a plate in Arezzo dated 1528 (*Maioliche umbre decorate a lustro* 1982, pl. 54), a plate in Baltimore (Prentice von Erdberg & Ross 1952, no. 48), both probably by Xanto; and a plate in Pesaro (Mancini Della Chiara 1979, no. 100).

68 Broad-rimmed bowl

Lustred in the workshop of Maestro Giorgio, Gubbio, 1524; perhaps painted by 'FR'.

Painted in blue, green, yellow, orange, brown, purple, white; golden and reddish lustre: the Judgement of Paris; in the centre, Mercury. Reverse: in lustre, floral scrolls, and *1524 M?G?* DIAM 26.5 cm

69

and *Que stabant uix hospitibus spectanda sepulchra : Quellibet arbitrio iam uidet. illa suo.* (the tombs which used to stand where they could hardly be seen by visitors can now be seen by anyone at will) *.f.L.R.* DIAM 38 cm

MLA 1970, 12–11, 1

Bibl. Robinson 1862, no. 5240; Rackham 1932, p. 214, pl. IVA; 1957A, p. 102, pl. XLVIII; 1959, no. 297, pl. 128B, 129; Rackham & Ballardini 1933, p. 402, fig. 19; Berney Sale 1946, lot 35; Tait 1976; Mallet 1980, p. 158.

The composition follows a Marcantonio engraving (B XIV, p. 317, no. 422), based on a Roman sarcophagus placed in the forecourt of St Peter's in Rome (Bober & Rubinstein 1986, pp. 232–3). The inscription, copied from the engraving, refers to the fact that the sarcophagus could be seen by the public.

Two pieces of maiolica are similarly signed on the reverse: a dish in Budapest (Ballardini 1933–8, 1, no. 235) lustred, signed *.f.L.R.*, and dated 1529; and a fragment in the Bargello (Conti 1971, no. 41), signed *.F.L.R.* Stylistically these seem to lie between the works signed 'FR' and the first fully signed works of Xanto.

71 Dish

Attributed to Francesco Xanto Avelli, Urbino, *c.* 1530

Painted in blue, yellow, orange, brown, black, green, purple, white: Danae and the infant Perseus being put out to sea. Reverse: *De Danae|e|Perseo il fer' destino.|o|fabula|o| historia* (the savage destiny of Danae and Perseus; fable or history), followed by a flourish resembling *y.* DIAM 41.3 cm

MLA 1855, 12–1, 113

Bibl. Bernal Sale 1855, lot 2105.

According to classical legend, Danae was made pregnant by Jupiter in a shower of gold. She and her son Perseus were put out to sea by her father, but rescued. The story is not in Ovid, but is in the 1497 paraphrase of the *Metamorphoses*, fol. XXXIIIr. The figures are loosely based on figures in engravings (B XIV, p. 10, no. 8; p. 89, no. 104; p. 160, no. 196; B XV, p. 195, no. 17).

The *y*-flourish occurs on a number of pieces from around 1530, often with the words *nota, fabula* or *historia*; a few of these are signed by Xanto. Rackham's belief that some of these pieces are by another hand than Xanto's is refuted by Mallet 1970–1, part 3.

MLA 1851, 12–1, 8; formerly Abbé Hamilton collection
Bibl. Ballardini 1933–8, 1, no. 151, figs 138, 294; Rackham 1957A, p. 108.

In classical legend a golden apple was offered to the most beautiful of the goddesses. Paris was brought by Mercury to judge between Juno, Minerva and Venus. Venus promised him the loveliest woman in the world (Helen) and Paris awarded her the prize.

The reclining figure of Paris is based on the river-god in Marcantonio's engraving, *The Judgement of Paris* (B XIV, p. 197, no. 245). The group of goddesses echoes Marcantonio's earlier engraving of the subject (B XIV, p. 254, no. 339). The painting may possibly be by 'FR'; cf. 163.

69 Dish on low foot

By 'FR', probably Urbino district, *c.* 1520–5

Painted in blue, purple, grey, yellow, green, brown, turquoise, black, orange, white: a building under construction; four men watching. Signed lower right: *.F.R.*

Restorations to rim. DIAM 27.8 cm
MLA 1855, 12–1, 102

Bibl. Bernal Sale 1855, lot 2047; Fortnum 1873, pp. 488, 505; Solon 1907, fig. 36; Rackham & Ballardini 1933, pp. 398, fig. 4; Rackham 1951, p. 110; 1957A, p. 102; Mallet 1970–1, part 3, p. 170; 1976, p. 8; Tait 1976, p. 6.

Five other known pieces have FR on the front: V&A (Rackham 1940A, nos 795, 796, 799); Melbourne (Mallet 1976); Sotheby's, 10 May 1962, lot 34. Rackham and Ballardini believed 'FR' worked in Faenza, but Mallet (1976, p. 17) gives cogent reasons for believing he spent much of his career in the Urbino district.

The subject is apparently the building of Solomon's Temple (I Kings 6; II Chronicles 2–3).

70 Dish on low foot

Attributed to Francesco Xanto Avelli, Urbino, *c.* 1528–30

Painted in blue, green, yellow, orange, brown, purple, white: a lion-hunt in Roman costume. Reverse: decoration *alla porcellana*,

70

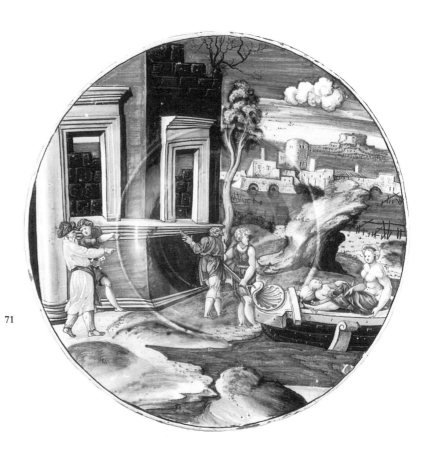

71

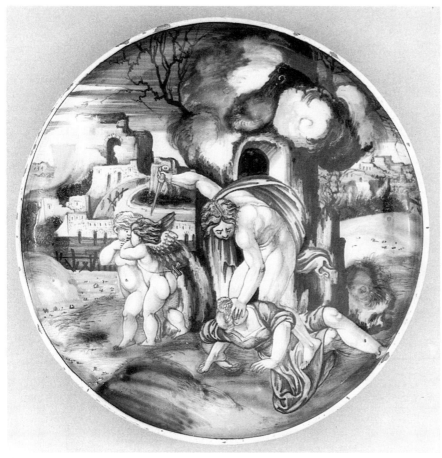

72

72 Dish on low foot

Attributed to Francesco Xanto Avelli,
Urbino, *c.* 1530

Painted in blue, green, orange, yellow,
brown, black, purple, white: Venus under
attack from an armed man; two winged *putti*
in the background. Reverse: *Uener' stratiata
et il figliuolo î fuga. nota* (Venus assaulted and
her son running away; note), followed by a
flourish resembling *y*. DIAM 25.9 cm

MLA 1855, 12–1, 95

Bibl. Bernal Sale 1855, lot 2006.

The subject is probably an invention of
Xanto's. The foreground figures are
adapted from an engraving by Marco
Dente da Ravenna, after Bandinelli, of
The Massacre of the Innocents (B XIV, p. 24,
no. 21). The *putti* are a favourite group
of Xanto's, of unidentifed origin.

73 Plate

By Francesco Xanto Avelli, Urbino,
1531

Painted in blue, yellow, green, orange,
brown, purple, black, white: Aeneas
carrying Anchises from Troy, accompanied
by Ascanius; on a tree, a shield of arms
representing Hercules and the lion. Reverse:
*.1531. Quest' è colui che piâse sotto Antandro.
historia. frâcesco Xanto, Auelli da Rouigo î
Urbino pîse* (this is he who wept under
Antander; history; Francesco Xanto Avelli
of Rovigo painted this in Urbino).
DIAM 26 cm

MLA 1855, 12–1, 45

Bibl. Bernal Sale 1855, lot 1753; Ballardini
1933–8, II, no. 13, figs 13, 225; Mallet 1970–
1, part 3, pp. 180–2; figs 21, 22; Lessmann
1979A, p. 169.

The figures are from the engraving of
Aeneas and Anchises by Caraglio (B XV,
p. 94, no. 60), after Raphael's design for
the *Fire in the Borgo* in the Vatican. The
landscape and architecture are additions
by Xanto. The story of the escape of
Aeneas, his father Anchises, and son
Ascanius at the end of the Trojan Wars
is from Virgil's *Aeneid* 2. The
inscription is from Petrarch (*Triumph of
Love*, 1, 106–7). Antander was a port of
call on Aeneas' journey from Troy to
Italy; Aeneas wept because of the death
of his wife Creusa.

Xanto painted several versions of this
subject (Lessmann 1979A, p. 169; also
Caruso Sale 1973, lot 37; one, now
destroyed, dated 1542, once in the
Schlossmuseum, Berlin, Inv. K 1768).

From the same set as 216. The arms
may possibly be for Squarzioni of
Ferrara. Ten dishes from the set are
recorded, dated 1531 and 1532
(Rackham 1940A, p. 211; Watson 1986,
p. 130).
Illustrated in colour

74 Salt cellar

By Francesco Xanto Avelli, Urbino,
1532

The top painted on a blue ground in orange,
brown, yellow, white, green, black: three
pairs of winged *putti* joined at the legs,
holding shields of arms of Pucci of Florence,
with an *ombrellino*; the depression for the salt
painted in *bianco sopra bianco* and yellow, with
a daisy and *Fran: Xanto.A.Roui:* On the
sides, black-ground grotesques
incorporating *1532*. The corners moulded as
foliate dolphin-masks. A later gilt-copper
mount covers damage to the edges. L (max.)
15.7 cm

MLA 1855, 12–1, 110

Bibl. Bernal Sale 1855, lot 2081; Ballardini
1933–8, II, no. 60, fig. 57; Hausmann 1972,
p. 270.

This and 222 are from a set of which
over thirty pieces survive. The arms of
Pucci are accompanied by the *ombrellino*,
or canopy, indicating a connection with
the Papacy (Galbreath 1972, pp. 27–37).
The identification of the arms as those of
Piero Maria Pucci (Van de Put &
Rackham 1916, p. 105) has not been
proved.

74

77

73

82

203

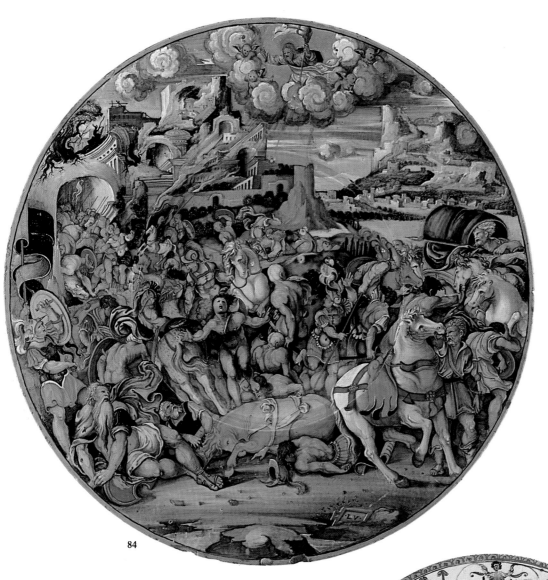

84

90

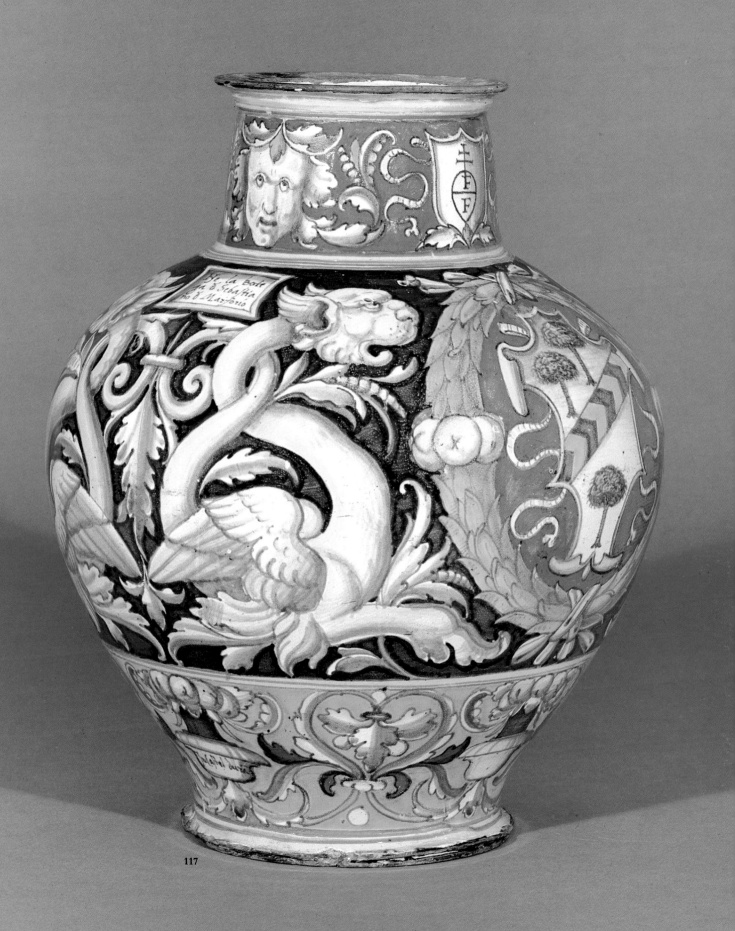

117

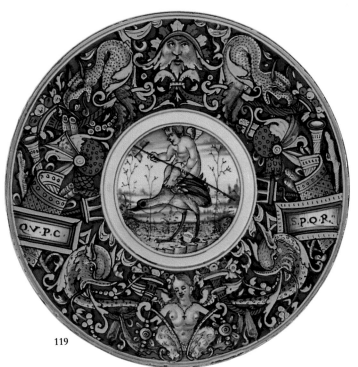

119

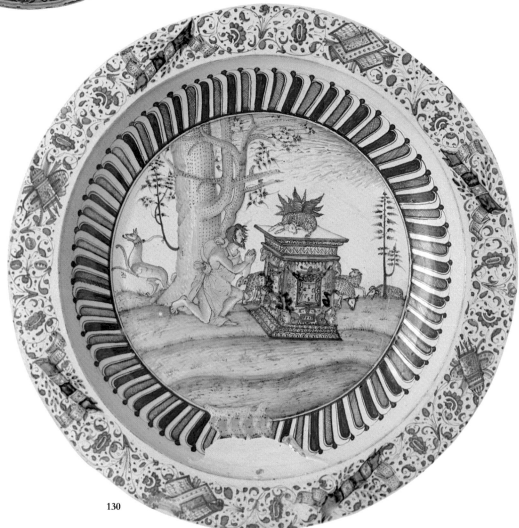

130

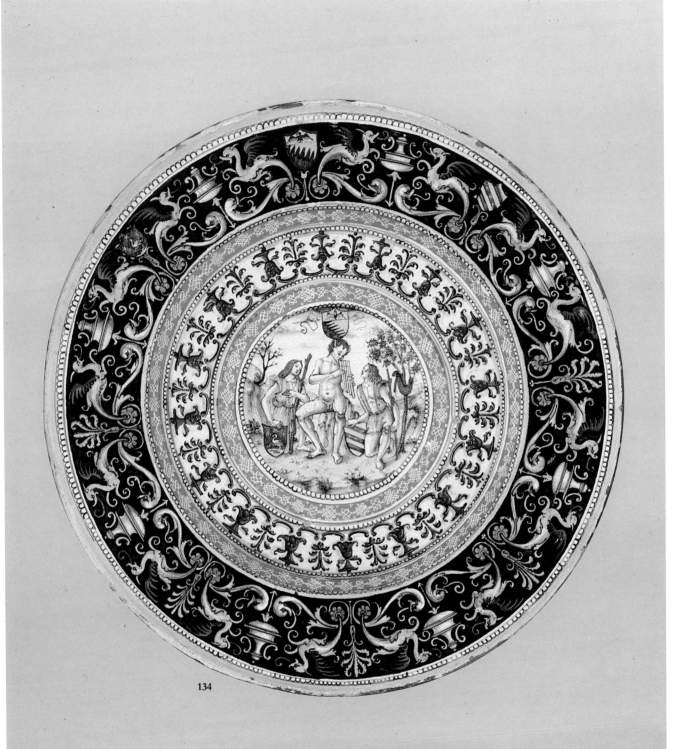

134

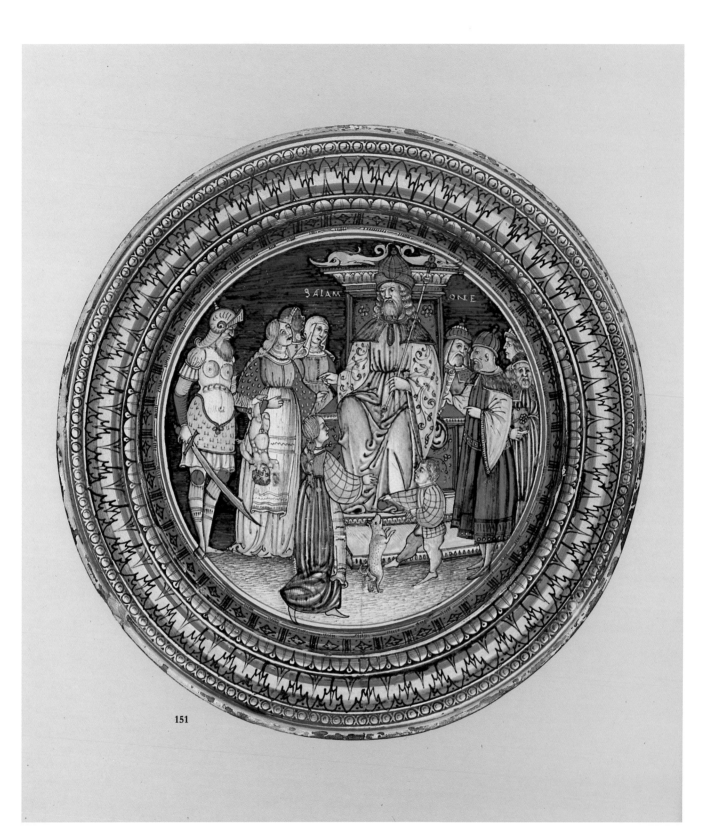

151

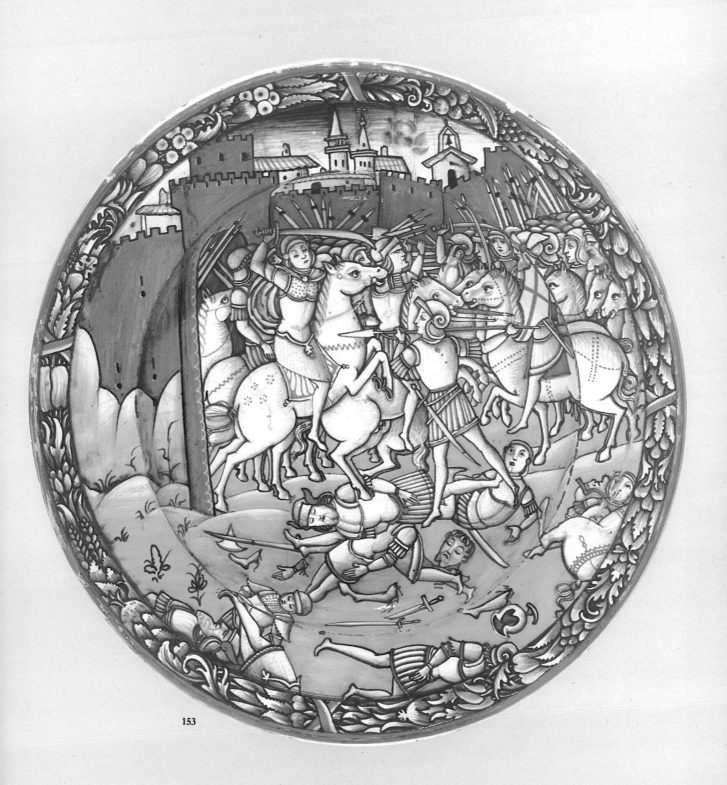

153

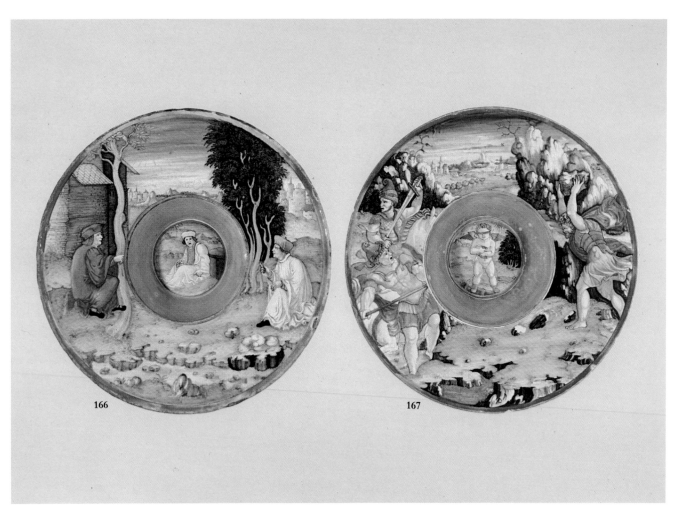

166

167

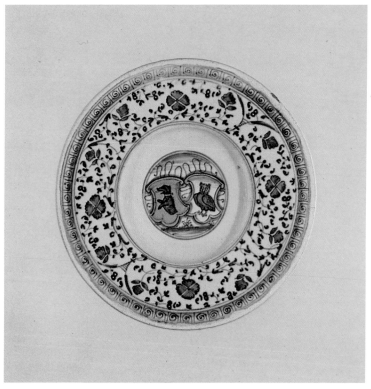

176

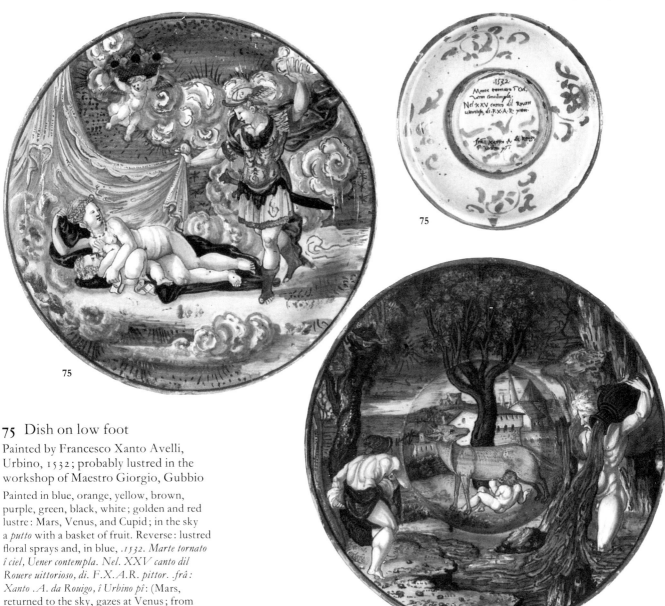

75

75

76

75 Dish on low foot

Painted by Francesco Xanto Avelli,
Urbino, 1532; probably lustred in the
workshop of Maestro Giorgio, Gubbio

Painted in blue, orange, yellow, brown,
purple, green, black, white; golden and red
lustre: Mars, Venus, and Cupid; in the sky
a *putto* with a basket of fruit. Reverse: lustred
floral sprays and, in blue, *.1532. Marte tornato
î ciel, Uener contempla. Nel. XXV canto dil
Rouere uittorioso, di. F.X.A.R. pittor. .frâ:
Xanto .A. da Rouigo, î Urbino pî:* (Mars,
returned to the sky, gazes at Venus; from
canto 25 of *Rovere, the Victorious* by
F.X.A.R., painter. Francesco Xanto Avelli
of Rovigo painted this in Urbino).
DIAM 26.2 cm

MLA 1855, 3–13, 12; given by A. W. Franks
Bibl. Fortnum 1873, pp. 345, 363; Rackham
1933, p. 62; Ballardini 1933–8, II, no. 64,
figs 61, 262; Ballardini Napolitani 1940,
pp. 909–10; Mallet 1984, p. 400, pl. CXIII.

The subject is from a poem by Xanto in
praise of Francesco Maria I Della
Rovere, Duke of Urbino. There
survives (Vitaletti 1918; Cioci 1979) the
manuscript of a sonnet sequence by
Xanto, in which the Duke is described
as the son of Mars, with comparable
imagery. The sonnet sequence in its
extant form, however, contains a
passage which may refer to the assault
by the Emperor Charles V on Goleta in

North Africa in 1535 (Mallet 1984,
p. 399); if so, the scene on the plate must
illustrate a different, earlier, poem, or an
earlier version of the sonnet sequence.

The figures are adapted from
Marcantonio engravings – the flying
putto from the *Parnassus* (B XIV, p. 200,
no. 247; fig. xix, p. 122), Venus from
one of the erotic engravings after
drawings by Giulio Romano known as
the *Modi* (Lawner 1984, p. 81), Mars
from the *David* (B XIV, p. 13, no. 12).

76 Broad-rimmed bowl

Painted by Francesco Xanto Avelli,
Urbino, 1533; probably lustred in the
workshop of Maestro Giorgio, Gubbio

Painted in blue, green, orange, yellow,
brown, white, purple, black; golden and red
lustre: a she-wolf suckling Romulus and
Remus; right, a standing river-god; left, a
man carrying the infants out to be exposed.
Reverse: in lustre, foliate scrolls and *N*; in
blue, *.1533. De Marte i figli alla pietosa Lupa.
Nel.XLIII. Lib: de Trogo pôpeio. .frâ: Xanto
.A. da Rouigo î Urbino.* (The sons of Mars
with the gentle wolf. From Book 43 of
Trogus Pompeius. Francesco Xanto Avelli
of Rovigo, in Urbino). DIAM 26.6 cm

MLA 1854, 2–13, 1

Bibl. Fortnum 1873, pp. 364; Solon 1907,
fig. 42; Ballardini 1933–8, II, no. 98, figs 92,
281; Ballardini Napolitani 1940, p. 919;
Mallet 1979, p. 282 .

The inscription cites the Roman historian Trogus Pompeius as a source for the well-known legend of Romulus and Remus, founders of Rome, who were saved from exposure as babies by a wolf. References like this are characteristic of Xanto's pretensions to erudition.

Other examples of Xanto's work with lustre and the mark *N*: Caruso Sale 1973, lot 37; Rackham 1940A, no. 728; Giacomotti 1974, no. 866.

The left-hand figure is adopted from one of the *Modi* (Petruzzellis-Scherer 1980, fig. 31; Lawner 1984, p. 79); the river-god from an engraving by Caraglio (B XV, p. 86, no. 50).

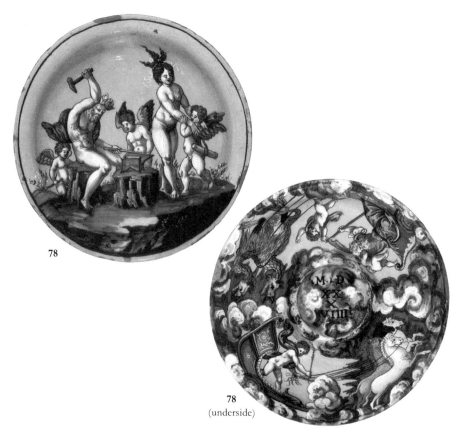

78

78
(underside)

77 Broad-rimmed bowl

By Francesco Xanto Avelli, Urbino, 1533

Painted in blue, green, orange, brown, yellow, purple, black, white: Amphiaraus hiding in a cave, discovered by Polynices; on the right, Eriphyle fingering a necklace. Reverse: *.1533. L'auara, e, rea moglier di Amphiarao. Nel .libro d Ouidio. .F. Xâto. A. Rouig: î Urbino.* (The avaricious and wicked wife of Amphiaraus. From Book [. . .] of Ovid. Francesco Xanto Avelli of Rovigo, in Urbino). DIAM 25.7 cm

MLA 1855, 12–1, 53

Bibl. Bernal Sale 1855, lot 1797; Ballardini 1933–8, II, no. 94, figs 88, 282; Mallet 1980, p. 157, pl. XXVI C.

According to Greek legend, the priest Amphiaraus attempted to avoid taking part in the attack on Thebes, foreseeing his own death. He hid, but his wife Eriphyle was bribed by Polynices with a necklace and betrayed him. Despite the inscription, the story is not in Ovid; Xanto's source was the 1497 paraphrase of Ovid where the story is inserted (fol. LXXXI). The inscription echoes Petrarch (*Triumph of Love*, I, 143–4).

The subject was a favourite of Xanto's; other treatments: Ballardini 1933–8, II, nos 18, 19; Strauss Sale 1976, lot 45 (all 1531); Watson 1986, no. 51 (1532).

The figures are adapted from different engravings (B XIV, p. 7, no. 6; B XIV, p. 274, no. 360; B XV, p. 89, no. 53). *Illustrated in colour*

78 Saucer-dish

Perhaps by Francesco Xanto Avelli, Urbino, 1539

Yellow ground; painted in blue, brown, orange, black, green, white: Vulcan forging

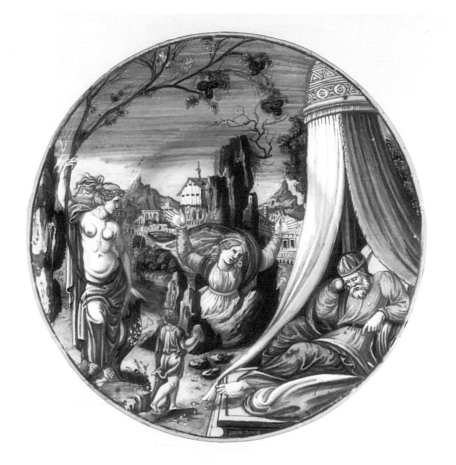

79

an arrow, watched by Venus and three cupids. Reverse: in a cloudy sky, Saturn and his children in a chariot drawn by dragons, Apollo in a chariot drawn by horses, and .M.D.XXXVIIII.. DIAM 17.1 cm

MLA 1878, 12–30, 373; Henderson Bequest
Bibl. Robinson 1862, no. 5250; Fortnum 1873, pp. 349; G. Liverani 1941A, pl. II(a) & (b)

The front is after an engraving by Marco da Ravenna (B XIV, p. 184, no. 227); Saturn and Apollo on the reverse are after a series of woodcuts of the planets (F. Lippmann, *The Seven Planets*, International Chalcographical Society 1895, pl. Fi, Fiv).

This double-sided piece may have formed part of a so-called *impagliata* set; these were groups of bowls and other pieces designed to fit together for presentation to women at childbirth (G. Liverani 1941A; Piccolpasso 1980, II, pp. 30–1).

79 Plate

By Francesco Xanto Avelli, and/or associates, Urbino, 1542

Painted in blue, yellow, orange, purple, green, brown, black, white: the dream of Astyages; in the centre, a figure representing Asia. Reverse: *.1542. D'Astiage Rè di Media il sogno graue* (the momentous dream of Astyages, King of Media). DIAM 27.5 cm

MLA 1878, 12–30, 439; Henderson Bequest
Bibl. Henderson 1868, pl. V; Ballardini Napolitani 1940, p. 915; T. Wilson 1985B, p. 907.

The story is from Trogus Pompeius: Astyages dreamt that from his daughter grew a vine which overshadowed Asia, prefiguring the greatness of his grandson Cyrus. Earlier treatments of the subject by Xanto: Ravanelli Guidotti 1985A, no. 97; Parpart Sale 1884, lot 936; Testart Sale 1924, lot 23; Lessmann 1979, p. 565, no. VII; one in Leipzig. For versions by followers of Xanto, see 97. The figure on the left is after Marcantonio (B XIV, p. 284, no. 373); the boy Cyrus perhaps after B XIV, p. 231, no. 306; the figure of Asia after Zoan Andrea, after Mantegna (B XIII, p. 296, no. 3).

One of a group of works dated 1541 or 1542, some of which are signed *X* and one (Mallet 1984, pls CXI, CXII) marked as made in Urbino in the workshop of 'Francesco de Silvano'.

8 Urbino *istoriato* of the High Renaissance

Between 1525 and 1575 the heartland of *istoriato* maiolica was Urbino and the nearby town of Castel Durante (renamed Urbania by Pope Urban VIII in 1636). Piccolpasso noted that 'a good part of the *maestri* who work in Urbino are from Castel Durante'; furthermore, some men who worked in nearby Pesaro were trained in Castel Durante or Urbino. This 'Urbino school' of maiolica painters is sometimes called the 'Metauro school' after the river which runs through the district.

Although quantitatively Castel Durante may have been the more productive town, most of the best *istoriato* painters seem to have worked in the ducal capital, Urbino, particularly in the workshop set up before 1520 by Guido Durantino, alias Guido Fontana; this family workshop continued to function at least till Guido's death around 1576, and apparently maintained consistently high technical and artistic standards. In 1565 Guido's son Orazio Fontana set up independently of his father. There are indications that the Fontana workshops enjoyed the particular patronage of Guidobaldo II, Duke of Urbino; and by the 1560s Orazio Fontana was celebrated enough to be called to Turin as master potter to the Duke of Savoy, and to be sending maiolica to the Medici court in Florence.

How many other workshops in the Urbino district were producing *istoriato* in the middle of the sixteenth century is unclear. For some reason there is a good deal of marked and dated Urbino *istoriato* from the early 1540s, but little from the following twenty years. The only workshop, other than those of the Fontana, to produce marked work in any quantity was that of Guido di Merlino, which had among its painters in the 1540s the prolific Francesco Durantino. Other individual painters are recognisable, but no other workshop emerges from the homogeneity of the 'Urbino style'.

LITERATURE Pungileoni and Raffaelli, in Vanzolini 1879; Fortnum 1896, pp. 188–223; Lessmann 1979B; Mallet 1987.

80 Dish on low foot

Workshop of Guido Durantino, Urbino, 1535

Painted in blue, yellow, orange, green, brown, black, white: Jupiter with a thunderbolt approaching the bed of Semele; left, Juno and Semele talking; from Jupiter's hand hangs a coroneted shield of arms of Montmorency. Reverse: *fabula de Gioue & Semele Nella botega de M° Guido durantino In Vrbino* (Story of Jupiter and Semele. In the workshop of Maestro Guido Durantino in Urbino) *1535.* DIAM 25.5 cm

MLA 1855, 12–1, 44
Bibl. Perhaps Crozat Sale, Paris, 14 December 1750; Bernal Sale 1855, lot 1751; Fortnum 1873, pp. 335, 359; Ballardini 1933–8, II, no. 209, figs 200, 363; Rackham 1940A, p. 209; G. Liverani 1958, figs xxiii, xxiv; Rasmussen 1984, p. 182.

According to Ovid, *Metamorphoses* 3, Juno, wife of Jupiter, was jealous of Semele, one of the 'loves of Jupiter'; she disguised herself as an old woman and persuaded Semele to ask Jupiter to appear in his full glory. When he did so Semele was destroyed, though their son Bacchus was saved. The composition is based on an illustrated edition of the *Metamorphoses*, perhaps the one printed in Venice 1533.

Marked works from the workshop of Guido di Nicolò of Castel Durante, later known as Guido Fontana, range in date from the 1528 plate signed by Nicola da Urbino, up to 1542; some of the finest Urbino maiolica of the 1540s, 1550s and 1560s is also attributed to the workshop. See Rackham 1940A, pp. 271–84; Rackham 1940B; Lessmann 1979B; Negroni 1986; Mallet, 1987.

Anne de Montmorency (1493–1567), Grand Maître of France, was a distinguished soldier and the architect of French policy in Italy and a great art-patron of the French Renaissance. Eighteen pieces of the set made for him in 1535, all with subjects from classical mythology, have been noted. A service made in the same workshop in the same year for another Frenchman, Cardinal Duprat, consisted entirely of Biblical subjects (Mallet 1987).

81 Plate

By Orazio Fontana, probably in the workshop of Guido Durantino, Urbino, 1544

Painted in green, blue, brown, orange, yellow, black, white: a boar-hunt. Reverse:

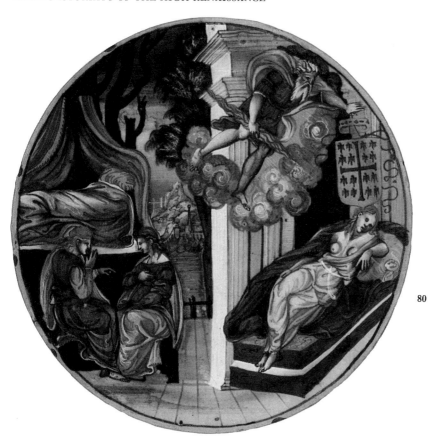

80

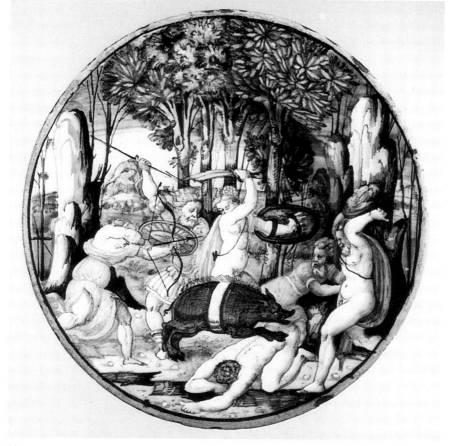

81

Lacacia d̄l porcho calidonio (the hunting of the Calydonian boar) *1544*, and *ORATIO* in monogram. DIAM 24.1 cm

MLA 1855, 12–1, 75

Bibl. Bernal Sale 1855, lot 1927; Robinson 1856, p. 199; Fortnum 1873, pp. 332, 342, 360; Rackham 1940A, p. 271; G. Liverani 1957, p. 133, pl. LXVI; 1958A, p. 40, figs xxvi, xxvii; Clifford & Mallet 1976, p. 399; Mallet 1987.

Orazio Fontana has always been one of the most famous names in maiolica. Five other surviving plates have the monogram of his name, with dates between 1541 and 1544. A seventh monogrammed plate, destroyed in Berlin in the Second World War, was marked as made in the workshop of Guido Durantino in 1542 (G. Liverani 1957).

The story of the Calydonian boar is in Ovid, *Metamorphoses* 8. The goddess Diana, enraged at being ignored in sacrifices, sent a monstrous boar to ravage Calydon; several Greek heroes and heroines, including Meleager and Atalanta, succeeded in killing it. The composition echoes the woodcuts in various illustrated editions of the *Metamorphoses*.

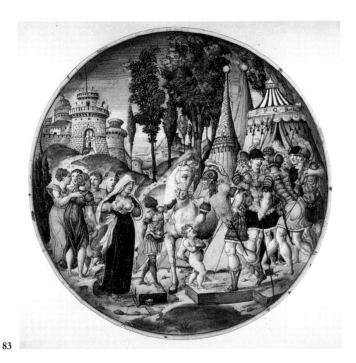

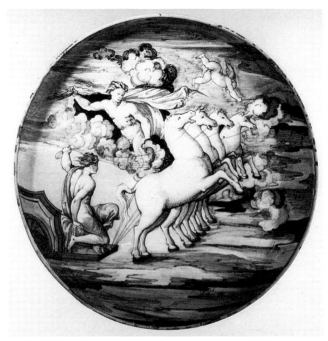

83 85

82 Plate

Urbino, 1542

Painted in blue, yellow, green, orange, brown, black, white: Hercules carrying the 'Pillars of Hercules'; beneath a blackish prelatial hat, a shield of arms, *an oak tree proper, on a chief sable a cross pattée argent.* Reverse: *1542 Herchole. .Chô. le. Colône. Vrbi* (Hercules with the columns. Urbino). DIAM 26.2 cm

MLA 1855, 12–1, 52

Bibl. Bernal Sale 1855, lot 1791; Rackham 1940A, p. 290; Lessmann 1979A, p. 265.

Four other pieces with these unidentified arms are recorded (Lessmann 1979A, p. 265); the painter has been called, after a dubious interpretation of the arms, the 'painter of the Della Rovere dishes'; cf. Rackham 1940A, p. 290; Ravanelli Guidotti 1985B, pp. 146–7; Watson 1986, p. 144. 203 is also by him. *Illustrated in colour*

83 Dish on low foot

By Francesco Durantino, perhaps in the workshop of Guido di Merlino, Urbino, 1544

Painted in blue, green, yellow, orange, brown, black, white: the mother and son of Coriolanus imploring him not to attack Rome. Reverse: yellow rings and *come martio choriolano sbandito uenne contra ali Romani insieme cô li volsci : & come la matre lo homilio uedi tituliuio alibro secondo : d̄ la prima acapi XXV* (how Martius Coriolanus was exiled and

came against Rome with the Volscians; and how his mother humbled him; see Livy, Book II of the first [decad], chapter 25) *frâcesco durantino 1544.* Broken and repaired DIAM 26.7 cm

MLA 1855, 12–1, 74

Bibl. Bernal Sale 1855, lot 1920; Fortnum 1873, p. 404; Rackham 1940A, p. 284; Scheidemantel 1969, p. 49; Lessmann 1979A, p. 183; T. Wilson 1985A, p. 79, pl. XXVIII.

The painter who signed 'Francesco Durantino' (Lessmann 1979A, p. 183) was one of the most prolific of all Urbino *istoriato* painters. A document dated 1543 (*Rassegna bibliografica dell'arte italiana* 4(1901), pp. 202–4) records a business agreement between him and Guido di Merlino, proprietor of one of the main potteries in Urbino (Lessmann 1979A, p. 175; Negroni 1986, p. 18); a plate in Vienna, dated 1543 (*Faenza* 29 (1941), pl. XXIIIA), signed 'in the workshop of Maestro Guido di Merlino, by the hand of Francesco Durantino'; and one in Schwerin, similarly signed, dated 1544, may be products of this collaboration. Other pieces of this period signed by Francesco are dated 1543 (Olding 1982, no. 47) and 1546 (Dahlbäck Lutteman 1981, no. 5). In 1547 he left Urbino to take over a kiln at Monte Bagnolo outside Perugia (see 94).

The inscription is from a favourite source of Francesco's, the illustrated Italian version of Livy published in

Venice in 1493 (cf. 217); the composition echoes the book's primitive woodcut. Coriolanus (Livy, II, 40) was a Roman noble who, sent into exile, led an army of Volscians against Rome. He was dissuaded from attacking the city by his mother and family.

84 Dish

Perhaps Urbino, *c*, 1545

Painted in blue, yellow, green, orange, brown, purple, grey, black, white: the conversion of Saul (Acts 9); on a tablet, .LV. Reverse: yellow rings. DIAM 54 cm

MLA 1885, 4–20, 2

Bibl. Marryat 1857, pp. 56–7; Fortnum 1873, p. 326; Fountaine Sale 1884, lot 60; Moore 1985, no. 25.

The composition, one of the most ambitious and up-to-date on all maiolica, echoes Michelangelo's painting of the subject in the Cappella Paolina in the Vatican (1542–5); there are also echoes of Raphael and Giulio Romano. The handling recalls work by Nicola da Urbino and from Guido Durantino's workshop. LV may be the initials of the painter. Some pieces in this style may have been made by artists from the Urbino district working in Venice; cf. T. Wilson 1987. *Illustrated in colour*

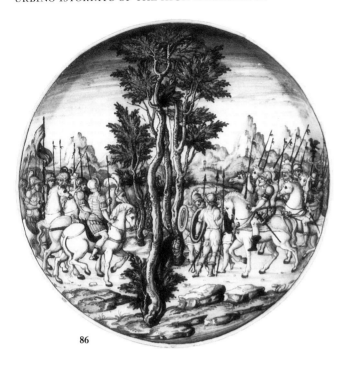

86

86
(underside)

85 Dish on low foot

Perhaps Urbino, *c.* 1540–5

Painted in blue, brown, yellow, orange, green, grey, black, white: Apollo driving his chariot; above, Jupiter with a thunderbolt, and Cupid. Reverse: yellow rings and *Venere.e.bella.e.madre d' Amore. il sole è bello et èfigliol di Gioue: il sole e fatto rè d'ogni splendore: E questo a fiamme l'universo moue*: (Venus is beautiful and the mother of Love; the Sun is beautiful and the son of Jupiter. The Sun is king of all radiance, and he moves the world to flames). Restoration to edge. DIAM 27.7 cm

MLA 1855, 12–1, 46

Bibl. Bernal Sale 1855, lot 1755; Dennistoun 1909, III, p. 404.

The composition reproduces part of an engraving (B XV, p. 200, no. 24) by the 'Master of the Die'. The inscription is adapted from the verses beneath the engraving.

86 Dish

Urbino, *c.* 1545–65, perhaps workshop of Guido Durantino

Painted in blue, green, yellow, orange, brown, purple, black, white: soldiers meeting. Reverse: in the sea, sea-deities, monsters, and Cupid. Foot cut away. Restoration to edge. DIAM 19.8 cm

MLA 1878, 12–30, 374; Henderson Bequest

An unidentified Roman history subject, perhaps from the Punic Wars.

87 Salt cellar

Perhaps workshop of Guido Durantino, Urbino, *c.* 1535–45

Painted in green, blue, yellow, orange, brown, black, white: in the well, an armed naked female, perhaps Minerva; on the sides, Cupid uncovering sleeping Venus, and a reclining god. Restorations. L 14.5 cm

MLA 1852, 11–29, 4

87

88 Plate

Perhaps workshop of Guido Durantino, Urbino, *c,* 1550–75

Painted in blue, green, brown, orange, yellow, grey, red, black, purple, white: a landscape with buildings and two lovers; a shield of arms in the sky. Reverse: yellow rings. Broken and repaired. DIAM 27.6 cm

Henry Reitlinger Bequest, Maidenhead
Bibl. Falke 1899, no. 103.

For the arms (probably Salviati), see 113. From a large set consisting entirely of landscapes (Borenius 1928, p. 38; Rackham 1940A, p. 277; Giacomotti 1974, no. 1026). The style is akin to products of the Fontana workshops (Mallet 1987).

89 Moulded dish

Castel Durante, *c.* 1550–65

Painted in blue, yellow, orange, green, brown, black, white: Neptune creating the horse, surrounded by archers, masks, and foliage. Reverse: moulded pattern picked out in blue. DIAM 22.8 cm

MLA 1878, 12–30, 451; Henderson Bequest
Bibl. Henderson 1868, pl. VII; Rackham 1940A, p. 337.

The scene shows an episode in the mythical contest between Neptune and Athene (Minerva) for the privilege of naming Athens: Neptune created the horse, but was defeated by Athene, who created the even more useful olive tree.

Among pieces similarly painted are a set with an unidentified coat-of-arms and the motto SAPIES DOMINABITUR ASTRIS, some of which are dated 1551; also a group of drug jars, some marked as made in Castel Durante (cf. 128). A dish apparently by the same hand in Arezzo has on the reverse the name

88

89

Andrea da Negroponte, and the whole group has therefore been attributed to the 'workshop of Andrea da Negroponte' (Lessmann 1979A, p. 148; Ravanelli Guidotti 1985A, pp. 118–20). However, without archival confirmation of a Castel Durante potter of this name, it cannot be ruled out that Andrea da Negroponte was the client, not maker.

90 Plate

Probably workshop of Guido Durantino or Orazio Fontana, Urbino, *c.* 1560–70

Painted in greyish brown, blue, yellow, orange, white, purple, black: Amadis (left) killing the jailer and subduing the guards of a dungeon, before rescuing a lady (*The Ancient, Famous and Honourable History of Amadis de Gaule*, London 1618–19, I, p. 126).

Border and reverse: grotesques on a whitened ground, incorporating fantastic birds, part-human creatures, and medallions imitating engraved gems. Within the foot, on a scroll set against a lightly sketched tree, *Hincâse de rodillas los carçeleros a Amadis. XXXXVII.* (the jailers fall on their knees before Amadis. 47). DIAM 23.3 cm

MLA 1885, 4–20, 3

Bibl. Fortnum 1873, p. 340; Fountaine Sale 1884, lot 32.

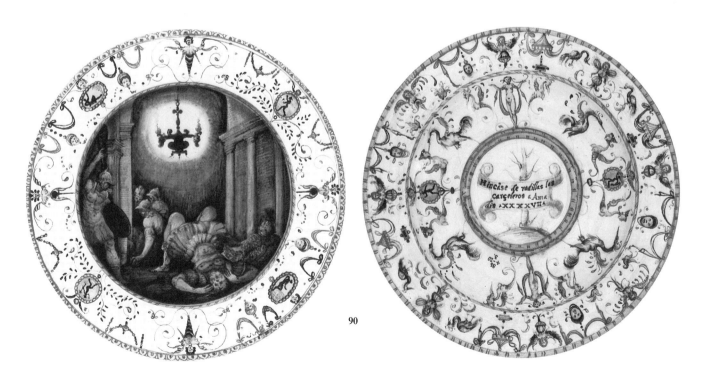

90

Part of one of the most ambitious maiolica services ever made, with Spanish inscriptions and numbered scenes from the popular romance *Amadis of Gaul*. From this service: two large oval dishes, a vase, and two other small plates (Olivar 1953; Falke 1914–23, no. 288). The highest number on surviving pieces is 166, but the larger pieces include more than one numbered scene, so the set may have consisted of fifty to a hundred pieces. The set was presumably made for a Spaniard; its scale and the fact that the oval dishes were said when sold in 1837 (De Monville Sale 1837, lot 15) to come from the Escorial, suggest the recipient was King Philip II or one of the Spanish court. See 208 for sets for Spanish clients.

The iconography of the set reflects only sporadically the illustrated editions of *Amadis*; the maiolica painters were perhaps supplied with drawings by a professional artist, as for the Julius Caesar set designed by Taddeo Zuccaro about the same time, as a gift from the Duke of Urbino to Philip II (Gere 1963). One of the Amadis plates is apparently signed SC . . . (Olivar 1953, p. 120; a similar signature is on one of the Julius Caesar service, Fountaine Sale 1884, lot 54; Gere 1963, fig. 36). The near-monochrome style of this plate is highly unusual.
Also illustrated in colour

91 Vase with serpent handles

Workshop of Orazio Fontana, Urbino, probably 1565–71

Painted in blue, orange, green, yellow, brown, purple, black, white: on each side, river-deities in a landscape. Around the base, FATE.IN BOTEGA.DE ORATIO.FONTANA (these were made in the workshop of Orazio Fontana). Restorations. Ormolu base and cover added *c.* 1765. H (overall) 56 cm
MLA, The Waddesdon Bequest (1898), 61; formerly Horace Walpole collection, Strawberry Hill (one of a pair bought by him in Paris 1765–6)
Bibl. Walpole 1784, p. 52; Strawberry Hill Sale 1842, 23rd day, lot 93; Fortnum 1873, p. 342; Read 1902, no. 61; Solon 1907, fig. 40; Rackham 1940A, p.276; Tait 1981, pp. 37, 40, col. pl. VII; T. Wilson 1985A, p. 69, pl. XXI(a).

After 1544 Orazio Fontana's activities are uncertain until he appears in a document of 1564 in the service of the Duke of Savoy. In 1565 he was back in

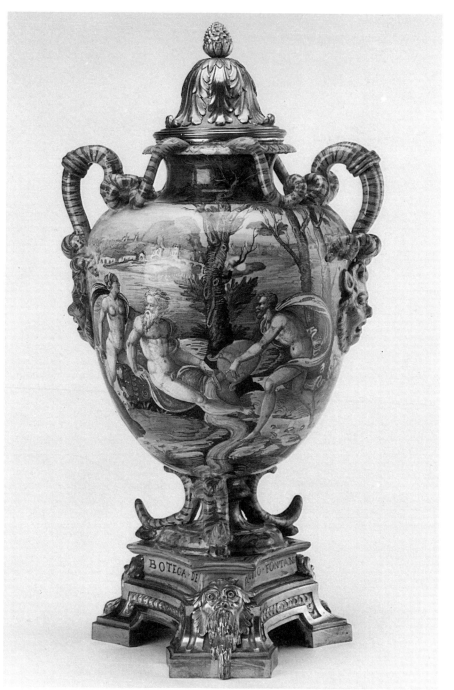

91

Urbino setting up his own successful workshop. This and similarly marked pieces were probably made in Urbino between 1565 and his death in 1571 (Fortnum 1896, pp. 203–11; Rackham 1940A, p. 276; Lessmann 1979A, p. 190).

92 Plaque

Probably by Flaminio Fontana, Urbino, 1583

Painted in blue, orange, green, yellow, brown, black, white: the Apostle Paul; on a slab: .P.E.S. PAULIS. (perhaps 'For the church of St Paul') .1583..F.F. Restorations. 51.6 × 34.7 cm
MLA 1885, 5–8, 31; given by A. W. Franks
Bibl. Rackham 1933, p. 65; Norman 1976, p. 222.

Flaminio Fontana was the son of Guido

92

9 The diffusion of the 'Urbino style' and Faenza *istoriato c.* 1530–70

The formula for *istoriato* painting, developed in Urbino and Castel Durante in the 1520s and 1530s, was a successful and fashionable one. By the 1530s a generation of painters who had grown up under the influence of Xanto and Nicola were fully trained and at home in the idiom. A number of them left Urbino to take their skill to other markets, and with them the 'Urbino style' spread to a series of other centres. This section illustrates the movement of these painters – south-west to Gubbio and the Perugia area, a little way north and east to Pesaro and Rimini, and further north to the Veneto. In Faenza Baldassare Manara, the most distinctive local painter of the 1530s, developed a style blending the Faenza tradition with elements derived from Urbino *istoriato*. The further development of Faenza *istoriato* is seen in the work of Francesco Mezzarisa, and also of Gianbattista Dalle Palle, who moved from Faenza to work in Verona.

Some *istoriato* with the mark of Virgiliotto Calamelli's workshop in Faenza is extremely close to contemporary work from the Urbino region. 106 illustrates the problems of attribution in this area.

LITERATURE Ballardini 1929; Ravanelli Guidotti 1984; Mallet, forthcoming.

93 Fragment of dish

Attributed to Francesco Urbini, in or for the workshop of Maestro Giorgio, Gubbio, 1534

Painted in blue, green, manganese, yellow, orange, white; red and golden-brown lustre: Mercury turning Battus into stone. Reverse: lustre scrolls and *1534 M:G:*
W (max.) 11 cm
MLA 1889, 9–2, 27; given by A. W. Franks
Bibl. Dennistoun Sale, Christie's, 14 June 1855, lot 118; Ballardini 1933–8, II, no. 169, figs 160, 324; Mallet 1979, p. 293, no. 10.

The story is from Ovid, *Metamorphoses* 2. Mercury had stolen some cattle from Apollo. Battus saw what had happened, and promised to keep the secret; but when Mercury returned in disguise, Battus revealed where the cattle were hidden, whereupon Mercury turned him into touchstone.

The figure-drawing resembles

Durantino's son Nicola; he worked for his uncle Orazio and ran the workshop after Orazio's death in 1571 (Vanzolini, 1879, I, p. 110; cf. Scatassa 1904); this workshop, like many potteries in Urbino, was in the parish of St Paul, and the plaque may have been made for the parish church. A bowl in the Wallace Collection, made for Cosimo I de' Medici in 1574 (Norman 1976, C107; Spallanzani 1979, p. 121), is signed FFF (Flamino Fontana fecit).

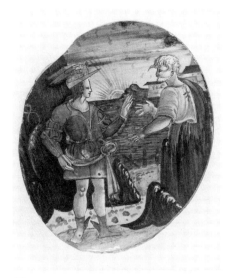

93

Xanto's, and Francesco Urbini seems to have been trained in Urbino. A lustred dish dated 1534 has the words *in gubio* in blue, *i.e.* in the second, not the third (lustre), firing; it and a group of similar dishes bearing lustred dates between 1531 and 1536 were probably painted as well as lustred in Gubbio (Mallet 1979). In 1537 he was working in Deruta, where he signed a dish (V & A). His work there influenced the principal Deruta artist of the following decades, Giacomo Mancini, 'El Frate'.

94 Dish on low foot

Attributed to Francesco Durantino, Monte Bagnolo, 1547

Painted in green, blue, yellow, orange, brown, black, white: Marsyas and Apollo. Reverse: *Vilan scurtichato p mā dē Apollo* (peasant flayed by the hand of Apollo) . . . *amôte bagnolo 1547*, followed by a squiggle. Damaged; neutral infill. DIAM 25.5 cm
MLA 1895, 12–20, 2; given by A. W. Franks

For the story of Marsyas, see 60. The composition seems to show awareness of Giulio Romano (cf. Hartt 1958, figs 202, 212).

Francesco Durantino worked in Urbino around 1543–6; see 83. In 1547 he took over a kiln at Monte Bagnolo, outside Perugia, where he worked until about 1554. Two other pieces are marked at Monte Bagnolo: a bowl dated 1549 (Conti 1971, no. 35), and a signed bowl (Scheidemantel 1968) dated 1553. A forthcoming study by Giocondo Ricciarelli will publish important archival documentation on the Monte

Bagnolo enterprise. It was an isolated operation with no discernible impact on other Umbrian factories.

95 Dish on low foot

By the 'Argus painter', Pesaro, *c.* 1535–40

Painted in yellow, blue, brown, orange, green, black, white: Mercury stealing Io from Argus; left, Juno; in the sky, Jupiter with a thunderbolt. Reverse: blue scrolls and *como apollo tolse la uaca a argano fato in pesaro* (how Apollo took the cow from Argus. Made in Pesaro). DIAM 27 cm
MLA 1855, 12–1, 101
Bibl. Bernal Sale 1855, lot 2042; Fortnum 1873, pp. 159, 166; Mallet 1980, pp. 154–5, pl. XX; Berardi 1984, p. 186.

A confused version of the story of Argus, who had a hundred eyes (Ovid, *Metamorphoses* 1): Juno set Argus to guard Io, a beautiful woman who had been turned into a cow by Jupiter. Mercury sent Argus to sleep by playing his pipes, then cut off his head. The composition echoes the woodcut in an

Italian verse edition of the *Metamorphoses* (Venice 1533).

The painter is named, after this dish, the 'Argus painter'. Mallet (1980, 1985) attributes to him other pieces marked as made in Pesaro, and suggests he was trained in Urbino. His work is the earliest identified Pesaro *istoriato* in the Urbino manner. Cf. 194.

96 Dish on low foot

Workshop of Girolamo dalle Gabicce, Pesaro, 1544

Painted in yellow, green, blue, orange, brown, black, purple, white: Caesar seated on a throne, Cicero bringing him a volume. Reverse: *Cicerone et julie cesare cuâdo idete le lege 1544 in la botega d̄ mastro girolamo da le gabice. In pesaro* (Cicero and Julius Caesar when he gave the laws. 1544, in the workshop of Maestro Girolamo of Le Gabicce, in Pesaro). Restoration to rim. DIAM 27 cm
MLA 1888, 9–5, 1; given by C. D. E. Fortnum
Bibl. Fortnum 1873, pp. 157–8, 165; 1897, C 419; Rackham 1940A, p. 305; 1948, p. 30, pl. X; Ballardini 1938, pl. 56; G. Liverani

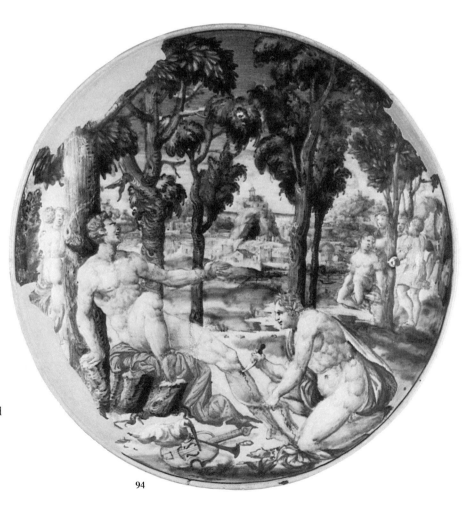

94

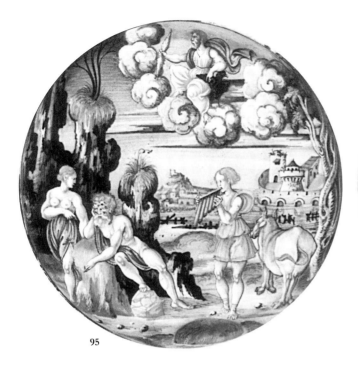

95

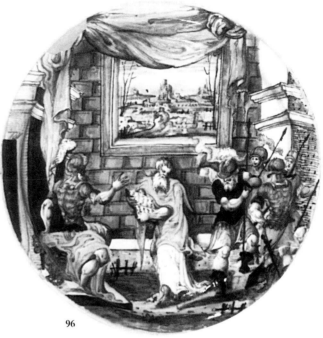

96

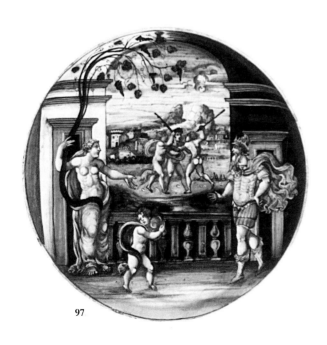

97

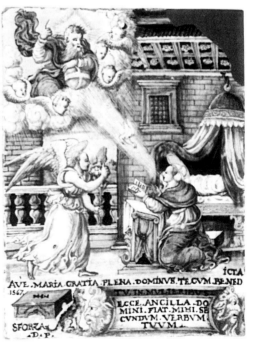

98

1958A, p. 41, figs xxxiii, xxxiv; Biscontini Ugolini 1978, p. 30, pl. IX(c); Mallet 1980, p. 154; Gresta 1983, pp. 154–5; 1986, p. 271, pls 1, 2; Berardi 1984, p. 183.

The composition is based on a woodcut in the 1533 Venetian edition of Dio Cassius, *Delle guerre e fatti de Romani,* fol. XCIr, illustrating decrees passed in honour of Julius Caesar. Dio does not mention Cicero as being involved.

Girolamo di Lanfranco of Le Gabicce (a village along the coast from Pesaro) was born *c.* 1500, moved to Pesaro as a boy, and is documented as the proprietor of potteries there, with periods elsewhere, until his death in 1578 (Albarelli 1986). His workshop was the main producer of *istoriato* in Pesaro in the 1540s. This dish is probably by a painter called (after a plate in Milan) the 'painter of the Planet Venus'; a group of works bearing dates between 1542 and 1545 have the same distinctive handwriting (Rackham 1940A, nos 914–15; Biscontini Ugolini 1978; Berardi 1984, pp. 183–4); cf. 213.

97 Dish on low foot

Perhaps by Sforza di Marcantonio, Pesaro, 1551

Painted in blue, yellow, orange, grey, brown, green, purple, black, white: right, Astyages; left, his daughter with a vine growing from her loins; foreground, her son Cyrus; background, boys fighting. Reverse: *Dil uechio Astiage Rè l'alta uisione* (the lofty vision of King Astyages) *1551.* DIAM 23.3 cm

MLA 1985, 10–2, 1

Bibl. Christie's, 1 July 1985, lot 262; T. Wilson 1985B, p. 907, fig. 89.

Astyages, King of the Medes, dreamt that his grandson would overthrow him; the treatment repeats in a garbled form Xanto's versions of the story (cf. 79). This subject and inscription were used by Sforza in a plate dated 1576 (Lessmann 1979A, Appx., no. XXXIV); the subject is an example of the lasting influence of Xanto on Sforza's repertoire; cf. 98, and Mallet, forthcoming.

98 Plaque

By Sforza di Marcantonio, Pesaro, 1567

Painted in yellow, orange, blue, green, grey-brown, black, purple, white: the Annunciation, with a text from the *Magnificat.* Signed *.1567. SFORZA. D.P.* Restoration to corner. 26.5 × 20.4 cm

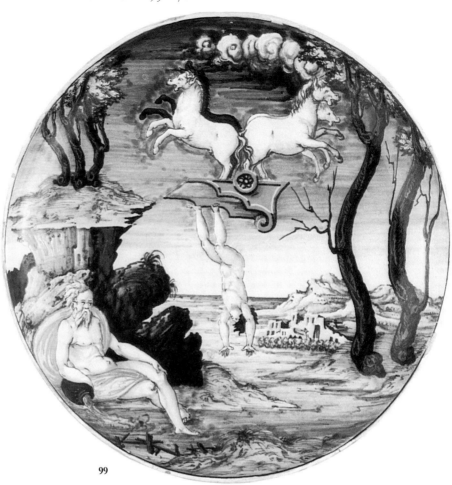

99

MLA 1893, 6–14, 2; given by A. W. Franks

Bibl. Molinier 1892, p. 45, no. 92; Leonhardt 1924, pp. 536, 539; Biscontini Ugolini 1979, pp. 9–10, pl. IV; Lessmann 1979A, p. 345; Berardi 1984, p. 188.

Freely based on an engraving attributed to Marco da Ravenna (B XIV, p. 16, no. 15). The meaning of *DP* is uncertain: *da Pesaro* and *dipinse* have been suggested.

Sforza di Marcantonio's two known fully signed works are this panel and one in Bologna (Ravanelli Guidotti 1985A, no. 129). A number of works dated between 1561 and 1576 marked *S* are probably also by him. He was originally from Castel Durante, but seems to have been in contact with Xanto, and so perhaps in Urbino, around 1540. He is recorded in documents as in Pesaro from 1550 to 1552, and from 1563 until his death *c.*1581 (Biscontini Ugolini 1979; Albarelli 1986).

99 Dish on low foot

Rimini, attributed to Giulio da Urbino in the workshop of Maestro Alessandro, 1535

Painted in blue, green, yellow, orange, brown, black, pink, white: the Fall of Phaethon; left, a river-god. Reverse: yellow rings and *1535 De fetonte :– :In arimin:* (Of Phaethon. In Rimini). DIAM 26.8 cm

MLA 1855, 12–1, 98

Bibl. Bernal Sale 1855, lot 2021; Fortnum 1873, pp. 565–6; Ballardini 1933–8, II, no. 183, figs 176, 334; Rackham 1940A, p. 309; Rasmussen 1980, p. 85; Gardelli 1982, p. 82, fig. 107; Mallet, forthcoming.

The story of Phaethon, son of the sun-god, who tried to drive his father's chariot and was killed, is from Ovid, *Metamorphoses* 2.

One of a group of plates marked as made in Rimini in 1535; others: Kube 1976, no. 94; Giacomotti 1974, no. 99; Norman 1976, C 74; and formerly Spero collection (Mallet, forthcoming); they are probably by the painter of a jug in Bologna (Ravanelli Guidotti 1985A,

100

no. 80) dated 1535 and signed by *Iulio da urbino in botega de mastro alisandro a rimino.* Giulio's hand has also been identified in pieces marked *In urbino* and bearing dates between 1533 and 1535, and on a plate marked *In uerona*, seemingly dated 1541 (Rasmussen 1980; Mallet, forthcoming). There is no proof that he is the 'Giulio da Urbino' mentioned in the 1568 edition of Vasari's *Lives* (Vasari 1878–85, VII, pp. 615–16) as making porcelain at the court of Alfonso II d'Este at Ferrara.

100 Dish

Venice, or possibly Urbino district, 1549

Painted in blue, orange, green, yellow, brown, purple, white: an allegory of the civilising power of eloquence. Reverse, in a square panel: *Qui.in.agris.bestiar.more.passin. uagabantur.et.hi.in.unû.ratione.conpulsi.primû.ad. utilia.et.honesta.propter-insolentia.reclamantes. deinde.propter.rationê.et.orationê.studiosius: mites.ex feris.et.mansuetos.reddidit.Eloquentia.* (Those who once wandered like beasts, when driven by reason to unite, at first rudely rejected everything useful and honourable,

but then paid more attention to rational speech, and Eloquence turned them from brutality into gentle and civilised beings). Outside the panel: *1549* and *.MAZO.* DIAM 46.5 cm
Mr Bruno Schroder
Bibl. Catalogue d'une collection remarquable d'objets d'art, Paris, 8–9 March 1869, lot 49; Rackham 1904, p. 17, no. 71; Cook Sale, Christie's, 7–10 July 1925, lot 65; Rackham 1955, pp. 14–17, pl. VIII; 1957B, pp. 32–4; Lessmann 1979A, p. 388; Ravanelli Guidotti 1985A, p. 106.

The inscription is abbreviated from Cicero's *De Inventione Rhetorica*, I. The scene represents the raising of man from a bestial condition (the disorderly nude figures in the background) to a civilised one (the attentive, clothed foreground group) by the power of eloquence – an exceptionally elaborate allegory for maiolica.

The painter has been called 'Mazo' as if the word were a signature; in fact, it is probably a Venetian dialect form of *maggio*, i.e. May. It would seem more sensible to call him the 'Eloquence

painter'. Iconographical links in his work with Xanto (T. Wilson 1985B, p. 907; Mallet, forthcoming) and his use of drawings by Battista Franco (Mallet, 1978, p. 404) suggest he was trained in Urbino; stylistic affinities with Venice *istoriato* indicate that he spent much of his career there.

101 Dish

Perhaps Faenza, 1533

Painted in blue, yellow, green, orange, brown, black, white: Daedalus flying, and Icarus falling to the ground; lower right, a river-god. Reverse: scale pattern and *1533.P.* DIAM 24.7 cm
MLA 1855, 8–11, 1
Bibl. Christie's, 27 Feb.–1 March 1855, lot 318; Ballardini 1933–8, II, no. 79, figs 75, 266; G. Liverani 1968, p. 694, fig. 3; Mallet, forthcoming.

The mythical inventor Daedalus made wings out of wax and feathers; his son Icarus flew too near the sun, the wax melted, and he fell to his death (Ovid, *Metamorphoses* 8).

101

The figures are all from engravings also used by Xanto: B XIV, p. 24, no. 21, cf. Ballardini 1933–8, II, no. 12; B XIV, p. 200, no. 247, cf. *ibid.*, no. 89; B XIV, p. 7, no. 6, cf. *ibid.*, no. 151; B XIV, p. 277, no. 362, cf. *ibid.*, no. 23. The graphic models used demonstrate that this painter was in contact with Xanto. The colouring and the pattern on the reverse are akin to the work of Baldassare Manara. Mallet has suggested that the painter may have been trained in Urbino, but working in Faenza. *P* is perhaps his initial.

102 Broad-rimmed bowl

By Baldassare Manara, Faenza, 1534

Painted in blue, green, yellow, orange, brown, purple, black, white: Tuccia carrying water in a sieve; right, a man with a wand. The shield of arms on the left may be for Guadagni of Florence, the other two are unidentified. Reverse: scale pattern in orange and yellow, and MDXXXIIII. F.ATNANASIVS. B..M.

DIAM 24.7 cm

MLA 1855, 12–1, 94

Bibl. Frati 1852, no. 78 (probably this piece); Sale catalogue, Paris, 13–15 Dec. 1853, lot 69; Bernal Sale 1855, lot 1999; Fortnum 1873, pp. 483; Ballardini 1933–8, II, no. 123, figs 120, 299; Rackham 1940A, p. 263; Mallé n.d., p. 26, fig. 14.

Tuccia was a Roman Vestal Virgin; to refute a charge that she had broken her vow of chastity, she carried a sieveful of water from the Tiber to the Temple of Vesta (Valerius Maximus, VIII, i, 5).

Baldassare Manara was a member of one of the major pottery families of Faenza. He is first recorded in archives in 1526 and died in 1546 or 1547

(Grigioni 1932). This piece blends the Faenza tradition with elements derived from Urbino, notably the colouring and disposition of figures in a landscape. A plate from the same armorial set is in the V&A (Rackham 1940A, no. 800); the identity of 'Athanasius', perhaps the first owner of the set, is unknown. Manara was the first Faenza painter to make a habit of signing his work; other signed pieces are: 221; Oxford, Ashmolean Museum (two, undated, Fortnum 1897, C482, 483); Paris, Petit Palais (undated, Join-Dieterle 1984, no. 36); Prague (undated, Vydrová 1973, no. 61); Malibu, J. Paul Getty Museum (undated, ex-Sotheby's, 22 Nov. 1983, lot 209); private collection, Italy (dated 1534, Ballardini 1933–8, II, no. 127); Cambridge, Fitzwilliam Museum (dated 1534, *ibid.*, II, no. 126); and V&A (dated 1535, Rackham 1940, no. 801).

103 Plaque

Workshop of Francesco Mezzarisa, Faenza, *c.* 1545

Painted in blue, orange, yellow, green, brown, purple, black, white: the Crucifixion; on a cartouche, *Justifichati.sumus. p. Christo* (through Christ we are justified) *.I..S..C.* 39.5 × 36 cm

MLA 1885, 5–8, 29; given by A. W. Franks

Bibl. Fortnum 1873, p. 363; Ballardini 1933, pp. 526–7, fig. 2; Ravanelli Guidotti 1984, pp. 190–1, 195, pls LXVIII, LXIX(a).

The design is taken (omitting secondary figures) from an engraving dated 1541, probably after Francesco Salviati (Ravanelli Guidotti 1984, pl. LXIX(b); B XV, p. 18, no. 8).

The attribution to Mezzarisa's workshop is based on the similarity to a plaque in Palermo (Ravanelli Guidotti 1984, pl. LXVI) with his name and the date 1544. Francesco Mezzarisa (first documented 1527, died after 1581) ran one of the largest workshops in Faenza: in 1546 he was capable of taking on an order from a Genoese merchant in Palermo to supply 7,025 vessels (Ballardini 1933A, 1943–5; Collina 1973). He was a protagonist in the development of 'Faenza white'. *Illustrated overleaf*

104 Dish on low foot

Workshop of Virgiliotto Calamelli, Faenza, *c.* 1550–70

Painted in blue, orange, green, purple, brown, white: Neptune in his chariot

102

104

calming a tempest (Virgil, *Aeneid*, I, 135).
Reverse: yellow and orange rings and, in
blue, ·⃝ℛℱ⃝· . DIAM 23 cm

Mr William Beare

Bibl. Sotheby's, 7 Dec. 1971, lot 15; Mallet
1974, p. 13, pl. XVII; Join-Dieterle 1984,
p. 130.

VR AF is the workshop mark of
Virgiliotto Calamelli of Faenza. This is
one of a group of *istoriato* dishes with
the mark which are painted in the
contemporary Urbino manner; see
Gennari 1956; Lessmann 1979A, p. 106;
Join-Dieterle 1984, pp. 128–31. A major
part of the workshop's production was
'Faenza white'; cf. 234.

The design is from the engraving
known as the *Quos Ego* (p. 127).

105 Dish

Painted by Gianbattista Dalle Palle,
Verona or Faenza, 1560

Painted in blue, orange, yellow, green,
purple, brown, black, white: the Children of
Israel emerging from the Red Sea, while the
pursuing Egyptians drown (Exodus 4).
Reverse: *L ostinato farao somerse imare*
giabatista dalepale da faecia feci (the obstinate
Pharaoh drowned in the sea; I Gianbattista
Dalle Palle from Faenza made it) *1560*
DIAM 29.8 cm

Courtauld Institute Galleries (Gambier-Parry
Bequest)

Bibl. Mallet 1967, p. 151; G. Liverani 1967A,
p. 33; Jestaz 1972–3, part 1, pp. 233–4;
Lessmann 1979A, p. 378; Courtauld Galleries
1979, no. 116.

Gianbattista Dalle Palle was a member
of one of the pottery families of Faenza,
related by marriage to the Calamelli
(G. Liverani 1967A). A signed plate
painted not on tin glaze but on slip-
coated earthenware, is marked *In Verona*
and dated 1563, but it is not known how
much of his career he spent in Verona.

The composition is from the woodcut
after H. S. Beham in a Bible picture-
book published in Frankfurt in 1533.

106 Dish

Possibly workshop of Virgiliotto
Calamelli, Faenza, *c*. 1550–70

Painted in blue, green, orange, brown, grey,
yellow, black, white: episodes from the
romance of Cupid and Psyche: left, Psyche
carried by the west wind; foreground,
Psyche asleep; right, Psyche with her
(invisible) attendants at the palace of Cupid.
Reverse: blue arches and pointed ovals,
yellow rings, and:

Zephir le gonfia, come uela in naue,
La ueste, et poula inun pian dietro al monte
Onde, dormito un sonno assai souaue,
A un palagio ne uiene presso a' una fonte

Cui mentre mira, & gran marauiglia haue,
S'ode dir da non uiste uoci, & pronte
Cio tutto é tuo, noitue, che guardi omai:
Lauati, e'corca, e' poscia a cena andrai.

(The west wind blows out her gown like the
sail of a ship, and sets her down in a plain
beyond the mountain. From there, after a
most sweet sleep, she comes to a palace by
a fountain. While she gazes in amazement she
hears unseen willing voices: 'All you see is
yours, and we are yours; bathe and rest, and
then you shall go to supper'.) DIAM 43.7 cm

MLA 1855, 12–1, 80

Bibl. Bernal Sale 1855, lot 1937; Fortnum
1873, p. 342.

The romance of Cupid and Psyche is
from *The Golden Ass* of Apuleius
(second century AD) which was popular
in the Renaissance. The composition is
closely based on an engraving (B XV,
p. 214, no. 44) by the 'Master of the
Die'; the verses are copied from the
engraving.

This plate and one in Brunswick
apparently formed part of an ambitious
Cupid and Psyche set. The Brunswick
plate is attributed by Lessmann (1979A,
no. 44) to Virgiliotto Calamelli's
workshop, as being similar to the
istoriato pieces marked VR AF. However,
an origin in the Urbino district cannot
be ruled out. Fortnum thought the plate
'an undoubted work in [his] best
manner' by Orazio Fontana.

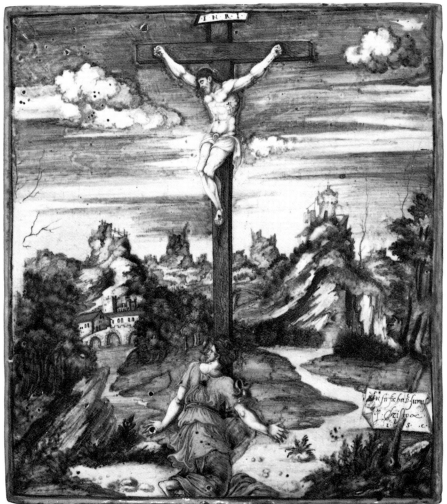

103

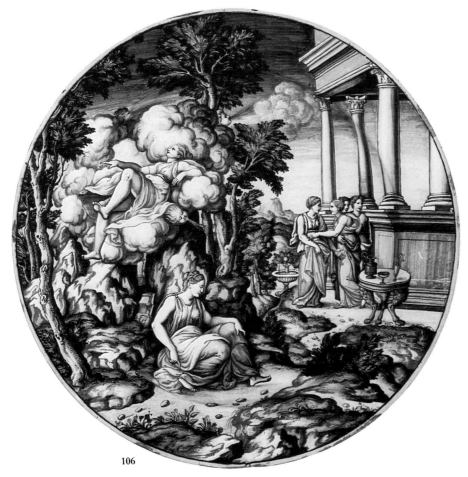

10 High Renaissance ornament

From around 1500 maiolica design came increasingly to reflect the influence of ancient Rome. Elements of Roman architectural and sculptural ornament had been used by artists throughout the fifteenth century, but a fashion for fantastic painted ornament in the classical manner developed after the discovery around 1480 of the painted rooms of the 'Golden House', the vast palace in the centre of ancient Rome built for the Emperor Nero before his death in AD 68. The style of painting in the Golden House came to be called 'grotesque' for reasons stated by Benvenuto Cellini in his *Autobiography*: 'These *grottesche* have been given this name in modern times, having been found by scholars in underground caverns in Rome; these were originally bedrooms, bathrooms, studies, living rooms, and the like. They were discovered underground because the level of the earth has risen since ancient times and the rooms have been buried. The word used in Rome to describe these underground chambers is *grotte*; and the word *grottesche* is derived from this'. These 'grotto-paintings' were eagerly copied by artists, and diffused by sketchbooks and ornament prints, and the word came to be loosely used for decoration incorporating bizarre monsters and fantasies, more or less distantly echoing classical originals.

A compendium of the ornament used on maiolica about 1550, from the perspective of the Urbino region, is provided by Piccolpasso: his pattern drawings include 'grotesques', 'trophies' (compositions of classicising arms and armour, and musical instruments), 'knots', 'candelabra', *bianco sopra bianco*, and several types of plant ornament. He also includes elements of Eastern origin—*alla porcellana* (blue-and-white designs based on Chinese porcelain) and 'arabesques' (tight scrollwork derived from Islam).

LITERATURE Ward-Jackson 1967; Dacos 1969.

105

106

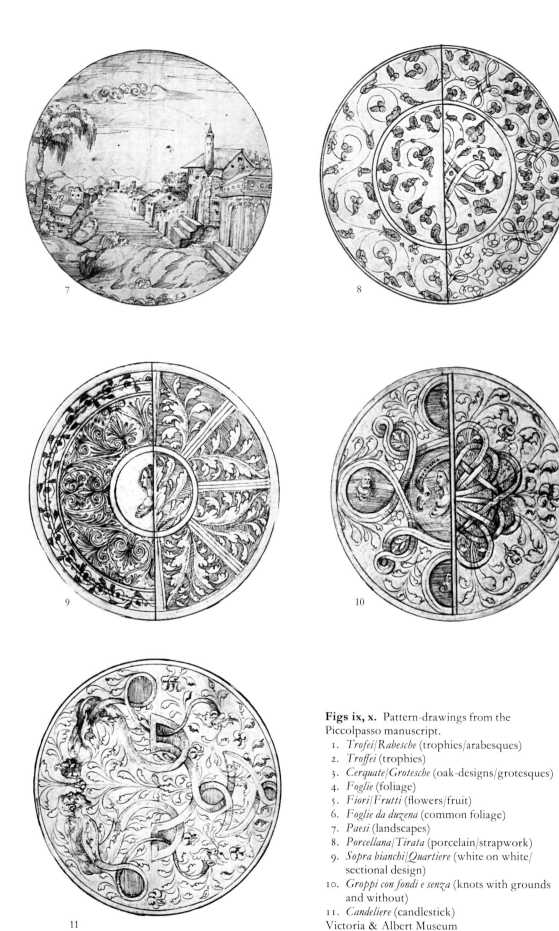

Figs ix, x. Pattern-drawings from the Piccolpasso manuscript.

1. *Trofei/Rabesche* (trophies/arabesques)
2. *Troffei* (trophies)
3. *Cerquate/Grotesche* (oak-designs/grotesques)
4. *Foglie* (foliage)
5. *Fiori/Frutti* (flowers/fruit)
6. *Foglie da duzena* (common foliage)
7. *Paesi* (landscapes)
8. *Porcellana/Tirata* (porcelain/strapwork)
9. *Sopra bianchi/Quartiere* (white on white/ sectional design)
10. *Groppi con fondi e senza* (knots with grounds and without)
11. *Candeliere* (candlestick)

Victoria & Albert Museum

107 Virgin and Child

Emilia-Romagna or the Marches,
c. 1490–1510

Painted in blue, orange, yellow, green,
purple, black: the Virgin and Child
enthroned; on the sides, panels with St
Sebastian, and Mary Magdalene with AVE
MARIA. On the front of the throne, narrow
bands of orange-ground ornament, including
masks and cornucopias. On the reverse, a
damaged inscription .ÞO. NICHOLO. . .
Battered. H 49 cm

MLA 1903, 8–10, 1; given by S. Fitzhenry
Bibl. Rackham 1940A, p. 47; Della
Gherardesca 1950, p. 79; Berardi 1984,
pp. 213–15, 224 note 39.

'Don Nicholo' may have been the man
who commissioned the group; it seems
optimistic to suppose it an artist's
signature.

Numerous figure-groups in similar
style made for churches, wayside
shrines, or private chapels have
survived; the most imposing is a
Deposition in the Metropolitan Museum,
dated 1487. Comparable Madonnas are:
Hausmann 1972, no. 112; Los Angeles
County Museum, ex-Oppenheimer Sale
1936, lot 40; Ballardini 1933–8, 1, no. 17,
dated 1499. The usual attribution of
these sculptures is to Faenza (Mallet
1974, pp. 6–7); Berardi has suggested
Pesaro as the place of origin.

The profusion of ornament contrasts
with the more sculptural Madonnas
from the Della Robbia workshop.

108 Two vases of fruit, flowers and vegetables

Della Robbia workshop, Florence,
c. 1490–1520

The vases moulded in relief with bands of
scales, interlace and gadroons; covered with
a blue glaze; traces of gilding. The tops
painted in green, yellow, purple and blue.
Damaged; each vase originally had two
handles, now missing. H (overall) 1) approx.
37.5 cm; 2) approx. 34.5 cm

MLA 1903, 10–10, 1 & 2; bought from H.
Wallis
Bibl. Bardini Sale, Christie's, 5–7 June 1899,
lot 203; Solon 1907, fig. 5; Marquand 1920,
p. 36, no. 23; Cora 1973, p. 187, no. 7,
pl. 307c.

One of the innovative achievements of
the great Florentine sculptor Luca Della
Robbia (1400–82) was his technique of
sculpture in tin-glazed earthenware. The
Della Robbia family workshop
continued for several generations; one

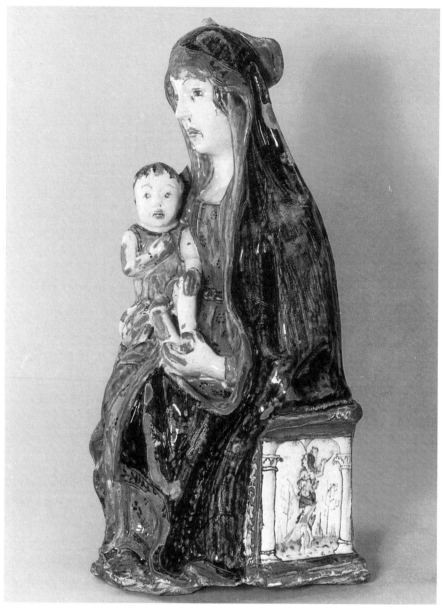

107

product was flower vases such as this,
used for decoration in churches and
homes. The application of gold to
earthenware was perhaps first attempted
in this workshop.
Illustrated on pp. 4–5

109 Pharmacy jar

Perhaps Montelupo, *c.* 1510–40

Apparently tin-glazed over a slip; painted in
blue, yellow, green: a panel of grotesques
incorporating monsters, dolphins, and
foliate scrollwork; beneath, COMINO PESTO
(crushed caraway); decoration *alla porcellana*
round base and neck. Reverse undecorated.
H 34.5 cm

MLA 1885, 5–8, 23; given by A. W. Franks
Bibl. Drey 1978, pl. 15C.

Several similar jars survive, perhaps
from the same set: Rackham 1940A,
no. 248; V & A 7841–1861; Giacomotti
1962, fig. 17; Pringsheim Sale 1939, lot
43; sold Paris (Drouot, Rive Gauche),
29 June 1977, lot 11; two in Leipzig,
Gaude 1986, no. 62; two in the Museo
Civico, Massa Marittima, one of them
with a coat-of-arms, *gules, a lion argent
holding an axe* (stated locally to be from
the local convent of Santa Chiara). Cf. a
jug excavated at Montelupo (F. Berti &
Pasquinelli 1984, p. 108).

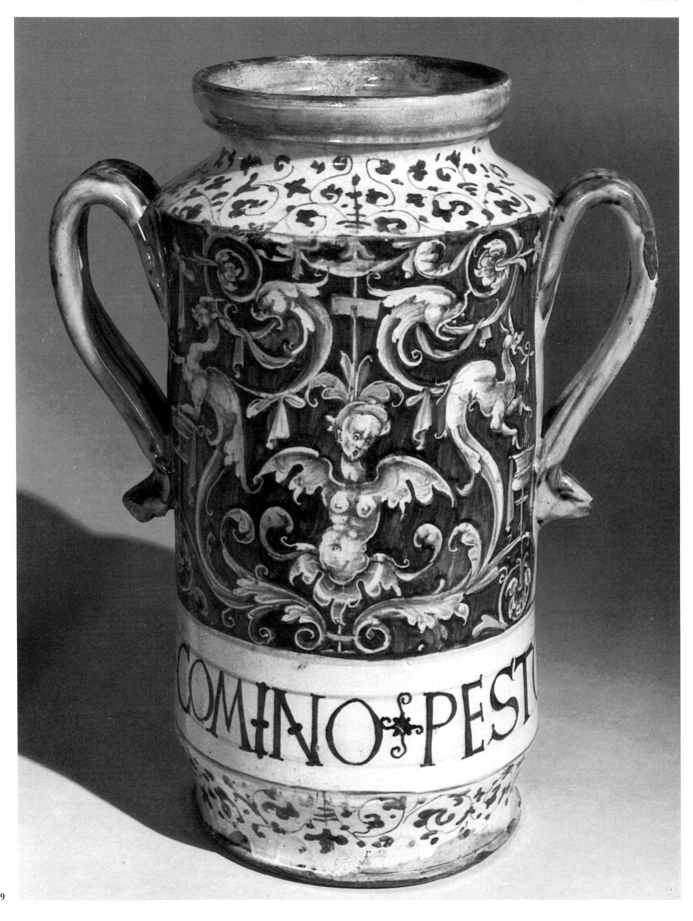

110, 111

110 Broad-rimmed bowl

Probably Faenza, *c.* 1500–20

Painted in white, blue, orange, yellow: plant and abstract decoration. Reverse: blue and purple rings. DIAM 23.1 cm

MLA 1878, 12–30, 415; Henderson Bequest

111 Broad-rimmed bowl

Perhaps Faenza, *c.* 1510–30

Painted in blue, white, green, orange, yellow: a man carrying a sheep; on sides and rim, *bianco sopra bianco* and narrow bands of blue and orange ornament. Reverse: blue flower sprays and a fleur-de-lis with a curving tail. DIAM 21.7 cm

MLA 1878, 12–30, 413; Henderson Bequest
Bibl. Rackham 1940A, p. 81.

The iconography echoes Early Christian representations of Christ as the Good Shepherd, derived from a Hermes type in Greek art.

112 Plate

Faenza, 1524

Greyish-blue glaze; painted in blue, white, yellow, green, orange, red: a man in a turban holding a tablet with indecipherable characters, surrounded by plant ornament in white; on the rim, foliate scrollwork with dolphins, fruit, and *1524*. Reverse: flower sprays and a mark resembling an inflatable ball. DIAM 24.2 cm

MLA 1855, 12–1, 68
Bibl. Bernal Sale 1855, lot 1885; Ballardini 1933–8, I, no. 157, fig. 127.

For the mark, see 45.

113 Plate

Faenza, probably 1531

Greyish-blue glaze; painted in blue, white, green, orange, yellow, brown: a shield of arms, *argent, three bends double-embattled gules*, supported by *putti*; around it, ornament in white; on the rim, foliate scrollwork, dolphins, winged cherub-heads, and masks. Reverse: rosettes and scrollwork distantly echoing Chinese porcelain; in the centre, two concentric circles crossed by two loops and with four tangent loops. DIAM 37.3 cm

MLA 1855, 12–1, 100
Bibl. Bernal Sale 1855, lot 2037.

The arms were used by the Salviati, one of the principal families of Florence, and are also recorded for Avogadro/ Avvocati. This plate formed part of an ambitious set: jar, Rackham 1940A, no. 290; bowl, Mallé n.d., no. 19; plate with Parnassus, Van de Put & Rackham 1916, no. 715, all dated 1531; also a bowl, Vydrová 1973, no. 38, and plate,

M.X. Sale, Paris, 9–10 May 1927, lot 56. The bowls resemble in form and decoration the 1529 bowl from the workshop of Piero Bergantini (see 45); it is possible that this set was made in the Bergantini workshop.

114 Fluted dish on low foot

Faenza, *c.* 1535–50

Painted in blue, orange, green, yellow, brown, white: Lucretia about to kill herself with a sword; swirling foliate ornament with dolphins, following the moulded pattern. Reverse: blue and orange dashes. DIAM 29.1 cm

MLA 1878, 12–30, 450; Henderson Bequest
Bibl. Henderson 1868, pl. VII.

The figure is presumably the Roman heroine Lucretia, who accused Sextus Tarquinius, son of the King of Rome, of raping her, and committed suicide to prove the truth of her charge.

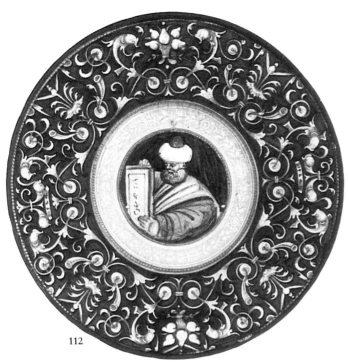

112

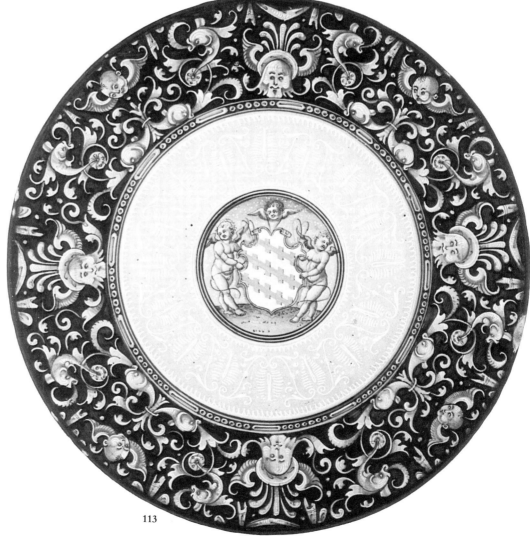

113

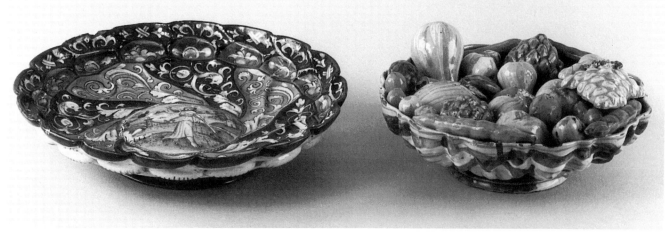

114, 115

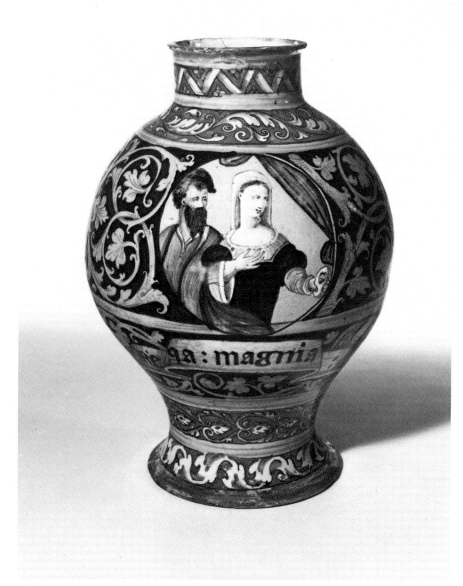

116

115 Dish of fruit and vegetables

Faenza, *c.* 1545–75

Moulded dish on low foot, filled with vegetables, fruit and nuts. Painted in blue, yellow, green, orange, brown, black, white. Beneath the foot, ⟨mark⟩ · DIAM 23.8 cm

MLA AF 3206; Franks Bequest, 1897
Bibl. Fortnum 1873, p. 527.

Bowls of imitation fruit were a Faenza speciality in the sixteenth century (Rasmussen 1984, pp. 103–4; Malagola 1880, p. 514). The idea was perhaps derived from the Della Robbia workshop.

There is no proof of the theory that the mark denotes a Faenza potter called Enea Utili (Join-Dieterle 1984, p. 134). It occurs on wares similar to those with the VR AF mark of Virgiliotto Calamelli.

116 Pharmacy jar

Probably Faenza, *c.* 1540–60

Painted in blue, yellow, orange, green, black, white: curling tendrils and leaves; in a roundel, a man and woman; on a scroll, *Reqa: Magnia*: Around neck and foot, foliate and ribbon decoration. H 33.2 cm

MLA 1856, 12–13, 7

The inscription denotes an opiate called *Requies Magna*, 'the great rest' (Drey 1978, p. 218). Two comparable jars are marked *1548* and *Fate in Faenza* (Giacomotti 1974, nos 959, 960).

117 Pharmacy jar

Workshop of Sebastiano di Marforio, Castel Durante, 11 October 1519

Painted in blue, green, orange, yellow, purple: two pairs of monsters, each pair flanking a garland containing a shield of

arms, *argent, a bend sinister azure charged with four chevrons vert, between three trees eradicated proper.* On the neck, masks, and shields with an owner's mark incorporating FF and a double cross; around the base, foliate scrollwork and vases of fruit. On tablets: *A di xi de Octobre fece 1519/Ne la Botega d̄ Sebastiano d̄ Marforio/In Castel durā* (made in the workshop of Sebastiano di Marforio in Castel Durante, 11 October 1519).
H 36.5 cm

MLA 1855, 12–1, 59

Bibl. Raffaelli 1846, p. 17; Bernal Sale 1855, lot 1841; Fortnum 1873, pp. 294, 298, 305; Ballardini 1933–8, I, no. 88, fig. 87; Rackham 1940A, p. 205.

Giuseppe Raffaelli, in 1846, described four vases which were until 1837 in the Purgotti pharmacy at Cagli, not far from Urbania/Castel Durante. This jar and one in the V&A are evidently two of these; the other two have not been traced. A smaller jar with the same arms and owner's mark is in Glasgow (Olding 1982, no. 19). The arms are unidentified, but the set was probably made for a local religious pharmacy.

Sebastiano di Marforio, active at least from 1505 until 1541 (Leonardi 1982B, pp. 160–1) ran one of the principal potteries in Castel Durante. No other marked work is known.
Illustrated in colour

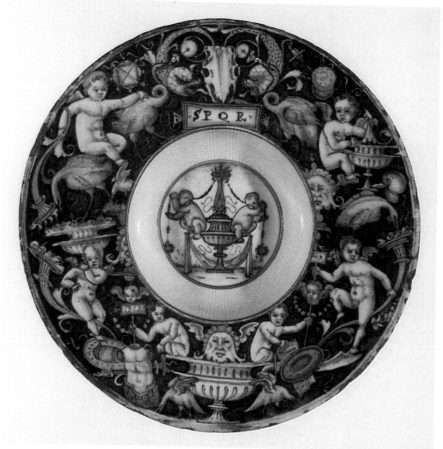

118

118 Broad-rimmed bowl

Possibly workshop of 'Giovanni Maria', Castel Durante or Urbino, *c.* 1505–15.

Painted in blue, orange, green, yellow, white: in the well, two *putti* playing on a flaming urn; *bianco sopra bianco* on the sides; on the rim, grotesques including *putti* playing, birds, an animal skull, vases, masks, cornucopias, trophies, curling ribbons, and tablets with SPQR. Reverse: blue rings and a spiral. DIAM 22.8 cm

MLA 1855, 12–1, 63

Bibl. Bernal Sale 1855, lot 1856; Rackham 1928-9, part 1, p. 439, fig. 6.

For 'Giovanni Maria', see 119.

119 Plate

Perhaps the Marches or Venice, *c.* 1505–25

Painted in blue, green, yellow, orange, purple: a winged *putto* riding a water bird and holding a toy windmill; on the rim, grotesques incorporating masks, monsters, weapons, cornucopias, musical instruments, and tablets lettered S.P.Q.R. (Senatus Populusque Romanus) and Q.V.P.C.

(unexplained). Reverse: blue sprays and crossed lozenges. DIAM 22.1 cm

MLA 1855, 12–1, 107

Bibl. Bernal Sale 1855, lot 2061; Solon 1907, fig. 10; Rackham 1928-9, part 2, pp. 89–90, fig. 21.

This brilliant plate is one of several pieces (Rackham 1928-9; Rackham 1940A, pp. 169–77; Berardi 1984, pp. 145–6, 166) associated by Rackham with a bowl in New York (Fourest 1982, pl. 57) marked as made in Castel Durante in 1508 by 'Zouâmaria Vrô', probably the documented potter Giovanni Maria di Mariano. In fact, they do not seem all to be by a single painter, nor from a single workshop. Unless there were two potters of the same name, Giovanni Maria was in Castel Durante in 1508, in Urbino in 1520 and 1530 (Negroni 1986, pp. 16–19), and in Venice in 1523 (Berardi 1984, p. 9): so itinerant a *maestro* may not have had a consistent workshop style.

The windmill is similar to the one on 126 and was evidently a popular child's toy.
Illustrated in colour

120 Dish on low foot

The Marches and/or Gubbio, 1529

Painted in blue, grey-brown, white: symmetrical entwining monsters and foliate tendrils, vases and a tablet with *1529*; on the lower vase, EDRU(?). Tiny traces of lustre.
DIAM 21.8 cm

MLA 1855, 12–1, 93

Bibl. Bernal Sale 1855, lot 1995; Ballardini 1933–8, I, no. 231, fig. 213; Norman 1976, p. 101.

Cf. Giacomotti 1974, no. 756, dated 1533 and fully lustred.

121 Vase

Urbino district, *c.* 1525–35

Painted in blue, grey, white, brown: grotesques incorporating masks, trophies of arms and musical instruments, cornucopias, strapwork, ribbons, and foliage. One handle replaced in wood. H 31.2 cm

MLA 1855, 12–1, 112

Bibl. Bernal Sale 1855, lot 2088.

Cf. Piccolpasso's drawings of *grotesche, trofei,* and *candeliere.*

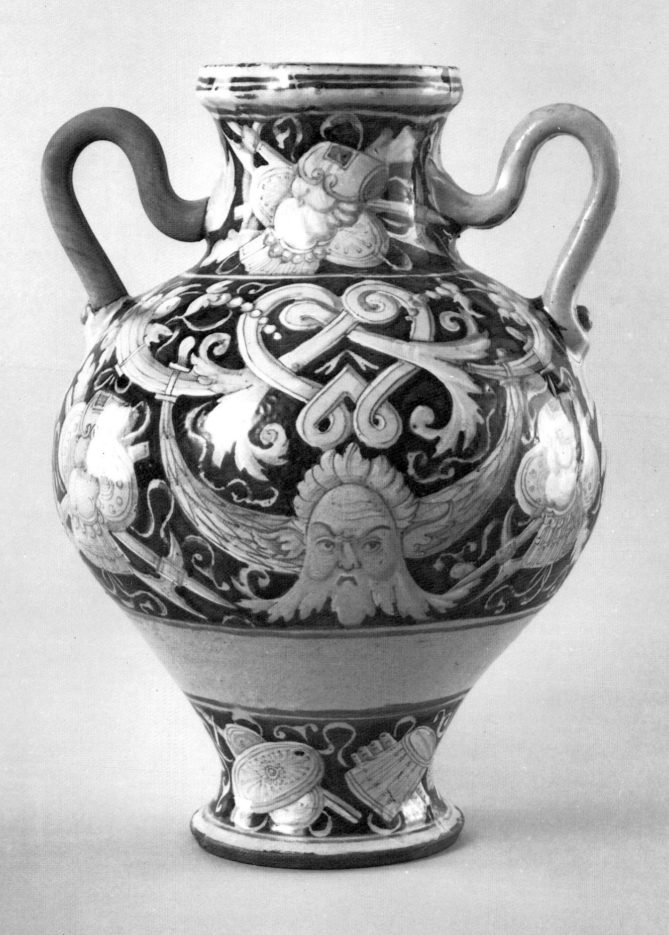

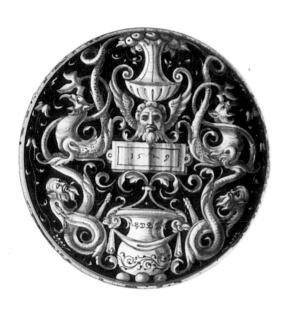
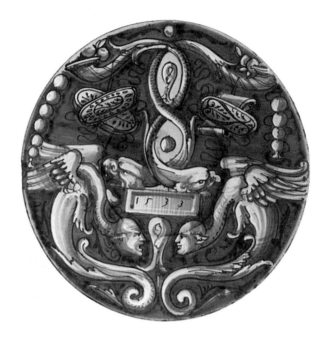

120, 122

122 Plate

Urbino district, 1533

Painted in green, brown, white: symmetrical entwining monsters, trophies of arms, and cornucopias; on a tablet, *1533*. DIAM 25.9 cm

MLA 1855, 12–1, 67

Bibl. Bernal Sale 1855, lot 1882; Ballardini 1933–8, II, no. 85, fig. 80.

Cf. Piccolpasso's drawing of *grotesche*.

123 Broad-rimmed bowl

Probably Urbino district, 1540

Painted in blue, yellow, brown, white: a winged *putto* with a rod, seated among rocks; on the rim, trophies of arms, cornucopias, and tablets with *1540*. DIAM 24.5 cm

MLA 1878, 12–30, 453; Henderson Bequest

124 Plate

Urbino district, *c.* 1530–60

Painted in white, green, yellow, blue, orange, black: an unidentified shield of arms, *gules, a dexter arm, vambraced azure, holding a sword azure, the hilt sable, accompanied by a letter T; a chief of the Empire*; on the rim, *bianco sopra bianco* and an oak wreath. DIAM 23.3 cm

MLA 1878, 12–30, 432; Henderson Bequest
Bibl. Hausmann 1972, p. 256.

Cf. Piccolpasso's drawing of *sopra bianchi*. A larger plate from the set is in the Metropolitan Museum.

125 Dish on low foot

Urbino district, *c.* 1525–45

Moulded in relief with interlacing oak branches. Painted in blue, yellow, orange, brown, green: in the centre, a classicising male head in a wreath. Restoration to edge. DIAM 25.2 cm

MLA 1855, 12–1, 108

Bibl. Bernal Sale 1855, lot 2066; Dennistoun 1909, III, p. 416; Norman 1976, p. 65.

Piccolpasso calls this pattern *cerquate* (oak pattern) with the comment: 'These are much in use with us [i.e. the potters of the Duchy of Urbino] from the veneration and duty we owe to the oak tree [*Rovere* – the family name of the Dukes of Urbino] in the shade of which we live happily, so that this can be called the Urbino style of painting'.

126 Broad-rimmed bowl

Lustred and perhaps painted in the workshop of Maestro Giorgio, Gubbio, 1524

Painted in blue, green, yellow; red and golden lustre; a *putto* with a toy windmill; on the rim, grotesques and trophies, incorporating weapons and armour, monsters, torches, foliate scrollwork, cornucopias, and tablets with *1524*, and *florid uirtus* (flourishing virtue). Reverse: lustre rings. DIAM 27.2 cm

MLA 1851, 12–1, 14; formerly Abbé Hamilton collection
Bibl. Ballardini 1933–8, I, no. 143, fig. 144.

127 Plate

Perhaps Umbria or the Marches, 1534

Painted in blue, yellow, orange; brownish lustre: musical instruments, trophies of arms, and a tablet with *1534*. Reverse: blue cusped scales. DIAM 21 cm

MLA 1878, 12–30, 402; Henderson Bequest
Bibl. Ballardini 1933–8, II, no. 131, fig. 125.

The plate is not typical of the main lustre centres, Gubbio and Deruta, and may be an example of lustre manufacture elsewhere.

⇦121

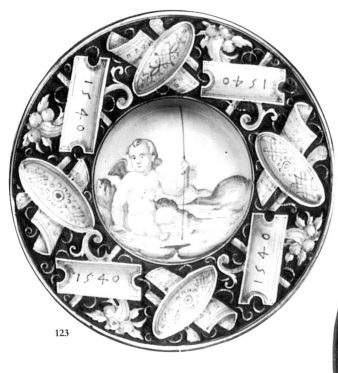

123

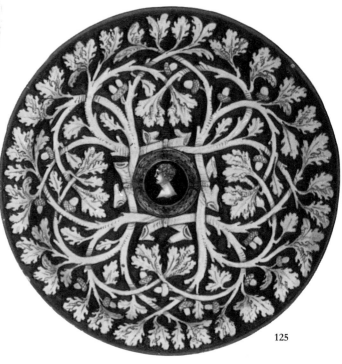

125

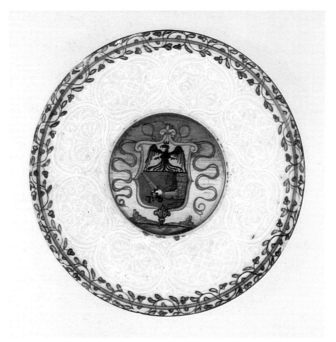

124

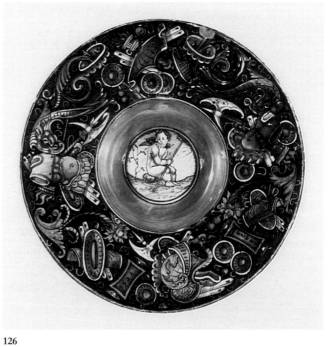

126

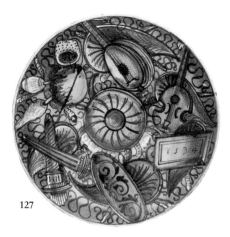

127

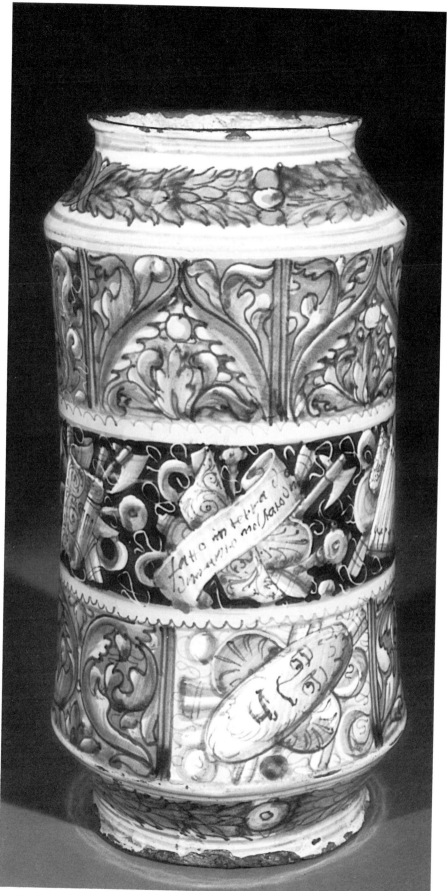

128 Pharmacy/storage jar

Castel Durante, *c.* 1550–55

Painted in blue, green, grey, orange, brown, yellow, white: decoration including wreaths, roundels with a classical head and a rabbit, cornucopias, trophies of arms, monsters, scrolling foliage, ribbons, and scrolls inscribed *c3cc° VIOLITO* (violet-flavoured sugar-candy) and *fatto in terra d̄ durante nel stato du . . .* (made in Durante land in the state of Urbino). H 34.3 cm

MLA 1855, 7–31, 1; bought from Monsieur Signol

Similar *albarelli* include one at Sèvres (Giacomotti 1974, no. 794) marked as made 'in Castel Durante, 7 miles from Urbino' and apparently dated 1555; according to Fortnum (1897, p. 73) they were part of a set acquired by Signol, a Paris dealer, in Sicily.

A related set (Drey 1985) has *istoriato* subjects apparently by the same painter as the 'Andrea da Negroponte' dish (see 89); both sets may be from the same workshop. Also similar is a jar (Leonardi 1982A, no. 39) marked *In Castello Durante 1562 per mastro Simono*; for 'Maestro Simone', cf. Ragona 1976; Leonardi 1982B, p. 168.

128

11 The Renaissance in Tuscany

Although maiolica and incised slipwares were made in most parts of Tuscany in the sixteenth century, this section focuses on the artistic achievement on maiolica of the two great cultural power-houses, Florence and Siena.

Florence in the Renaissance was supplied with pottery only to a limited extent from workshops in the city; the documentary and archaeological evidence suggests that the largest producers in the region were specialised 'pottery villages', especially Montelupo on the River Arno between Florence and Pisa. Montelupo was a flourishing centre of maiolica production by 1400, and some of the most prominent potters in Florence in the fifteenth century came from there. In recent years a large well in Montelupo has been excavated by archaeologists and volunteers, and the pottery from it now in the local museum is an impressive conspectus of the production of a village which came in the sixteenth century to dominate local production, and to conquer export markets all over the Mediterranean and Europe.

In 1498 two potters from Montelupo, Stefano and Piero di Filippo, took over a pottery in the outbuildings of the Medici villa at Cafaggiolo, north of Florence. Their family managed the Cafaggiolo pottery for over a hundred years; between 1500 and 1530 they produced some of the most striking maiolica painting anywhere. The workshop mark was SP in monogram; this presumably stood for Stefano and Piero, but remained in use after Piero's death, c. 1507. Cafaggiolo is the only place in Tuscany where lustreware was demonstrably made. Production was never on a large scale, and it is perilous to attribute to Cafaggiolo anything without the SP mark. The kiln site, however, is known, and it is hoped that before too long excavation may throw more light on this famous factory.

Tile pavements in the Siena churches of San Francesco and Sant' Agostino are evidence that Sienese potteries were capable of producing excellent work in up-to-date styles by the 1480s. In the early sixteenth century several potters from Faenza are recorded to have come to work in Siena, among them a man named Benedetto di Giorgio, whose

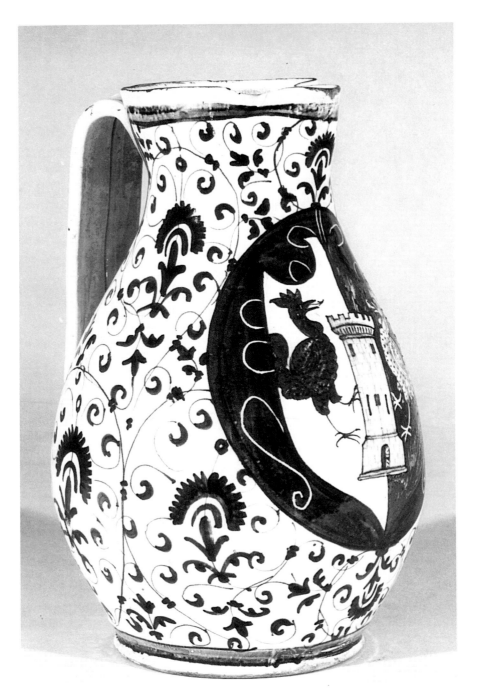

129

name, Maestro Benedetto, is on 133. A further group of pieces presumably made in Siena centres round 134, with the arms of Pandolfo Petrucci, and the tile pavement laid in his palace about 1509. Bernard Rackham believed the 'Petrucci' plate and the 'Maestro Benedetto' plate to be by the same painter; if this were true, it would seem probable that all the Siena pieces here included, and indeed virtually all the top-quality maiolica attributable to early sixteenth-century Siena, were made in a single workshop, belonging to a man from Faenza. This conclusion has been vigorously resisted by Sienese scholars. Key pieces have been brought together here in the hope of throwing light on the problem.

LITERATURE *Cafaggiolo*: Cora & Fanfani 1982; Alinari 1986.
Montelupo: Vannini 1977; F. Berti & Pasquinelli 1984; F. Berti 1986.
Siena: Douglas 1902, 1937; Guasti 1902; Luccarelli 1975, 1983, 1984; Migliori Luccarelli 1983.

129 Jug

Cafaggiolo, *c.* 1500–15

Painted in blue, reddish brown, orange, green, purple: arms, *per pale argent and gules, a tower argent between two cocks counterchanged*; the rest of the surface decorated *alla porcellana*. Beneath the handle, SP in monogram, crossed. H (max) 33.5 cm
MLA 1890, 7–16, 11; given by A. W. Franks
Bibl. Craven Sale, Christie's, 1–4 July 1890, lot 86; Rackham 1940A, p. 113; Hausmann 1972, p. 123; Cora & Fanfani 1982, no. 34.

The half-cogwheel motif is characteristic of the Florence-region version of *alla porcellana* decoration. The arms are unidentified but may be punning (Torregalli?).

130 Dish

Cafaggiolo, 1513–21

Painted in blue, green, yellow, orange: a man kneeling before an altar with a sheep burning; the altar inscribed GLOVIS and SPQR; on the sides, imitation gadroons; on the rim, *alla porcellana* decoration incorporating trophies and four logs sprouting new shoots. Reverse: scrolls, squiggles and crossed circles with (twice) SP in monogram, crossed, and *Inchafaggiuolo*. A layer of white slip between the red clay and the tin glaze is revealed where the glaze has run. DIAM 48 cm
MLA AF 3189; Franks Bequest, 1897

Bibl. Fortnum 1873, p. 93; Rackham 1940A, pp. 111, 118; Cora & Fanfani 1982, no. 47; T. Wilson 1984, pp. 436–7, pl. CXLVIII.

The subject is apparently Abel sacrificing (Genesis 4), though the subject is unusual in Renaissance art without Cain. GLOVIS (see 19) and the sprouting logs (a symbol of rebirth) were *imprese* used by two members of the Medici family, Pope Leo X (d. 1521) and his brother Giuliano. SPQR (the Senate and People of Rome) could refer either to the Pope or to Giuliano, who was made a citizen of Rome in 1513. The plate was perhaps made for one of these two men.

A slip was often applied beneath a tin glaze on Tuscan maiolica, particularly with red clays which might show through the white glaze. It is described as the standard technique for wares 'if you want to paint them and make them beautiful' by the Sienese writer Vannoccio Biringuccio in his *Pirotechnia* (1540, fol. 145v).
Illustrated in colour

131 Dish

Attributed to the 'Vulcan painter', probably Tuscany, *c.* 1510–35

Painted in blue, yellow, green, orange, white: a satyr piping to a naked woman and child in landscape. Reverse decorated in blue and red. Two suspension holes in foot.
DIAM 33.5 cm

MLA 1855, 12–1, 66
Bibl. Bernal Sale 1855, lot 1877; Rackham 1940A, p. 110; G. Liverani 1941B, pp. 30–2, pl. XV; Cora & Fanfani 1982, no. 78; Fourest 1983, pl. 38.

The figures are from an engraving by Dürer (B VII, p. 83, no. 69), perhaps inspired by a description by Lucian of an ancient painting showing a female centaur suckling twins. The painter's immediate source may have been the reversed version of the Dürer engraving, dated 1507, by Giovanni Antonio da Brescia (B XIII, p. 326, no. 16). The central tree seems to echo a different Dürer engraving (B VII, p. 86, no. 73).

The authorship of this dish is controversial, and it has been attributed to Faenza. In the writer's opinion it is by the same brilliant painter as plates with Marcus Curtius (Lessmann 1979A, no. 83) and the Fall of Phaethon (Rackham 1940A, no. 314); it may have been the same painter who painted a

plate in the V&A with Vulcan (Rackham 1940A, no. 315), called the 'Vulcan painter'. For other pieces attributed to him, see Rackham 1940A, p. 110.
Illustrated overleaf and on the cover

132 Dish

Probably Montelupo, 1500–30

Painted in blue, green, red, yellow: concentric patterns round a chequered centre. The reverse partially glazed. DIAM 33.6 cm
MLA 1890, 12–13, 2; given by A. W. Franks

Fragments of similar pieces have been found at Montelupo (Cora 1973, pls 247b, 267a; F. Berti & Pasquinelli 1984, p. 106); for the claim that wares of this pattern were made at Narbonne in France, see Rackham 1940A, pp. 122–3; Chompret 1955, p. 18.

133 Plate

Workshop of Maestro Benedetto, Siena, *c.* 1510

Painted in blue, blue-black, white: St Jerome contemplating a skull, surrounded by strapwork; on the rim, foliate sprays and a wreath. Reverse: a foliate tendril; on a tablet, *fata ī Siena da Mº benedetto* (made in Siena by Maestro Benedetto). DIAM 24.5 cm
Victoria & Albert Museum, 4487–1858
Bibl. Fortnum 1873, p. 137; Douglas 1902, pp. 442–5; 1937, pp. 89–90; Ballardini 1938, fig. 33; Rackham 1940A, no. 373; G. Liverani 1958A, p. 27, figs xiv, xv; Hausmann 1972, p. 193; Fourest 1983, pl. 53; Luccarelli 1984, p. 302, pl. LXXIV.

Benedetto di Giorgio from Faenza was in Siena from about 1503 to his death in 1522 (Migliori Luccarelli 1983, pp. 282–3). This plate and a fragment of a similar one dug up in Siena (Douglas 1937) are his only known marked works. The inscription suggests, but does not prove, that Benedetto painted the plate himself. Cf. Piccolpasso's drawing of *tirata*.

134 Plate

Siena, *c.* 1510

Painted in blue, black, brown, yellow, orange, green, red, white: Pan with his pipes, with two kneeling shepherds; above Pan's head, a shield of arms of Petrucci; the shepherd on the left holds a shield, *azure, a crane in its vigilance proper, in chief three stars or*; the right-hand shepherd has *or, three bends azure, the middle bend charged with three stars or*; concentric bands of ornament; on the rim,

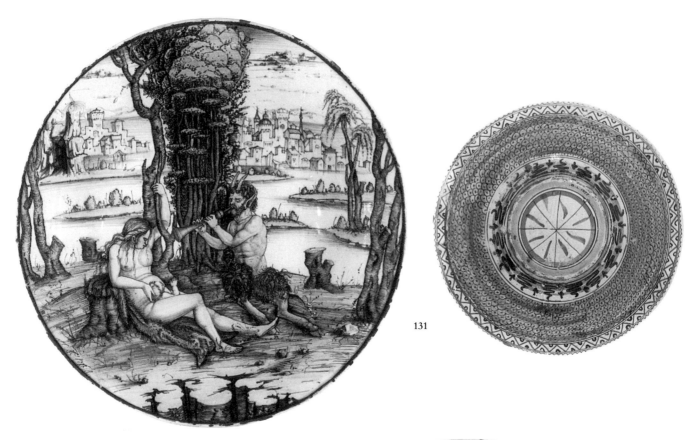

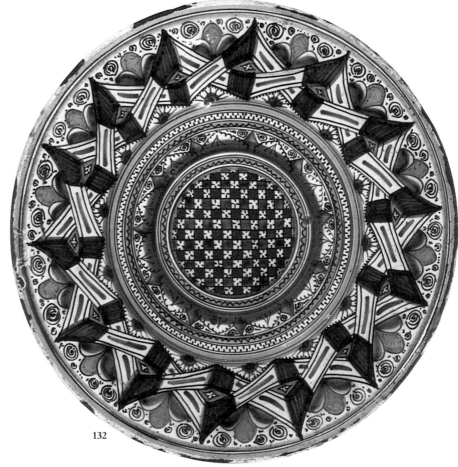

131

grotesques incorporating monsters, vases, dolphins, and the three shields of arms repeated. Reverse partially glazed; within the foot, a rough incised cross. DIAM 42 cm
MLA 1855, 12–1, 114
Bibl. Bernal Sale 1855, lot 2106; Fortnum 1873, p. 132; Ballardini 1938, fig. 36; Rackham 1940A, p. 127; 1963, pl. 45a; Fourest 1983, pl. 51.

The arms above Pan's head are those of Pandolfo Petrucci (d. 1512), the ruler of Siena, for whom the Palazzo Petrucci was built. It seems possible a pun may be intended on Pan/Pandolfo. The subsidiary coats-of-arms have not been identified, but the left-hand one may be for Battaglini or Pigiarelli (both of Orvieto). The grotesques on the border are virtually identical to some of the tiles of the Petrucci Palace pavement (135). The central scene is in the manner of Umbrian painting and was perhaps executed to a drawing by Pintoricchio, Signorelli, or (most probably) Girolamo Genga; all three were at work on the paintings for the palace *c.* 1508–12 (Davies 1961, p. 475). Cf. pp. 45, 115–17.
Illustrated in colour

132

135 Floor tile

Siena, *c.* 1509–13

Painted in black, blue, yellow, green, orange, red: 'grotesque' design incorporating urns, dolphins, cornucopias, etc. 19.8 × 13.5 cm

MLA 1854, 11–2, 2

Bibl. Rasmussen 1984, pp. 126–7.

From a pavement installed in his palace by Pandolfo Petrucci, a large section of which is now in the V & A (Rackham 1940A, no. 386; cf. Rasmussen 1984, pp. 126–7). Three of the tiles are dated 1509; another 1513, the year after Petrucci's death. The black-ground grotesques seem to show the influence of Pintoricchio's ceiling for the Piccolomini library (*c.* 1502–7). Before coming to Siena, Pintoricchio had been one of the first artists to make a detailed study of the ancient 'grotto-paintings' in Rome.

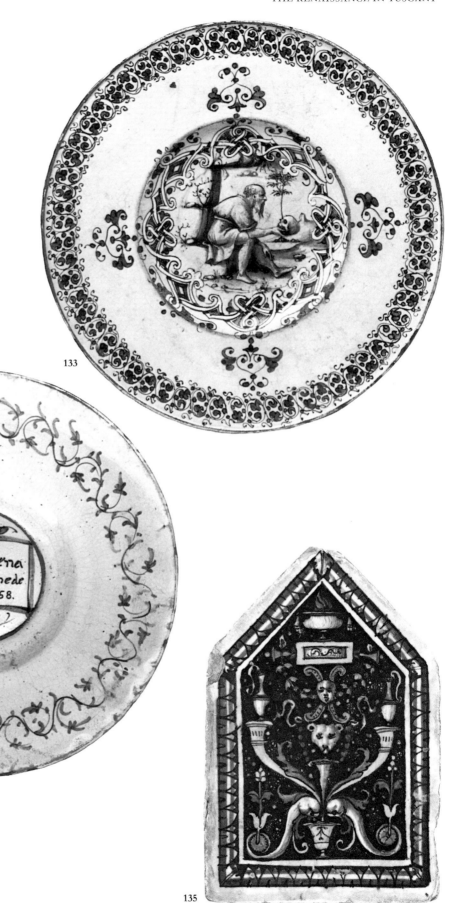

133

133

135

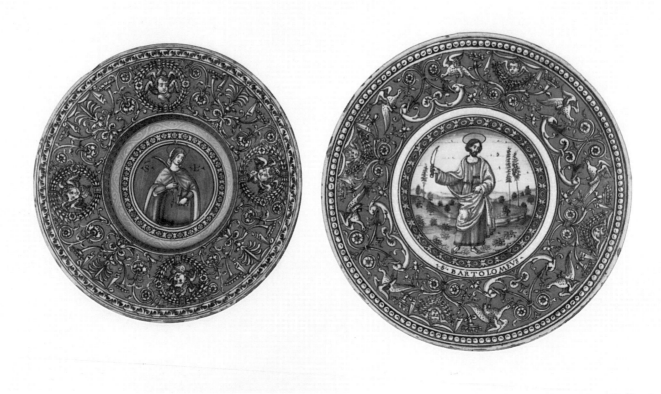

137, 136

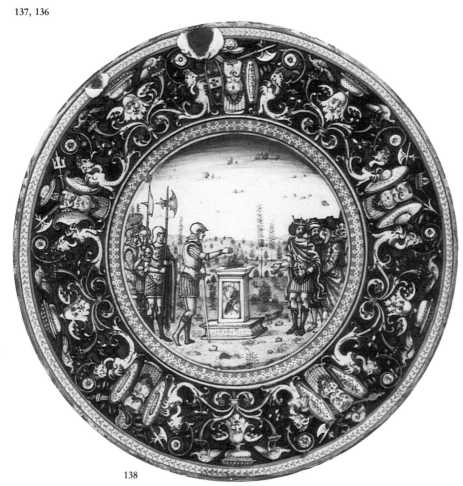

138

136 Plate

Siena, *c*, 1500–15

Painted in blue, orange, green, yellow, red, white: St Bartholomew holding the knife with which he was flayed; on the rim, a band of *bianco sopra bianco* with s. BARTOLOMEVS, and a broad band of orange-ground grotesques incorporating birds, dolphins, cherub-heads, cornucopias, and scrollwork. Reverse: blue and orange scale pattern, interlace, and .I.P. DIAM 26.7 cm

MLA 1855, 12–1, 109

Bibl. Bernal Sale 1855, lot 2070; Marryat 1857, p. 46; Fortnum 1873, p. 134; Rackham 1940A, p. 127.

Part of a set marked IP and representing saints, including Lucy (137), James, and Mary Magdalene (Rackham 1940A, nos 375, 376).

The centres of this plate and 137 seem to be by the painter of 138. IP and FIO may denote the owners, rather than the painter or workshop.

137 Broad-rimmed bowl

Siena, *c.* 1500–15

Painted in orange, blue, green, yellow, red, white: St Lucy (.s̄..l̸.) with book and martyr's palm; narrow bands of decoration on the sides; on the rim, orange-ground grotesques. Reverse: blue and orange scale pattern and .i.p. DIAM 23 cm

Courtauld Institute Galleries (Gambier-Parry Bequest)

Bibl. Marryat 1857, p. 46; Marryat Sale 1867, lot 847; Fortnum 1873, p. 134; Mallet 1967, p. 148, fig. 51; Courtauld Galleries 1979, no. 113.

138 Plate

Siena, *c.* 1510–20

Painted in blue, orange, green, yellow, red, white: Mucius Scaevola before Porsenna, burning his hand on an altar bearing arms, *azure, on a fess or between three stars or, a fleur de lis azure* (probably for Giocondo, of Florence); concentric bands of decoration; on the rim, grotesques incorporating masks, vases, trophies of arms, birds, monsters, and scrollwork. The glaze has run at two points, apparently revealing a slip beneath the glaze. Reverse: blue and orange scale pattern, foliate ornament, and, amidst squiggles, .f., and i within o, all beneath a contraction mark. DIAM 25.8 cm

MLA 1878, 12–30, 408; Henderson Bequest; bought in Siena in 1846 by E. Piot

Bibl. Delange 1853, p. 103; Rattier Sale 1859, lot 16; Robinson 1862, no. 5163; Fortnum 1873, pp. 130, 134; Borenius 1930, p. 26; Rackham 1940A, pp. 127–8.

Mucius Scaevola was a celebrated Roman model of courage: when Porsenna, King of the Etruscans, brought an army against Rome, Scaevola went out to try and assassinate him. When caught, he put his hand on a burning altar to show his contempt for pain (Valerius Maximus, III, iii, 1).

The Scaevola scene seems to be by the painter of 134, 136, 137, but the border by another hand.

12 Deruta

One of the economic developments characteristic of the Renaissance was the concentration of pottery production in a number of smallish towns, where tin-glazed wares were produced on an increasingly industrial scale for ever wider markets. Montelupo, Castel Durante, and Castelli are examples of such 'pottery towns'. The main centre in Umbria was the little town of Deruta, a few miles south of Perugia, which then as now existed almost entirely from the pottery industry.

The importance of Deruta as a producer of pottery in the sixteenth century has often been underestimated. The first history of maiolica, the *Istoria delle pitture in majolica fatte in Pesaro*, by the Pesaro scholar Giambattista Passeri (1758), attributed to Pesaro a range of lustrewares which we now know to be from Deruta, and injected a long-lasting confusion into the subject. Deruta was already a pottery centre in 1358, when quantities of Deruta pottery were supplied to the Convent of St Francis at Assisi. By 1500 Deruta production had risen in quantity and quality, and the town was supplying run-of-the-mill and presentation pottery to a wide market, including Rome. A particular speciality was lustre, and Deruta workshops were the most prolific producers of Italian lustrewares in the first half of the sixteenth century. In his *Description of the Whole of Italy*, published in 1550, Leandro Alberti wrote: 'The earthenwares made here are renowned for being made to look as if they were gilt. It is such an ingenious technique that up to now no other workman in Italy has been found to equal them, although attempts and experiments have often been made. They are called *Majorica* wares . . .'

Alberti presumably did not know of, or forgot about, the Maestro Giorgio workshop in Gubbio; it would, moreover, be a mistake to think that Deruta and Gubbio had a monopoly in lustre: there is good reason to think that the technique was known in Faenza and at Cafaggiolo, and no reason to doubt that it was, from time to time, tried in potteries elsewhere. One estimate is that there were thirty to forty kilns working in early sixteenth-century Deruta, of which three or four were producing lustre.

Deruta pottery is rarely marked or dated, with the exception of work by the mid-sixteenth-century painter Giacomo Mancini, who called himself 'El Frate'. Attributions to Deruta rest primarily on the evidence of excavated fragments; it is a fair assumption that most fragments dug up in a small pottery-producing town like Deruta were made locally. The regional museum of Umbrian ceramics currently being created at Deruta may make possible a more precise assessment of Deruta production; for the moment there remain doubts, in particular, whether certain lustrewares were made in Deruta or elsewhere.

Although Deruta served a wide area, many of its products have a distinctively Umbrian character. It is rare for Deruta *istoriato* to be derived from the Raphael-school prints that were so ubiquitous in the Marches; Deruta painters were much more likely to use compositions by local artists like Perugino and Pintoricchio. The dominance of religious subjects reflects the powerful local influence of the cult of St Francis at Assisi. Deruta shapes, too, are distinctive: big dishes with a translucent lead glaze on the reverse, flattened-spherical water jugs, and shallow basins with a central emplacement are particularly typical. Another characteristic of Deruta in the first half of the sixteenth century is its conservatism, which makes it difficult to assign reliable dates. In general it seems that the production of high-quality lustreware at Deruta began about 1500 and petered out after 1550. Unlustred wares continued to be produced to traditional formulas until the decline to a down-market and artistically rather uninteresting production by 1600.

LITERATURE Rackham 1915; De-Mauri 1924; *Antiche maioliche di Deruta* 1980; *Maioliche umbre decorate a lustro* 1982; Fiocco & Gherardi 1983, 1984.

Lustrewares

139 Pharmacy jar

Deruta, 1502

Painted in blue-black, orange, green; yellowish lustre: foliate, scale, and ray patterns; on a shield applied to the spout, the same monogram as on 38, repeated beneath the handle; beneath the spout, a moor's head; on either side, an unidentified beribboned shield of arms, apparently *or, two lions affronté gules supporting an eagle displayed sable, crowned or.* Round the middle, OXIZACARA and, in lustre, *1502.* Restorations. H (to rim) 26 cm

MLA 1855, 12–1, 57

Bibl. Bernal Sale 1855, lot 1832; Rackham 1915, p. 34, pl. IF; Ballardini 1933–8, I, no. 26, fig. 32; Drey 1978, pp. 40, 46–8, pl. 13B; *Maioliche umbre decorate a lustro* 1982, p. 93, no. 3; Fiocco & Gherardi 1983, pp. 91–2.

From the same series as 38, 150. This jar is the only lustred piece of the series and one of the earliest dated examples of Italian lustreware. *Oxysaccara* was a preparation of sugar and vinegar.

140 Dish

Deruta, *c.* 1500–40

Painted in blue; yellowish-brown lustre: a bishop-saint holding book and crozier; the border in sections, with scale and foliate decoration. Reverse lead-glazed: a vase with scrolling handles sketched to one side. Two suspension holes in foot-ring. DIAM 39.8 cm

MLA 1855, 3–13, 4; given by A. W. Franks

The saint is in the manner of Perugino. The vase on the reverse may be intended as an emblem of Deruta, cf. *Antiche maioliche di Deruta* 1980, pp. 25, 36–7.

141 Dish

Deruta, *c.* 1500–40

Painted in blue; yellowish-golden lustre: an adoring angel with a flower; the border in sections, with foliate, scale, and other motifs. Reverse lead-glazed: two simple scrolls and N(?). Two suspension holes in foot-ring. DIAM 41 cm

MLA 1852, 6–24, 1; formerly Abbé Hamilton collection

Bibl. Christie's, 16 June 1852, lot 6.

The angel is in the manner of Perugino or Pintoricchio.

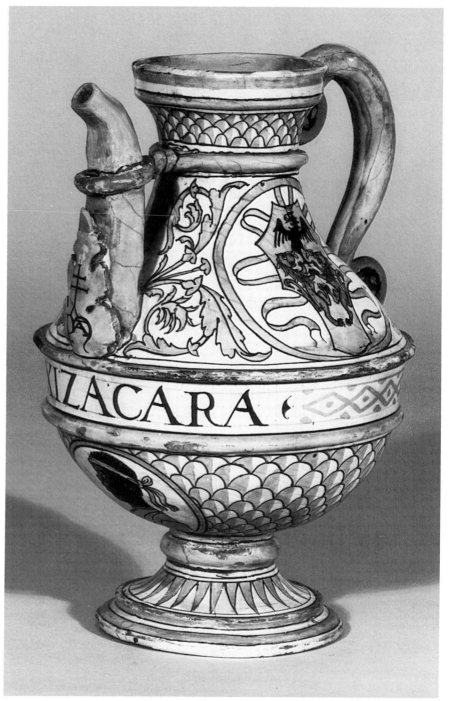

139

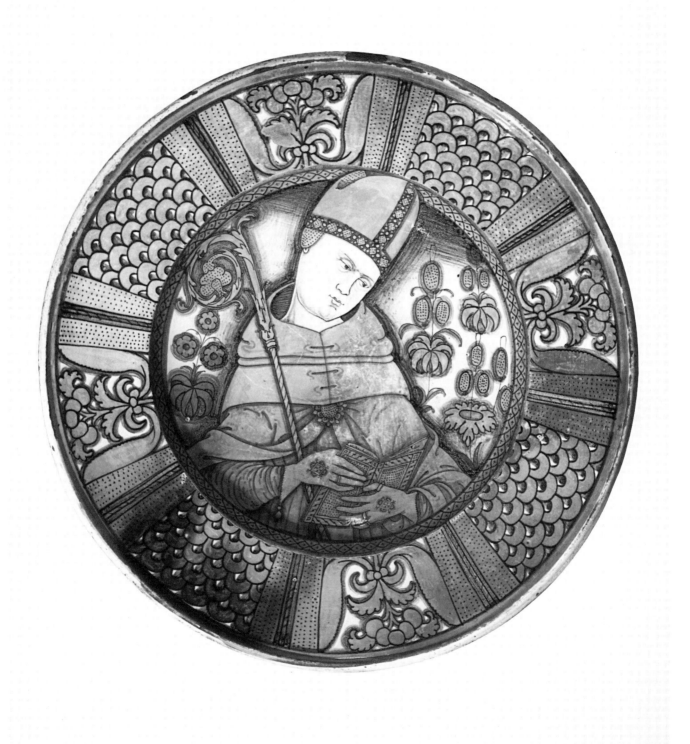

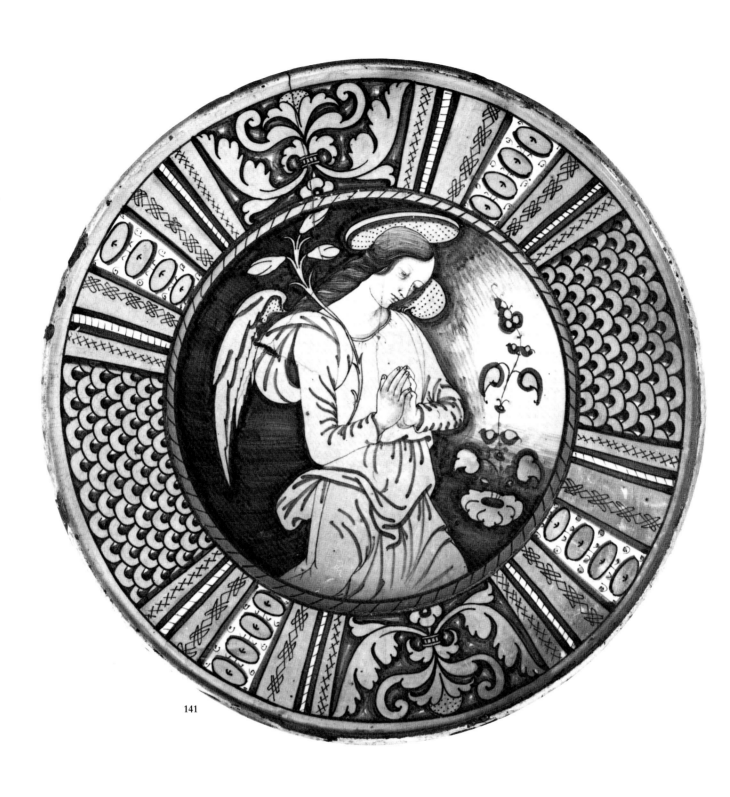

141

142 Dish

Deruta, *c.* 1500–40

Painted in blue; golden-brown lustre: a
woman, with stylised plants; scale pattern on
sides and rim. Reverse: lustre rings and, in
brown, a monogram of N, O, and perhaps Q.
DIAM 31.9 cm
MLA 1855, 12–1, 81
Bibl. Bernal Sale 1855, lot 1944; Fortnum
1873, p. 194; Guasti 1902, pp. 324–5; Sutton
1979, pp. 337–8, figs 7, 8.

The monogram is the only one known
on wares of this type; it may represent
the artist, but seems as likely to indicate
the owner.

143 Jug

Deruta, *c.* 1500–40

Painted in blue; golden-brown lustre: foliate
and scale ornament. Repairs to lip. H (to
rim) 16.7 cm
MLA 1878, 12–30, 361; Henderson Bequest
Bibl. Henderson 1868, pl. VI.

The shape was used at Deruta for
lustred and unlustred jugs (cf. Rackham
1940A, no. 424; Giacomotti 1974,
no. 513).

144 Bowl on high foot

Deruta, *c.* 1500–30

Painted in blue, and green; brownish lustre:
in the bowl a running stag with stylised
plants, surrounded by rays and flowers;
exterior: rays and flowers. DIAM 21.8 cm
MLA 1878, 12–30, 369; Henderson Bequest
Bibl. Henderson 1868, pl. V; Wallis 1905A,
figs 87, 88.

145 Dish

Perhaps Deruta, *c.* 1510–50

Painted in blue, orange, green; golden
lustre: a shield of arms, *quarterly azure and
argent; impaling: or, on a mount of three hillocks
vert, a rose gules slipped vert*, flanked by GV and
CA; curling scrollwork and flowers. Reverse
lead-glazed; two suspension holes in foot-
ring. DIAM 27.5 cm
MLA 1855, 6–26, 1

The arms are unidentified
(cf. Giacomotti 1974, no. 640). The
decoration is inspired by Islamic design.
Gresta 1986, p. 293, argues that pieces of
this type were made at Pesaro.
Cf. Rackham 1959, no. 338, dated 1514.

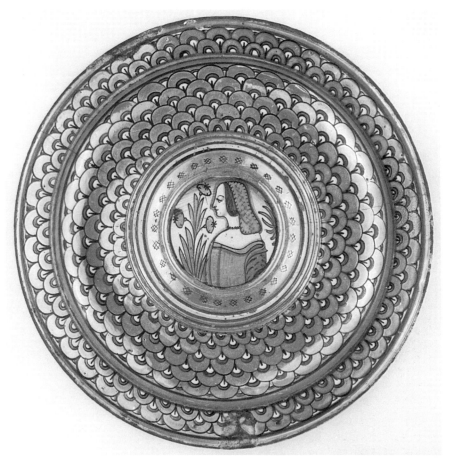

142

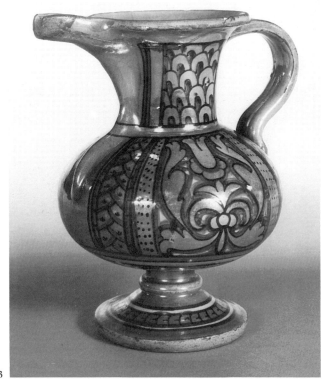

143

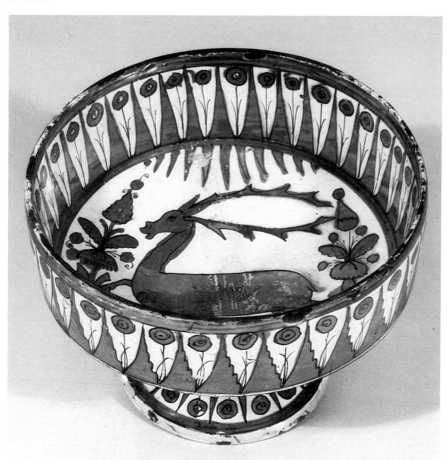

146 Plate

Deruta, *c.* 1510–40

Painted in blue and yellow; golden-brown lustre: grotesques around a 'vase' structure.
DIAM 22.6 cm
MLA 1878, 12–30, 401; Henderson Bequest

The decoration on the 'vase' resembles 145.

147 Dish

Probably Deruta, *c.* 1530–60

Moulded in relief on rim and sides. Painted in blue and green; yellowish-gold lustre: Mucius Scaevola putting his hand in the fire; on the sides, spiral gadroons; on the rim, grotesques in relief incorporating *putti* riding serpentine monsters. Reverse: lustre rings.
DIAM 43.5 cm
MLA 1855, 12–1, 71
Bibl. Bernal Sale 1855, lot 1895.

For Mucius Scaevola, see 138.
 A dish with comparable decoration (Giacomotti 1974, no. 663) is dated 1546.

144

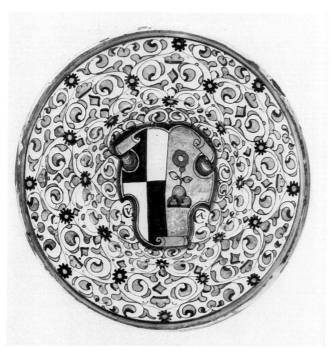

145

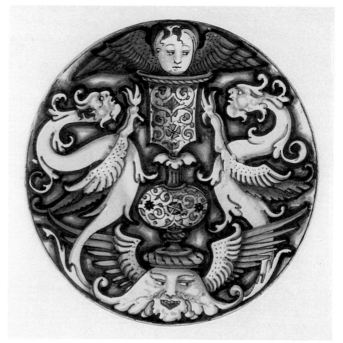

146

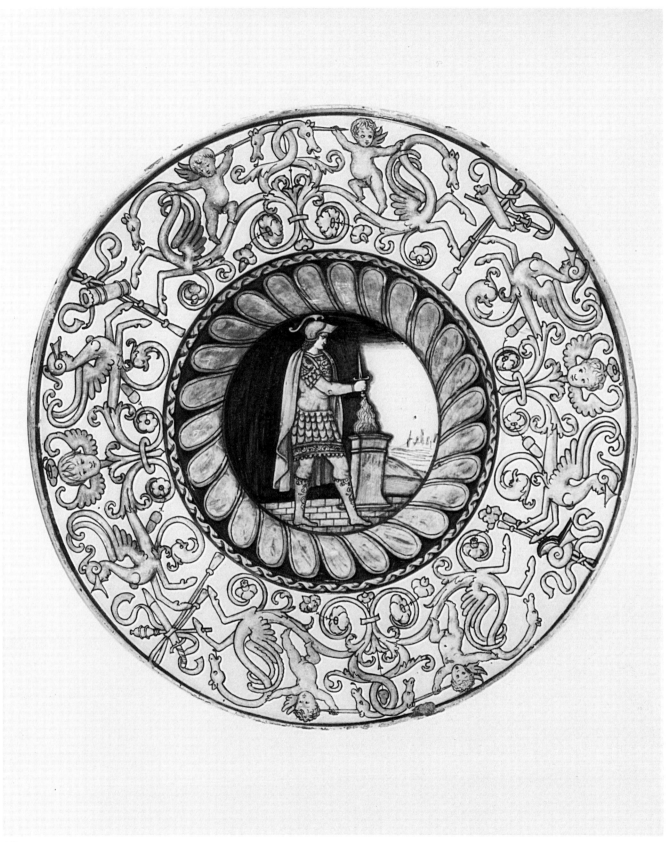

147

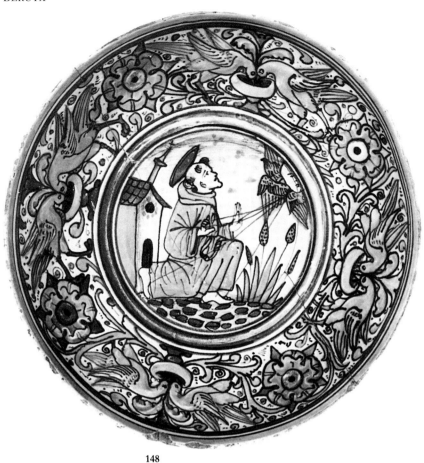

148

149

148 Bowl

Deruta or Gubbio, *c.* 1525–50

Moulded in relief. Painted in blue; golden and red lustre: St Francis receiving the stigmata; pairs of birds drinking, and flowers. Reverse: lustre rings. The lustre has fired unevenly. DIAM 20.5 cm

MLA 1856, 7–12, 2

Red lustre was used at Deruta, but less regularly than at Gubbio. This piece has affinities both with Deruta (Fiocco & Gherardi 1983) and Gubbio products.

149 Statue

Probably Deruta, 16th century

Figure of St Roch, a pilgrim with scallop-shell pilgrim badge, showing a plague sore in his thigh. Painted in blue, purple, orange-brown; brownish lustre. Around the base, *.D.S..R⁰..B.O.S.G.D.R.O.M.P.e* (presumably a dedicatory inscription, undeciphered). A gap between his left foot and the base is packed with broken pottery. Reverse partly unglazed. H 75 cm

MLA 1905, 7–22, 1; given by C. Fairfax Murray

St Roch (d. 1327) was venerated as a protector against the plague. A hole in his head originally held a halo; in his hand he would have held a pilgrim's staff.

Unlustred wares

150 Pharmacy jar

Deruta, 1501

Painted in blue, orange, yellow, green, black: interlace on an orange ground; on a shield applied to the spout, the same monogram as on 38; beneath the spout, a moor's head; round the middle, *.OXIMEL.SIMRECE...1501.* Glaze flaked; restorations to spout and foot. Beneath the foot, incised symbols. H (to rim) 26.2 cm

MLA 1855, 12–1, 58

Bibl. Bernal Sale 1855, lot 1833; Solon 1907, fig. 32; Rackham 1915, p. 34, pl.1H; Ballardini 1933–8, I, no. 27, fig. 33; Drey 1978, p. 46, pl. 13A; Fiocco & Gherardi 1983, pp. 91–2.

From the same series as 38 and 139; cf. Kube 1976, no. 34; Beckerath Sale 1913, no. 351; Shinn 1982, no. 10. See also Sotheby's, 17 March 1987, lots 27, 28.

Spouted pharmacy jars were used for liquids. *Oximel simplex* was made from a mixture of honey and vinegar.

150⇨

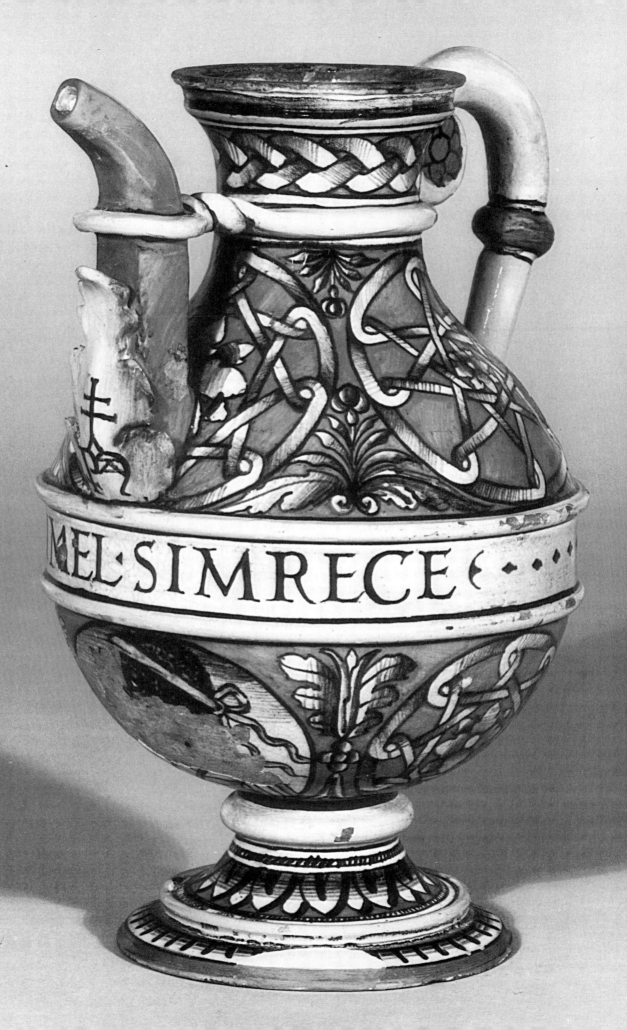

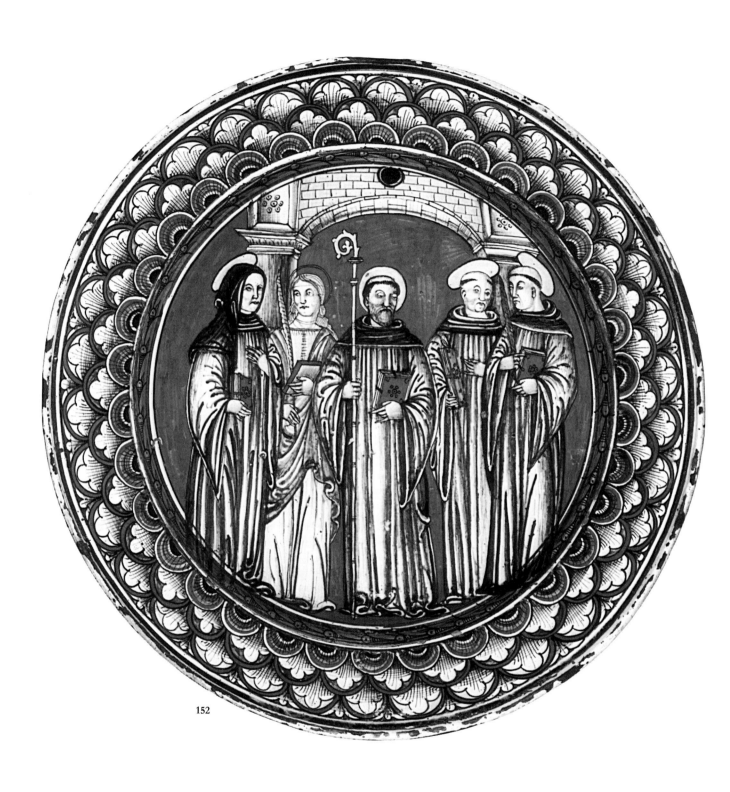

152

151 Dish

Perhaps Deruta, *c.* 1500–20

Painted in blue, yellow, brown, green, purple: the Judgement of Solomon (I Kings 4); a soldier holds the child ready to cut it in half, while the two mothers argue their cases to Solomon; in the foreground, a boy playing with a dog and ball; on the border, concentric bands of decoration. Reverse partially lead-glazed; three suspension holes in foot-ring. Broken; repaired with rivets.
DIAM 47 cm
MLA 1855, 3–13, 2; given by A. W. Franks
Bibl. Franks 1850, no. 551; Fortnum 1873, p. 92.

Perhaps based on a woodcut.
Illustrated in colour

152 Dish

Perhaps Deruta, *c.* 1500–20

Painted in blue, brown, yellow, green: Saints Scholastica, Justina, Benedict, Maurus, Placid, within a wreath; on the rim, elaborate scale pattern. Reverse partially lead-glazed; four suspension holes in foot-ring.
DIAM 45.8 cm
MLA 1855, 3–13, 1; given by A. W. Franks
Bibl. Franks 1850, no. 541; Fortnum 1873, p. 92.

The saints, associated with the Benedictine Order, are derived from an engraving by Benedetto Montagna (B XIII, p. 338, no. 10). This dish and 151 are by the same extraordinary painter.

153 Dish

Deruta, *c.* 1500–20

Painted in blue, green, orange, yellow, black: a battle scene; round the edge, a wreath. Reverse lead-glazed, with simple scrolls. Two suspension holes in foot-ring.
DIAM 27.5 cm
MLA 1855, 12–1, 50
Bibl. Bernal Sale 1855, lot 1779.

Similar in style to 38. No source for the design has been traced, but it may be derived from a woodcut similar to the title page of *Deche di Tito Livio vulgare historiate*, Venice 1493.
Illustrated in colour

154

154 Plate

Deruta, *c.* 1500–20

Painted in blue, orange, yellow, green: a female profile surrounded by narrow bands of decoration. Reverse: blue radial lines, hatched in orange. DIAM 20.1 cm
MLA 1878, 12–30, 428; Henderson Bequest
Bibl. Solon 1907, fig. 9.

Cf. Fiocco & Gherardi 1983, pl. XXII(a) (fragments found at Deruta).

155 Dish

Deruta, *c.* 1490–1525

Painted in blue, brown, yellow, green: a woman in profile; on a scroll
PÊDORMIRENONSAQVISTA (nothing is gained by sleeping); scale pattern border. Reverse lead-glazed: in green, two simple scrolls and *S*; suspension holes in foot-ring. Restorations. DIAM 40 cm
MLA 1853, 2–21, 5
Bibl. Pugin Sale, Sotheby's, 12 Feb. 1853, lot 131; Fortnum 1873, p. 164; Sutton 1985, p. 106, pl. V; T. Wilson 1985A, p. 71, pl. XXII.

The slogan appears on 'portrait' dishes and others with the Virgin teaching Jesus to read (e.g. Giacomotti 1974, no. 602).
Illustrated on p. 17

156 Broad-rimmed bowl

Deruta, *c.* 1515–30

Painted in blue: a doe attacked by a dog; on the rim, monsters. Reverse: neat scrolls.
DIAM 24.3 cm
MLA 1878, 12–30, 417; Henderson Bequest
Bibl. Fortnum 1873, p. 427; 1896, p. 232; Rackham 1940A, p. 146; Mallet 1970–1, part I, p. 264.

Attributed by Rackham to the painter of a plate marked *fatto in Diruta* (Rackham 1940A, no. 430; cf. *ibid*, no. 492). A plate in similar style (Kube 1976, no. 44) is dated 1524. A nearly identical deer on a lustred dish (Ricci 1927, no. 68) suggests that the same workshop was producing both lustred and unlustred wares.

157 Broad-rimmed bowl

Deruta, *c.* 1515–30

Painted in blue: a female profile in a winged head-dress; on the rim, monsters. Reverse: neat scrolls. DIAM 24.4 cm
MLA 1878, 12–30, 418; Henderson Bequest
Bibl. Fortnum 1873, p. 427; 1896, p.232.

By the same painter as 156.

157

156

158 Dish

Deruta, *c.* 1530–60

Painted in blue, orange, yellow, green: a
mounted warrior in what is meant as Turkish
costume; the border in sections, with foliate
and scale decoration. Reverse lead-glazed:
two simple scrolls and a crossed zig-zag.
DIAM 38.5 cm

MLA 1855, 3–13, 3; given by A. W. Franks

Horsemen, in European or Turkish
clothes, were a favourite subject for
Deruta painters; cf. Hausmann 1972,
p. 214; also *Antiche maioliche di Deruta*
1980, p. 78, a dish with similar border
dated 1556. Fiocco and Gherardi (1984,
pp. 412–13) suggest that pieces of this
type were made in the Mancini
workshop.
Illustrated on p. 1

159 Dish

Deruta, *c.* 1530–60

Painted in blue, yellow, orange, green: in the
central emplacement, a strutting bird;
around this, scrolling sprays; on the rim,
stylised plant decoration. Reverse: star motif
with a crossed *M* in the centre.
DIAM 32.6 cm

MLA 1885, 5–8, 38; given by A. W. Franks
Bibl. Rackham 1915, p. 33.

The crossed *M* is common on unlustred
Deruta pieces and may indicate the
Mancini workshop (Fiocco & Gherardi
1984, p. 412).

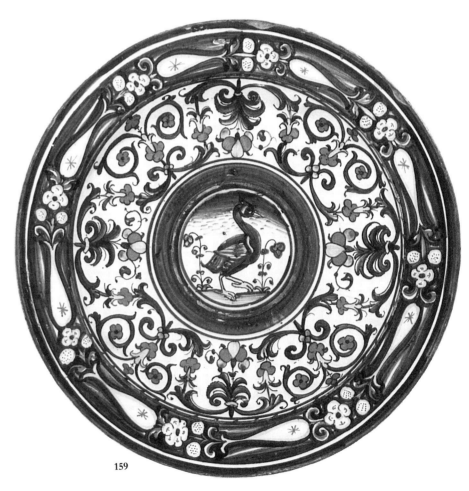

159

13 Maestro Giorgio Andreoli of Gubbio

Gubbio, in the mountains north-east of Perugia, was during the Renaissance part of the Duchy of Urbino. It owes its place in the history of Renaissance ceramics to the development by a single family firm of a business specialising in the application to pottery of red and golden lustres. Giorgio di Pietro was born in Lombardy *c.* 1465–70 and moved to Gubbio around 1490. By 1498 he was well established and called 'Maestro', or 'Mastro': in that year he was granted citizenship of Gubbio and exemption from taxes by Guidobaldo I, Duke of Urbino. 'Maestro Giorgio Ltd', run by Giorgio together with his two brothers, was a successful business; in 1519 Giorgio's privileges were renewed in a brief from Pope Leo X in which he was described as 'an excellent master without rival in the art of *maiolica* [i.e. lustrewares], whose work brings honour to the city, lord and people of Gubbio in all the nations to which the pottery of his workshop is exported, as well as the great income it brings in customs dues'. Giorgio continued to run the firm until 1536, when he handed over to his sons Vincenzo and Ubaldo; he died around 1553.

The first dated piece attributable to Giorgio's workshop is dated 1515, and the first known marked work is dated 1518. When he began making lustre, where he learnt the technique, and what his work before 1515 looked like, are unanswered questions. From 1518, his output can be closely followed because the workshop made a practice of painting the date and *M°G°* on the underside of pieces lustred there.

Piccolpasso visited the workshop *c.* 1540–50, when it was run by Vincenzo ('Maestro Cencio'), and comments on the application of what he calls *maiolica*, i.e. lustre: 'I propose to go no further without discussing *maiolica*, from what I have heard from others (I have never made it myself or seen it made). I do know it is painted onto supplied pieces [i.e. pieces already painted and twice fired]. I have seen this at Gubbio in the house of one Maestro Cencio of that place and this is how they paint it: they leave the places where the lustre is to be applied without putting any sort of colour on; that is, for instance, an arabesque, or rather grotesque . . . will

be put on a little plate and the leaves that would normally be green are left white, only the outlines being drawn; it is then fired to completion like other pieces; then the spaces are filled with *maiolica* . . . The kiln chambers are made small, three or four feet on each side, because the technique [*arte*] is unreliable, so that often only six pieces out of a hundred come out well; but the technique itself is a fine and clever one, and when the pieces are good they seem like gold . . .'

Geographically, Gubbio is roughly half-way between the larger-scale pottery centres of Deruta, where golden lustre was used in large quantities and red lustre occasionally, and the Urbino/ Castel Durante area. A 'Paolo of Deruta' is recorded to have been working for Giorgio in 1516, and painters called Giovanni Luca of Castel Durante and Federico of Urbino in 1525. The products of Maestro Giorgio's workshop are linked stylistically with both Deruta and the Marches. The relationship with Urbino and Castel Durante is particularly interesting in the case of *istoriato* wares of the 1520s and 1530s. It is known that painters from the Urbino region, like Francesco Urbini, worked at Gubbio; it seems likely that some pieces painted in Urbino were sent over the mountains to have lustre applied in Maestro Giorgio's workshop. 75 and 76 are signed by Xanto *in Urbino* and lustred; the lustre is in the manner of Maestro Giorgio and was probably applied in Gubbio; but the possibility cannot be completely ruled out that lustre was sometimes added in Urbino. A recently published document from the Urbino archives (Negroni 1986, pp. 18–19) records a lease taken out by Vincenzo in 1538 on the contents of the workshop of the recently deceased Nicola di Gabriele; so by that date at least 'Maestro Giorgio Ltd' had an out-station in Urbino. Equally, unlustred *istoriato* may well have been made in Gubbio (see 189). Whether pieces like 163 and 166 were originally painted in Castel Durante/Urbino or Gubbio is a debated issue among maiolica scholars and not yet resolved.

To Piccolpasso and his contemporaries the technique of iridescent lustre was mysterious, half-akin to the alchemist's timeless aim of making gold. Although some may now think that certain pieces of lustred *istoriato* would look better without the

lustre, Maestro Giorgio has always fascinated collectors. This fashion was at its height in the middle of the nineteenth century (hence the number of pieces in the museums of London and Paris), but it has never really faded; some of the highest prices paid by maiolica collectors in recent years have been paid for works from Maestro Giorgio's workshop.

LITERATURE Mazzatinti 1931; Falke 1934; *Maioliche umbre decorate a lustro* 1982; *Dizionario Biografico degli Italiani*, s.v. Andreoli; Fiocco & Gherardi 1985A.

160 Broad-rimmed bowl

Probably workshop of Maestro Giorgio, Gubbio, 1518

Painted in blue and green; golden and pinkish lustre: a cross surmounting a ladder, and F, G, KO, surrounding a hand pointing upwards; on the rim, scrolling grotesques incorporating monsters, cornucopias, masks, and baskets of fruit. Reverse: in lustre, scrolls, crossed diamonds, and *1518*. DIAM 24·5 cm

MLA 1855, 12–1, 69

Bibl. Bernal Sale 1855, lot 1892; Fortnum 1873, p. 195; Ballardini 1933–8, I, no. 70, pl. 67, 253; Rackham 1940A, p. 216.

On the border is still visible the word *Azuro*, an instruction from the painter who drew the design to an assistant to fill in the blue ground.

The badge, probably representing an ecclesiastical institution, is unidentified. Other dishes from the same set: Ballardini 1933–8, I, nos 67–9; another (Rackham 1940A, no. 642) has the dates 8 March 1517 (in blue on the front) and 1518 (in lustre on the back).

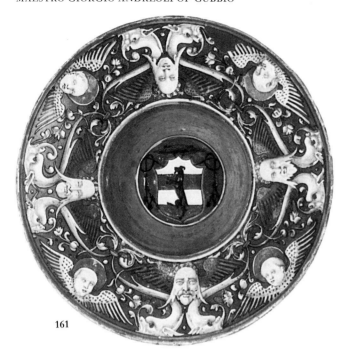

161

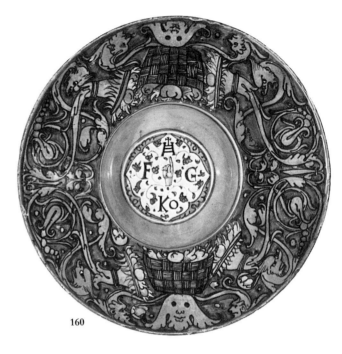

160

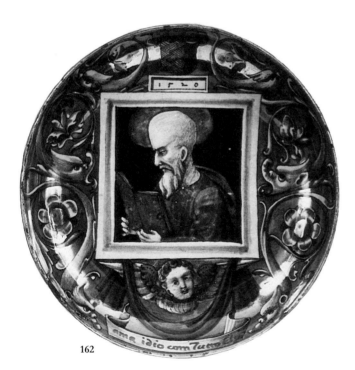

162

162 Bowl

Workshop of Maestro Giorgio, Gubbio, 1520

Painted in blue and yellow; red and golden lustre: in a square panel, a saint reading; decoration incorporating scrolling dolphins, a winged cherub-head, flowers, a basket of fruit, *1520*, and a scroll with *ama idio com tutto el co*ʳᵉ (love God with all your heart). Reverse: lustre rings. DIAM 18·7 cm

Ashmolean Museum, Oxford (Fortnum Bequest)
Bibl. Robinson 1862, no. 5221; Fortnum 1897, C430; Ballardini 1933–8, I, no. 102, fig. 99; Mallet 1978, p. 400, fig. 5.

This bowl and a similar one (Ballardini 1933–8, I, no. 101) are perhaps by the painter of 161.

163 Plate

Lustred in the workshop of Maestro Giorgio, Gubbio 1524; perhaps painted by 'FR'

Painted in blue, green, yellow, brown, purple, orange, white; golden and reddish lustre: a river-god holding a palm branch and rudder, in a landscape. Reverse: in lustre, floral scrolls and *1524 M.ᵉG.ᵒ* DIAM 24 cm

MLA 1851, 12–1, 7; formerly Abbé Hamilton collection
Bibl. Solon 1907, fig. 33; Ballardini 1933–8, I, no. 152, figs 139, 296; Rackham 1940A, p. 223; 1957A, p. 108; G. Liverani 1968, p. 697; *Maioliche umbre decorate a lustro* 1982, p. 40, fig. 22; Fourest 1982, pl. 42.

Cf. 68

161 Broad-rimmed bowl

Probably workshop of Maestro Giorgio, Gubbio, *c.* 1515–20

Painted in blue, blue-black, white; red and golden lustre: an unidentified shield of arms, *barry of four argent and gules, a goat rampant sable*, beneath a black prelatial hat; on the rim, grotesques incorporating winged masks and cherub-heads, dolphins and floral tendrils, on a deep-red lustre ground. Reverse: arch motifs in lustre. Damaged on the edge; lustre worn. DIAM 25·5 cm

MLA 1878, 12–30, 389; Henderson Bequest
Bibl. Marryat 1857, p. 85; Henderson 1868, pl. VI.

A plate from the same set (Christie's, 2 July 1979, lot 144) is painted on an equally striking bright-blue ground.

164 Broad-rimmed bowl

Lustred and perhaps painted in the workshop of Maestro Giorgio, Gubbio, 1524

Painted in blue, green, white; golden and reddish lustre: a winged *putto* approaching an altar on which is an owner's mark incorporating an *S*; on the rim, trophies, incorporating *S* and *1524*. Reverse: in lustre, floral scrolls and *.1524 M.°G.°* DIAM 20·8 cm MLA 1851, 12–1, 13; formerly Abbé Hamilton collection
Bibl. Ballardini 1933–8, I, no. 141, figs 142, 292.

Part of a set made in 1524–5 for a client whose owner's mark appears on the rim. The fact that this mark appears in blue on the front of 164 and 165 and in lustre on the reverse of 166, 167, and 168, suggests the set was made as well as lustred in Maestro Giorgio's workshop. Other pieces from the set: Ballardini 1933–8, I, nos 169, 171; and BM 1851, 12–1, 15. Marks of this sort are common on maiolica, especially on pharmacy jars; they are thought to indicate ownership by an institution or an individual involved in commerce; cf. Bascapè & Del Piazzo 1983, p. 236.

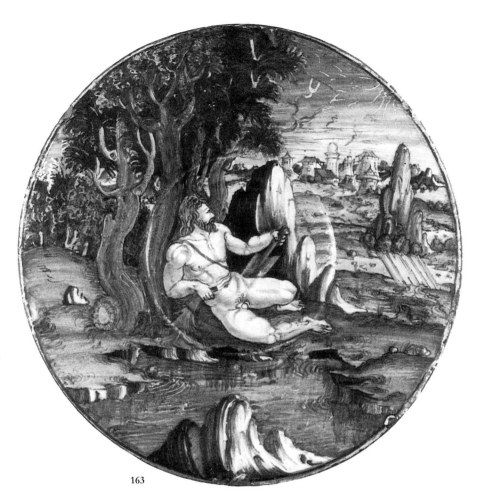

163

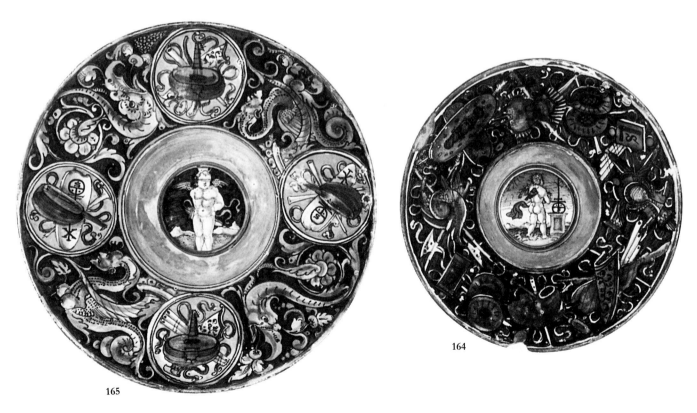

165

164

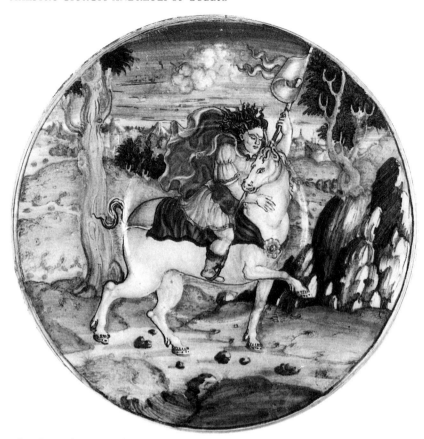

168

165 Broad-rimmed bowl

Lustred and perhaps painted in the
workshop of Maestro Giorgio, Gubbio,
1524

Painted in blue, green, yellow, white; golden
and pinkish lustre: Cupid, bound and
blindfolded; on the rim, grotesques
incorporating monsters, cornucopias, and
roundels with musical instruments; two
roundels have an owner's mark as on 164.
Reverse: in lustre, floral scrolls and *1524*.
M:G: DIAM 25·8 cm

MLA 1878, 12–30, 390; Henderson Bequest
Bibl. Bernal Sale 1855, lot 1739; Henderson
1868, pl. VI; Solon 1907, pl. XIV; Ballardini
1933–8, I, no. 142, figs 143, 293.

166 Broad-rimmed bowl

Lustred and perhaps painted in the
workshop of Maestro Giorgio, Gubbio,
1525

Painted in green, blue, grey, black, yellow,
orange, brown, white; golden and reddish
lustre: three men in academic dress debating.
Reverse: in lustre, floral scrolls, *1525 M:G:*,
and an owner's mark as on 164. DIAM
26.1 cm

MLA 1851, 12–1, 9; formerly Abbé Hamilton
collection
Bibl. Fortnum 1873, pp. 197–8; Bonini 1931,
pls XXIX, XXXIIIa; Ballardini 1933–8, I,

no. 170, figs 162, 299; Falke 1934, p. 332,
fig. 10.

The composition follows an engraving
by Marcantonio (B XIV, p. 305, no. 404);
the distant buildings are an addition of
the painter's. This piece, 167, and 168
are probably by the painter of the *Three
Graces* roundel in the V & A (Rackham
1940A, no. 673); it is debatable whether
he is also the painter of 68 and 163.
Illustrated in colour

167 Broad-rimmed bowl

Lustred and perhaps painted in the
workshop of Maestro Giorgio, Gubbio,
1525

Painted in blue, green, yellow, black, orange,
white; golden and reddish lustre: left, two
soldiers; right, a man about to hurl a rock
at them; in the well, blindfolded Cupid.
Reverse: in lustre, floral scrolls, *M:G: 1525*,
and an owner's mark as on 164. DIAM
26·7 cm

MLA 1851, 12–1, 10; formerly Abbé
Hamilton collection
Bibl. Fortnum 1873, pp. 197–8; Ballardini
1933–8, I, no. 168, figs 164, 301.

The men fighting are from an engraving
by Marcantonio (B XIV, p. 316, no. 420).
Cf. 166.
Illustrated in colour

168 Plate

Lustred and perhaps painted in the
workshop of Maestro Giorgio, Gubbio,
1525

Painted in blue, green, yellow, orange, grey,
brown, white; golden and reddish lustre: a
horseman holding a standard. Reverse: in
lustre, floral scrolls, *1525 M:G:*, and an
owner's mark as on 164. DIAM 25·4 cm

MLA 1851, 12–1, 12; formerly Abbé
Hamilton collection
Bibl. Fortnum 1873, pp. 197–8; Ballardini
1933–8, I, no. 167, figs 163, 300; Sutton
1985, p. 106, pl. VII.

The horseman and rider combine details
from Marcantonio's engravings of
Roman heroes (B XIV, pp. 154–5, nos
188–91). Cf. 166.

169 Broad-rimmed bowl

Workshop of Maestro Giorgio, Gubbio,
1527

Painted in blue and green; golden and
reddish lustre: a shield of arms, Vitelli
impaling Della Staffa, in a landscape; on
the rim, scrolling ornament. Reverse: in lustre,
floral scrolls and *1527 M:G: da ugubio*. DIAM
20·5 cm

MLA 1851, 12–1, 18; formerly Abbé
Hamilton collection
Bibl. Marryat 1857, p. 49, fig. 28; Ballardini
1933–8, I, no. 207, figs 192, 332; Rackham
1940A, p. 231.

Part of a set made for Niccolo Vitelli of
Città di Castello and his wife Gentilina
Della Staffa. Niccolo, a professional
soldier who commanded papal armies
for many years, is supposed to have
murdered her, and been himself
murdered in 1529 by her lover.
 Other pieces with the arms: Rackham
1940A, no. 692; Giacomotti 1974,
no. 671; Ballardini 1933–8, I, nos 205,

206; Sotheby's 4 Aug. 1961, lot 186; ex-Barker collection. All have differently designed border ornament.

170 Broad-rimmed bowl

Perhaps made and painted in the Urbino district; lustred in the workshop of Maestro Giorgio, Gubbio, c. 1531

Painted in brown, green, yellow, black, blue, orange, white; golden and red lustre: the Angel driving Adam and Eve from the Garden of Eden (Genesis 3). Reverse: in lustre, simple scrolls and traces of a mark, probably *1531 M°G°*. DIAM 30 cm

MLA 1855, 12–1, 43

Bibl. Bernal Sale 1855, lot 1750.

The figures are assembled from three

engravings: B XIV, p. 294, no. 388; B XIV, p. 247, no. 327; B XIV, p. 345, no. 464.

171 Plate

Probably workshop of Maestro Giorgio, Gubbio, c. 1520–30

Painted in blue, green, yellow, white; yellowish and red lustre: Judith holding the head of Holofernes (Judith 13); on the rim, scrolling foliage and fruit. Reverse: in lustre, rings and a sketched profile head. DIAM 31·4 cm

MLA 1851, 12–1, 4; formerly Abbé Hamilton collection

Bibl. Fortnum 1873, p. 193.

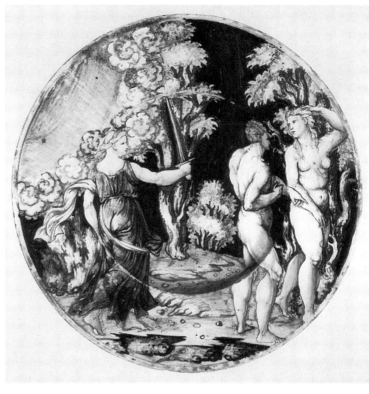

169

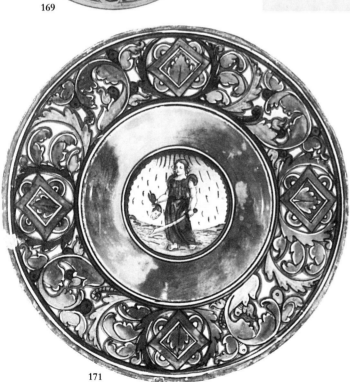

171

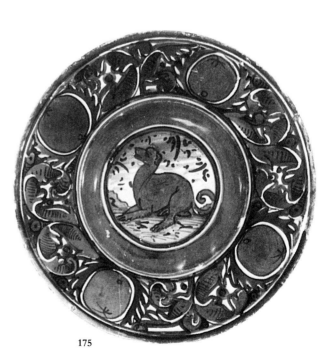

175

172 Dish on low foot

Probably workshop of Maestro Giorgio, Gubbio, 1530

Moulded in relief; painted in blue; golden and reddish lustre: *yhs*, and straight and wavy rays. Reverse: in lustre, rough scrolls and *1530*. DIAM 23·4 cm

MLA 1878, 12–30, 394; Henderson Bequest
Bibl. Henderson, 1868, pl. VI; Ballardini 1933–8, I, no. 248, figs 232, 358.

Part of the production of Maestro Giorgio's workshop from around 1530 consisted of dishes pressed over moulds to produce relief designs in distant imitation of embossed metalwork. The 'Sacred Monogram' (IHS, the first three letters of the name of Jesus in Greek) surrounded by rays was associated with the Franciscan saint, Bernardino of Siena (1380–1444).

173 Dish on low foot

Probably workshop of Maestro Giorgio, Gubbio, *c.* 1530–45

Moulded in relief; painted in blue; golden and reddish lustre: St Mary Magdalene with her pot of ointment; on the rim, ovals and discs. Reverse: in lustre, rough scrolls and *D*. DIAM 18·7 cm

MLA 1878, 12–30, 399; Henderson Bequest
Bibl. Henderson 1868, pl. VI.

The mediocre painting is characteristic of moulded pieces. Much of the run-of-the-mill production of Gubbio had religious themes. *D* may be the mark of the man responsible for the lustring.

174 Salt cellar

Probably workshop of Maestro Giorgio, Gubbio, *c.* 1530–45

Painted in blue and green; golden and reddish lustre: leaf patterns. Restorations. H 6.9 cm

MLA 1878, 12–30, 375; Henderson Bequest
Bibl. Henderson 1868, pl. VI.

The salt has wells at the top and bottom to be usable either way up.

175 Plate

Probably workshop of Maestro Giorgio, Gubbio, *c.* 1530–45

Painted in blue and green; crudely applied brown and reddish lustre: a dog; on the rim, fruit and foliage. Reverse: in lustre, simple scrolls and *N*. DIAM 27·4 cm

MLA 1855, 3–13, 6; given by A. W. Franks
Bibl. Fortnum 1873, p. 206.

This dish is included here in support of Piccolpasso's statement that not all lustrewares turned out well. *N* first appears on lustrewares attributed to Maestro Giorgio's workshop in 1531 (cf. 76); it is perhaps the mark of the man responsible for the lustring (*Maioliche umbre decorate a lustro* 1982, p. 70).

174

14 The Renaissance in Venice

In the history of maiolica, as in the history of oil-painting, Venice stands somewhat apart from the mainstream. Indeed, maiolica was not 'native' to Venice at all, and most of the pottery made in sixteenth-century Venice was incised slipware rather than tin-glaze. Nonetheless, some of the most charming of all Renaissance maiolica was made there, in a distinctive tradition determined by the Republic's pivotal trading position between the eastern Mediterranean, Italy, and northern Europe.

Throughout the Renaissance a good deal of the maiolica made in Venice was produced by men from other parts of Italy, particularly the Marches; and it may well be that some of the pieces usually thought to be from Faenza, Castel Durante or Urbino were actually made in Venice. A distinctively Venetian maiolica style had developed by about 1515, when a specialised branch of the industry apparently began producing armorial sets for the wealthy merchant families of Augsburg and Nuremberg: between 1515 and 1530 several such sets were made, in a style derived from Chinese porcelain and Islamic blue-and-white. The renown of Venetian maiolica at this date was such that in 1520 Alfonso I, Duke of Ferrara, commissioned a set of jars from a Venetian potter and got no less a person than Titian to deal with the commission.

The technique of painting on a greyish-blue (*berettino*) glaze was in use in Venice by the 1540s, when a series of impressive examples with decoration in blue and/or white were made: among these are works marked with the names of Maestro Lodovico and Maestro Jacomo da Pesaro. *Berettino* glazes remained in use in the Veneto for relatively run-of-the-mill production into the seventeenth century.

In the second half of the sixteenth century Venetian workshops produced large quantities of maiolica: rapidly painted *istoriato* dishes and large storage jars with fruit-and-flower decoration and/or portraits are particularly characteristic. The most prolific workshop seems to have been that run by or employing a potter–painter called Domenego da Venezia.

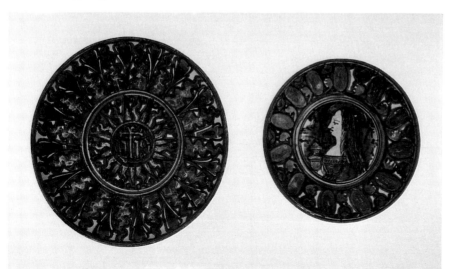

172, 173

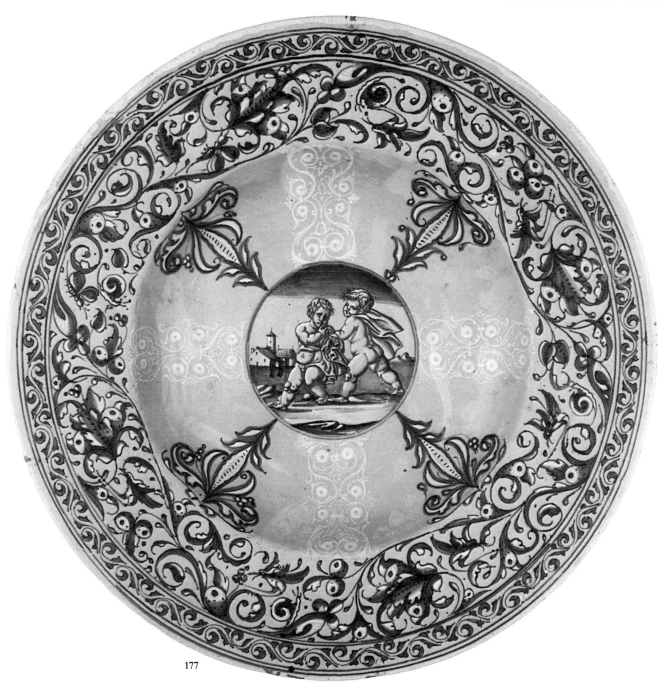

177

LITERATURE Moschetti 1931; Conton 1940; Morazzoni 1955; Lessmann 1979A; Alverà Bortolotto 1981; Spallanzani 1981; Siviero 1983; T. Wilson 1987.

176 Plate

Probably Venice, 1516 or later

Painted in blue, yellow, brown: arms of Meuting and Hörwarth; rim decorated *alla porcellana*. Reverse: a wreath *alla porcellana*.
DIAM 21.7 cm
MLA 1878, 12–30, 435; Henderson Bequest
Bibl. Henderson 1868, pl. VII; Hausmann

1972, p. 324; Rasmussen 1984, p. 215; T. Wilson 1987, pp. 186–7, pl. X.

Hans Meuting and Dorothea Hörwarth, both from Augsburg families, were married in 1516; the set with their arms was possibly made at the time, and is one of the earliest maiolica services for German families.
Illustrated in colour

177 Dish

Venice, *c.* 1540

Greyish-blue glaze; painted in blue and white: two boys playing; foliate ornament, including fruit, birds, insects, and a snail. Reverse: a wreath *alla porcellana*.
DIAM 44 cm
MLA 1891, 2–24, 2
Bibl. Hailstone Sale, Christie's, 12–20 Feb. 1891, lot 196; Hausmann 1972, p. 326; Rasmussen 1984, p. 224.

Perhaps from the workshop of Maestro Lodovico (cf. Rackham 1940A, no. 960); a similar plate is dated 1540 (Fortnum 1897, C492).

178 Dish

Venice, *c.* 1540–50

Pale blue-glaze: painted in green, blue, yellow, orange, brown, purple, white: a mask with fruit and leaves. Reverse: sketch of a woman, and a wreath *alla porcellana*.
DIAM 45.5 cm
Victoria & Albert Museum 1768–1855
Bibl. Bernal Sale 1855, lot 1986(a); Fortnum 1873, p. 600; Rackham 1940A, no. 970; Morazzoni 1955, pl. 24; Alverà Bortolotto 1981, p. 85, pl. LXXX.

Piccolpasso illustrates similar ornament as 'fruit . . . a Venetian style of painting, very pretty things'.

179 Storage jar

Attributed to Domenego da Venezia, Venice, *c.* 1560–70

Painted in blue, green, orange, yellow, purple, white: a tablet inscribed *Mostarda f.* (fine mustard) supported by two men, in a landscape; bands of foliage above and below. H 38 cm
MLA 1852, 11–29, 3

The painting resembles a jar in Frankfurt marked as made in 1568 by Domenego (Alverà Bortolotto 1981, pl. XC; cf. Lessmann 1979A, p. 409), and some of a series in Messina, one of which is signed and dated 1562 (Pavone 1985).

180 Plate

Probably Padua, 1550

Blue-grey glaze; painted in blue, orange, yellow, green, purple, black, white: the head of Pompey presented to Julius Caesar; on the rim, masks and foliate strapwork. Reverse: linked arches and *Del grâ ponpeo l'onorata testa 1550 +* (the honoured head of great Pompey) *.1550. +* repeated near edge. DIAM 22.6 cm
MLA 1855, 12–1, 48
Bibl. Bernal Sale 1855, lot 1775; Fortnum 1896, p. 311; Rackham 1933, p. 73.

The cross has been thought to denote a Paduan workshop, but an origin elsewhere in the Veneto for this and a similarly feeble example in the V & A (Rackham 1940A, no. 989) is possible.
 The inscription refers to the murder of the Roman general Pompey and echoes Petrarch's sonnet 102.

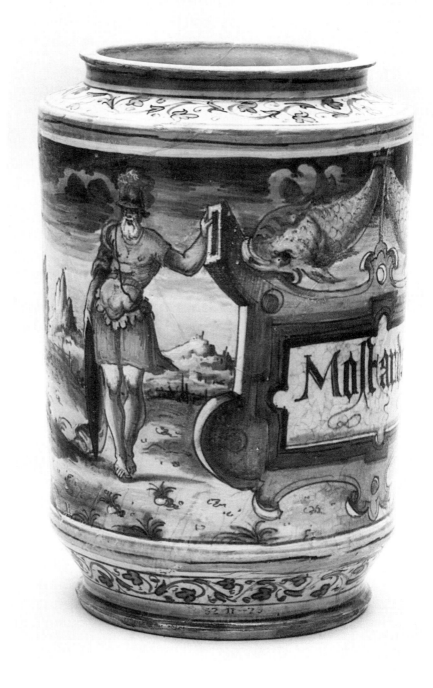

179

181 Plate

Padua, 1563

Painted in yellow, blue, orange, green, brown: the enchantress Circe stirring a magic brew. Reverse: overlapping arches and *Circiss ouidio instoria* (Circe, as told by Ovid) *1563.N. +.F..* DIAM 21.7 cm
MLA 1855, 3–13, 14; given by A. W. Franks
Bibl. Fortnum 1873, pp. 609, 611; Moschetti 1931, pp. 56, figs 42–3; Rackham 1940A,

p. 332; Morazzoni 1955, pl. 69; G. Liverani 1958A, p. 43.

Probably by the same painter as two plates marked *a padoa*: one dated 1563 (Giacomotti 1974, no. 1246), the other 1564 (BM 1855, 12–1, 105; Moschetti 1931, figs 39–41). *NF* is unidentified.

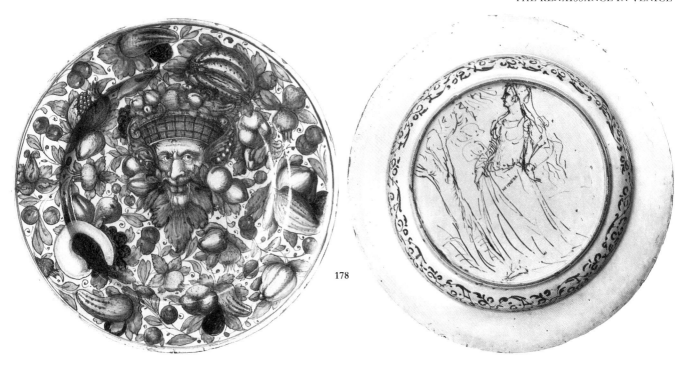

178

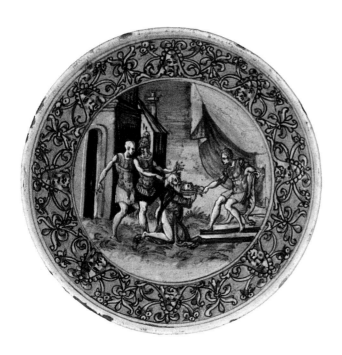

180, 181

15 The design sources of *istoriato* maiolica

Central to all Renaissance art was *disegno* – a term combining what in the modern mind has become two separate concepts, 'drawing' and 'design'. *Disegno* is as important to *istoriato* maiolica as it is to other forms of Renaissance painting. Already on medieval Italian pottery there is a prominent drawing in manganese, round the broad areas of green. The lions and other heraldic animals on relief-blue jars have a superficial similarity to their equivalents on Valencian lustreware, but whereas the Hispano-Moresque painters seem to

have painted their creations in free brushwork, their Italian counterparts added outlining in manganese. Line-drawing remained a crucial skill to the maiolica painter throughout the Renaissance.

With the development of *istoriato* around 1500, maiolica became a fully fledged branch of Renaissance painting. It was not, however, a branch where the painters in general had time, training, or incentive for original invention, and they turned for inspiration to the most easily available graphic sources. Piccolpasso's drawing of maiolica painters at work shows drawings or prints pinned up on the walls.

Workshops in modern Italy often keep a supply of drawings for copying, tracing, or pricking-through; the practice in the Renaissance was probably not very different.

Following the invention of printing in Germany, woodcut and engraving developed rapidly in south Germany in the second half of the fifteenth century. In particular, the sophisticated work of Martin Schongauer (*c.* 1450–91) and Albrecht Dürer (1471–1528) was admired in Italy; their prints were widely diffused and Dürer especially was copied repeatedly by Italian engravers. Unsurprisingly, many *istoriato* painters in Italy in the first quarter of the

Figs. xi. Maiolica painters in a workshop; from the Piccolpasso manuscript. Victoria & Albert Museum.

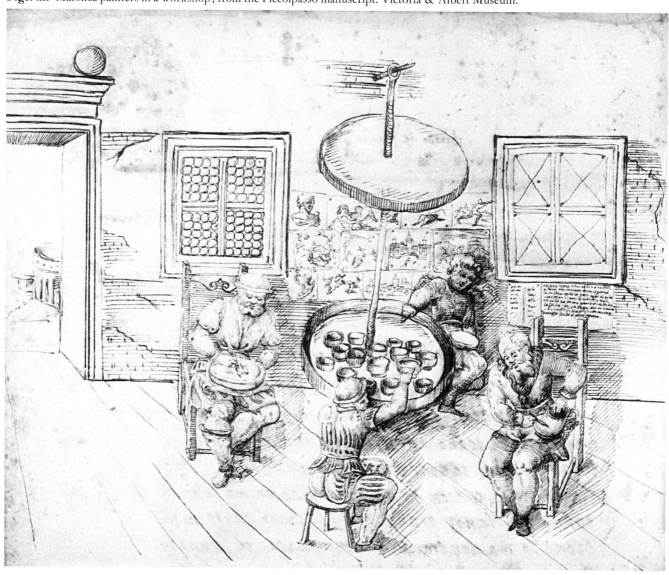

sixteenth century used versions of engravings by Schongauer and Dürer.

Although there are several examples of the use of earlier Italian engravings as models by maiolica painters, it was not until about 1520, when the influence of Raphael had become all-pervasive in Italian art, that Italian engravings became the main source material for *istoriato* maiolica. In the ten years before his death in 1520 Raphael co-operated closely with the engraver Marcantonio Raimondi in the production of numerous engravings based on drawings by Raphael and his pupils. Such was the success of Marcantonio and associates like Marco da Ravenna, Agostino Veneziano, Gian Giacomo Caraglio, and the 'Master of the Die', that the Raphael manner came to be the dominant factor in Italian engraving. In turn, Marcantonio-school engravings came to be the most popular source material for *istoriato* maiolica painters, particularly in the Urbino district.

The ways in which maiolica painters handled their sources varied. Sometimes a composition would be taken over wholesale, with the minimum modification required to adapt the scene to a circular format; sometimes only the figures, or a selection of them, would be used, with architecture or a landscape background of the painter's own invention; or single figures could be reworked into an entirely new composition. An extreme case is the work of Francesco Xanto Avelli, who made a practice of combining figures from several different engravings; Xanto seems to have kept a stock of drawings of single figures from engravings and to have delighted in reusing them at improbable angles and in odd combinations. His adaptations of figures from the erotic engravings known as the *Modi* are especially bizarre.

Another easily available source of compositions was illustrated books, particularly the Italian versions of classical authors produced by Venetian printers. The most popular was the set of woodcuts from the Italian prose paraphrase of Ovid's *Metamorphoses*, first published in Venice in 1497, which were reworked in several subsequent editions. Eight pieces in this book have compositions taken more or less directly from Ovid illustrations, reflecting the vogue for subjects from the *Metamorphoses* among maiolica painters

and their clients. Illustrated editions of Roman historians were similarly quarried. These woodcuts were often primitive and the maiolica painters needed to fill them out to produce a successful result.

It would not, however, be correct to think that maiolica painters knew the work of the great painters of the day only through engravings. There are several occasions when a maiolica plate seems to be derived from a 'major' work of art which is not known to have been engraved at the time: 186, derived from Michelangelo's Sistine ceiling, is one example; 84, which presupposes knowledge of Michelangelo's painting in the Cappella Paolina in Rome, seems to be another: in each case the artist must have known the Michelangelo composition through drawings, or have seen it himself. The same is true of 49 and 50, which are derived from a fresco by Luca Signorelli.

Towns like Faenza and Urbino were small communities, and there is every reason to suppose that professional painters may sometimes have earned an honest penny by providing drawings for the local maiolica industry. But drawings of this kind would naturally have been ephemeral and the number of cases where a major artist can be shown to have made designs specifically for maiolica is small. Some pieces give grounds to suspect that the composition was provided by someone other than the painter: for example, 134, made for Pandolfo Petrucci of Siena, has a figure grouping reminiscent of Umbrian art, and it seems likely that the design was the work of one of the Umbrian-school painters who had been brought to Siena by Pandolfo to decorate his palace. Similarly, the virtuoso composition of the 'Lapiths and Centaurs' dish (45), made in Faenza in 1525 for Francesco Guicciardini and his wife, is reminiscent of Signorelli.

A special case of ceramic painters drawing directly on the work of local painters is Deruta. The presentation dishes which are the most famous products of Deruta often took their subjects from works by Perugino and Pintoricchio; the workshops presumably had drawings of paintings in local public buildings, such as the Collegio del Cambio in Perugia, and churches. This practice seems to have been virtually confined to Deruta and

reflects the isolation of Deruta from developments on the wider artistic stage.

The earliest known case of a surviving drawing used for maiolica, and probably specially made for it, is the drawing (fig. xv, p. 117) in a sketchbook at Lille, attributed to Jacopo Ripanda, which was used for four surviving maiolica plates, all apparently made in Faenza *c*. 1520–30. The drawing was derived from a fresco painted for Pandolfo Petrucci in Siena by Girolamo Genga (*c*. 1476–1551), and artists like Genga, who worked for many years as architect and 'court designer' to the Dukes of Urbino, or the Urbino painter Timoteo Viti (1469–1523), seem likely to have provided a link between developments in the 'major arts' and the Urbino maiolica workshops; but no piece of maiolica has been identified which can positively be associated with a maiolica design by either.

The earliest case where a sequence of drawings can be shown to have been specially commissioned for maiolica is the Trojan War series designed by Battista Franco for Guidobaldo, Duke of Urbino around 1545 (195); these designs were used in a major presentation service soon after being made, and some of them, or copies, remained in maiolica workshops to be used again and again. The only other service which has been demonstrated to have been specially designed by a Mannerist artist was also commissioned by Duke Guidobaldo; this is a set of scenes from the life of Julius Caesar, commissioned from Taddeo Zuccaro for a service made *c*. 1560–2 as a present from the Duke to King Philip II of Spain. There are pieces surviving from what look like other major sets on a single theme which lead one to suspect the involvement of an 'outside designer' – for example, the sets with subjects from the Punic Wars (209) or from *Amadis of Gaul* (90); but it has not yet proved possible convincingly to associate any other professional painter with specific pieces of maiolica.

Towards the middle of the sixteenth century printers in France and Germany started producing cheap miniature Bible picture-books, which provided a stock of basic illustrations well suited to the maiolica painter's needs for day-to-day *istoriato* painting. The most influential of these was the *Quadrins Historiques de la*

Bible, first published in 1553 in several languages by Jean de Tournes in Lyons. This was used in Italy, and heavily by the Italian immigrant maiolica painters who worked in Lyons (257).

The source material available to maiolica painters, if they chose, included the broad range of the arts of the Renaissance. There are occasional examples when they seem to have based their designs on medals; and there is a Cafaggiolo plate in the V & A on which the painter represented a famous local work of sculpture, the marble St George by Donatello. In their representation of favourite subjects, like Diana and Actaeon, or Apollo and Daphne, the maiolica painters could draw on the iconographic language shared not only by painters and graphic artists, but by the makers of plaquettes and medals, *nielli* and engraved gems, furniture-makers and book-illuminators. Every Renaissance artist, in whatever medium, knew without needing a model what a Madonna and Child, or a Diana and Actaeon, 'should' look like. Decorative patterns of the types illustrated by Piccolpasso and the grotesques characteristic of Urbino maiolica of the later sixteenth century are, similarly, part of a shared language. Doubtless, the painters had pattern drawings in their workshops, and sometimes they used ornament prints, but specific sources are difficult to trace. However much, or however little, maiolica painters adapted or added to their graphic models, and however sophisticated or primitive the model itself, the coloured ceramic object that resulted was a new work of art, a product of the technical and stylistic traditions of a particular workshop. A 'close copy' of a Marcantonio print on a Faenza plate of 1525 is a very different thing from one made in Urbino in 1550.

LITERATURE Rackham 1913; Leonhardt 1920; Gere 1963; G. Liverani 1968; Jestaz 1972–3; Clifford & Mallet 1976; Petruzzellis-Scherer 1980, 1982; *Maioliche umbre decorate a lustro* 1982, pp. 25–57; Ravanelli Guidotti 1983A, 1985B.

182 Pharmacy/storage jar

Florence district, *c.* 1460–80

Painted in blue, orange, purple: decoration imitating Valencian flower pattern; on one side, a medallion of a man wearing a tall hat. H 26.2 cm

MLA 1906, 4–18, 1; bought from H. Wallis
Bibl. Carmichael Sale, Christie's, 12–13 May 1902, lot 111; Wallis 1904, fig. 46; Cora 1973, fig. 167a–b.

The portrait resembles a Florentine engraving of *c.* 1460, captioned 'El Gran Turco', perhaps after Antonio Pollaiuolo (fig. xii; Hind 1938–48, I, p. 195). The iconography goes back to Pisanello's medal (fig. xiii) of the Emperor of Constantinople, John VIII Palaeologus (Weiss 1966). If the engraving was the painter's source, the jar would be perhaps the earliest example in existence of a maiolica design following an engraving.

Above: **Fig. xiii.** John VIII Palaeologus; bronze medal by Pisanello, 1438. See 182.

Right: **Fig. xii.** Florentine engraving, perhaps after Antonio Pollaiuolo, *c.* 1460. Kupferstichkabinett, West Berlin. See 182.

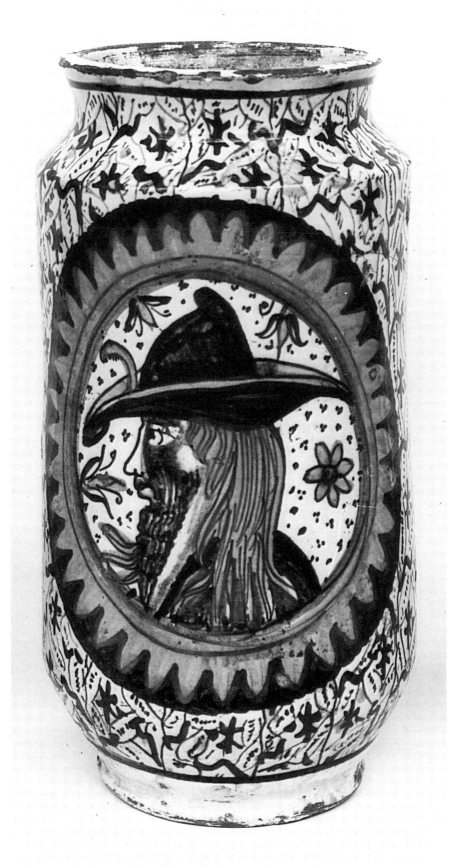

183 Dish on low foot

Faenza, *c.* 1515–25

Lilac-blue glaze; painted in blue, yellow, brown, green, grey, red, purple, white: Christ washing the feet of his disciples (John 13); border of grotesques incorporating winged creatures. Reverse: blue, yellow, and orange hatched arches and a mark resembling an inflatable ball. Shattered; repaired; neutral infill. DIAM 23.7 cm
Henry Reitlinger Bequest, Maidenhead
Bibl. Rackham 1937, p. 66, fig. VII; 1940A, pp. 84–5, 95; Damiron Sale 1938, lot 41; Chompret 1949, fig. 457.

After a woodcut (fig. xiv) by Dürer (B VII, pp. 119, no. 25) or the engraved copy by Marcantonio (B XIV, p. 403, no. 593). Pirated copies of German prints were produced in Italy, and it is sometimes impossible to tell whether a maiolica painter used the original or an Italian copy.

Attributed by Rackham to the 'Assumption Painter'. On the mark, see 45.

184 Dish

Faenza, *c.* 1520–5, perhaps made in the Casa Pirota

Painted in blue, green, yellow, orange, brown, purple, white: prisoners, and an orator addressing a military commander. Reverse: scale pattern; blue, orange and yellow rings. Foot cut away. DIAM 25.2 cm
MLA 1855, 12–1, 83
Bibl. Bernal Sale 1855, lot 1952; Shaw 1932, 1933; Rackham 1930A, pp. 146–7, pl. XXXII; 1940A, p. 81; G. Liverani 1950B, pp. 104–7; Giacomotti 1974, p. 86.

The design is from a fresco by Girolamo Genga in the palace of Pandolfo Petrucci in Siena, painted *c.* 1509. A drawing attributed to Jacopo Ripanda, based on the fresco, is in an album at Lille, one page of which is dated 1516; the drawing (fig. xv) is close in detail to the plate and may have been the painter's immediate source. Two pieces of maiolica are from the same design: one in the Louvre (Giacomotti 1974, no. 337), dated 1524, the subject described on the back as the 'story of Caesar the Roman Emperor'; the other (Damiron Sale 1938, lot 75), with the mysterious word *Gonela* on the reverse. A dish with a simplified version of the subject was at Sotheby's, 21 November 1978, lot 45. The curved shadow in the right-hand corners of the drawing

184

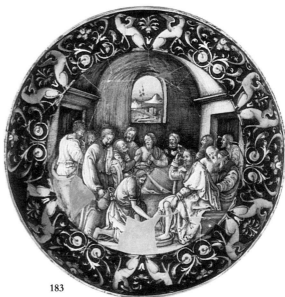

183

Left: **Fig. xiv.** *Christ washing the feet of his Disciples*;
woodcut by Albrecht Dürer, *c.* 1509–10.
See 183.

Below left: **Fig. xv.** A scene from Roman history;
drawing attributed to Jacopo Ripanda, *c.* 1516.
Musée des Beaux-Arts, Lille. See 184.

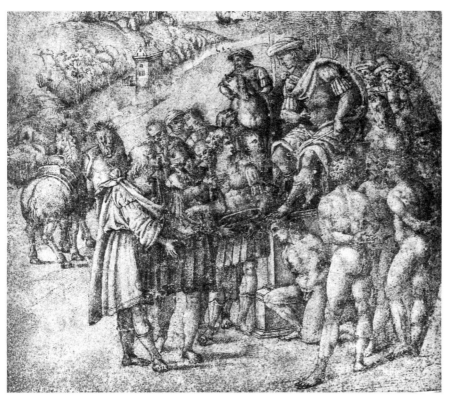

suggests it may have been intended as a model for maiolica, or adapted as such.

The subject of Genga's fresco is uncertain. Tátrai (1978) suggests it is Fabius Maximus ransoming prisoners from Hannibal (Plutarch, *Fabius Maximus*, viii). If the maiolica painter who described it as a 'story of Caesar' was right, the subject may be the negotiations between Caesar and Ariovistus over the Aeduan hostages (Caesar, *Gallic War*, I).

This dish was attributed by Rackham to the 'Master C.I.', but the coherence of the work attributed to this painter is questionable (Rasmussen 1984, p. 88). Cf., rather, the two marked pieces from the Casa Pirota (at Sèvres, Fourest 1983, pl. 43, dated 1525; and Bologna, Ravanelli Guidotti 1985A, no. 42); also 41 and 42.
Also illustrated in colour

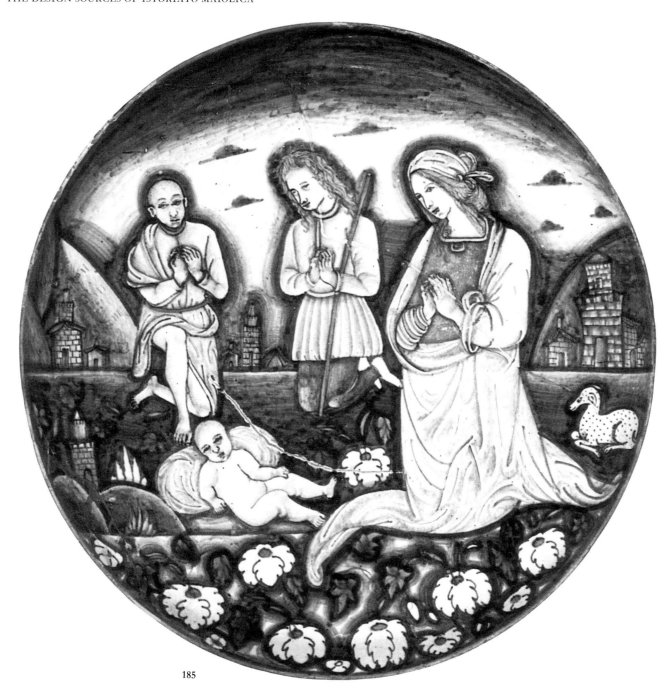

185

185 Dish on low foot

Probably Deruta, *c.* 1510–40

Painted in blue, green, yellow, orange: the
Virgin and shepherds adoring the infant
Jesus. Restorations. DIAM 30.4 cm

MLA 1878, 12–30, 421; Henderson Bequest

Bibl. Robinson 1862, no. 5184; Rackham
1940A, p. 146.

The subject is from a composition used
several times by Pietro Perugino, e.g. in
the Collegio del Cambio in Perugia
(fig. xvi).

186 Dish on low foot

Perhaps Faenza, *c.* 1525–35

Blue-grey glaze; painted in blue, green,
yellow, orange, brown, white: a man,
woman, and child in a landscape. Reverse:
blue and orange scale pattern and a cross.
DIAM 22.5 cm

MLA 1855, 12–1, 82

Bibl. Bernal Sale 1855, lot 1951; Solon 1907,
pl. 14.

The figures are from one of the
spandrels on Michelangelo's ceiling in
the Sistine Chapel (fig. xvii),
representing the infant Josias and his
parents, painted 1511–12: placed in a
landscape, the scene on the dish seems to
suggest the Holy Family's rest on the
flight into Egypt. The lumps on the
man's forehead are apparently a
misunderstanding of tufts of hair in the
fresco. The fresco was engraved by
Marcantonio (B XIV, p. 66, no. 59), but

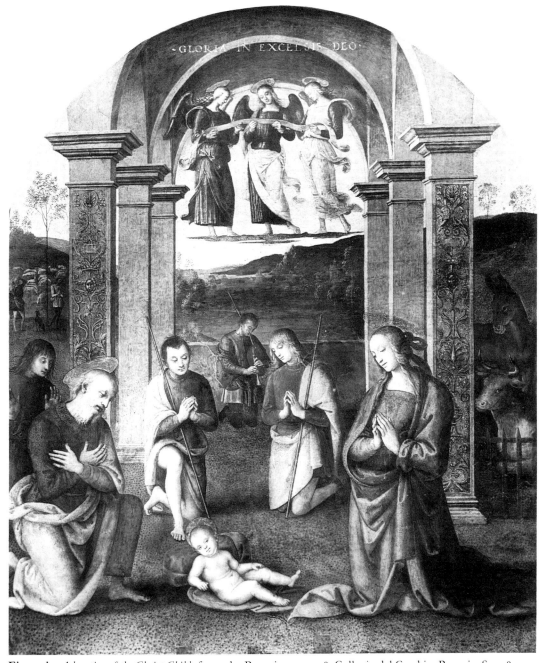

Fig. xvi. *Adoration of the Christ Child*; fresco by Perugino, *c.* 1498. Collegio del Cambio, Perugia. See 185.

the plate is closer to the fresco than to the engraving.

187 Plaque

Perhaps Faenza, *c.* 1520

Painted in blue, yellow, green, brown, orange, white: the Sacrifice of Isaac (Genesis 22). The panel has cracked and the colours run in the kiln. 26 × 28.5 cm

MLA 1885, 5 8, 27; given by A. W. Franks

Bibl. Rackham 1933, p. 41; 1940A, pp. 84; G. Liverani 1958A, p. 26.

The composition is copied from a Venetian woodcut by Ugo da Carpi (fig. xviii), the design of which is traditionally attributed to Titian.

The plaque was attributed by Rackham to the 'Assumption painter'.

188 Dish on low foot

Perhaps Faenza, *c.* 1530–5

Lilac-grey glaze; painted in blue, yellow, green, orange, brown, red, black, white:

Apollo, the Muses, and flying *putti*. Reverse: blue and white rings and a crossed trident.

DIAM 24.8 cm

MLA 1855, 12–1, 42

Bibl. Bernal Sale 1855, lot 1746; Fortnum 1873, p. 519.

The composition is a rustic version of Marcantonio's engraving (fig. xix; B XIV, p. 200, no. 247), after Raphael's design for the *Parnassus* in the Vatican.

186

Fig. xvii. *Josias*; fresco by Michelangelo, *c.* 1510. Sistine Chapel, Vatican. See 186.

This was one of the most popular engravings with maiolica painters (Hausmann 1972, p. 259). The painter has added the landscape and omitted the flanking poets.

For a comparable trident on pieces with tinted glaze, cf. Rackham 1940A, nos 288, 305; Hausmann 1972, no. 123; Giacomotti 1974, no. 319.

189 Dish on low foot

Perhaps Urbino district, or Umbria, *c.* 1520–5
Painted in blue, green, brown, purple, yellow, orange, white: the abduction of Helen. Reverse: blue scrolls and four sets of undeciphered characters (perhaps *hh*). Warped. DIAM 31 cm
MLA 1855, 12–1, 47
Bibl. Bernal Sale 1855, lot 1757; Fortnum 1873, pp. 295, 300; Rackham 1933, p. 58; Join-Dieterle 1984, p. 172.

The seizure of Helen by the Trojans was the incident which sparked off the Greek invasion of Troy. The painter's immediate source seems to have been an engraving by Marco Dente (B XIV, p. 171, no. 210; fig. xx). The subject was a favourite with maiolica painters (Giacomotti 1974, pp. 267–8).

The pattern on the reverse resembles the only *istoriato* piece definitely painted as well as lustred in Gubbio (Join-Dieterle 1984, no. 54); it is an interesting hypothesis that this unlustred dish was made in Gubbio.

190 Dish

Attributed to Nicola da Urbino, Urbino, *c.* 1530

Painted in blue, brown, orange, yellow, green, black, white: St Paul blinding Elymas before Sergius Paulus (Acts 13). Beneath Sergius Paulus' throne: .L.SERCIUS PAULLUS. ASIAE. PROCOS CHRISTIANAM FIDĒ AMPLECTITUR. SAULI. PREDICATIONE (L. Sergius Paulus, Proconsul of Asia, embraces Christianity on the preaching of Saul). On the right the glaze has run. DIAM 45.2 cm
MLA 1885, 5–8, 36; given by A. W. Franks

The composition follows closely the engraving by Agostino Veneziano (B XIV, p. 48, no. 43; fig. xxi), after one of Raphael's cartoons for the Sistine Chapel tapestries. Cf. Giacomotti 1974, no. 842; Ravanelli Guidotti 1983A, no. 130.

Below : **Fig. xviii.** *Sacrifice of Isaac* ; woodcut by Ugo da Carpi, *c.* 1515. See 187.

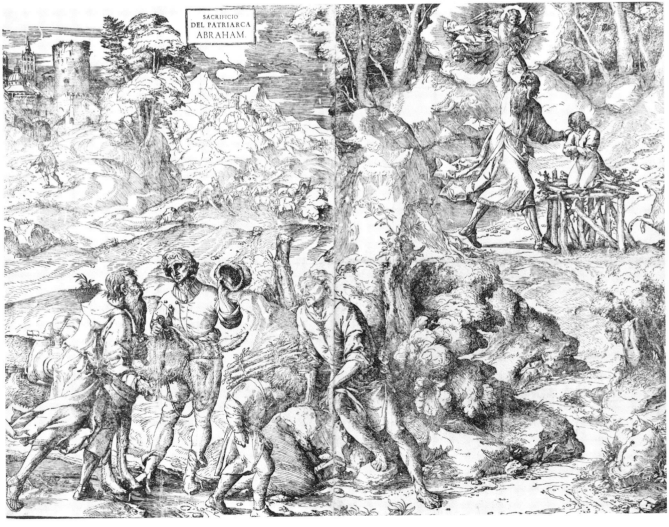

Right: **Fig. xix.** *Parnassus*; engraving by Marcantonio Raimondi after Raphael. See 188; also 59 and 75.

188

189

Right: **Fig. xx.** *The Abduction of Helen*; engraving by Marco Dente, perhaps after Raphael. See 189; also 220.

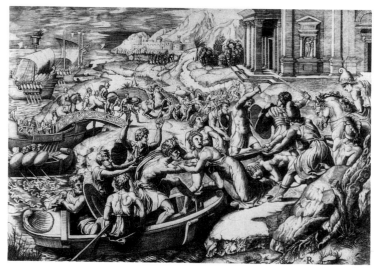

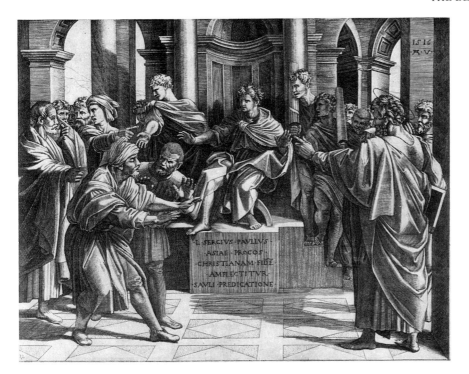

Fig. xxi. *St Paul blinding Elymas*; engraving by Agostino Veneziano after Raphael. See 190.

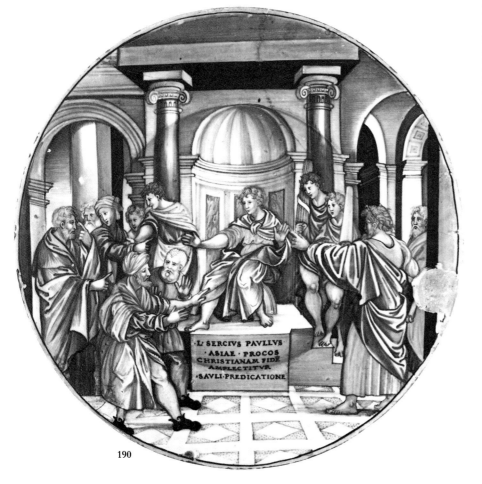

190

191 Plate

Perhaps Tuscany, 16th century

Reddish earthenware; painted on a slip beneath a transparent glaze, in blue, green, yellow, red: the Triumph of Bacchus in India; on the rim, romping *putti* and animals. Reverse partially covered with slip and transparent glaze: trellis pattern, arrowheads, dashes and squiggles. Broken and repaired. DIAM 40.9 cm

MLA 1878, 12–30, 420; Henderson Bequest
Bibl. Robinson 1862, no. 5176; Henderson 1868, pl. VII; Rackham 1951, p. 111.

In 1517 Alfonso I d'Este commissioned from Raphael a painting of *The Triumph of Bacchus in India*; Raphael never completed the painting but his design was engraved (fig. xxii; B XV, p. 297, no. 32; cf. Knab, Mitsch & Oberhuber 1983, pp. 135, 140, fig. 134). The plate copies the left-hand half of the engraving. The orgiastic Oriental procession is a theme derived from Roman sarcophagi (Wind 1950).

The plate is technically and stylistically unusual; cf. a tile pavement in the Villa Caserotta in Val di Pesa, Tuscany, of which some tiles are in Faenza (no. AB 4755–8); but also Norman 1976, C159, attributed to the nineteenth century. Painting on slip was a cheaper alternative to tin glaze.

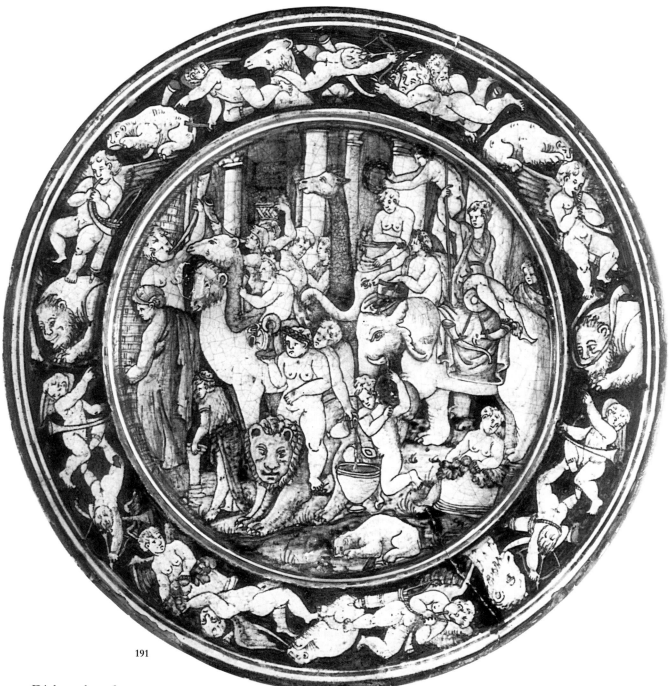

191

192 Dish on low foot

Attributed to Francesco Xanto Avelli, Urbino, *c.* 1530

Painted in blue, yellow, orange, brown, purple, green, near-black, white: a satyress in the centre, and Cupid escaping from Psyche in a landscape with a river-god. Reverse: *Psiche segue Cupido et lui la fuggie. fabula* (Psyche follows Cupid and he flees from her. A story), followed by a flourish resembling *y.* DIAM 25.8 cm

MLA 1855, 3–13, 13; given by A. W. Franks

The subject is from Book 5 of Apuleius' *Golden Ass.* Psyche had broken her promise to her lover Cupid by lighting a lamp to look at him; he awoke and flew away. She was found in despair near a river, in which she had tried to drown herself, by Pan, who was teaching the nymph Echo to play the pipes. Xanto has conflated Pan and Echo into a goat-legged female.

The figures are assembled from subsidiary figures in four separate engravings from the workshop of Marcantonio Raimondi. Psyche is from

the *Martyrdom of St Lawrence* (B XIV, p. 89, no. 104; fig. xxiii); the flying Cupid from the *Crouching Venus* (B XIV, p. 235, no. 313; fig. xxv(a)); the female satyr adapted from a figure of Dido in the *Quos Ego* (B XIV, p. 264, no. 352; fig. xxiv; cf. B XIV, p. 217, no. 284); the river-god from the Uranus in the *Birth of Venus* (B XIV, p. 243, no. 323; fig. xxv(b)).

A virtually identical group of Cupid, Psyche, and river-god is on a plate at Polesden Lacey (Mallet 1970–1, part 3, pp. 174–6, pl. II), attributed to Xanto.

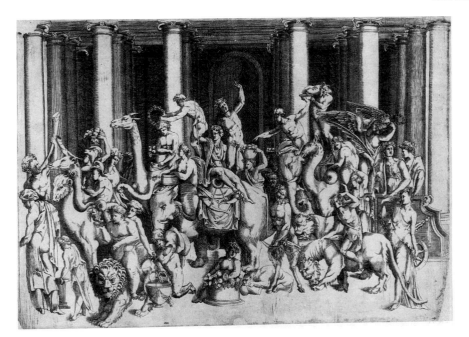

Fig. xxii. *The Triumph of Bacchus in India*; engraving after Raphael. See 191.

193 Dish

Deruta, *c.* 1500–25

Painted in blue and green; golden and red lustre: a capon and hawk, with their owner approaching; on a scroll, VENTVRA DIO (In the hands of God). The reverse partially lead-glazed; two suspension holes in foot-ring. Restoration to rim. DIAM 37.5 cm

Ashmolean Museum, Oxford (Fortnum Bequest)

Bibl. Montferrand Sale, Christie's, 14–16 Nov. 1859, lot 213; Fortnum 1897, C425; Rackham 1940A, p. 149; Mallet 1978, p. 400, fig. 4.

Derived from a woodcut in the edition of Aesop published in Naples in 1485 (fig. xxvi). The fable tells how a hawk tried to convince a capon to be glad of the approach of their master; the capon was justifiably afraid of being slaughtered, and fled.

194 Dish on low foot

By the 'Argus painter', Pesaro, *c.* 1535–40

Painted in blue, green, yellow, orange, brown, black, white: left, Picus on horseback; centre, Circe dumbstruck by his handsomeness; right, Picus pursuing the boar. Reverse: *de pico e de Circe fato in pesaro* (of Picus and Circe. Made in Pesaro). Broken and repaired. DIAM 26.6 cm

MLA 1855, 12–1, 89

Bibl. Bernal Sale 1855, lot 1979; Fortnum 1873, pp. 159, 165; Mallet 1980, p. 156, pl.XXIV; Berardi 1984, p. 186.

The story is from Ovid, *Metamorphoses* 14. Picus, son of Saturn, was hunting when the enchantress Circe fell in love with him; she created a phantom boar to entrap him in the woods, then tried to induce him to make love to her; when he refused, she turned him into a woodpecker. The design is from a woodcut (fig. xxvii) in the 1497 Ovid, omitting subsidiary figures and modifying the costumes.

Illustrated on p. 130

195 Plate

Urbino or Castel Durante, probably *c.* 1545–51

Painted in orange, blue, yellow, brown, grey, green, black, purple, white: Priam welcoming Helen to Troy; around the rim, satyrs, *putti*, eagles, and trophies. Reverse: yellow lines and IL RE TROIAN RICEVE HELLENA BELLA (the Trojan King receives lovely Helen). DIAM 41 cm

Victoria & Albert Museum C31–1973

Bibl. Clifford & Mallet 1976, pp. 395, 404 (no. 5); Mallet 1987.

This plate corresponds with a drawing (fig. xxviii; Gere & Pouncey 1983, no. 152) which is apparently an early copy of a maiolica design by Battista Franco (*c.* 1510–61). According to Vasari, Guidobaldo II, Duke of Urbino, commissioned a series of Trojan War subjects from Franco, who had been working for him on frescos in Urbino Cathedral; Vasari says that Guidobaldo 'thought his drawings, when carried out by those who made excellent earthenware vessels at Castel Durante and who had much used Raphael of Urbino's engravings and those of other able men, would be very effective. So he made Battista do a large number of drawings which when executed in that, the finest earthenware in all Italy, turned out marvellously well. Such great quantities of these vessels were therefore made and of so many kinds that they would have sufficed for and done honour to a royal service, and the painting on them would not have been better had they been done in oils by the finest artists . . . Duke Guidobaldo sent a double service of this ware to the Emperor Charles V and a service to Cardinal Farnese, brother of Signora Vettoria his wife'.

This plate appears to be from a set made in the 1540s. Vasari implies the set commissioned by Guidobaldo was made in Castel Durante, but Mallet (1987) suggests the series was painted in Urbino by Camillo Gatti, a maiolica painter apparently trained by Franco himself. The border on the plate is symmetrical, reflecting the fact that the design gives only half the pattern.

Franco's drawings remained in use in local maiolica workshops (cf. 240) and other dishes with the subject are recorded (Ravanelli Guidotti (1983B, pp. 474–7; 1985A, p. 180).

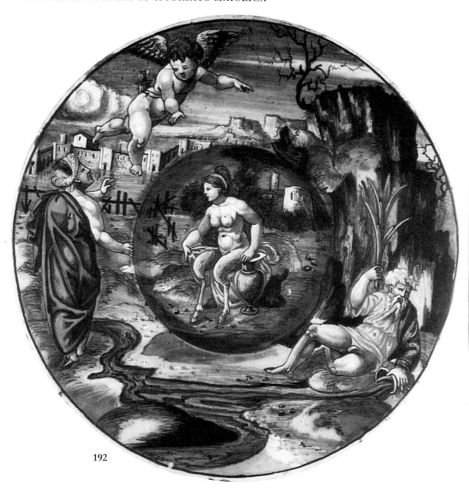

192

Above: **Fig. xxv.** a) The *Crouching Venus* by Marcantonio Raimondi; b) *Birth of Venus* by Marco Dente after Raphael; engravings. See 192.

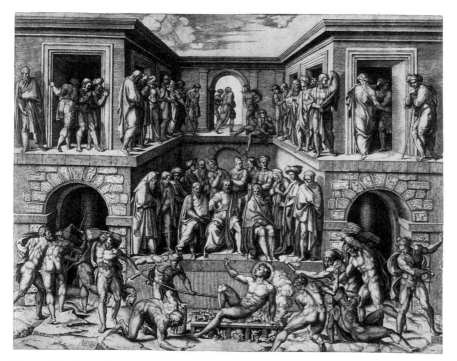

Fig. xxiii. *Martyrdom of St Lawrence*; engraving by Marcantonio Raimondi after Bandinelli. The figure entering a doorway (top right) is the source for the left-hand figure (Psyche) on 192. See also 220.

Right: **Fig. xxiv.** The *Quos Ego* (scenes from the *Aeneid*); engraving by Marcantonio Raimondi after Raphael. The seated figure of Dido (centre right) is transformed by Xanto into a satyress on 192. See also 65, 104, 216.

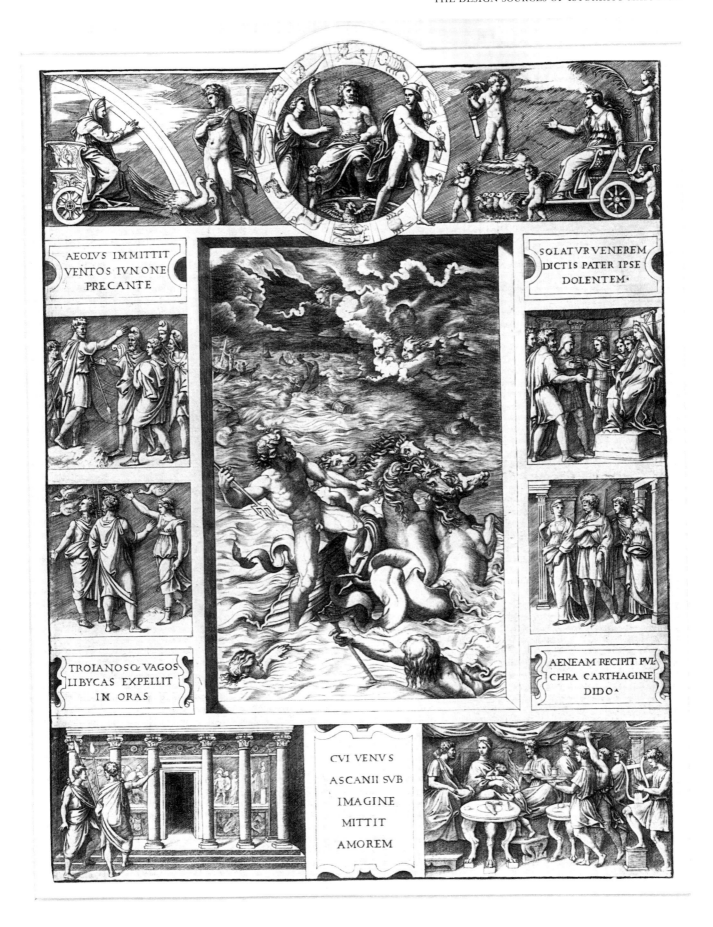

Fig. xxvi. *The capon and the hawk*; woodcut from Aesop's *Fables*, Naples 1485. British Library. See 193.

193

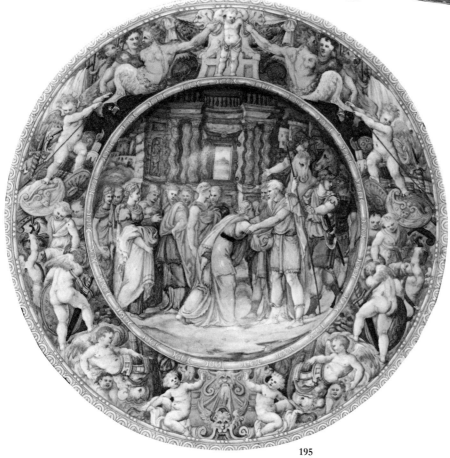

195

Right: **Fig. xxviii.** *Priam welcoming Helen to Troy*; drawing after Battista Franco. See 195.

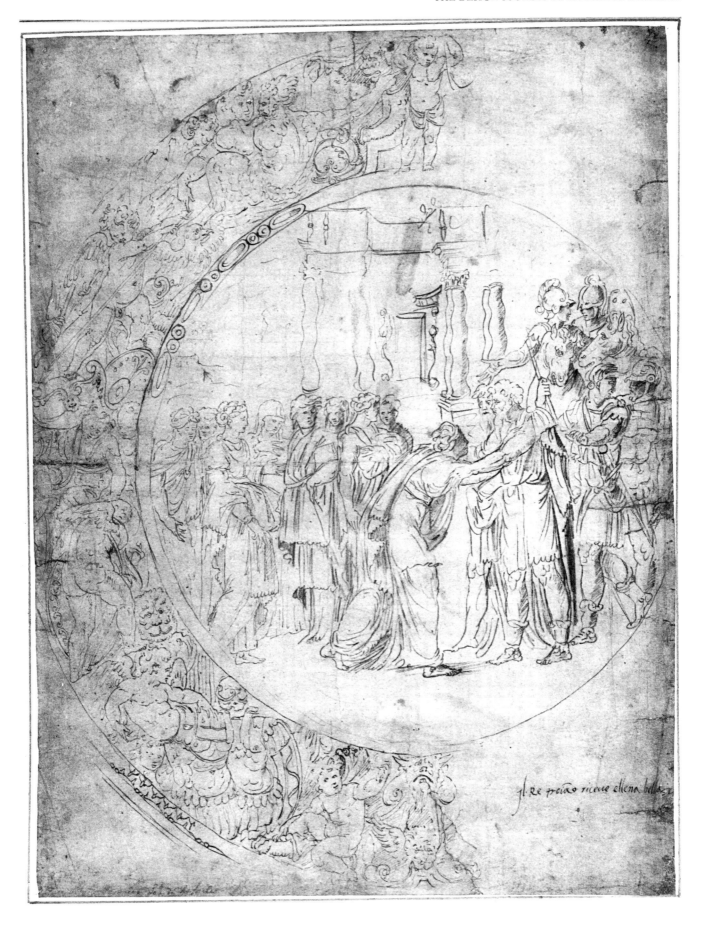

Below : **Fig. xxvii.** *Picus & Circe* ; woodcut from *Ovidio methamorphoseos vulgare*, Venice 1497, British Library. See 194.

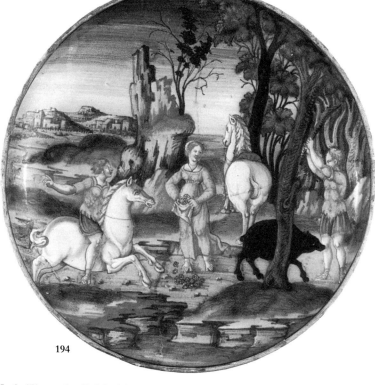

194

Left : **Fig. xxix.** *Zedekiah before Nebuchadnezzar* ; woodcut from *Quadrins Historiques de la Bible*, Lyons, 1555 edition. British Library. See 196.

196 Fluted dish

Probably Lyons, *c.* 1580–90

Painted in blue, orange, yellow, green, brown, grey, purple, white: Zedekiah, King of Judah, brought in chains before Nebuchadnezzar. Reverse: .IIII.ROIS. XXV.

MLA 1963, 11–5, 1; given by Mrs G. E. Green and Mrs G. I. Vinall

The story is from 2 Kings 25 (the fourth book of Kings in the Latin Bible). The composition is from the 1553 Lyons *Quadrins Historiques de la Bible* (fig. xxix). The severed heads in the background are an addition by the painter.

196

16 Heraldry

Italian heraldry is an awkward field. Until the creation of the Italian monarchy in 1860, there was no single heraldic authority in Italy, and nothing to stop various families using the same arms; nor were there any generally applied rules for combining arms or for 'differencing' the arms of different branches of a family. As a result the arms on Renaissance maiolica can often not be tied down to a particular family; and even where the family can be identified, there may be no way of telling which member of the family the piece was made for, unless there is a clue, like two coats-of-arms side by side to denote a husband and wife, or some mark of noble or ecclesiastical rank. The addition of one of the personal devices (*imprese*) popular with Renaissance aristocrats can also point to a particular individual. But even when a coat-of-arms clearly refers to an individual, uncertainties remain. An armorial plate may have been commissioned by the 'owner' of the arms for his (or her) personal use; or made as a gift from him to someone else, or from someone else to him. A piece bearing the arms of a Pope or ruler may never have been seen by him, but been used by a supporter or subject as a sign of loyalty, like a Coronation mug.

Some pieces associated with particular individuals are from sets of which enough has survived to enable us to assess what they were like when complete. The sets produced in the Urbino region in the 1520s and 1530s, like Nicola da Urbino's set for Isabella d'Este (51, 52), or Xanto's for a member of the Pucci family (74, 222), consisted mainly of *istoriato* plates and dishes of various sizes; there is no clear-cut theme running through the subjects, which is surprising in the case of a patron as intellectually demanding as Isabella d'Este. In the 1540s large services began to be produced with carefully programmed subjects, like the set with scenes from the Punic Wars (209). The set celebrating the wedding in 1579 of the Duke of Ferrara, on the other hand, was decorated mainly with grotesques, but consisted of a variety of ambitiously modelled shapes.

Alongside the Italian market, maiolica workshops had a valuable export trade. Commissions from south Germany ranged from *alla porcellana* sets made for Augsburg and Nuremberg merchant families, to the colossal set made in Faenza in 1576 for the Duke of Bavaria (235–6). Among the Frenchmen who had maiolica made for them in Urbino was Anne de Montmorency, the greatest non-royal patron of the French Renaissance (80). Later, Urbino potters cornered the market in lavish services for grandees of Spain. No Renaissance piece for an English patron has been identified.

Heraldry is valuable for the maiolica historian in providing dating evidence, and enabling the reconstruction of sets; these would usually, though not always, have been from a single workshop, although the larger sets involved several painters. More important, perhaps, is the direct link a coat-of-arms or *impresa* provides between maiolica and some of the greatest men and most discriminating patrons of the Renaissance.

LITERATURE Marquand 1919; Galbreath 1972; Bascapè & Del Piazzo 1983.

Popes and churchmen

197 Dish

Deruta, *c.* 1503–13

Painted in blue; brownish lustre: the arms of Pope Julius II supported by wyverns; plant pattern on rim. Reverse lead-glazed; three suspension holes in foot-ring. DIAM 41.5 cm
MLA 1878, 12–30, 377; Henderson Bequest *Bibl.* Henderson 1868, pl. V; Ballardini 1938, frontispiece; Rackham 1940A, p. 152.

Giuliano Della Rovere (1443–1513) became Pope as Julius II in 1503. The greatest artistic patron of the Renaissance, he began rebuilding St Peter's, and commissioned Michelangelo to paint the Sistine ceiling, and Raphael the Vatican *Stanze*. *Illustrated in colour*

198 Bowl

Florence district, *c.* 1513–21

Painted in blue, orange, green, red, yellow: the arms of Pope Leo X, supported by *putti*; on the sides *putti* playing with mermaids and

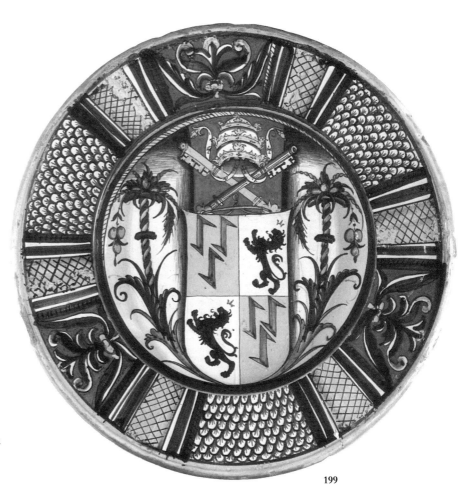

199

feeding monsters, with four *imprese*: 1) a ring and three feathers, with SENPER (always) and PONTETIA.DIVINA. (divine power?); 2) a nail driven through a wheel, with VIVIMUS.SUMUS. (we live, we are); 3) a yoke, with SVAVE (gentle) and PONTETIA DIVINA.; 4) an eagle and .RENOVABITUR. (it will be renewed). Exterior: *putti* with shields of the arms of Medici (three times), Strozzi, Salviati and Orsini. Damage to exterior. DIAM 36.5 cm

MLA 1855, 12–1, 76

Bibl. Bernal Sale 1855, lot 1932; Fortnum 1873, p. 93; Solon 1907, fig. 23; Falke 1933B, p. 115; Rackham 1940A, p. 105; Hausmann 1972, p. 133; Cora & Fanfani 1982, no. 24; T. Wilson 1984, pp. 434–6, pls CXLV–CXLVII; Sutton 1985, p. 106, pl. VI.

A compendium of arms and devices connected with Giovanni de' Medici (1475–1521), the son of Lorenzo the Magnificent, elected Pope as Leo X in 1513; the arms on the exterior are of families connected by marriage with the Medici. The devices round the inside are associated with the Pope: the ring and feathers was a Medici family *impresa* (cf. 16); the nailed-down wheel represents halting the turning wheel of Fortune; the yoke signifies the gentle Medici control of Florence; and the eagle is a symbol of rebirth (T. Wilson 1984).

Falke and Rackham attributed the bowl to the Cafaggiolo painter 'Jacopo'; this seems doubtful. Heukensfeldt Jansen 1961, no. 20, also with the arms of Leo X, is by the same painter.
Illustrated in colour

199 Dish

Deruta, *c.* 1522–3

Painted in blue, orange, yellow, green: the arms of Pope Hadrian VI; rim in sections with foliate and scale ornament. Reverse lead-glazed; two suspension holes in foot. Broken; repaired with rivets. DIAM 42.5 cm

MLA 1855, 12–1, 62

Bibl. Bernal Sale 1855, lot 1854.

Adrian of Utrecht became Pope in 1522, but died the following year. He was the last non-Italian Pope until 1978. A rare and early datable example of this kind of decoration.

200 Broad-rimmed bowl

Painted by Francesco Xanto Avelli, Urbino, 1535; probably lustred in Gubbio

Painted in blue, green, yellow, orange, purple, brown, black, white; golden and red lustre: an unexplained allegory; in the centre, a shield of arms of the Pesaro family of Venice, with a cross above. Reverse: lustred scrolls and, in black, *.1535. Quâto rouina al fì chi troppo sforzasi* (disaster is the final result of trying too hard) *.X.* DIAM 18.5 cm

MLA 1878, 12–30, 403; Henderson Bequest

Bibl. Pourtalès Sale 1865, lot 1696; Castellani Sale 1871, lot 104; Ballardini 1933–8, II, no. 199, figs 193, 351.

From a set with the arms of Jacopo Pesaro, Bishop of Paphos in Cyprus (then part of the Venetian empire). Other pieces of the set: Ballardini, 1933–8, II, nos 196, 197, 198, 200; and Metropolitan Museum. Xanto habitually used the smaller plates of sets for allegorical inventions. Two of the figures are based on engravings (B XIV, p. 89, no. 104; B XV, p. 95, no. 62).

201 Plate

Probably Urbino district, *c.* 1540

Painted in blue, green, orange, brown, black, yellow, white: the daughters of Minyas, and Bacchus; arms: Medici impaling Pucci, beneath a cardinal's hat. Reverse: *le fabulatricie di baccho* (the tale tellers of Bacchus). DIAM 26.4 cm

MLA 1853, 5–28, 6

Bibl. Sotheby's, 15–16 April 1853, lot 215; Norman 1976, p. 197; Rasmussen 1984, p. 180.

Antonio Pucci of Florence (1483–1544) was made a cardinal by the Medici Pope Clement VII in 1531; like many cardinals, he combined his arms with those of the Pope who promoted him. Other pieces from the set: Rackham 1940A, nos 916, 917; Christie's, 29 May 1962, lots 125, 126; Fountaine Sale 1884, lot 307; Metropolitan Museum; Cleveland Museum of Art; Gardiner Museum, Toronto, ex-Courtauld Sale 1975, lot 29; Frati 1852, no. 79; Sotheby Parke-Bernet (NY), 1–3 Nov. 1973, lot 178. All except one have classical subjects.

The story is from Ovid, *Metamorphoses* 4: the three daughters of Minyas sat spinning and telling stories, refusing to take part in a festival to Bacchus, who thereupon turned them into bats.

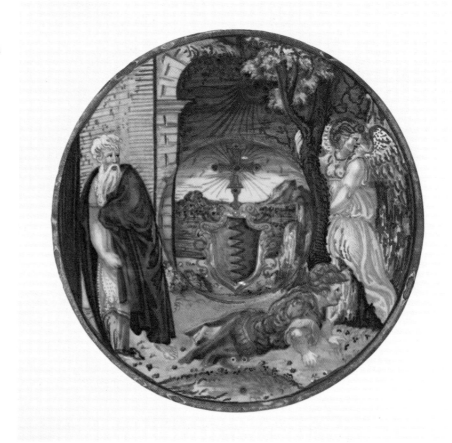

200

Men of letters

202 Plate

Faenza, 1525

Bluish-grey glaze; painted in blue, white,
green, yellow, orange, red: winged *putti*
holding a shield of arms, Guicciardini
impaling Salviati; on the sides, decoration in
white; on the rim, grotesques incorporating
masks, dolphins, winged cherub-heads, and
tablets with *1525*. Reverse: plant sprays, and
a mark resembling an inflatable ball.
Restorations to rim. DIAM 26.1 cm
MLA 1855, 3–13, 22; given by A. W. Franks
Bibl. Fortnum 1873, pp. 478, 494; Solon
1907, col. pl. VII; Ballardini 1933–8, I,
no. 159, pl. 150, 302R; 1940, pp. 3–9, pl. IIa.

The arms are those of the Florentine
historian Francesco Guicciardini and his
wife Maria Salviati, who were married
in 1508. Similar plates with the same
arms: Ballardini 1940, pl. IIB; Conti
1980, pl. 240; cf. 45. The set was made
while Guicciardini was papal Governor
of Romagna and partly based in Faenza;
it may have been a gift to him from the
city, but no proof of this has been
found.

For the mark, see 45.
Illustrated in colour with 45

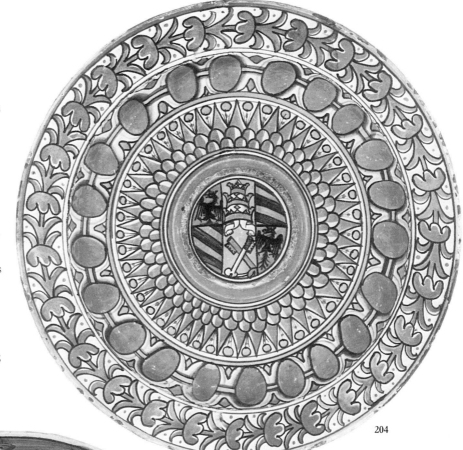

204

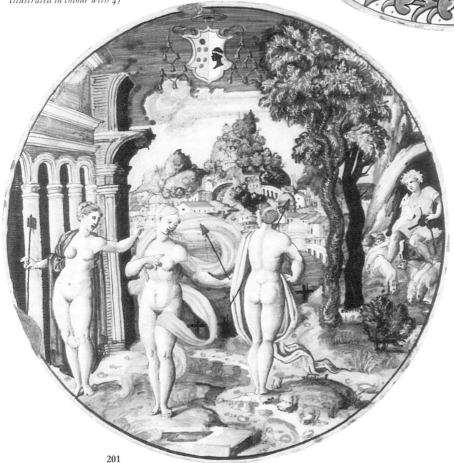

201

203 Plate

Urbino, 1539–47

Painted in brown, yellow, blue, green,
orange, purple, black, white: soldiers
rushing to arms; in a tree, a shield of arms
beneath a cardinal's hat. DIAM 27.2 cm
MLA 1888, 2–15, 1; bought from H. Wallis
Bibl. Fountaine Sale 1884, lot 317; Solon
1907, fig. 39.

By the same painter as 82. The arms are
for Pietro Bembo (1470–1547), Venetian
scholar and writer, made cardinal in
1539.

The subject is from an engraving by
Agostino Veneziano (B XIV, p. 318,
no. 423) after Michelangelo's never
completed 1504 design for painting the
Council Chamber in the Palazzo
Vecchio, Florence. The subject is the
Battle of Cascina, an obscure episode in
a war between Florence and Pisa in
1364. Cellini in his *Autobiography*
described the cartoon: 'Michelangelo
portrayed a number of footsoldiers who,
the season being summer, had gone to
bathe in the Arno. He drew them at the

very moment the alarm is sounded and
the men all naked run to arms, so
splendid in their action that nothing
survives of ancient or modern art that
touches the same lofty point of
excellence'.
Illustrated in colour with 82

Rulers

204 Dish

Perhaps Deruta, *c.* 1500–8

Painted in blue and green; brown and
pinkish lustre: a coat-of-arms; concentric
bands of decoration; the sides moulded with
oval depressions. Reverse: lustred rings and
interlacing arches. DIAM 33.2 cm

MLA 1855, 12–1, 51

Bibl. Bernal Sale 1855, lot 1786.

The arms are a simplified form of those
of the Montefeltro Dukes of Urbino;
this version, with the crossed keys and
tiara of the Papacy, was used from 1474,
when Federico da Montefeltro was
appointed standard-bearer of the Roman
Church, until the death of his son
Guidobaldo in 1508.

205 Fluted dish

Probably workshop of Guido
Durantino or Orazio Fontana, Urbino,
c. 1560–70

Painted in blue, orange, yellow, green,
brown, purple, grey, black, white: Phalaris
watching Perillus being roasted in the
bull; right, the arms of Guidobaldo II Della
Rovere, Duke of Urbino, within the collar of

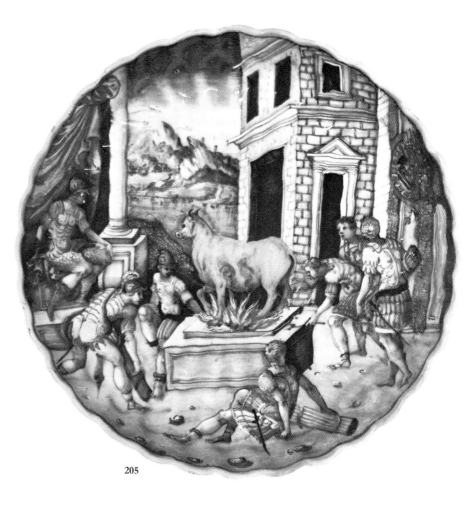

205

Right: **Fig. xxx.** Alfonso II and
Margherita Gonzaga, with the *Ardet
Æternum impresa*. Bronze medal, probably
made in 1579. See 206.

206

the Golden Fleece, surmounted by three posts. Reverse: *Perillo*. Foot cut away. Restoration to edge. DIAM 27 cm

MLA AF 3320; Franks Bequest, 1897
Bibl. Fortnum 1873, p. 158; Rackham 1940A, p. 277; Ravanelli Guidotti 1985A, p. 152.

Perillus made a bronze bull as an instrument of torture for the tyrant Phalaris, and was himself roasted in it.

Several pieces in similar style with the same arms (Ravanelli Guidotti 1985A, p. 152; three others at Ickworth (National Trust)) are marked as a gift from Duke Guidobaldo to an Augustinian friar called Andrea da Volterra; this dish may have been part of the gift. Guidobaldo was a major patron of the maiolica of his local region. This piece must have been made between his appointment (1558–9) to the Order of the Golden Fleece, the most prestigious order of chivalry in Europe, and his death in 1571. The three posts are the turning posts of a Roman stadium, an *impresa* adopted by Guidobaldo to signify endeavour towards virtue and glory (Ruscelli 1566, pp. 289–94).

206 Salt cellar

Perhaps workshop of Antonio Patanazzi, Urbino, *c.* 1579

Modelled with rams' heads, masks, lions' paws, and scrollwork. Painted in yellow, orange, blue, green, brown, purple, black: in the well, burning 'asbestos', and *ARDET ÆTERNVM* (it burns for ever).
H (max.) 15.5 cm

MLA 1884, 6–18, 3
Bibl. Fountaine Sale 1884, lot 61; Norman 1976, p. 226.

The set bearing this *impresa* was one of the most elaborate ever made. At least 27 pieces have survived (Biscontini Ugolini 1975; Ravanelli Guidotti, forthcoming), including salts, large basins, jugs, and flasks, and dishes of various shapes and sizes. The device and motto occur, attributed to Curtio Borghesi, in Camillo Camilli's *Imprese illustri* (Venice 1586, p. 37); the device represents a lump of 'asbestos', a mythical stone which, once lit, could never be put out. The device, an emblem of love, occurs on the reverse of a medal (fig. xxx) with portraits of Alfonso II, Duke of Ferrara, and his third wife, Margherita Gonzaga. The service was probably made for their wedding in 1579. See 242.

Foreigners

207 Plate

Attributed to Domenego da Venezia, Venice, *c.* 1560–70

Painted in blue, orange, yellow, green, purple, grey, white: Mucius Scaevola and Porsenna; shields of arms with helm, crest, and mantling. Reverse: blue and yellow rings. DIAM 29.1 cm

MLA 1855, 12–1, 104
Bibl. Bernal Sale 1855, lot 2054; Lessmann 1979A, p. 438.

For Mucius Scaevola, see 138. For the attribution to Domenego, cf. 179, and Pavone 1985, pl. XV(a).

The arms are those of the Bavarian families Hopfer and Ayrer (Lessmann 1979A, nos 681, 682; Rackham 1959, no. 451). The wedding in question has not been traced.

208 Flask

Perhaps workshop of Antonio Patanazzi, Urbino, *c.* 1575–1600

Flask, the coiled handles ending in masks; the cap has a screw fitting. Painted in orange, blue, yellow, brown, black, purple, white: on each side, a coroneted shield of arms, surrounded by banners, and with an angel as crest; grotesques on a whitened ground incorporating monkeys, monsters, half-human figures, rampant lions, and masks. Two slots cut into the foot. Restorations.
H (overall) 39 cm

MLA, The Waddesdon Bequest (1898), 64
Bibl. Molinier 1889, no. 553; Gavet Sale 1897, lot 396; Read 1902, no. 64; Van de Put 1905; Lessmann 1979A, p. 237; Tait 1981, p. 41, fig. 21.

The arms are those of Fernando Ruiz de Castro, 6th Count of Lemos (1548–1601), one of the greatest grandees of Spain. This 'pilgrim flask' and a salt (Lessmann 1979A, no. 254) are from a set similar to the '*ardet æternum*' set (206, 242). The red floriated cross behind the shield is the cross of the Order of Calatrava, of which he became a member in 1575.

Some of the most elaborate of all Renaissance maiolica was made for Spanish noblemen: other examples are the service designed *c.* 1560 by Taddeo Zuccaro for Guidobaldo II, Duke of Urbino, as a gift to King Philip II of Spain (Gere 1963), a set made for Inigo d'Avalos, Archbishop of Turin (Robinson 1862, no. 5263; Rackham 1940A, no. 845), one for Juan Fernando de Zuñiga (Ainaud de Lasarte 1952, fig. 759), and probably the 'Amadis' set (90).

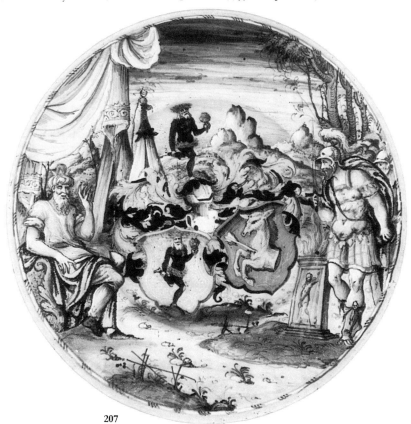

207

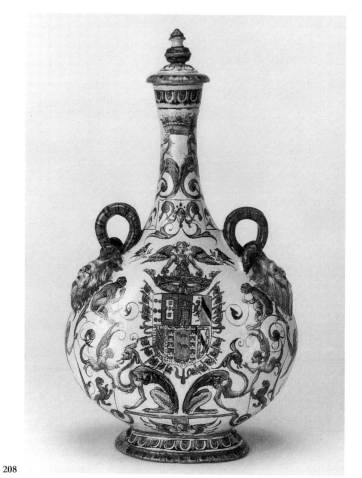

208

programme. John Gere has commented that the design of some of the plates is reminiscent of Battista Franco (cf. 195). At least twenty-one pieces from what may be a separate Hannibal series exist, numbered on the reverse up to at least 144.

Close in style to 88; cf. Lessmann 1979B, p. 342; Mallet 1987. The authenticity of a plate (D'Yvon Sale 1892, lot 59), apparently from the numbered Hannibal set, described as marked 'Orazio Fontana', is unconfirmed.

Unknown

209 Plate

Probably workshop of Guido Durantino, Urbino, *c.* 1540–60

Painted in blue, green, orange, yellow, grey, brown, black, purple, white: Hannibal's cavalry attacking the enemy as they cross the River Tagus; in the sky, a patch where a coat-of-arms was intended. Reverse: yellow rings and *Annibale sul Tago uenne, e uinse, E'l tristo seme de Banditi estinse.* (Hannibal reached the Tagus and conquered, and wiped out the miserable race of bandits). DIAM 32.5 cm

MLA 1878, 12–30, 445; Henderson Bequest *Bibl.* Sale, Paris, 12–15 Feb. 1855, lot 180; Henderson 1868, pl. VII.

The subject is the Carthaginian general Hannibal defeating a force of Spaniards (Livy, XXI, 5). The plate comes from a series (Norman 1976, p. 208) with scenes of the Punic Wars. Space was left for a coat-of-arms, but for some reason this was deleted, or never added. No source has been traced for the iconography or the neat couplets; the painter seems to have been following a special

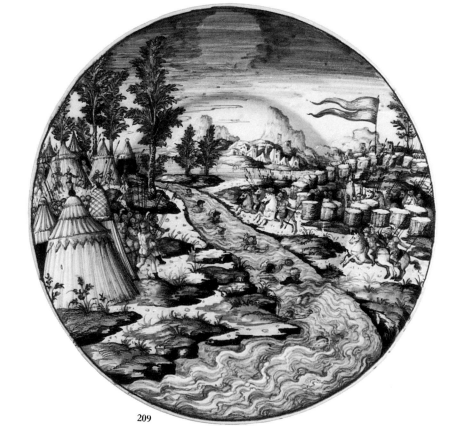

209

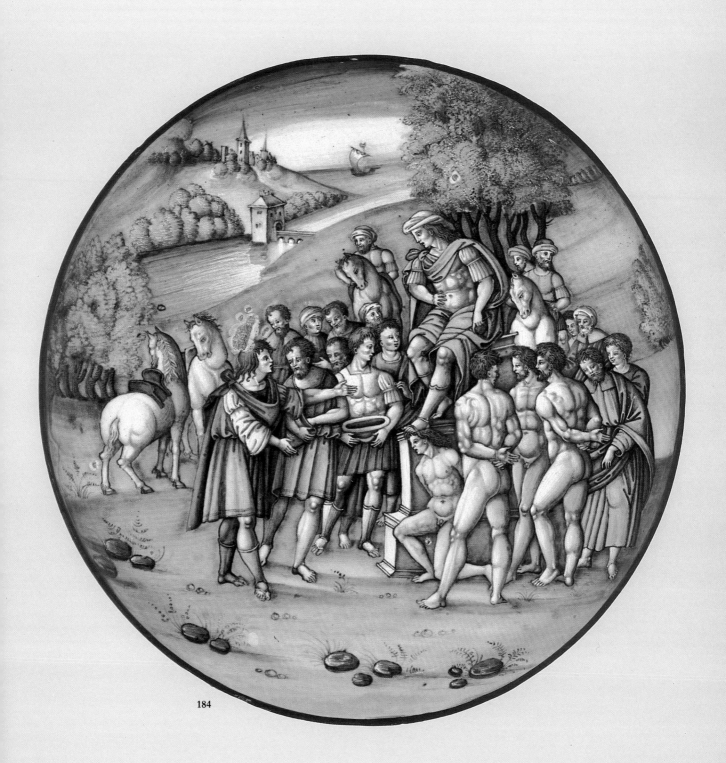

184

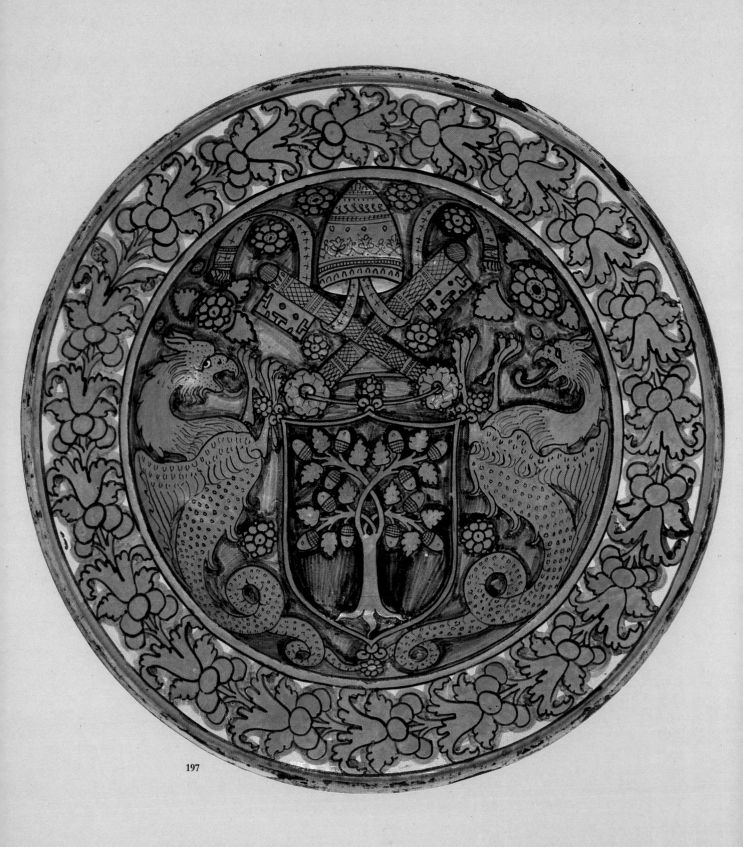

197

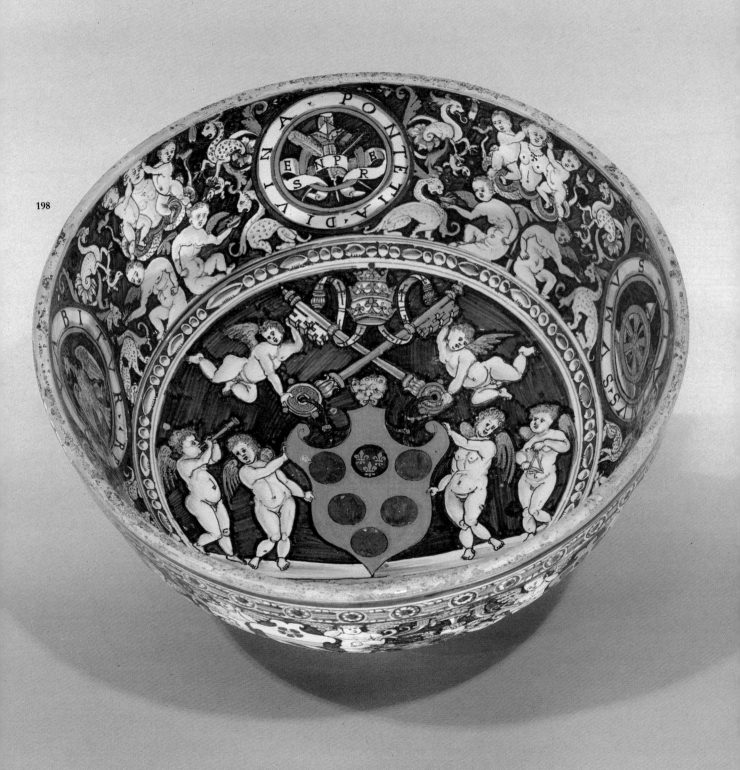

198

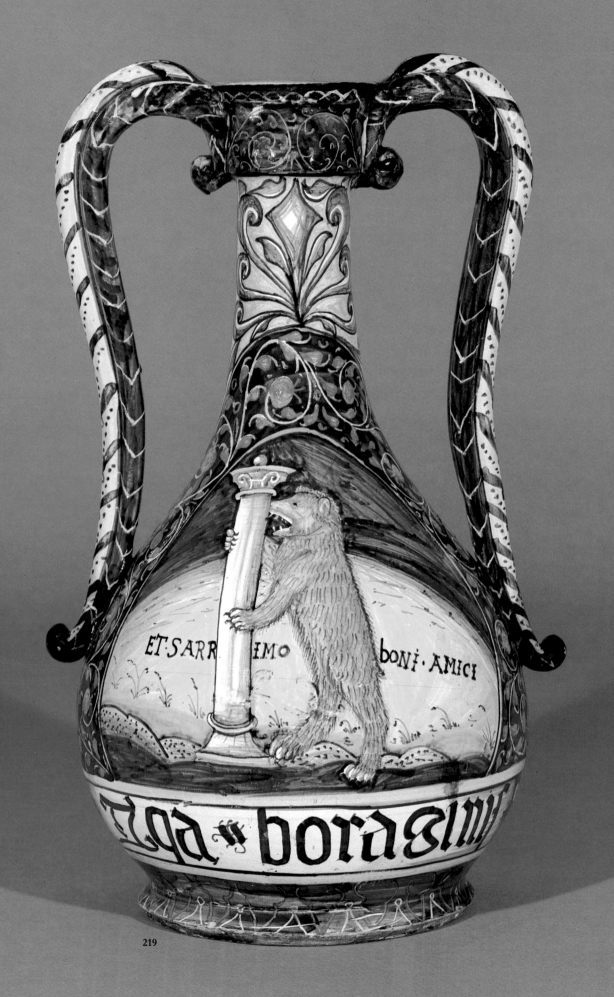

ET·SARR ... IMO boni·AMICI

219

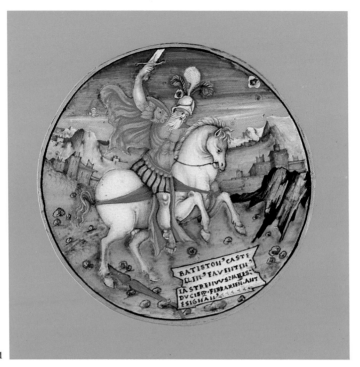

221

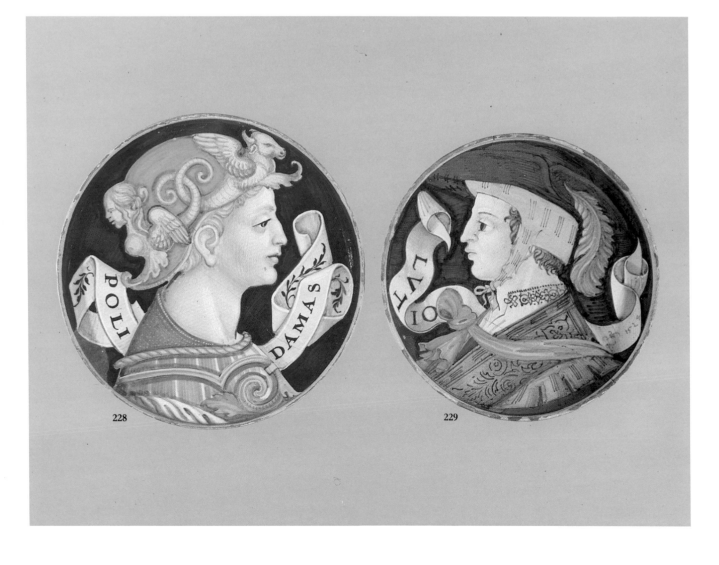

228

229

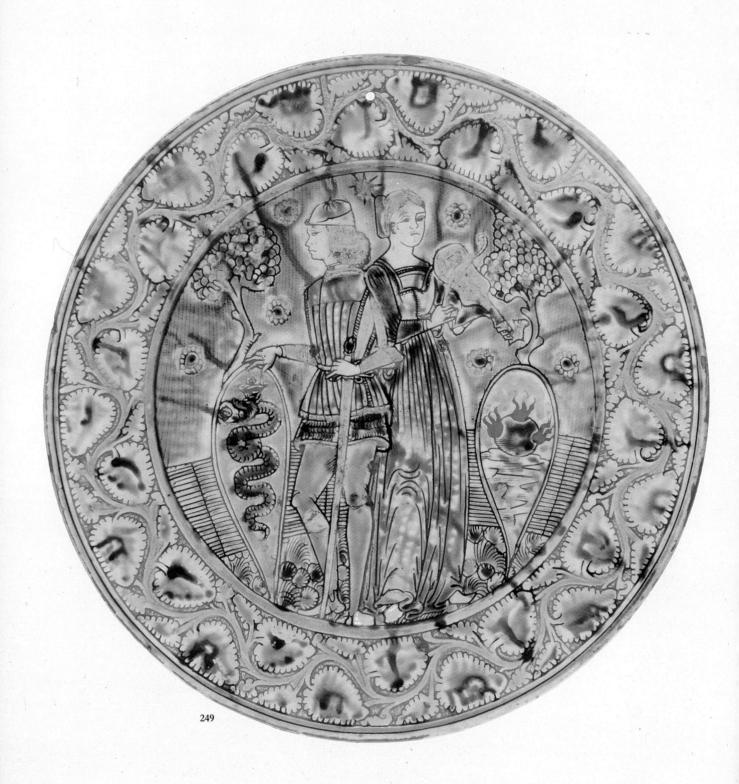

249

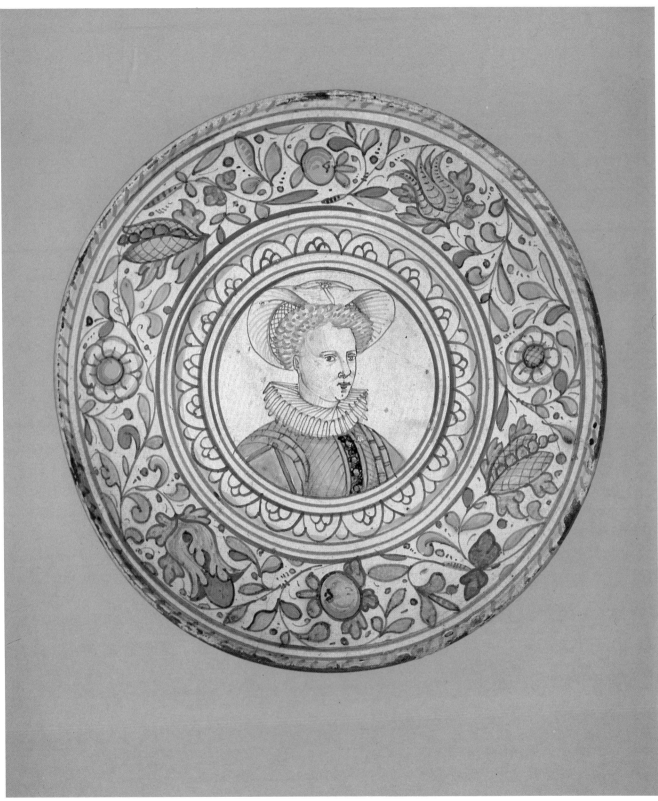

259

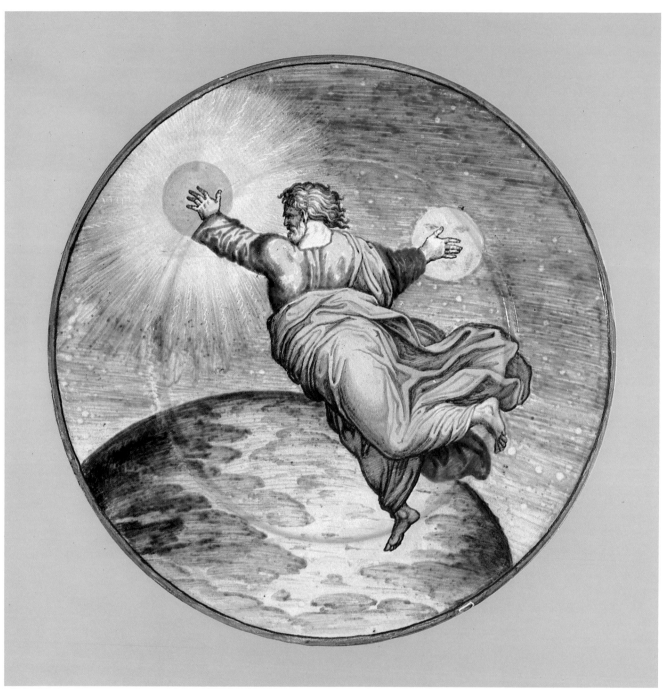

270

17 Stories from the classics

A renewed interest in the literature of the ancient world was central to Renaissance culture, and *istoriato* maiolica fully reflects this. The great majority of the stories depicted on maiolica are from the classics. However, maiolica painters were decidedly not at the cutting edge of humanist scholarship: their knowledge of classical literature and myth was mostly indirect, partial, and unreliable. Depictions of classical stories are often taken over directly from compositions by painters or engravers. When maiolica painters did make direct use of texts, the book they quarried most intensively was Ovid's *Metamorphoses*, which had been widely known all over medieval Europe; and the version they used time and time again was the Italian paraphrase made in the 1370s by Giovanni Bonsignore and printed, with convenient little woodcuts, in Venice in 1497. This edition included allegorical interpretations, but it was the picturesque possibilities of the *Metamorphoses*, not its supposed deeper meanings, that appealed to maiolica painters. Other favourite classical writers, like Virgil, Valerius Maximus, and Livy, were also accessible in Italian versions. 214, which tells a story from Suetonius, is based on a design by Giulio Romano, and the maiolica painter demonstrates by the inscription that his knowledge of the classics did not extend to knowing the difference between Augustus and Julius Caesar.

The earliest systematic treatments of classical subjects on maiolica were apparently a series of panels with subjects from the Trojan Wars, made in Urbino around 1530, involving Xanto and at least one other painter (see 215). Around 1536 Xanto painted a series of panels of the life of Cyrus; this was an unusual subject, but derived from a Latin author well known in the Middle Ages and available in Italian, Justin's summary of Trogus Pompeius. Xanto was uniquely well read for a maiolica painter (his citations include Ovid, Virgil, Valerius Maximus, Livy, and Trogus Pompeius, as well as Petrarch, Ariosto, and himself), but there is no reason to think he read easily any language other than Italian.

A few sets made in the Urbino district

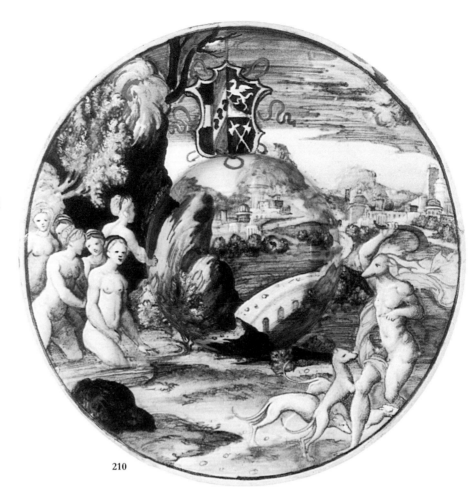

210

in the 1540s were made on elaborate historical or literary programmes worked out by scholars. However, the countless plates with 'favourite tales from Ovid' are more typical, and an accurate wider index of the way in which the unlearned were affected by the 'rebirth' of classical literature.

LITERATURE Tervarent 1950.

210 Broad-rimmed bowl

Urbino district, or possibly Venice, *c.* 1535–40

Painted in blue, yellow, green, purple, brown, black, orange, white: Diana and Actaeon; a shield of arms on a tree. Reverse: yellow rings and *Acteon conuersus in ceruú* (Actaeon changed into a stag).
DIAM 19.1 cm
MLA 1878, 12–30, 447; Henderson Bequest

Actaeon was out hunting when he accidentally saw Diana and her attendants bathing; whereupon Diana turned him into a stag and he was torn to pieces by his own hounds (Ovid, *Metamorphoses* 3). This was the most

popular of all classical stories with Renaissance maiolica painters (Castelli 1979).

The arms are for Nikolaus Rabenhaupt von Suche, Chancellor of Lower Austria (d. 1538), and his wife Genoveva Lamparter; other pieces from the set: see Pataky-Brestyánszky 1967, nos 33–6; Rasmussen 1984, p. 180; Watson 1986, p. 183.

211 Plate

Probably workshop of Guido Durantino, Urbino, *c.* 1540–60

Painted in blue, orange, green, yellow, purple, brown, black, white: Latona and the Lycians. Reverse: yellow rings and *La dea latona*: (the goddess Latona). DIAM 27.7 cm
MLA 1855, 12–1, 92
Bibl. Bernal Sale 1855, lot 1991.

Latona, mother of Apollo and Diana, came to a pond in Lycia. Some local peasants muddied the water to stop her drinking, and were punished by being turned into frogs (Ovid, *Metamorphoses* 6).

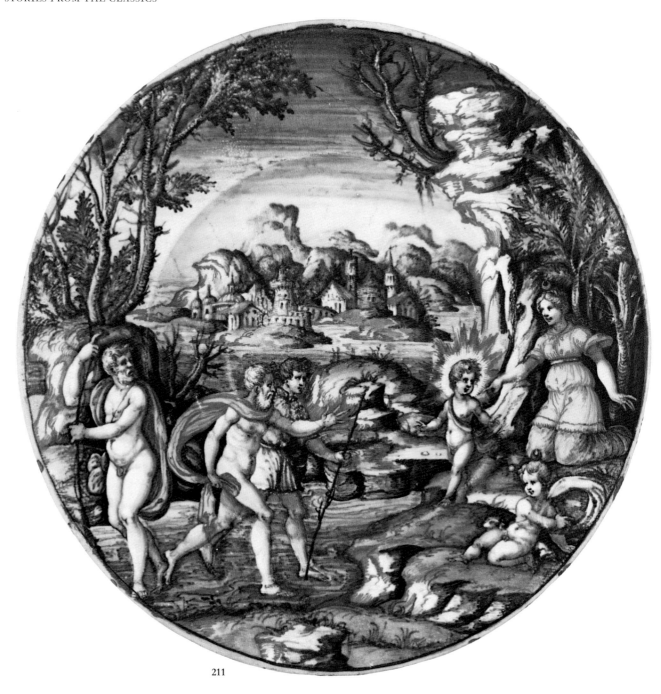

211

212 Plate

Probably Urbino district, *c.* 1540–50

Painted in blue, brown, green, orange, yellow, black, purple, white: Hercules killing Achelous in the form of a bull, watched by water-nymphs. Reverse: yellow rings and the arms of Lancierini.

DIAM 24.3 cm

MLA 1878, 12–30, 443; Henderson Bequest
Bibl. Henderson 1868, pl. v.

The river-god Achelous fought

Hercules over Deianira; Achelous lost, despite changing himself into a snake, then a bull (Ovid, *Metamorphoses* 9). The composition is from an engraving by Caraglio after Rosso (B XV, p. 86, no. 48).

From an armorial set (cf. Amayden 1910, II, p. 1) with mainly classical subjects; others: BM 1878, 12–30, 442; Giacomotti 1974, nos 873–9; Gillet 1956, no. 86; Rackham 1958, p. 151,

no. 9; Hausmann 1972, no. 212; Fortnum 1897, C445; Sotheby Parke-Bernet (NY), 3–4 Dec. 1982, lot 133; Padua, Museo Civico.

213 Broad-rimmed bowl

Probably workshop of Girolamo dalle Gabicce, Pesaro, 1545

Painted in blue, green, orange, yellow, purple, brown, black, white: a shepherd telling Orpheus of the death of Eurydice;

centre, the god Proteus. Reverse: yellow lines, and *crudel niuela ti porte. orfeo ch la tua nifa.e.belisima et difunta* (I bring you, Orpheus, the cruel news that your beautiful nymph is dead) *1545.* DIAM 22 CM

MLA 1878, 12–30, 441; Henderson Bequest

Bibl. Henderson 1868, pl. VII.

After his bride Eurydice was bitten by a snake and killed, the legendary musician Orpheus went down to the Underworld in an unsuccessful attempt to retrieve her. The subject and wording are from Poliziano's *Favola di Orfeo*, 1472, the earliest Italian pastoral drama of the Renaissance. The handwriting is the same as on 96, and the plate is probably by the same painter.

214 Plate

Probably Urbino district, *c.* 1540–70

Painted in blue, green, yellow, orange, brown, purple, black, white: a legend of the infancy of Octavian. Reverse: ÷ *La Natiuita De Julio Cesare* (the birth of Julius Caesar). DIAM 27.9 CM

MLA 1913, 12–20, 116; Barwell Bequest

Bibl. Fountaine Sale 1884, lot 22.

According to a legend told by Suetonius, the infant Octavian (later the Emperor Augustus), left in his cradle overnight, could not be found one morning; he was eventually found on a tower, facing the sun. The painter has copied an engraving after Giulio Romano's design for the 'Room of the Caesars' in the Ducal Palace in Mantua (B XV, p. 155, no. 174; Hartt 1958, I, pp. 170–2), but has mixed up Augustus with Julius Caesar.

215 Plaque

Urbino, attributed to Francesco Xanto Avelli, *c.* 1528–38

Painted in yellow, brown, orange, blue, green, purple, black, white: Sinon before Priam; they are captioned *SINON.G.* (Sinon the Greek) and *.PRIAMO..T.R.* (Priam, King of Troy). Along the bottom (damaged), [*Trad*]*itor Sinô da Pastor molti Uiê preso. e'l falso alfî cô parla...*[*in*]*ganna*, (the treacherous Sinon is captured by many shepherds and in the end the lying man deceives . . . with words). H 30.3 CM

MLA 1906, 12–10, 1; given by Sir H. H. Howorth

Bibl. Fountaine Sale 1884, lot 367; Mallet 1980, p. 156, note 20.

After a ten-year siege, the Greeks captured Troy by cunning: they pretended to sail away, but left a great

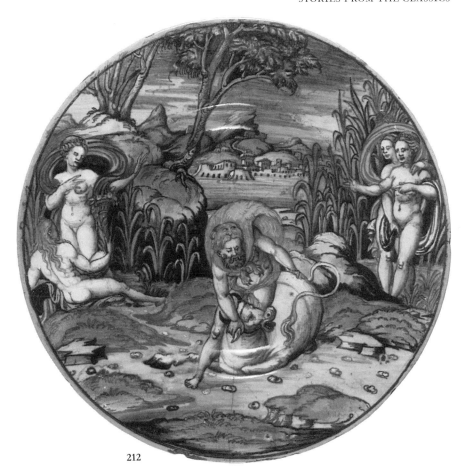

212

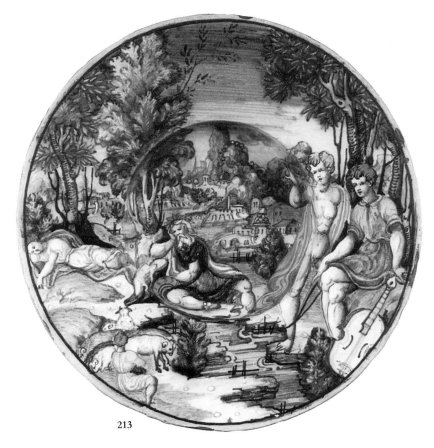

213

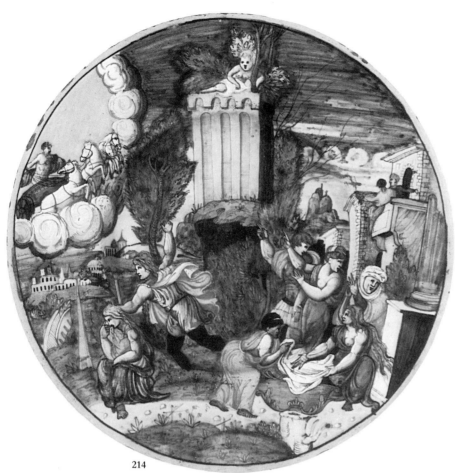

214

wooden horse behind, full of hidden soldiers. A Greek called Sinon tricked the Trojans into bringing the horse within the walls, after which the Greeks could sack the city. The story was widely known through Book 2 of Virgil's *Aeneid*.

Five plaques of the same dimensions in Brunswick, of about 1530, one of which is by Xanto (Lessmann 1979A, nos 134–7, 143), have Trojan War subjects; this plaque may be a little later.

216 Plate

By Francesco Xanto Avelli, Urbino, 1532

Painted in yellow, green, blue, brown, orange, black, white: Calanus on a pyre addressing Alexander: *IO TI VEDRÒ DI CORTO* (I shall see you soon); hanging from the ceiling a shield of arms. Reverse: *.1532. Calano î fuoco ad Alessandro disse: Nel cap: VI.dĨ.L.I.di Ualerio Mass: .frâ: Xanto .A. da Rouigo, î Urbino pî:* (Calanus' words in the fire to Alexander. In Book I, chapter 6, of Valerius Maximus. Francesco Xanto Avelli of Rovigo painted this in Urbino).
DIAM 27 cm

MLA 1913, 12–20, 120; Barwell Bequest
Bibl. Ballardini 1933–8, II, no. 39, figs 38, 263; Jestaz 1972–3, part I, p. 230.

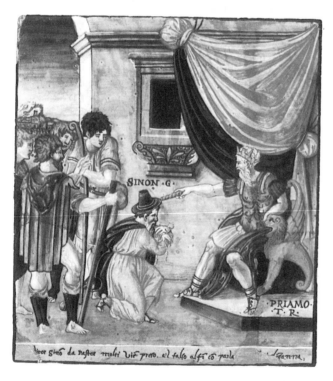

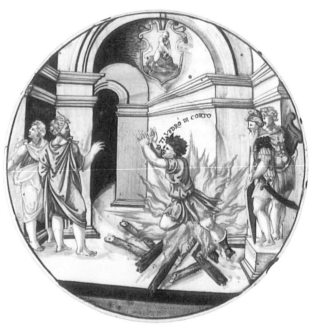

215, 216

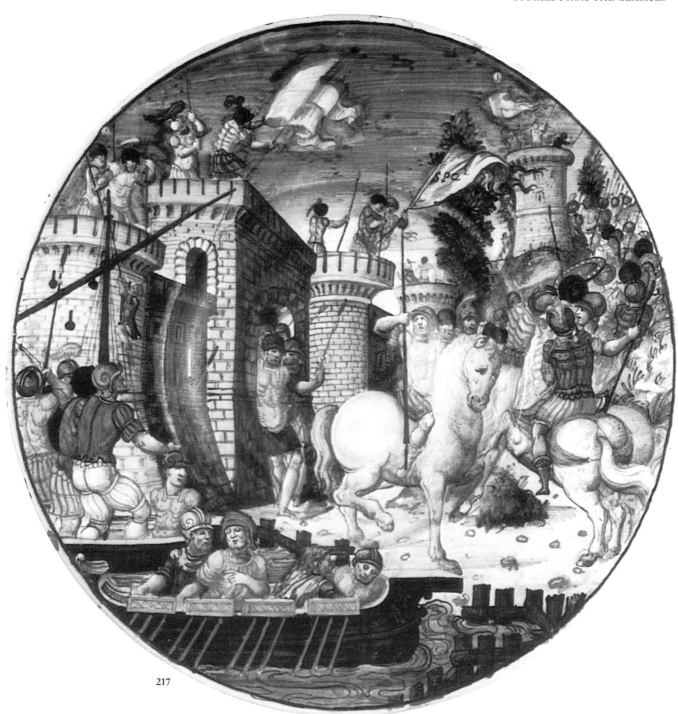

217

Xanto's source for the story of Calanus, an Indian sage who burnt himself to death prophesying the death of Alexander the Great, was an Italian translation of Valerius Maximus. The figures (cf. Kube 1976, no. 74) are from engravings (B XIV, p. 12, no. 10; B XIV, p. 264, no.352, see fig. xxiv).

From the same set as 73.

217 Plate

Attributed to Francesco Durantino, Urbino, c. 1540–5

Painted in blue, yellow, green, orange, brown, black, white: Scipio Africanus leading his legions out of New Carthage. Reverse: *Come Scipione lasato gaio lelio con li nauali conpagni a guardia dela citta : elui senretorno incanpo : ÷ uedi titoliuio alibro dechatertia sexto a capitulo L.* (How Scipio left Gaius Lelius with the marines to guard the city, and returned to camp. See Livy, Book VI of the third decade, chapter 50).

DIAM 28.6 cm

MLA 1852, 5–24, 1

Bibl. Sotheby's, 11 May 1852, lot 217.

The subject (Livy, XXVI, 48) is from the Punic Wars: the Roman general Scipio Africanus, having captured New Carthage, left a garrison in charge. The wording is from the 1493 Italian Livy; cf. 83.

18 Contemporary subject matter

Much of the *istoriato* maiolica of the Renaissance deals with the conventionally idealised worlds of classical mythology or history, or Biblical antiquity. The landscape and architecture in front of which the stories are staged reflect only indirectly the background of the Italy in which the painters lived. All the more interesting are the few examples where maiolica painters deal directly with identifiable political events, give us portraits of contemporary figures, or take their subjects from contemporary literature.

The one maiolica artist who seems to have had a consistent taste for representing contemporary and recent events was Francesco Xanto Avelli. Several surviving works by him represent the political crises of Italy in the 1520s and 1530s. Equally unusual was his portrayal of scenes from Ariosto's *Orlando Furioso* in 1531 and 1532.

218 Plate

Probably Venice, perhaps by an artist trained in Faenza, *c.* 1495

Painted in blue, yellow, orange, green, purple: the Doge of Venice superintending the loading of a ship with bags of money marked *march* (small silver coins), *troni* (silver coins of Doge Niccolò Tron), *docati ancôn:* (Ancona ducats), *docate vê* (Venetian ducats), *docate ugar* (Hungarian ducats), *docate, papal* (papal ducats), *venetia* (Venice). On a panel, the words *fate fate fate et non parole* (action,

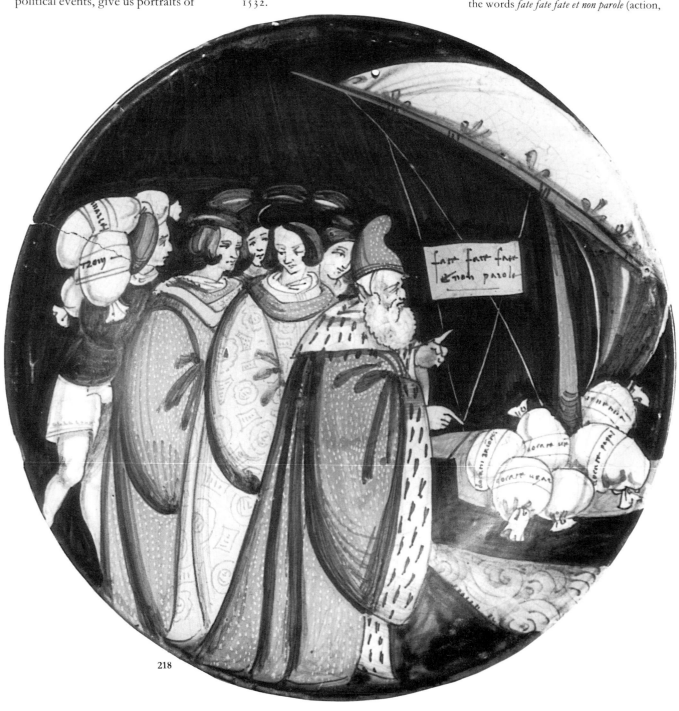

218

142

222, 220

action, action, not words). Reverse: blue and orange concentric lines, arches and dashes.
DIAM 28.1 cm
Fitzwilliam Museum, Cambridge C62–1927 (Leverton Harris Bequest)
Bibl. Harris 1922; Ballardini 1922; Borenius 1931, pp. 6–7, 15–16; pl. IX, Xb; Rackham 1940A, p. 84; Morazzoni 1955, pp. 55–7, pl. 8; G. Liverani 1958A, pl. 28; 1976, pp. 57–8; Alverà Bortolotto 1981, p. 54, pl. XXXB; Ravanelli Guidotti 1985A, p. 58; Wilson 1987, pp. 184–5, fig. 1.

In 1494–5 an army led by King Charles VIII of France invaded Italy. A 'Holy League', including Venice, Pope Alexander VI, the Duke of Milan, and the Holy Roman Emperor, was hurriedly formed to resist its further advance, and in April 1495 a fleet sailed from Venice for the relief of Naples. The plate shows Doge Agostino Barbarigo superintending the loading of one of these ships.

In style the plate resembles work attributed to Faenza (e.g. a jug dated 1499, Ravanelli Guidotti 1985A, no. 32), but the subject suggests it may have been painted in Venice. Rackham, Liverani and Ravanelli Guidotti attribute it to the painter known as the 'Caricature painter'; this seems doubtful.

219 Pharmacy bottle

Probably Castelli, after 1511

Painted in blue, yellow, orange, green: a bear (representing the Orsini) hugging a column (for the Colonna) with the words *ET. SARRIMO BONI. AMICI* (and we shall be good friends); on a scroll, *aqa.boraginis* (borage water). The front and sides have plant and geometric decoration; the reverse white with broad blue scrolls. H (max.) 45 cm
MLA 1852, 11–29, 2
Bibl. Fortnum 1873, p. 487; *Faenza* 24 (1936), p. 5, tav.1; Rackham 1940A, p. 78; G. Liverani 1958A, p. 24; Drey 1978, pl.18B; Fourest 1983, pl. 37; Pompeis *et al.* 1985, pl. 1; Fiocco & Gherardi 1985B, pl. 1; T. Wilson 1985A, p. 71, pl. XXI(C).

The bear hugging the column is an emblem of friendship between the two principal families in Rome, the Orsini and Colonna; the jar may commemorate a formal reconciliation in 1511 between the families, after centuries of feuding.

This jar belongs to a large series of jars of various shapes, but more or less similar in style, known as the 'Orsini–Colonna pharmacy jars' (e.g. Rackham 1940A, nos 250–7; Giacomotti 1974, nos 247–56). Recent finds of fragments of similar type at Castelli, and points of resemblance between the jars and some tiles from the nearby church of San Donato make it likely that most, if not all, of them were made at Castelli. Two examples are apparently signed by a man named Orazio, possibly Orazio Pompei, a leading maiolica painter at Castelli in the mid-sixteenth century; it may be that all the jars were made in the workshops of the Pompei family. Two jars of the type have the arms of Orsini and one has the motif of a bear; it seems likely that they were made for the Orsini, who were until 1525 in feudal control of Castelli. The large number of these jars that survive and the stylistic variations between them indicate that they were made over a period of time and probably for more than a single pharmacy.
Illustrated in colour

220 Plate

Painted by Francesco Xanto Avelli, Urbino, 1534; probably lustred in the workshop of Maestro Giorgio, Gubbio

Painted in blue, yellow, green, brown, orange, purple, black, white; red and gold lustre: right, a woman standing on a ball and leaning on a crooked stick; centre right, a soldier on horseback jumping a wall; left, a figure in armour moves to aid another who has fallen and dropped a sceptre. Reverse: lustre floral scrolls and, in blue, *.1534. Cadette il Re Cristiâ sotto Pauia* (the Christian King fell beneath Pavia). *F.X.* Broken and repaired. DIAM 28.1 cm

143

MLA 1855, 3–13, 11; given by A. W. Franks
Bibl. Fortnum 1873, p. 347; Ballardini 1933–8, II, no. 153, figs 144, 321.

The scene is an allegory of the Battle of Pavia in February 1525, at which Francis I, King of France (with the title 'most Christian King'), was defeated by troops fighting for the Holy Roman Emperor and taken prisoner, whereupon the French lost control of the Duchy of Milan. The fallen figure with the sceptre represents Francis I, and the figure standing on a ball presumably Fortune, but the exact point of the allegory is unclear.

The figures are reworked from Marcantonio engravings: B XIV, p. 89, no. 104 (fig. xxiii, p. 126); B XIV, pp. 170–1, nos 209–10 (fig. xx, p. 122), and B XIV, p. 186, no. 231, the fallen figure being based on a copulating woman in one of the *Modi*; cf. Lawner 1984, p. 65.

221 Plaque

By Baldassare Manara, Faenza, 1536

Painted in blue, green, orange, yellow, brown, white: a horseman brandishing his sword; a broken spear on the ground. On a tablet, *BATISTON' CASTELLIN' FAVENTIN' IÃ STRENVVS : MILES : DUCISQ. FERRARIEN. ANTESIGNAN'* (Battistone Castellini of Faenza, now [?] a brave soldier and champion to the Duke of Ferrara). Reverse: *Mile Cinque Cente tenta sei adi tri de luje. Baldesara manara faentine fa CieBat* (1536 on the third of July, Baldassare Manara of Faenza made this). DIAM 21.5 cm

MLA 1855, 3–13, 10; given by A. W. Franks
Bibl. Frati 1852, pp. 7–8, 16, no. 77; Fortnum 1873, pp. 483, 496; Malagola 1880, pp. 234, 238, 487; G. Liverani 1940, pp. 78–82.

According to Malagola, this roundel formed part of a tomb once in the monastery of San Domenico in Faenza, and had beneath it a plaque (now at Sèvres, Liverani 1940, pl. xxb) with Latin verses in posthumous praise of his military prowess, and the date 1542 or 1543. Little is known of Battistone Castellini; it seems likely that Romoaldo Maria Magnani (*Vita de' santi . . . di Faenza*, 1741, p. 315) was wrong in supposing him to be the same man as the Capuchin friar Fra Battista da Faenza (cf. F. Liverani & Bosi 1974, pp. 70–2). The plaque may have been one of a series.
Illustrated in colour

222 Plate

By Francesco Xanto Avelli, Urbino, 1532

Painted in brown, green, yellow, orange, blue, purple, black, white: Astolfo on horseback, blowing his magic horn; on the cornice, a shield of arms, Pucci with an *ombrellino*. Reverse: in blue, *.1532. Nel Regno femineo col corno Astolfo Nel.XVIII. câto del furioso d̄. M.L. Ariosto. ÷ frâ Xâto. A. da Rouigo, î Urbino.* (Astolfo in the kingdom of women with his horn. In canto 18 of the *Furioso* of Messer L. Ariosto. Francesco Xanto Avelli of Rovigo in Urbino). DIAM 26.1 cm

MLA 1913, 12–20, 121; Barwell Bequest
Bibl. Rattier Sale 1859, lot 7; Ballardini 1933–8, II, no. 53, figs 50, 252R; Ballardini Napolitani 1940, p. 919.

The subject is from the greatest poem of the Renaissance, the fantasy-epic *Orlando Furioso*, by Lodovico Ariosto. Astolfo, the English duke, and his companions are trapped in the land of women: any man who comes there has to fight ten men, and make love to ten women in one night, or be put to death. Astolfo puts everyone to flight by blowing a blast on his magic horn, and enables his companions to escape. The episode is in canto 18 of the first version of the poem, published in 1516, but canto 20 of the definitive 1532 edition.

Other plates by Xanto with subjects from Ariosto are in the V & A (Rackham 1940A, no. 724) and Fitzwilliam (also Pucci service; ex-Berney Sale 1946, lot 22), both dated 1532; another, dated 1531, is in the Los Angeles County Museum. For the Pucci set, see 74.

The figures are assembled from five Marcantonio-workshop engravings: B XIV, p. 183, no. 226; p. 345, no. 464; p. 104, no. 117; Astolfo (cf. 76) and the fallen figure from the *Modi* (Lawner 1984, pp. 79, 69).

19 *Belle donne*

Drawing women was always a a favourite activity of Italian pottery painters, and female profiles are a common decorative motif all through the Renaissance. Rarely, if ever, however, do the 'portraits' on Renaissance pottery give the impression of showing the features of actual people, drawn from life.

A particular Renaissance phenomenon is the so-called *coppe amatorie* ('love dishes'). Typically they have a picture of a woman with her name and the word *bella* (beautiful), sometimes varied to *diva* (divine), *unica* (unique), or *graziosa* (charming). These dishes are generally presumed to have been gifts from men to their girlfriends. On the other hand, the frequency of classicising names like Hippolyta or Minerva suggests that they may sometimes be literary allusions, rather than the names of actual girls. Elizabethan sonnets addressed to 'Sylvia' or 'Stella' are a comparable genre.

Some 'portrait' dishes, particularly those portraying men, do not seem to refer even in this allusive way to living people. 228 is one of a number of dishes painted with men or women in theatrical armour, which may have been part of sets of 'famous men and women'. Why such relatively obscure figures as the Trojan Polydamas should have been chosen is problematic. A few representations of men in contemporary costume, with less historicising names, also exist. It is open to doubt, however, whether dishes like the 'Lutio' (229) were gifts to young men from lovers of either sex.

223 Cup

Southern Umbria or northern Lazio, *c.* 1380–1450

Painted in manganese and green: a woman in profile. Severely warped. One of the two handles and part of rim missing. DIAM 12 cm

MLA 1910, 2–14, 29; bought from D. Fuschini; purportedly dug up in Orvieto

224 Storage jar

North/Central Italy, *c.* 1460–90

Painted in blue, purple, yellow, green: on one side, a woman in profile in a contour panel with 'Gothic' foliage; on the other, in a contour panel, a heart pierced by a scroll with an obscure amorous inscription;

223

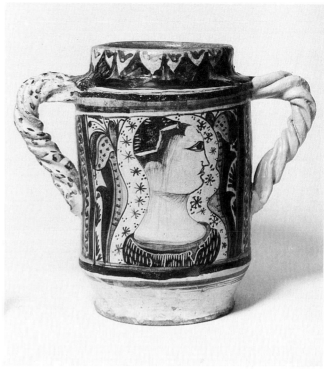

224

around the rim, pointed leaves. Twisted handles; beneath them, characters, on one side resembling AMIIIILXX, on the other MIIIILI with the last two symbols crossed by a ladder. Interior lead-glazed. Battered; one handle restored. H 29.3 cm

MLA 1904, 7–6, 1; bought from H. Wallis
Bibl. Wallis 1904, figs 1, 2.

It seems optimistic to interpret the characters down the sides as dates (1470?). Cf. Giacomotti 1974, nos 87–8.

225 Plate

Faenza, *c.* 1520–5

Painted in orange, blue, yellow, purple: a woman in profile; concentric bands of decoration. Reverse: blue and purple rings.
DIAM 24·1 cm

MLA 1878, 12–30, 427; Henderson Bequest

A similar piece once in Berlin (Ballardini 1933–8, 1, no. 130) was dated 1523.

226 Dish

Deruta, *c.* 1500–30

Painted in blue; yellowish-brown lustre: a woman; on a scroll NEM? SVA. SORTE. CHONTENTVS. (no-one is happy with his own destiny); on the rim, foliage and flowers. Reverse lead-glazed; two suspension holes in foot-ring. DIAM 41.5 cm

MLA 1878, 12–30, 376; Henderson Bequest
Bibl. Henderson 1868, pl. V.

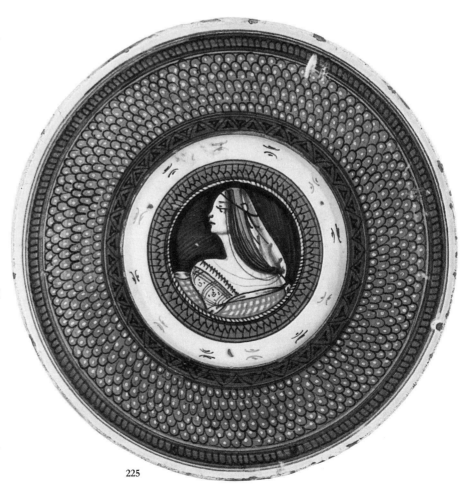

225

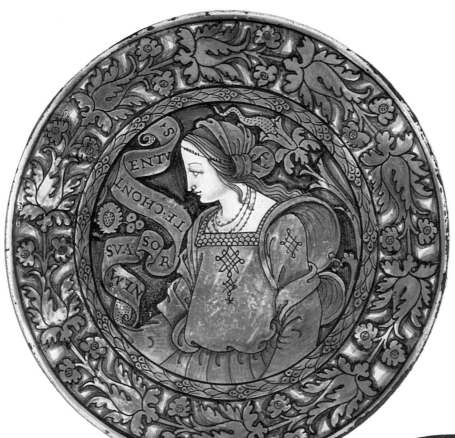

226

MLA 1878, 12–30, 423; Henderson Bequest *Bibl.* Henderson 1868, pl. VI.

The dish resembles a distinguished group of dishes with various figures from literature or history. These have been attributed to Nicola da Urbino (Falke 1917, pp. 14–15; Hausmann 1972, no. 175), but Rasmussen in his forthcoming Lehman Collection catalogue suggests they are by the painter of the 'Zouâmaria' bowl (see 119). The series reflects the Renaissance taste for 'portrait' sequences of famous men and women (Hausmann 1972, p. 240). 'Polydamas' is presumably the minor Homeric hero of the name (*Iliad* 18). The helmet is in a tradition of pageant-armour of which the most famous example is Leonardo's drawing in the British Museum (cf. Passavant 1969, figs 50–5; Hind 1938–48, II, pl. 53).

Illustrated in colour

Numerous such standardised female profiles were produced in Deruta; cf. 142, 154.

227 Dish

Perhaps Umbria or the Marches, 1524

Painted in blue, green, yellow, orange, brown: a profile of a woman; on a scroll, DIVA LUCIA BELA (divine and beautiful Lucia); on the rim, panels of scrolling foliate ornament including (twice) *1524*. Reverse, two wreaths *alla porcellana*; suspension holes in foot-ring. Restorations. DIAM 42.2 cm

MLA 1878, 12–30, 970; Henderson Bequest *Bibl.* Frati 1852, no. 124 (probably this piece); Sale catalogue, Paris, 30 April–4 May 1857, lot 20; Henderson 1868, pl. VI; Dennistoun 1909, III, p. 408; Ballardini 1933–8, I, no. 136, fig. 134.

228 Dish on low foot

Urbino or Castel Durante, *c.* 1510–30

Painted in blue, green, orange, yellow, brown, white: a man wearing a fantastic helmet; on a scroll, POLIDAMAS. Reverse: yellow rings. DIAM 23.3 cm

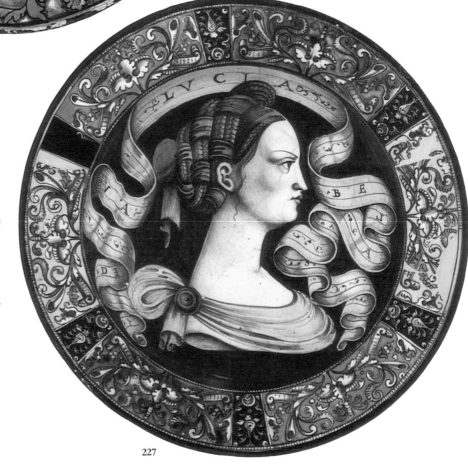

227

229 Dish on low foot

Urbino or Castel Durante, 1524

Painted in blue, grey, orange, brown, green, yellow, white: a young man wearing a broad-brimmed hat; on a scroll, *LVTIO 1524*. Broken and repaired; chipped. DIAM 21.3 cm

MLA AF 3318; Franks Bequest, 1897

Bibl. Ballardini 1933–8, I, no. 137, fig. 135; Rackham 1940A, p. 186; Polidori 1953, pl. XXIX.
Illustrated in colour

230 Plate

Made and painted in Gubbio, or possibly Urbino district, 1530; lustred in the workshop of Maestro Giorgio, Gubbio, 1531

Painted in blue, brown, white; golden and red lustre: a woman in profile; on a scroll, IPOLITA DIVA (Divine Hippolyta); on the rim, grotesques incorporating monsters, a winged head, a mask, cornucopias, oak tendrils, and a tablet with *1530* in blue, overpainted *1531* in lustre. Reverse: in lustre, simple scrolls and *1531 M?G?* DIAM 23.6 cm

MLA 1851, 12–1, 20; formerly Abbé Hamilton collection

Bibl. Ballardini 1933–8, I, no. 255, figs 217, 360; Join-Dieterle 1984, p. 146.

For the problems of attributing this kind of piece, see chapter 13.

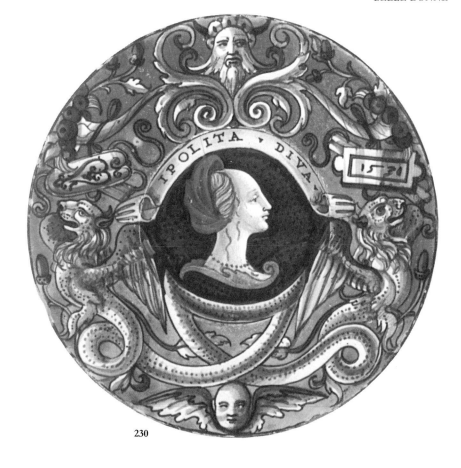

230

231 Dish on low foot

Made and painted in Gubbio, or possibly Urbino district; lustred in the workshop of Maestro Giorgio, Gubbio, 1530

Painted in blue, orange, green, yellow, black, white; golden and red lustre: a woman wearing an elaborate head-dress; on a scroll, *AVRA BELLA*. Reverse: in lustre, floral scrolls and *1530.M?G? da Ugubio.*
DIAM 22.2 cm

MLA 1851, 12–1, 19; formerly Abbé Hamilton collection

Bibl. Ballardini 1933–8, I, no. 240, figs 215, 353; Hausmann 1972, p. 244.

232 Dish on low foot

Probably Urbino district, *c.* 1530–40

Painted in blue, yellow, orange, brown, white: a woman in profile; on a scroll *MINERVA unicha* (unique Minerva).
DIAM 22.5 cm

MLA 1878, 12–30, 422; Henderson Bequest
Bibl. Henderson 1868, pl. VI.

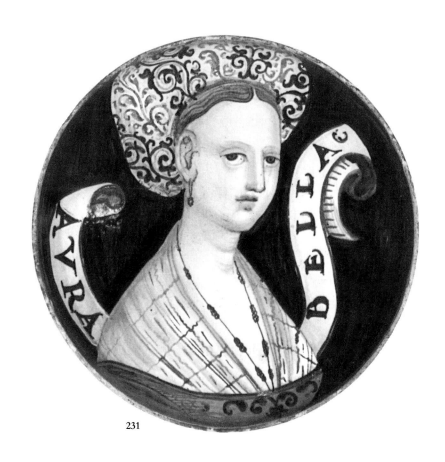

231

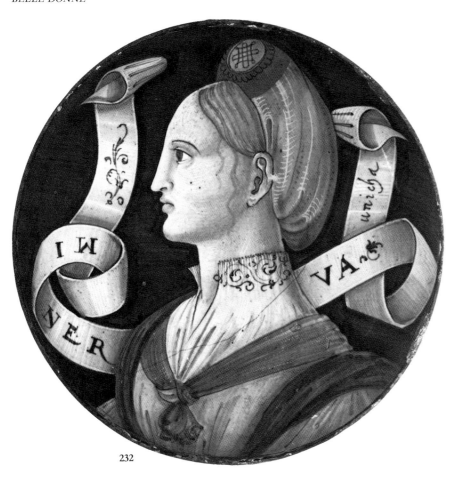

232

233 Spindle-whorls

16th century

Four spindle-whorls, inscribed DVRSIANA .
BELA., APPOLONIA B, CHASANDRA. B, and
SOR EUSTOCHIA.
DIAM 1.5 cm; 2.3 cm; 1.7 cm; 1.5 cm
MLA 1885, 5–8, 93, 94, 96, 98; given by
A. W. Franks
Bibl. Lane 1958, p. 83.

Spindle-whorls were used for weighting
thread during spinning; the smaller ones
might also have been worn as beads.
Examples with girls' names and B[ELLA]

are common, and were no doubt given
by men to their girlfriends, a cheaper
alternative to 'portrait' dishes. The
names on them are generally less high-
flown than those on dishes. Cf.
Rasmussen 1984, p. 106; one in the
V & A is dated 1564; one in the BM
(Middeldorf 1980, no. 354) is Medici
porcelain. Not all were love gifts: 'Suor
Eustochia' was clearly a nun. Examples
have been found in several pottery-
producing towns in Italy and local
attribution is hopeless.

20 'Faenza white'

By 1550 the artistic initiative in Italian
maiolica might have seemed to have
passed away from Faenza. The work of
mid-century Faenza *istoriato* makers like
Francesco Mezzarisa and Gianbattista
Dalle Palle looks positively provincial
compared to the grand Urbino products
of the period. Faenza, however, with its
numerous workshops, never ceased to
be one of the most sophisticated of
pottery towns, and soon produced a
radically new development, a more
'industrial' and less labour-intensive
type of maiolica which could be
produced in volume while reaching the
upper end of the market.

'Faenza white' was based on the high
quality of Faenza tin glazes. Its
characteristic was the so-called
compendiario manner of painting: a thick
white glaze, instead of being carefully
decorated, was partially painted in a
rapid sketchy style in a palette
dominated by blue and orange. Many
pieces were elaborately modelled or
pierced. A style more different from the
horror vacui of Urbino *istoriato* is hard to
imagine.

'Faenza white', which seems to have
been first made in the 1540s, was a
triumphant success, and rapidly came to
dominate the town's production. Two
Faenza potters played leading roles in
developing it – Francesco Mezzarisa and
Virgiliotto Calamelli, both of whom ran
large businesses. After Calamelli's death
his workshop was taken over by
Leonardo Bettisi, known as 'Don Pino',
who was responsible for some of the
largest maiolica services ever made: an
inventory of one made for Francesco de'
Medici in 1568 listed 307 pieces; and
over 120 pieces have survived of one
made in 1576 for the Duke of Bavaria
(235, 236). 'Faenza white' was widely
exported through Europe.

The impact of white maiolica as
tableware was expressed by Montaigne,
who encountered it on a journey
through Tuscany in 1581: 'Considering
the fineness of this earthenware which is
so white and clean it seems like
porcelain, I found it so cheap that it
seems to me really pleasanter for the
table than the pewter of France –
particularly what one finds in inns,
which is squalid'.

In Italy 'Faenza white' was widely
copied, notably in Tuscany, the Marches
and Turin, but Faenza's domination of

233

the market was never seriously challenged. Faenza potters in due course took their skills abroad, and *compendiario* pottery came to be made in France, the Netherlands, Germany, Switzerland and Central Europe.

With this development pottery in Europe came increasingly to replace metal and wood for use at table. 'Faenza white' is a fountainhead of the European tradition of 'faience', the fine tin-glazed tableware that was characteristic of European tables for two hundred years; only about 1800 was it finally ousted by Wedgwood and other industrial wares from Staffordshire. The English word 'faience' is the French form of 'Faenza' and its continued currency in most European languages is a telling testimony of the unprecedented success of 'Faenza white'.

LITERATURE Ballardini 1916, 1929, 1932; Giacomotti 1956; G. Liverani 1958B; Hausmann 1972, p. 178.

234 Pierced dish on high foot

Workshop of Virgiliotto Calamelli, Faenza, *c.* 1550–70

Painted in blue, orange, yellow: a *putto* holding a branch. Beneath the foot, in blue, ·V̄Ã· . DIAM 23.5 cm

MLA 1923, 6–11, 15
Bibl. Rosenheim Sale, Sotheby's, 3–4 May 1923, lot 277.

The mark ('Virgilio Faenza'?) is that of Virgiliotto Calamelli, who is documented in Faenza from 1531 and died *c.* 1570 (Ballardini 1916, 1918). The colossal scale of his business is indicated by an inventory of the contents of his workshop in 1556 (Grigioni 1934, pp. 143–51) listing several thousand pieces, including over a thousand of 'white work'. Versions of the mark occur frequently on fragments excavated at Faenza. Cf. 104.

234

235 Broad-rimmed bowl

Workshop of Leonardo Bettisi, Faenza, *c.* 1576

Painted in blue, yellow, orange, brown: Caesar being rowed across a river. At the bottom, *solitariamente Cesare pasa' il fium' chentra nel mare, tra Gaeta e' tara . . .* (Caesar crosses the river which enters the sea between Gaeta and . . . [?]); in the sky, the arms of the Wittelsbach Dukes of Bavaria. Reverse: in orange, *.DO.PI.* DIAM 24.7 cm
Henry Reitlinger Bequest, Maidenhead

The scene is apparently an episode from the civil war between Caesar and Pompey (cf. Appian, *Civil Wars,* II, 9), when Caesar tried to cross the Adriatic in a small boat; but the place-names have not been found in any accounts of this story.

Part of a large set, of which over 120 pieces survive (mainly still in Munich), made for Albrecht V, Duke of Bavaria; they include wine-coolers, flasks, salts, candlesticks, and dishes of various shapes and sizes; the subjects are from classical mythology, Roman history and the Bible. One piece is dated 1576. See Hager 1939; Zauli Naldi 1942; Biavati 1979; Rasmussen 1984, pp. 254–5; Join-Dieterle 1984, p. 136; Semenzato (Milan) Sale, 5 Nov. 1986, lot 36.

235, 236

237

The Faenza potter Leonardo di Ascanio Bettisi is recorded in documents from 1566 and was dead by 1589; the reason for his nickname 'Don Pino' is unknown. He was associated with Virgiliotto Calamelli before his death, and leased the Calamelli workshop from Virgiliotto's widow in 1570.

236 Broad-rimmed bowl

Workshop of Leonardo Bettisi, Faenza, c. 1576

Painted in blue, yellow, orange, brown: two troops of cavalry about to join battle; at the bottom, *caualeria di pôpeo. simoue côtra cesare* (Pompey's cavalry advances against Caesar); arms as 235. Reverse: in orange, .D̄O. P̄I. DIAM 25.2 cm

Henry Reitlinger Bequest, Maidenhead

The scene is apparently the beginning of the battle at Pharsalus between Caesar and Pompey in 48 BC (cf. Appian, *Civil Wars*, II, 11).

237 Dish

Faenza, c. 1540–80

Painted in blue, yellow, orange, brown, green, red: Diana turning Actaeon into a stag. DIAM 44·8 cm

Henry Reitlinger Bequest, Maidenhead

For Diana and Actaeon, see 210.

The use of red is exceptional, but Piccolpasso noted that he had 'seen it in the workshop of Virgiliotto in Faenza, as lovely as cinnabar, but unreliable'.

238 Collecting box

Probably Tuscany, 1565

Rectangular box, in two compartments. Painted in blue, yellow, orange, green, red: round the sides, angel-*putti* holding the Instruments of the Passion with AVE MARIA MATER DEI (Hail Mary, Mother of God); on the top, heraldic mounts surmounted by plants, roundels with the arms of Medici, and a roundel with *S*. Round the top, .ADI..14..DICÊBRE. 1565..FECIT. (made on 14 December 1565). Damaged. H (max.) 14.5 cm
MLA 1891, 3–17, 2; given by H. S. Pfungst; said to be from a church in Siena

A rather crude version of the *compendiario* style. The circular opening was probably intended for votive candles; the other side would have had a lockable door for the money of the faithful. The flowering mount may be the arms of the Sciarelli family of Siena (cf. C. Brandi *et al. Palazzo Pubblico di Siena*, Siena 1983, p. 409, no. 59). The Medici controlled Siena from 1555.

239 Jar

Workshop of Fortunato Filigelli, Asciano, 1600

Spouted jar; dimpled body; elaborate handle with animal heads. Painted in blue, yellow, green, reddish brown, purple: beneath the spout, the arms of Palmieri of Siena; reverse: .F.P. *Asciani die XII Maij 1600.* (FP, Asciano, 12 May 1600). Damaged. H (max.) 38 cm
MLA 1888, 7–2, 2; given by J. C. Robinson
Bibl. Fortnum 1896, p. 139; Guasti 1902, p. 341; Rackham 1933, p. 42; Cora 1961, p. 112.

F.P. stands for Fortunato Filigelli (Fortunatus Philigellus), a member of a family which ran a pottery at Asciano, south-east of Siena. Other marked works are dated 1578 and 1592 (Zauli Naldi 1958, pl. 3(c), 3(d); Bojani *et al.* 1985, no. 690).

238

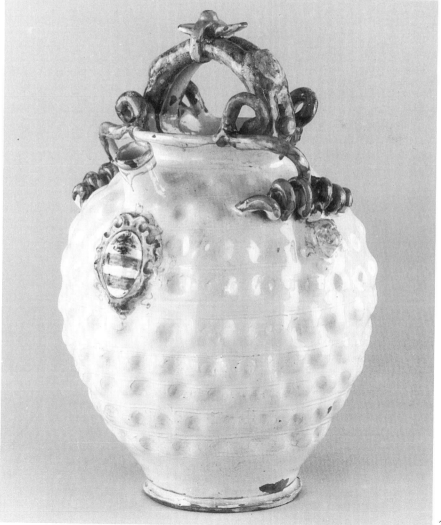

239

21 'Grotesque' painting of the late Renaissance

From the 1540s onwards grotesque-painting on a white ground came increasingly to oust other forms of decoration on the grander Urbino maiolica. The great repertoire of white-ground grotesques was the decoration in the Vatican Loggias carried out *c.* 1519 under Raphael's direction, largely by Giovanni da Udine. Vasari's indignant description echoes the Roman writer Vitruvius: 'Grotesques are a type of extremely licentious and absurd painting done by the ancients . . . without any logic, so that a weight is attached to a thin thread which could not support it, a horse is given legs made of leaves, a man has crane's legs, with countless other impossible absurdities; and the bizarrer the painter's imagination, the higher he was rated'.

White-ground grotesques on maiolica seem to have been an Urbino-region speciality which spread in more or less debased forms to other parts of Italy; from about 1550 the Urbino workshops produced some of the most ambitious maiolica of the Renaissance, including modelled pieces ostentatiously reflecting the shapes of contemporary silver.

Two family workshops in Urbino appear to have dominated production of this kind of maiolica. Up to at least 1575 some of the finest Urbino products, both *istoriato* and grotesque, were made by the Fontana family (Guido Durantino and his descendants). From 1580 several pieces, in a fairly consistent style, bear the names of various members of the Patanazzi family – Antonio, Alfonso, Francesco, and finally Vincenzo. The Patanazzi appear to have been the main producers of this sort of pottery in Urbino from the 1580s; but in the period around 1570–85 it is difficult to differentiate Fontana and Patanazzi products, and the relationship between the two workshops requires further research; e.g. 241.

240 Dish

Urbino district, *c.* 1560–5

Painted in blue, green, yellow, orange, brown, grey, black, white: Achilles putting on his armour, with other Greek soldiers. On the border, symmetrical grotesques on a whitened ground, with winged *putti* and satyrs. Reverse: yellow rings and *Achille*

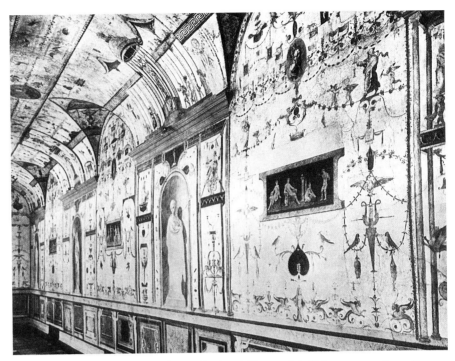

Above: **Fig. xxxi.** Grotesques, by Raphael and Giovanni da Udine, *c.* 1519. *Loggetta*, The Vatican.

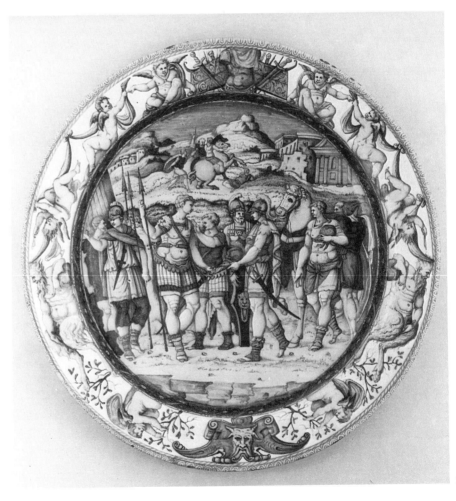

240

241

Sarma (Achilles arms himself).
DIAM 43.3 cm
MLA 1855, 12–1, 79
Bibl. Bernal Sale 1855, lot 1936; Clifford and
Mallet 1976, cat. 11, fig. 64.

The scene is from Book 19 of Homer's
Iliad: Achilles, the strongest soldier in
the Greek army, was offended by
Agamemnon and sulked. Only when his
friend Patroclus was killed did he put on
his armour and return to battle, to kill
the Trojan champion Hector. The dish
is based on a drawing by Battista Franco
(cf. 195); the symmetrical grotesques are
characteristic of maiolica from Franco's
designs. The designs were used and
reused in the Urbino region: cf. a nearly
identical dish, Clemente Sale 1931, lot

429; and a bowl with the same scene,
Conti 1971, no. 40.
 A spurious inscription stating that the
dish was made by Giorgio Vasari for
Ottaviano de' Medici in Urbino in 1530
has been added to the back.

241 Trilobed dish

Probably Urbino, *c.* 1570–80

Moulded on the underside with three pairs of
swans in scrolling panels. Painted on the
front in blue, orange, yellow, brown, green,
purple, grey, black, white: scenes from the
story of Joseph (Genesis 44–6), surrounded
by grotesques on a whitened ground
incorporating monsters, birds, dolphins,
human and part-human figures, and
architectural structures. Broken and
repaired. W (max.) 46.5 cm

MLA 1889, 9–2, 28; given by A. W. Franks;
formerly in Cockayne Hatley church,
Bedfordshire
Bibl. T. Wilson 1985B, p. 908.

Apparently from a series with Joseph
stories. The scenes are from the *Quadrins
Historiques* (see p. 113–14).
 This is linked by style and
iconography to pieces attributed to the
'Fontana workshop' (Dahlbäck
Lutteman 1981, no. 27; Bellini & Conti
1964, p. 152; Conti 1971, no. 21; cf.
Spallanzani 1979), but is apparently
from the same swan-mould as
Giacomotti 1974, no. 1081, from the
'*ardet æternum*' set, which is attributed to
the Patanazzi workshop; cf. Molinier
1892, nos 53, 54.

242 Flask

Probably workshop of Antonio Patanazzi, Urbino, 1579 or later

Flask, the coiled handles ending in masks; the cap has a screw fitting. Painted in orange, yellow, blue, green, purple, brown, white: grotesques on a whitened ground incorporating monkeys, semi-human figures, monsters, dolphins, ox-skulls; on each side, a medallion with an old man before a fire, representing winter, and Bacchus, representing autumn; above each medallion is a piece of burning 'asbestos' and ARDET ÆTERNVM (it burns for ever). Two slots cut into the foot. H (overall) 40 cm

MLA The Waddesdon Bequest (1898), 64
Bibl. Gowen Sale, Christie's, 23 Feb. 1857, lot 85; Molinier 1889, no. 552; Gavet Sale 1897, lot 392; Read 1902, no. 64; Van de Put 1905; Tait 1981, p. 40, fig. 20.

From the same set as 206; a companion flask probably represented spring and summer. Some pieces of the '*ardet æternum*' set resemble works marked by Antonio Patanazzi (G. Liverani 1967B; Lessmann 1979A, p. 234); but a large service like this could have involved several workshops, and more than one painter seems to have worked on the set.

Bottles of this form, usually called 'pilgrim flasks', were made in the Renaissance in precious metal, glass, pottery, and porcelain. The earliest dated maiolica example is from 1530 (Hausmann 1972, pp. 289–90). Making screw-stoppers was a virtuoso piece of potting which Piccolpasso describes at length.

243 Wine-cooler

Workshop of Francesco Patanazzi, Urbino, 1608

Painted in blue, brown, orange, yellow, green, black, white: in the centre, God discovering that Adam and Eve have eaten the forbidden fruit (Genesis 3), flanked by two winged female figures out of a scrollwork frame. The rest of the interior and the exterior decorated on a whitened ground with grotesques incorporating huntsmen, birds, monsters, and romping human and part-human figures. On a cartouche, *VRBINI EX FIGLINA FRANCISCI PATANATII* (Urbino, from the pottery of Francesco Patanazzi) *1608*. Three handles modelled as masks. Foot broken away. w (max.) 48 cm

MLA 1985, 10–1, 1
Bibl. Marryat 1857, p. 55; Fortnum 1873, p. 353; Fountaine Sale 1884, lot 391 (ill.); Chompret 1949, no. 1069; Parke-Bernet, New York, 25 Oct. 1968, lot 99; Sotheby's,

242

29 March 1971, lot 58; Lessmann 1979A, p. 234; Christie's, 1 July 1985, lot 272.

Works bearing the names of members of the Patanazzi family and dates between 1580 and 1620 are among the most imposing examples of grotesque-painted maiolica (Fortnum 1896, pp. 220–1; Lessmann 1979A, p. 234). This is the only piece bearing the name of Francesco; however, an account in the archives of the Santa Casa at Loreto (Grimaldi & Bernini 1979, p. 20) records a payment in 1585 for 'several jars decorated with grotesques to M.ro Franc.º Patanazo'; so Francesco may have been running the family workshop as early as 1585. Cf. Scatassa 1904, p. 27; further research in the Urbino archives

should produce further information on this important family.

The central scene is based on an engraving by Etienne Delaune (Robert-Dumesnil, IX, 28; cf. Rasmussen 1984, p. 209; Ravanelli Guidotti 1985A, pp. 191–2).

244 Eight tiles

Probably Siena, c. 1600–20

Painted in blue, green, yellow, brown, orange, black: grotesques incorporating birds, animals and part-human figures; one bears the arms of Bandini of Siena. Square: approx. 10.6 × 10.6 cm; hexagonal: approx. 18.5 cm long

MLA 1885, 5–8, 83–90; given by A. W. Franks

243

These and similar tiles in the V&A
(Rackham 1940A, no. 955) may have
come from the Palazzo Marsili, Siena
(Traldi 1985, p. 305).

245 Bowl

Urbino, workshop of Giacinto(?)
Grassi, 1654.

Painted in yellow, blue, green, purple,
brown: a man, woman, and child in a rugged
landscape; grotesques and roundels with
female figures, perhaps Diana, Venus, Flora
and another; grotesques on exterior. Two
damaged serpent handles. On the base:
Puertas [. . .] *54* .*F.G.* DIAM 45 cm

MLA Sloane Misc. 1689; Sloane collection,
1753; formerly Sterbini collection

Bibl. Fortnum 1873, p. 373; Norman 1976,
p. 24; Ravanelli Guidotti 1985A, p. 228;
T. Wilson 1985A, p. 69, pl. XX.

A similarly painted piece (Ravanelli
Guidotti 1985A, no. 186) has the words
. . . ACITO GRASSI IN URBIN, the initials
GF, and 1654. Both are late and
incoherent examples of the Urbino
grotesque style.

The iconography is obscure but the
theme may be the 'Golden Age'. *Puertas*
may mean *povertas*, 'poverty', or be
constructed from the Latin *puer* to mean
'childhood'. The left-hand roundel
echoes Agostino Veneziano's engraving
of the *Death of Cleopatra* (B XIV, p. 161,
no. 198); but it is difficult to see how
Cleopatra fits in.

The register of the Sloane collection
describes this as 'a cistern of
earthenware painted in Italy w^t sev^ll
figures by Puenas 1554'. The original
date, doubtless 1654, must have already
been fraudulently altered.

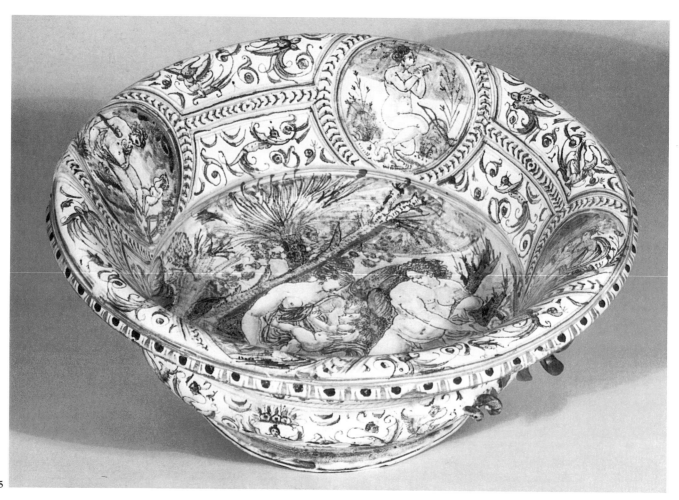

244

245

22 Renaissance porcelain

For medieval Europe the high-fired, translucent porcelain of China was something almost miraculous. The few pieces that reached Europe before 1450 were treasured and sometimes thought to have magical properties. The Venetian traveller Marco Polo, during his long stay in China at the court of Kublai Khan, which came to an end in 1292, saw this wonderful material being made. The term he used to describe it, *porcellana*, seems to have been the Italian word for a type of white shell, as close in texture to Chinese porcelain as anything known to medieval Europeans. It became the standard word all over Europe.

In the fifteenth century considerable quantities of blue-and-white Chinese porcelain were reaching the Islamic world, and both they and Islamic imitations increasingly found their way into the courts of Europe. The great entrepôt of trade between Europe and Islam was Venice, and it seems to have been in Venice that the first European attempts to imitate Chinese porcelains were made. There are references in 1504, 1518, and 1519, to the production in Venice of 'imitation porcelain', perhaps a form of the white glass called *lattimo*.

More fully documented is a later attempt to make porcelain under the auspices of Alfonso II, Duke of Ferrara. From about 1561 Alfonso had working for him two brothers, Camillo and Battista Gatti of Urbino. Camillo was killed in 1567 after a cannon he was examining accidentally exploded, but not before he had succeeded in producing what was considered a form of porcelain. The Florentine ambassador to Ferrara, writing to report the accident, describes Camillo as the 'modern discoverer of porcelain'. No surviving piece has ever been demonstrated to be an example of Ferrara porcelain.

In the 1568 edition of his *Lives,* Vasari wrote that a pupil of his, Bernardo Buontalenti, was working for Francesco de' Medici in Florence and would shortly be able to produce perfect porcelain. In 1574 Francesco succeeded his father as Grand Duke of Tuscany and the following year the Venetian ambassador to Florence recorded that 'Grand Duke Francesco has found the way of making "Indian" porcelain and in his experiments has equalled its

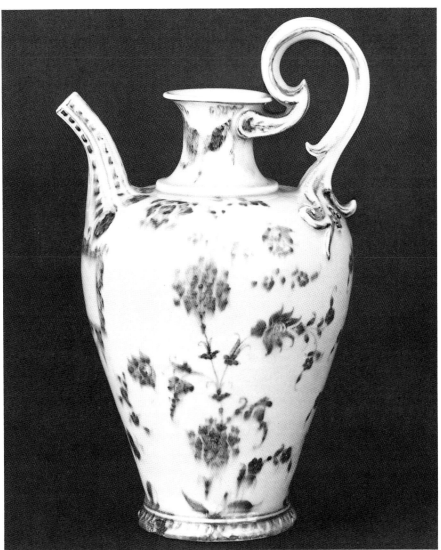

247

quality – its transparency, hardness, lightness and delicacy; it has taken him ten years to discover the secret, but a Levantine showed him the way to success'.

From these experiments the Medici workshops produced what is generally considered the first identifiable European porcelain. 'Porcelain' is not a precisely defined term, and Medici porcelain, which is usually classified as a 'soft-paste' porcelain, is a material very different from the 'hard paste' made in China. Recent analyses of Medici porcelain bodies and glazes suggest that its formula owed something to Near Eastern methods and something to the technology of Italian maiolica. This fits neatly with the evidence that a 'Levantine' helped find the formula, and the involvement in the project of maiolica experts like Flaminio Fontana, who is known to have spent time in

Florence between 1573 and 1578, and supervised porcelain firings.

The prime model for Medici porcelain was the Chinese porcelain imported into Florence. Pieces like 247 have Chinese porcelain as their inspiration, though the decorative details are from the maiolica tradition. Others seem to be original in shape and decoration, and some of the more inventive shapes may have been designed by men like Buontalenti, involved in the production of goldsmiths' work and carved hardstones in the court workshops.

The formula of Medici porcelain was a difficult one, and the high firing temperatures strained Italian ceramic technology to the limit. The project was expensive and needed generous support. After Francesco's death in 1587 production tailed off, and though there is evidence of continued production as

246

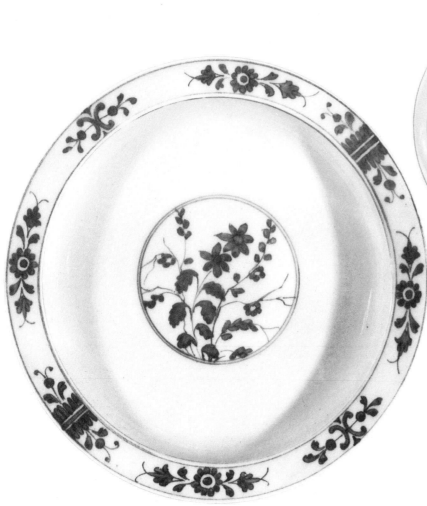

late as 1620, no surviving piece can be dated later than 1587.

Porcelain-making projects are one aspect of the spirit of exploration and experiment characteristic of Renaissance courts, which prepared the way for the development of modern science. In the history of ceramics, however, they are an isolated episode. In seventeenth-century Italian ceramics *chinoiserie* became rampant, but on blue-and-white maiolica rather than in renewed attempts at porcelain. The next major European attempts to make porcelain, in France in the 1670s, were quite unrelated to the Medici project.

LITERATURE Davillier 1882; Guasti 1902, pp. 383–432; G. Liverani 1936A, 1936B, 1959; Middeldorf 1938, 1980; Mottola Molfino 1976; Lessmann 1976; Spallanzani 1978B; Kingery & Vandiver 1984; Cora & Fanfani 1986.

246 Plate

Medici workshop, Florence 1575–87

Porcelain, painted in underglaze blue: floral designs. On the reverse, variants of a Chinese cloud motif, rosettes, and a mark representing the dome of Florence Cathedral, with .*F*. DIAM 24.8 cm
MLA 1889, 10–3, 1; given by
C. D. E. Fortnum
Bibl. Fortnum 1873, p. lxix; 1897, C201; Davillier 1882, p. 96, no. 9; Ricci 1918, no. 8; G. Liverani 1936A, pl. x(b); 1936B, no. 36; Morazzoni 1960, I, pl. 3(c); Tait 1962, pl. III; Middeldorf 1980, no. 351; Cora & Fanfani 1986, pp. 8–9.

The shape and decoration owe much to Chinese porcelain (cf. Krahl *et al.* 1986, nos 832, 883, 884, 1084). The mark is a notably inaccurate representation of Brunelleschi's dome.

247 Ewer

Medici workshop, Florence *c.* 1575–87
Ewer with high scrolling handle. Porcelain, painted in underglaze blue: floral sprays; beneath the spout a blank panel. The blue has run in firing. Unmarked.
H (max.) 25.5 cm
MLA 1887, 5–16, 2; given by
C. D. E. Fortnum; said to have come from the family of the master pharmacist of a Grand-Duke of Tuscany
Bibl. Davillier 1882, pp. 66–7, 97–8, no. 11; Fortnum 1897, C299; Ricci 1918, no. 10; G. Liverani 1936A, pl. VI(c); 1936B, no. 25; Biavati 1956, pl. XXV(d); Morazzoni 1960, I, pl. 3(a); Tait 1962, pl. III; Cora & Fanfani 1986, pp. 60.

The glaze is thicker and glossier than 247 and has cracked. Neither the shape nor design seems to be derived from Chinese porcelain, or from maiolica. Cf. Mottola Molfino 1976, pl. XLII, almost identical in shape but painted with polychrome grotesques.
Illustrated on previous page

248 Flask

Probably Medici workshop, Florence
c. 1575–80

Porcelain, painted in blue, black, brown, orange, yellow, green, white: a continuous scene on a black ground of naked men fighting; around the bottom, *trompe l'oeil* gadroons; around the neck, on a bright-blue ground, vases flanked by winged part-human figures, which terminate in scrolling foliage, making music. Inside the rim, a crown motif

in reddish brown. On either side are two applied spouts. The foot, and part of the spouts, have been cut away, and replaced (before 1848) with silver-gilt foot, rim and handles, engraved in Renaissance style, making the flask appear a vase. H (foot to rim) 19 cm

MLA 1889, 7–10, 1; given by R. N. Philips

Bibl. Gray Sale, Christie's, 21 May 1839, lot 104; Stowe Sale 1848, lot 483; Marryat 1850, p. 23, fig. 10; Robinson 1862, no. 5265a; Fortnum 1873, p. 341; Rackham 1940A, p. 289; Norman 1976, p. 205; Lessmann 1976, pp. 284–7; 1980, pp. 165–73, pl. XXXIII; G. Liverani, *Faenza* 62 (1976), p. 153; Middeldorf 1980, p. 184; T. Wilson 1985A, p. 70, pl. XXI(b); Cora & Fanfani 1986, pp. 19, 61; Mallet 1987.

The figures are extracted from an engraving by B. Beham (B VIII, p. 90, no. 16).

The original form of this object, with two pouring-spouts, can be seen from a flask in Brunswick painted with a continuous landscape; the two pieces may well be by the same painter. There are approximate parallels to the shape in blue-and-white Medici porcelain and it has been argued (Lessmann 1976, 1980) that both flasks are Medici porcelain. On stylistic grounds it would seem likely that both were painted by an Urbino-trained maiolica painter; this would fit in with the fact that Flaminio Fontana (see 92) was working in the Medici workshops *c.* 1573–8. On the other hand, the decoration is entirely different from that of any marked Medici porcelain, so much so that the piece has sometimes been thought of post-Renaissance date. There is a slight possibility that the BM and Brunswick flasks are products of another experimental porcelain project of the Renaissance; the men who succeeded in making porcelain at Ferrara in the 1560s were also from Urbino, so the Urbino affinities of the decoration are not a definite pointer to Florence; cf. Mallet 1987. However, recent scientific analysis has shown the composition and microstructure of the body and glaze to be indistinguishable from that of undisputed examples of Medici porcelain.

The 'vase' was much admired in the nineteenth century, when it was assumed to be tin-glazed earthenware. An annotated edition of the catalogue of the Stowe Sale in 1848 commented: 'This vase has long been considered a perfect *chef d'oeuvre* of Raffaelle ware. It is indeed a wonderful specimen of design and colour – the figures being pencilled with great delicacy of touch, and vigour of action; while in purity of outline it may fairly compete with the antique . . . One cannot fail to regret that a work so rare and beautiful was not bought for the British Museum.' Forty-one years later the son of the purchaser presented it to the Museum.

248. Illustrated with the later metal handles removed to show the remains of the two pouring-spouts.

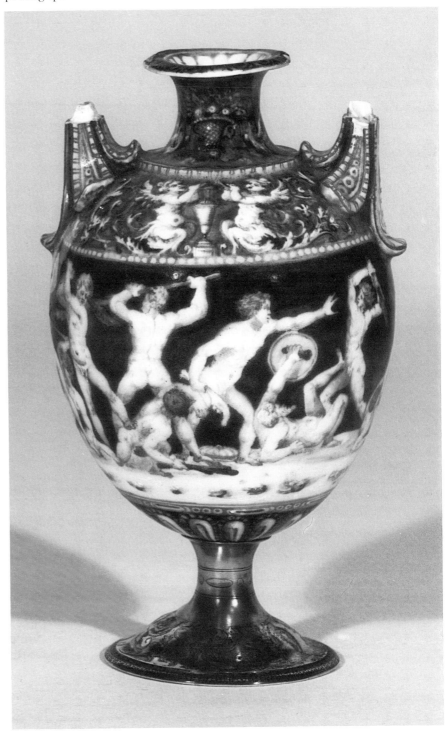

23 Incised slipwares

Through a great tract of northern Italy in the Renaissance the main form of pottery produced was not tin-glaze, but incised slipware. This technique, of distant Chinese origin, came to be widely diffused in the Byzantine and Islamic world and had been introduced into most parts of northern Italy before 1300. Reddish-bodied earthenware was coated with a pale-coloured liquid slip and decorated by scratching away part of the slip to reveal the darker body beneath; it was then covered with a transparent glaze. The design was often, in Italy, heightened with colours, which tended to run into the glaze so that the washy effect of the colour contrasted with the sharply incised decoration. Piccolpasso describes the technique (though it was not much used in his native Castel Durante) and says 'this form of decoration is called *sgraffio*'. From this the Victorian scholar J. C. Robinson coined the word *sgraffiato*, but there seems no need to use a pseudo-Italian term and the technique has here been described simply as 'incised slipware'.

Incised slipwares, mostly of fairly modest proportions, were made in countless places in northern Italy from the fourteenth century and are often difficult to 'place' or date accurately. South of a line running roughly from Pisa and Florence to Faenza, it was made less commonly. From about 1450 larger and more ambitiously decorative pieces began to be made in north-east Italy, competing with maiolica for the luxury market. There is much uncertainty about what was made where, but it seems that the most ambitious slipwares in the Renaissance were made in or near Venice, Padua, Florence, Ferrara, and Bologna. Even the finest, however, were seldom as up-market, nor as self-consciously 'artistic', as the best maiolica, and seem to have been for the most part for relatively local use. The decorators were fairly slow to adopt 'Renaissance' motifs in the antique manner, and seldom drew on prints after fashionable artists. Signed or dated pieces are also extremely rare. On the other hand, incised slipware sometimes has an almost caricature-like directness of drawing, which is just as vivid an expression of the culture of fifteenth-and sixteenth-century Italy as maiolica.

LITERATURE Archaeological work in northern Italy has generated a large number of local studies; only a few are listed here: Moschetti 1931; Baroni 1934; Conton 1940; Ferrari 1960; Siviero 1965, 1981; Reggi 1971, 1972, 1984; Mannoni 1975; Nepoti 1975, 1978; Lazzarini & Canal 1983; Blake 1986; Gelichi 1986; Ericani 1986.

249 Dish

Probably Ferrara, *c.* 1480–1510

Reddish earthenware, slip-coated; incised design, heightened with green, brown, yellow, purple-grey; transparent glaze: a young man and woman standing back to back; he holds a sword and a shield, *or, a crowned serpent azure devouring a child*; she holds a *lira da braccio* and has a shield with an exploding bombshell; behind them, a wattle fence, trees and rosettes on a dotted ground; on the rim, a foliate tendril. Reverse slip-coated and partially glazed. DIAM 40 cm

MLA 1855, 12–1, 70

Bibl. Bernal Sale 1855, lot 1894; Fortnum 1873, p. 69; Wallis 1905A, fig. 17; Ferrari 1960, pp. 90–2, fig. 139; Norman 1976, p. 54; Magnani 1981–2, II, pp. 132–5, pl. LXXVI.

This type of decoration was widely diffused through the district around the River Po, as far north as Padua. Major centres of production were Bologna and Ferrara, and the production of the two cities is difficult to distinguish. Recent writers have attributed many of the most ambitious pieces to Ferrara; this attribution is supported by the occurrence on some examples of devices used by the d'Este Dukes of Ferrara (Rasmussen 1984, no. 25; Beckerath Sale 1913, no. 162a; Magnani 1981–2, II, col. pl. LIX, all with a ring *impresa* used by Duke Ercole I).

The reference of the shields has not been resolved. The man holds a shield with the *biscione*, used in the arms of the Visconti and Sforza Dukes of Milan (cf. Magnani 1981–2, II, fig. 104, a fragment found at Ferrara; Litta *et al.* 1819–1923, for the use of the *biscione* by the Torelli family of Ferrara). The woman's shield contains a flaming bomb; this *impresa* was adopted by Alfonso I d'Este by *c.* 1502 (Hill 1930, no. 232), but no earlier use of it by the Estes has been traced. The hypothesis that the plate commemorates the marriage in 1491 of Alfonso and Anna Sforza, or that of Lodovico Sforza and Beatrice d'Este in the same year, remains unproved.

Illustrated in colour

250 Storage jar with crimped edges

Po plain or Veneto, *c.* 1490–1530

Reddish earthenware, exterior slip-coated; incised design, heightened with brown and green; transparent glaze. Foliate ornament, enclosing four roundels containing: a woman in profile, on a scroll, *sc. guta* (?); a dog; a man in profile with *ama* (?); a lion rampant. Interior lead-glazed. H 17.4 cm

MLA 1883, 10–19, 21; given by A. W. Franks

251 Container

Probably Venice, 1525

Cylindrical container on four stubby feet; animal-head spouts. Reddish earthenware, slip-coated; incised design, heightened with brown, greyish blue, green. Foliate tendrils round the body; ribbon-work at the ends. Underside: OLEUM (oil), *1525*, and AZETO (vinegar); on the ends VIN BIAN (white wine) and VIN NERO (black, i.e. red, wine). One of the animal heads restored, perhaps incorrectly. L 18 cm

MLA 1855, 12–1, 86

Bibl. Bernal Sale 1855, lot 1963; Fortnum 1873, p. 70; Rackham 1940A, p. 446; T. Wilson 1985A, p. 79, pl. XXX; 1987, pp. 184, 187, pl. XI.

A fragment of a similar container was fished out of the Venice lagoon (Alverà Bortolotto 1981, pls XIII, XIV). The form also occurs in Hispano-Moresque pottery (e.g. Ainaud de Lasarte 1952, figs 223, 251). The alternative uses indicated by the inscriptions are curious.

252 Dish

Northern Italy, perhaps Venice, 16th century

Reddish earthenware, slip-coated; incised design, heightened with blue-grey, brown, green, yellow; transparent glaze. Apparently Marcus Curtius about to leap with his horse into the chasm; on the rim, leaf pattern and (probably) C H V R C I O R (Curtio Romano). Reverse partially covered with slip and transparent glaze. Scratched beneath the unglazed foot is a shield of arms, perhaps *a pile, overall a bend sinister*, and AF crossed. Restorations. DIAM 47 cm

MLA 1889, 4–13, 1

Bibl. Hastings Sale, Christie's 20–1 March 1888, lot 146.

Marcus Curtius was a celebrated model of Roman self-sacrifice. When one day a chasm opened up in the Forum in Rome, the soothsayers said it would only close when the Roman people's most valuable possession was thrown in. Curtius, a young Roman noble,

believing Rome had nothing more precious than its valiant men, threw himself into the chasm (Valerius Maximus, v, vi, 2).

253 Dish

Tuscany, *c.* 1537–50

Reddish earthenware, slip-coated; incised design, heightened with blue-grey, brown, green; transparent glaze. The arms of Medici, crowned; concentric bands of decoration; on the rim, tiéd foliage with dolphins; top and bottom roundels with a leafy branch. Reverse partially glazed. Warped in firing. Broken; repaired with rivets. DIAM 42 cm

MLA 1894, 3–12, I

Bibl. T. Wilson 1984, pp. 437–8, pl. CILb.

The branch is an *impresa* used by Cosimo I, Duke of Florence, later Grand-Duke of Tuscany. According to the sixteenth-century writer on *imprese*, Paolo Giovio, it is the golden bough from Virgil's *Aeneid*; when a branch is torn away, a new one grows in its place, a supposed analogy with the Medici family. Giovio states that the *impresa* was used by Cosimo in the early years of his reign, which began in 1537 (Giovio 1978, pp. 72–3).

254 Bowl

Tuscany, *c.* 1540–80

Reddish earthenware, slip-coated; incised design, heightened with brown, purple, green, blue-grey; transparent glaze: a boy playing with a ball; around this, a wreath and broad band of tied curling foliage. Reverse partially glazed. DIAM 30.4 cm

MLA 1891, 2–24, I

Bibl. Hailstone Sale, Christie's, 12–20 Feb. 1891, lot 198A.

Cf. Baroni 1934, no. 531; Bojani *et al.* 1985, no. 455.

255 Dish

Probably Northern Italy, *c.* 1580–1600

Reddish earthenware, slip-coated; incised design, heightened with green, blue-grey, yellow, brown; transparent glaze: a young man and woman surrounded by *putti* romping in foliate and dolphin scrollwork, with vases and winged half-human figures. Reverse partially slip-coated and glazed. Broken and repaired. DIAM 41 cm

MLA 1855, 12–1, 91

Bibl. Bernal Sale 1855, lot 1986C.

Cf. Baroni 1934, no. 566, marked *BMF 1598.*

250

251

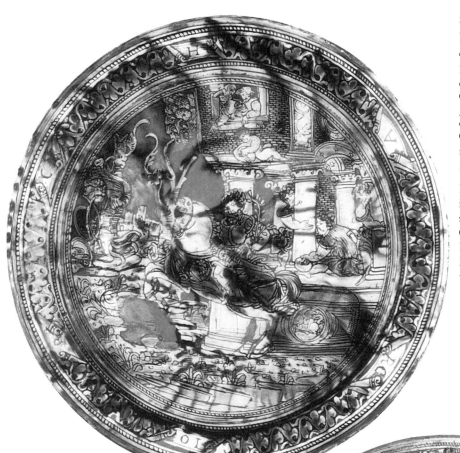

252

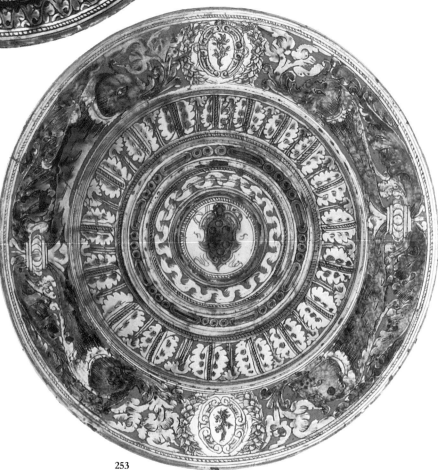

253

256 Two-handled bowl

Probably Lombardy or Liguria,
c. 1550–1650

Reddish earthenware, slip-coated; incised
design; brownish glaze: St James of
Compostela as a pilgrim, with s . ıā (Sanctus
Jacobus). Exterior: vertical and diagonal
dashes; base subsequently incised MF.
Chipped. DIAM 9.7 cm
MLA 1883, 11–6, 6; given by A. W. Franks
Bibl. Castellani Sale 1871, lot 37.

Bowls like this seem to have been used
in religious houses, where the owners
scratched their initials underneath.
Cf. Pringle 1977, no. 111 (from Genoa);
Baroni 1934, nos 490–9 (mostly from
Milan); Nepoti 1981, pp. 92–7, nos 69,
70, 93, 94 (from Pavia?).

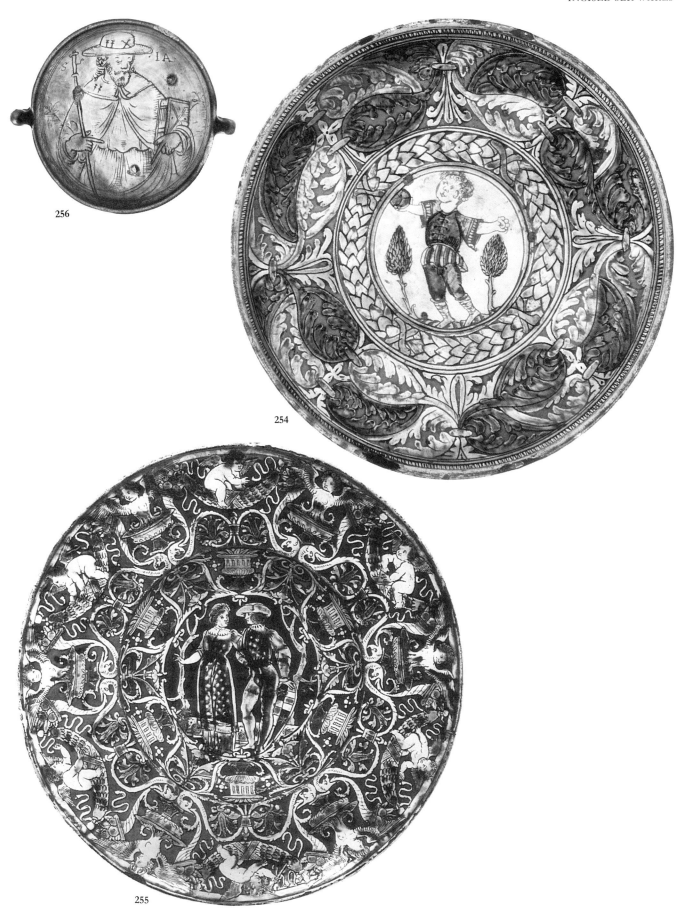

256

254

255

24 The diffusion abroad of Italian maiolica

From the end of the fifteenth century the Renaissance was successfully exported from Italy throughout Western Europe. Italian artists were in demand in the courts of France and England, and the course of French and English art was decisively affected by their work. Like painters and sculptors, Italian maiolica craftsmen were masters of a technique and a style which could be admired, not rivalled, outside Italy. During the sixteenth century Italian potters went to France, Spain, the Low Countries, and Central Europe, and played a leading role in the establishment of independent national traditions of tin-glazed earthenware.

The earliest identifiable works of an Italian maiolica painter abroad are tile panels painted in Spain by an artist called Niculoso Francisco Pisano; one is dated 1503, another 1504. Spain, unlike the rest of Europe, already had a flourishing tradition of tin-glazed pottery, and the influence of the Italian Renaissance was less overwhelming than elsewhere. More momentous in the long term was the emigration of Italian potters to France. In this process Lyons, the cosmopolitan city on the way from Paris to Italy, was a crucial staging-post. The Italian colony at Lyons included potters as early as 1510, and after 1550 the number grew. The main immigrant potters seem to have been from Liguria and Faenza. There is no piece at present attributable to any documented Italian potter at Lyons; however, several dishes in a style resembling the late sixteenth-century *istoriato* of Urbino have subjects drawn from the *Quadrins historiques de la Bible*, printed in Lyons, and some have captions in French on the back; the supposition that this type was made in Lyons has been confirmed by the discovery of 257, the only known marked example of Lyons *istoriato*.

Lyons was a major maiolica centre for only a few decades; meanwhile, a group of Italian potters (among them Jules Gambin (Giulio Gambini), who had previously worked in Lyons) had moved to Nevers, between Lyons and Paris, and set up a maiolica industry there under the patronage of Louis de Gonzague (Luigi Gonzaga), Duke of Nevers. During the seventeenth century, Nevers developed into a major producer of tin-glazed pottery in a distinctively French style, and is one of the fountainheads of French faience.

Lyons was the most direct, but not the only, channel through which Italian influence affected French maiolica in the sixteenth century. Girolamo Della Robbia worked at Fontainebleau and his work there seems to have influenced Bernard Palissy; the work of Antoine Sigalon of Nîmes is dependent on maiolica of Faenza type; and the most brilliantly original of all sixteenth-century French ceramic artists, Masseot Abaquesne of Rouen, worked in a style linked to that of the Italian artists who worked for François I at Fontainebleau.

The production of maiolica in the Italian fashion in the Low Countries started before 1500. By about 1510 an Italian called Guido Andries is known from documents to have been working in Antwerp. He is doubtless the 'Guido di Savino' of Castel Durante, who, according to Piccolpasso, 'brought the art' to Antwerp. Antwerp became a major centre for pottery somewhat in the Italian style. It was potters from Antwerp who established the industry in the northern (Protestant) Netherlands, notably Haarlem; from Haarlem was founded the tin-glaze industry of one of the greatest of all European pottery towns, Delft.

The link between Italy and the origins of tin glaze in England is direct: in 1567 two of Guido Andries's sons, Jasper and Joris, came to Norwich with a compatriot from Antwerp, Jacob Jansen, and started making tiles and pharmacy jars. Shortly afterwards Jansen moved to London and set up a workshop at Aldgate. From London factories run by immigrants, first at Aldgate, then in Southwark, grew the English delftware industry.

All over Europe the tin-glaze tradition can be traced back directly or indirectly to sixteenth-century immigrant Italians. As time went on the stylistic tradition of maiolica was swept aside in favour of *chinoiserie* or other more up-to-date designs; but the Italian style did not altogether lose its power to inspire imitations: some late seventeenth-century English delftware dishes are direct copies of Montelupo designs, and as late as the 1750s the Austro-Hungarian factory at Holitsch produced wares directly inspired by contemporary Italian maiolica.

LITERATURE *General*: G. Liverani 1937B
France: Damiron 1926; *Faïences françaises* 1980; Taburet 1981.
Low Countries: Rackham 1926; Nicaise 1934; Korf 1981; van Dam 1982–4.
England: Tait 1960–1; Hume 1977; Lipski & Archer 1984; Britten 1987.

257

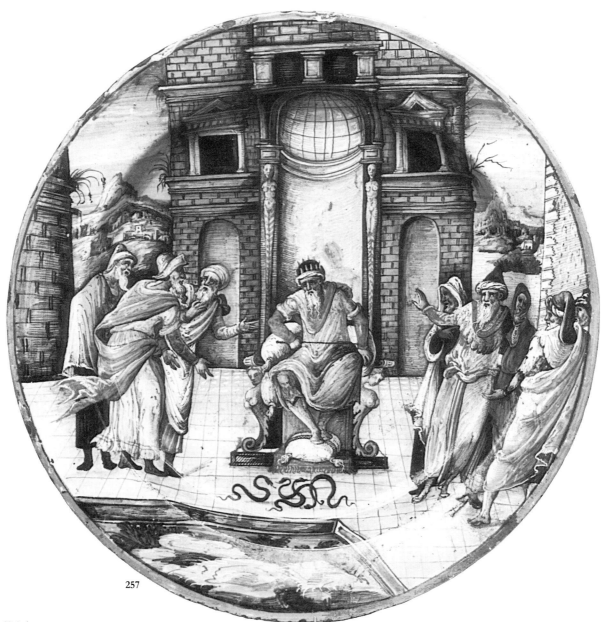

257

257 Dish

Lyons, 1582

Painted in blue, yellow, orange, brown, purple, green, black, grey, white: Pharaoh and the serpents. Reverse: yellow lines and *lla verga di faraô in serpentte* (Pharaoh's rod into a serpent) *1582 GTVF leon*. Restoration to rim. DIAM 41.5 cm

MLA 1959, 4–1, 1

Bibl. Sotheby's, 24 March 1959, lot 53; Boulay 1960, pp. 46–7; Giacomotti 1961, p. 104, pl. XXVIII.1; 1974, pp. 384–5; Fourest & Giacomotti 1966, pp. 24–5; *Faïences françaises* 1980, no. 58.

The story is from Exodus 7; Aaron performed a miracle before Pharaoh by changing a rod into a serpent; the Egyptian magicians did the same, 'but Aaron's rod swallowed up their rods'.

The painter has copied the illustration in the Lyons *Quadrins Historiques* (see pp. 113–14).

Apparently the only marked Lyons piece in existence; although the usual Italian name for the town was *Lione* this interpretation of *leon* is almost certainly correct. *GTVF* presumably denotes the maker or painter. No potter with the right initials has been traced in records, but it is tempting to interpret the two final letters as *Urbinate* or *Veneziano fece*.

258 Jar

Nevers, *c.* 1630–70

Painted in blue, green, yellow, orange, grey, purple, black: a continuous sea scene; a merman pulls the foot of a woman who is

clinging to a tree; two horses with a fish-tail emerge from the sea; a bull swims through the water with Europa on his back. Around the foot, scrolling foliage. On the lid, dolphins in the sea, one ridden by a *putto*. Restoration to lid. H (overall) 32 cm

MLA 1853, 1–24, 1; formerly Abbé Hamilton collection

Bibl. Lane 1947, pp. 38–9, pl. IIIA; 1948, pl. 12A.

Some of the figures are from prints – by Tempesta (B XVII, p. 151, no. 658), and Pierre Brébiette (Lane 1947, pl. IIIB).

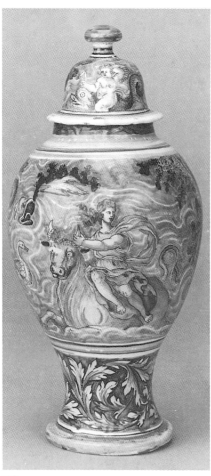

258

259 Dish

Low Countries, 1583; probably workshop of Cornelis Lubbertz, Haarlem

Painted in blue, green, orange, yellow, purple: a woman in contemporary costume; surrounded by a narrow band of overlapping arches and a broad band of leaf tendrils, fruit, and flowers. Reverse: *1583 – 10/ Januarii.* and a monogram *L* and *C*. Four suspension holes in foot-ring. DIAM 36.7 cm

MLA 1885, 5–8, 40; given by A. W. Franks
Bibl. Stengel 1908, p. 32–3, fig. 4 (as Nuremberg); Rackham 1926, pp. 43, 121, pl. 55, 53(a) (as Antwerp); G. Liverani 1937B, p. 16; Honey 1952, pp. 445–6; Korf 1981, figs 51, 52; van Dam 1982–4, pp. 6, 81.

In the late sixteenth century Haarlem was the most important tin-glaze centre in the northern Netherlands. Fragments of a dish said to have been dug up at Hoorn, with the same monogram and the date 1582, are in the Rijksmuseum (Korf 1981, fig. 50). Tin-glaze pottery in roughly similar style has been excavated at Haarlem (Korf 1968). However, the late-sixteenth-century products of the

northern Netherlands are hard to distinguish from those of the southern Netherlands; cf. a dish excavated in Antwerp, *Van Nederzetting tot Metropool*, Exhibition Catalogue, Volkskundemuseum, Antwerp 1982–3, no. 365. The alternative suggestion of an origin in England seems improbable. The border decoration echoes a Venetian motif (cf. 178 and Piccolpasso's drawings of *fiori* and *frutti*).
Illustrated in colour

260 Dish

Low Countries, perhaps Delft or Haarlem, *c.* 1640–70

Painted in yellow, orange, blue, purple: a winged *putto* in a landscape; surrounded by grotesques incorporating birds, insects, cornucopias, and leaf and flower tendrils. DIAM 46 cm

MLA 1929, 5–16, 1

Painted in a style blending *compendiario* with grotesques reminiscent of the Patanazzi workshop. For the attribution of dishes of this kind to the Protestant northern Netherlands, see Riesebieter 1927–8; van Dam 1982–4, pp. 69–74.

261 Jug

London (Southwark), *c.* 1630–5

Painted in blue, orange-yellow, green: a roundel with Samson tearing the jaws of the lion (Judges 14); the rest of the surface in panels with ribbon-work, shields, fans, flowers, etc.; near the base of the handle, $_T{}^HD$; on the neck, *IP*. H 28.2 cm

MLA 1931, 3–17, 1
Bibl. Tait 1960–1, part 2, p. 23, no. 18.

The roundel is distantly in the manner of Italian maiolica; the panels of decoration in blue are inspired by Chinese porcelain, but some of the detailing is Italianate. A jug in the V & A with an English inscription (Rackham & Read 1924, pl. v) from the same workshop has, in place of the Chinese ornament, fruit and flowers in the maiolica tradition.

The triangular initials are a convention of the time for husband and wife. *IP* may be the initials of the donor.

Iconographically, Samson is frequently hard to distinguish from Hercules, but Hercules is not usually fully clothed.

In the first half of the seventeenth-century the centre of English delftware

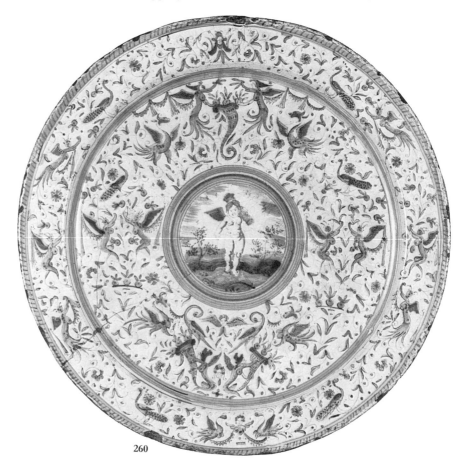

260

261

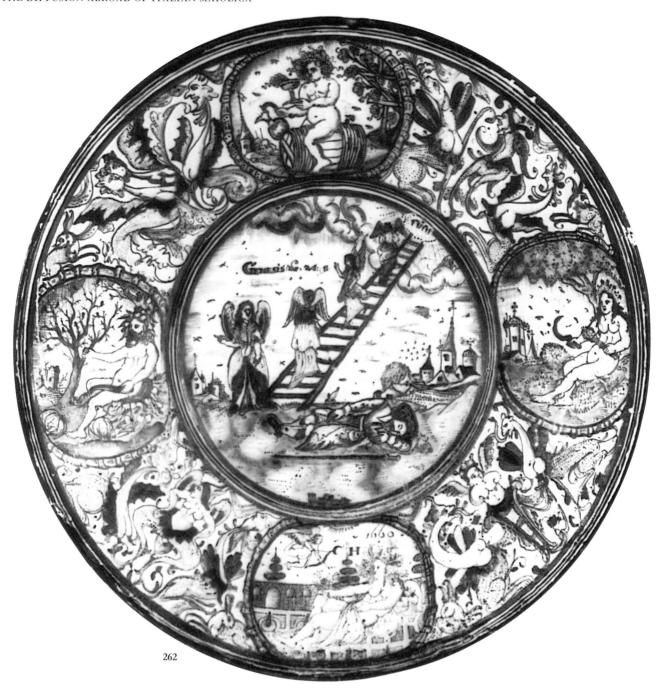

262

262 Dish

industry was Southwark; from there the industry spread to the south London suburbs and to other parts of England. On the Southwark delftware industry, see Davies 1969, Hume 1977, Britten 1987.

London (probably Southwark), 1660

Painted in blue, green, orange, yellow, purple: Jacob dreaming of angels ascending to Heaven and descending, with the caption *GENESIS: THE: 28: :11*; on the rim, 'grotesque' figures and animals with ovals representing the seasons; near the bottom, *CH 1660*. Suspension hole in foot-ring.
DIAM 41.6 cm
MLA 1855, 8–11, 2

Bibl. Hodgkin & Hodgkin 1891, p. 86, no. 309; Hobson 1903, E49; Garner & Archer 1972, p. 8; Lipski & Archer 1984, no. 35.

The central scene may be based on a Bible illustration. The grotesques are descendants of the Urbino style (cf. Lipski & Archer 1984, no. 95, dated 1649). *CH* recurs on a delftware pelican dated 1651 (*ibid.*, no. 1739).

25 The maiolica tradition in the 17th and 18th centuries

In the seventeenth century Italy lost its leading role in the development of European tin glaze and the initiative passed to France and the Low Countries. There continued, however, to be lively and varied production in several centres scattered through Italy. There are three main threads to the story of later Italian tin-glaze pottery: the tradition of Renaissance maiolica, Chinese blue-and-white porcelain, and the faience of France and Germany; the two latter influences were felt most strongly in northern Italy. This section focuses on pieces continuing the *istoriato* tradition in the Marches, Tuscany, and elsewhere. The centre with the most consistent tradition was the most isolated, the little town of Castelli, where the Grue and a few other family potteries maintained high standards in a distinctive local style until late in the eighteenth century. Good maiolica painters were few and far between, and some of the best *istoriato* painters, like Bartolomeo Terchi and F.A.X. Grue, travelled widely in the course of their careers.

LITERATURE Honey 1928; Ferrari & Scavizzi 1981.

263 Plate

Montelupo, *c.* 1600–60

Painted in yellow, blue, black, green, orange, purple: a soldier brandishing a long and a short sword, with the words SOTTO PEN^A DUGENTO SCUDI (under penalty of 200 *scudi*). Reverse: purple rings. DIAM 24.3 cm
MLA 1885, 5–8, 41; given by A. W. Franks

Dishes painted in this popular style with soldiers or other contemporary figures were characteristic of Montelupo in the seventeenth century. Cf. Giacomotti 1974, pp. 437–9; Bojani *et al.* 1985, pp. 241–50; Rackham 1940A, no. 1078, dated 1632. 200 *scudi* was perhaps the fine for an offence such as duelling.

264 Dish

By Ippolito Rombaldoni, Urbania, *c.* 1670–90

Painted in brown, blue, green, orange, yellow, purple, black, white: the laying of Christ in the tomb. Reverse: in brown, HR in cursive monogram. DIAM 28.4 cm
Henry Reitlinger Bequest, Maidenhead

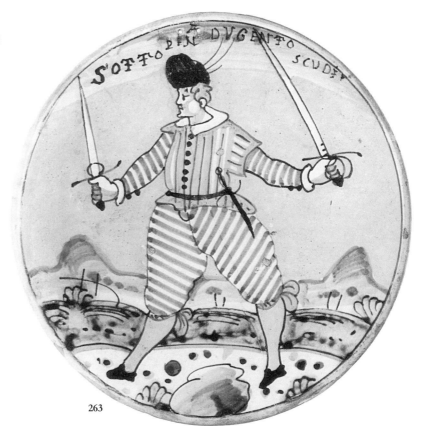

263

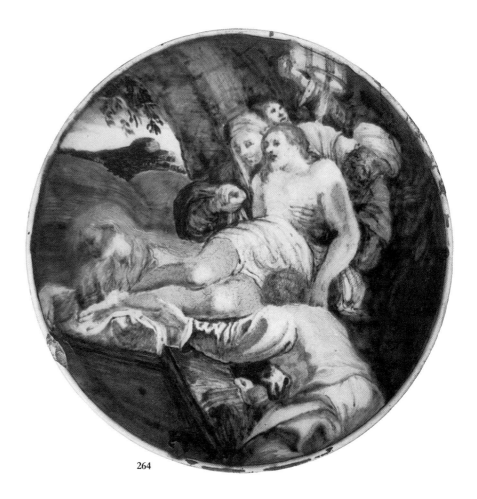

264

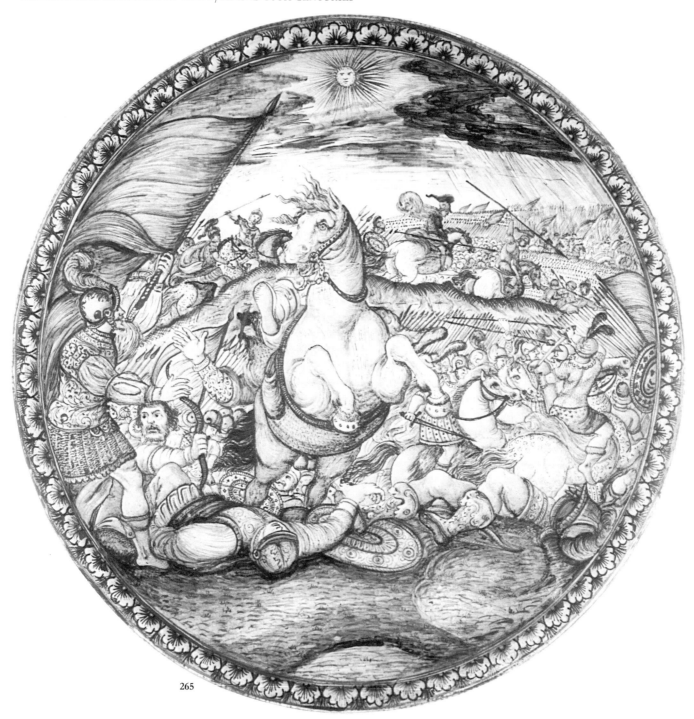

265

The composition reproduces a painting (*Maestri della Pittura del Seicento Emiliano*, Bologna 1959, no. 44) by Lorenzo Garbieri, perhaps a copy of a lost work by Lodovico Carracci.

Ippolito Rombaldoni of Urbania (formerly Castel Durante) was the most significant painter still producing *istoriato* in the Marches in the seventeenth century. For his work, see Giacomotti 1974, p. 462; Ravanelli Guidotti 1985A, p. 230.

265 Flat dish on high foot

Castelli, *c.* 1650–1700

Painted in green, mauve, blue, yellow, brown, purple; heavily ornamented with gold: the sun stands still at Joshua's command to let the Israelites complete a victory (Joshua 10); floral ornament on the raised border. DIAM 29 cm

MLA 1878, 12–30, 459; Henderson Bequest

After an engraving by Antonio Tempesta (B XVII, p. 130, no. 246). The

style is close to works attributed to Francesco Grue (e.g. Giacomotti 1974, no. 1379; cf. Moccia 1960).

266 Pharmacy jar

By Francesco Antonio Xaverio Grue, Naples, 25 November 1717

Painted in blue, green, yellow, brown, black: a seascape with a woman chained to a rock, a dolphin-like sea-monster, and a town. Within the rim; *NICOLAVS FERRARA IATROTECHNIS NEAPOLITANVS* (Nicola

Ferrara, pharmacist of Naples); around base, *RAPHETHICHOL*; within foot, *MDCCXVII VII KAL XBRIS Dr Grue f. Neap:* (25 November 1717. Doctor Grue made this. Naples). H 8.2 cm

MLA 1983, 1–1, 1

Bibl. Cherubini 1865, p. 24 (probably this piece); Donatone 1974B, p. 26; 1980, text to pl. 4; 1984, p. 34, pl. 64a and b; Sotheby's, 23 November 1982, lot 61; *Burlington Magazine* 127 (1985), p. 341, pls 25, 26.

Francesco Antonio Xaverio Grue (1686–1746), one of a remarkable dynasty of Castelli potters, was destined for the Church, and took a doctor's degree at Urbino; but by 1709 he was working as a pottery painter in Naples, where this little jar was made for a local pharmacist. Towards the end of his life he returned to Castelli (Donatone 1980). *Rapheticol* is a medical preparation from horseradish. The subject is presumably Andromeda and the sea-monster, without Perseus.

267 Plate

Northern Italy, *c.* 1650–1750

Lilac-grey glaze; painted in purple-brown, blue, yellow, green, orange: *putti* enacting a Bacchic revel among ruins. Reverse: simple fern sprays and a monogram, GR or GCR. DIAM 38.7 cm

MLA 1885, 5–8, 42; given by A. W. Franks
Bibl. Fortnum 1896, mark 423.

Numerous finely potted pieces in this style, with various marks, exist. The usual attribution to the factory at Angarano, near Bassano (cf. Baroni 1933; Giacomotti 1974, pp. 448–60), has not been proved, and the date and origin of this sophisticated pottery need further research. The iconography of this plate recalls sixteenth-century designs, e.g. Byrne 1981, no. 130, an engraving by Jonas Silber of Nuremberg.

268 Plate

Savona, *c.* 1670–1720

Painted in blue and manganese: a satyr and woman embracing in a landscape; *putti* with fruit. Reverse: simple scrolls and a shield of arms of Savona. Restoration to edge. DIAM 35.8 cm

MLA 1973, 7–1, 2; given by Miss C. Woodward

For the mark, used by the Isola factory in Savona, and perhaps other factories too, see Scarrone 1971, p. 186. The plate is characteristic of the flourishing potteries of Liguria through the seventeenth and eighteenth centuries in its use of blue and white in the manner of Chinese porcelain and of Delft.

269 Bottle

Perhaps Regio Parco factory, Turin, *c.* 1646–80

Pale-turquoise glaze; painted in blue: rocks and plants, with a bird and an antelope(?); bands of plant and abstract ornament round the neck. Beneath the base, a crowned shield charged with a cross. H 27 cm

MLA 1889, 12–16, 1; given by A. W. Franks
Bibl. Fortnum 1896, mark no. 468.

The form and decoration are of Chinese inspiration; cf. Krahl *et al.* 1986, no. 1300. The style is that of Ligurian blue-and-white pottery, but the mark has been attributed to the factory at Regio Parco in Turin, founded in 1646 and run by men from Liguria; cf. Vignola 1878, pp. 11–14; Viale 1963, p. 2, pl. 3.

270 Plate

By Ferdinando Maria Campani, probably Siena, 1733

Painted in blue, yellow, green, orange, brown, black: God creating the sun and moon, the earth below. Reverse: (from Genesis 1) *Fecit duo luminaria magna, et posuit in firmamento ut lucerent super terram/Ferdinando Maria Canpani Senese dipinze* (And God made two great lights and set them in the firmament to give light upon the earth. Ferdinando Maria Canpani of Siena painted this) *1733*. DIAM 26 cm

MLA 1855, 3–13, 17; given by A. W. Franks
Bibl. Fortnum 1873, pp. 130, 139; Rackham 1940A, p. 389; G. Liverani 1968, p. 707, fig. 35.

Based on an engraving by Chapron after Raphael's *Logge* (Robert-Dumesnil, VI, p. 219, no. 5). Cf. Hausmann 1972, no. 307. Ferdinando Maria Campani of Siena (1702–71) was a successful

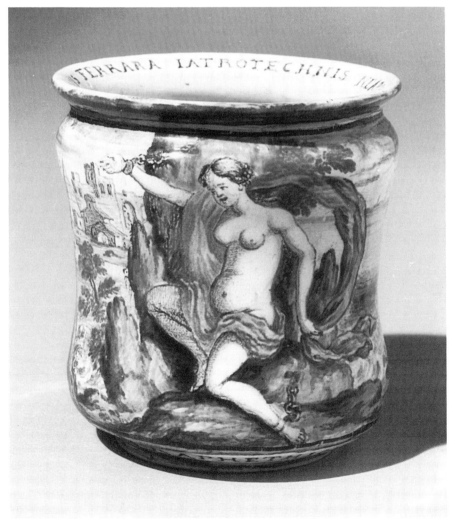

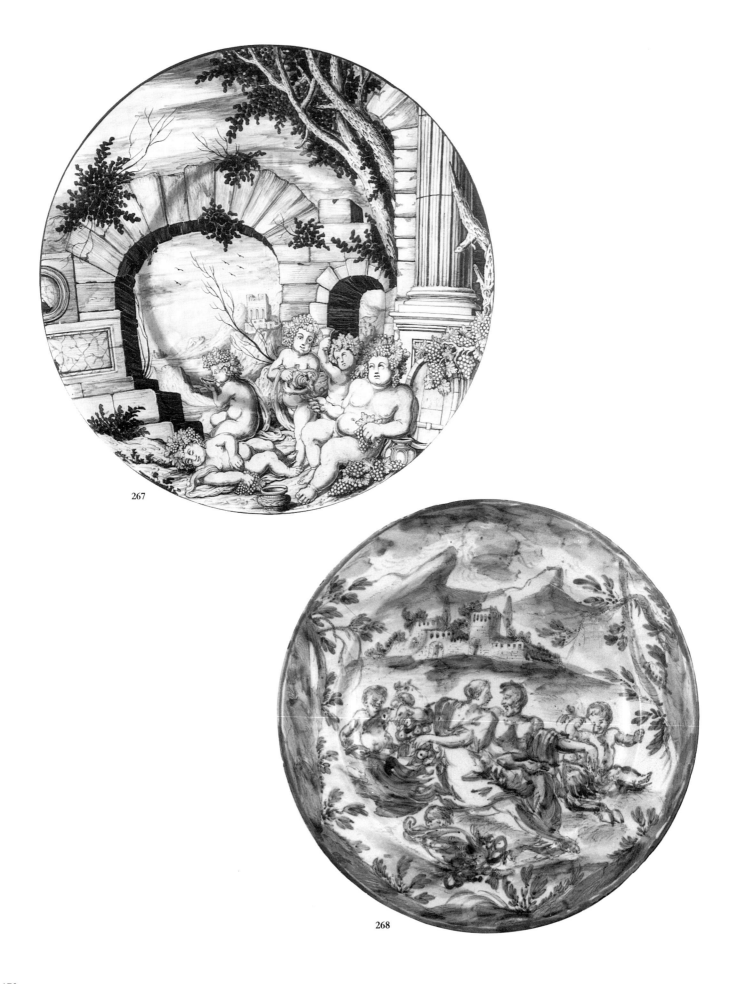

267

268

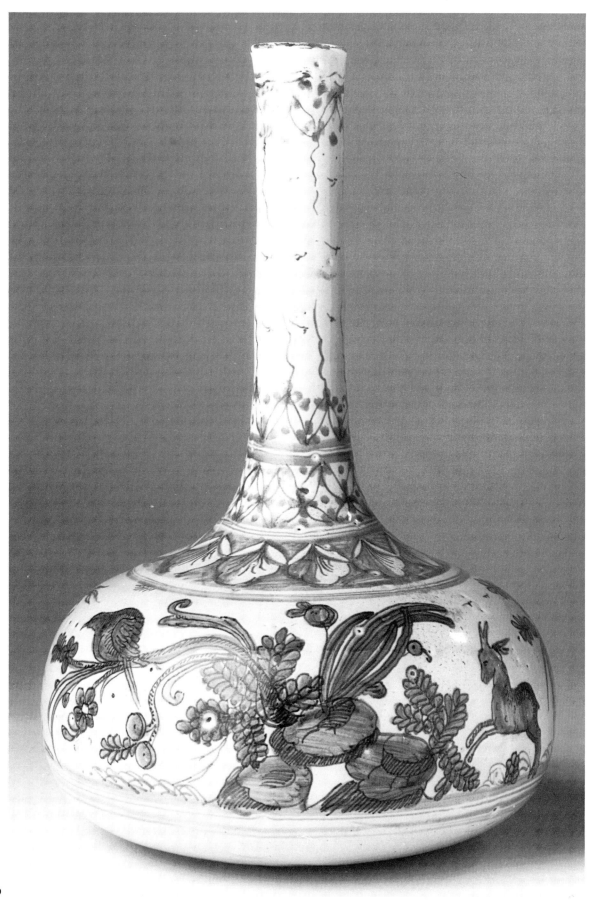

269

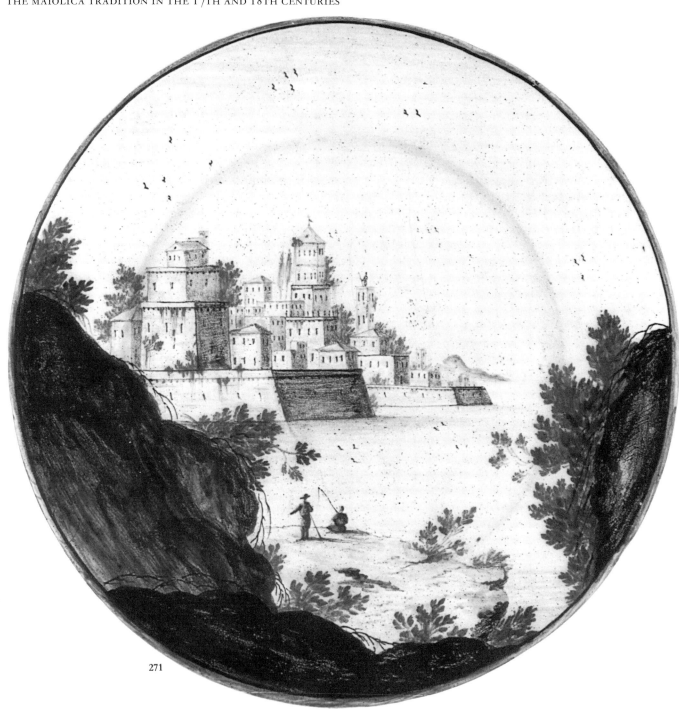

271

portraitist as well as perhaps the most gifted of all eighteenth-century maiolica painters. His work reflects something of a 'Raphael revival' on maiolica. See Guasti 1902, pp. 351–5; *Dizionario Biografico degli Italiani*; Pelizzoni & Zanchi 1982.
Illustrated in colour

271 Plate

By Bartolomeo Terchi, Bassano Romano, *c.* 1735–45

Manganese-flecked glaze, painted in green, brown, yellow, purple, black, blue: a seaside town, with fishermen among rocks. Reverse: *Bartt: Terchij Bassano.* DIAM 18.5 cm
MLA 1887, 6–17, 39; given by A. W. Franks
Bibl. Honey 1928, pp. 195–6, fig. IV; Rackham 1933, p. 42; 1940A, p. 391.

Bartolomeo Terchi was born in Rome in 1691; he worked in San Quirico d'Orcia, then Siena, then Bassano Romano (in Lazio), and returned to Rome in 1753. This plate was probably made early in his stay at Bassano, which began in 1735; a similar plate (Rasmussen 1984, no. 184) is dated 1736. He was at Siena in the same period as Campani and their styles are sometimes similar. See Pelizzoni & Zanchi 1982.

26 Fakes and problems

The history of fakes mirrors the history of collecting. Renaissance maiolica has never fallen completely out of favour with collectors, so the incentive for forgery has always existed. 245 has what a modern collector would regard as an impeccable provenance: it was bought by Sir Hans Sloane, perhaps in 1733; yet, before Sloane acquired it, the date had been altered from 1654 to 1554 to make it more 'collectable'.

The real history of maiolica fakes begins in the 1840s. In this period a characteristically mid-nineteenth-century interest in the 'industrial arts' of the Middle Ages and Renaissance among English and French collectors led to a rise in demand and prices for maiolica. In 1846 Giuseppe Raffaelli prefixed to his history of Castel Durante maiolica a passionate lament that Italy was being robbed of its ceramic heritage by foreigners; and in 1851 A. W. Franks noted to the Trustees of the British Museum that 'the whole of Italy has been so ransacked by foreign dealers that it is useless to expect any number of specimens to be discovered in that country'. At the same time the spirit of *Risorgimento* nationalism which was growing in Italy brought with it aspirations to recreate some of the past glories of Italian art. At least three separate 'revivals' of maiolica had root in the late 1840s: in Pesaro Pietro Gai developed a technique of lustreware; in Siena Bernardino Pepi began trying to copy Sienese Renaissance floor tiles; and at Doccia, near Florence, the Ginori porcelain factory started making maiolica in sixteenth-century style. In 1857 Joseph Marryat shocked the collecting world by a dramatic exposé of the Doccia copies, which he claimed were made at the instance of a Florence dealer. This information, Marryat said, 'will doubtless startle some of our readers who have being paying "fabulous prices" for undoubted Giorgios and Xantos . . . the imitation is so perfect as to deceive the most experienced judges'.

If Marryat was right a provenance going back to the 1850s is not itself a guarantee of authenticity. Furthermore, what has become of all the convincing fakes of Maestro Giorgio and Xanto which he mentions? It can only be assumed that many are lurking, unrecognised, in museums. All the

pieces included up to this point are believed to be genuine; those about which doubts have been expressed include 30, 34, 35, 39, 191, 224, 227, 248 and 255.

Doubts arise when there is something about a piece which does not 'fit'. Sometimes these doubts can neither be confirmed nor refuted. Scientific analysis can sometimes help; in particular, the modern technique of thermoluminescence can give a rough indication of age. But thermoluminescence is at its most effective when distinguishing longer periods than that between the High Renaissance and the 1850s, and is not always capable of resolving the issue. More developed scientific techniques may one day produce preciser datings; at present 'fake or genuine?' must sometimes remain a matter of opinion.

LITERATURE Conti 1974; Biscontini Ugolini 1980; *Maioliche umbre decorate a lustro* 1982.

272 Jug

Italian, before 1868

Painted in blue, yellow, orange: scrolling foliage with *putti*; beneath the lip a coat-of-arms; beneath the handle, on a tablet, *R.V.A. 1582*. H (to top of handle) 16.9 cm
MLA 1878, 12–30, 362; Henderson Bequest
Bibl. Henderson 1868, pl. V; Fortnum 1873, p. 568; 1896, p. 282.

Similar to the jug from the Isabella d'Este set illustrated by Darcel & Delange 1869; however, the jug was already in Henderson's possession in 1868, so its maker can hardly have been using this illustration.

The doubts expressed by Fortnum in 1896 about the authenticity of this jug have been confirmed by thermoluminescence. The BM records cite 'Mr Cantagalli' (of the Florence maiolica firm) as attributing it to 'Ginori', i.e. the Doccia factory, near Florence.

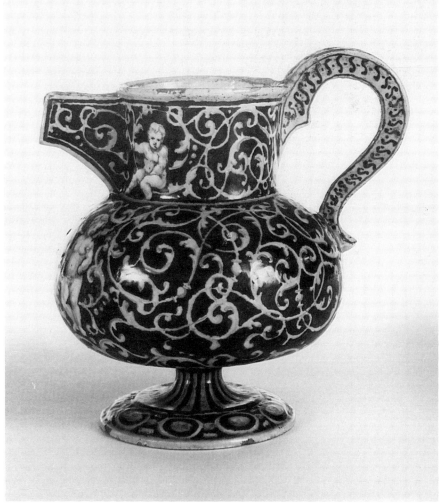

272

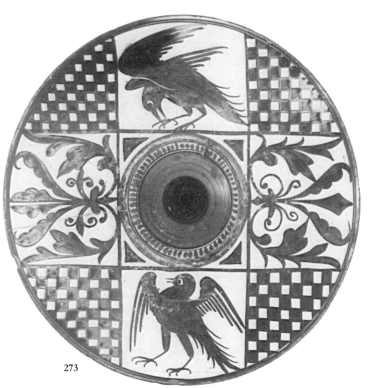

273

273 Plate

Origin and date uncertain; before 1868

Painted mainly in copper-coloured lustre and some blue: birds, chequers and foliate designs in square panels. Reverse: lustre rings and *C.* DIAM 23.9 cm

MLA 1878, 12–30, 382; Henderson Bequest

Bibl. Henderson 1868, pl. IV; Wallis 1905A, fig. 86

The designs are in solid lustre, with no discernible outline drawing. If it was made in Renaissance Italy, Tuscany would seem a possible attribution (cf. Cora & Fanfani 1982, no. 76). The birds are reminiscent of the work of William De Morgan (1839–1917), but this piece was already in Henderson's collection before De Morgan began using lustre in 1869.

275

274

274 Plate

Origin and date uncertain; before 1878

Painted in yellow, blue, green, black, purple, white, orange, brown: the Virgin Mary visiting Elizabeth (Luke 1); on a building, a tablet with *1559*; on the architecture *D* and *C*; at the bottom a shield of arms.

DIAM 27.6 cm

MLA 1878, 12–30, 456; Henderson Bequest

Based on an engraving after Salviati (B XV, p. 384, no. 1). The French-looking arms might suggest an attribution to an Italian painter working in France; but the plate seems more likely to be a fake.

275 Plate

Origin uncertain; 19th century

Painted in blue and brown; brownish lustre: a man in pageant-armour; on a scroll, MARCHO REGHVLO; background with scrolling flower tendrils. Reverse: lustred fern scrolls in Hispano-Moresque style. Two suspension holes near edge. DIAM 32 cm

MLA 1885, 5–8, 35; given by A. W. Franks

Bibl. Fortnum 1896, p. 114.

Thermoluminescence indicates this piece is probably of nineteenth-century origin, but it was sold to Franks in 1884 by a man who claimed to be able to trace its history back to the 1820s. This history was presumably spurious.

276 Bowl

Probably Orvieto, *c.* 1905–10

Painted in manganese and green: interlace, with four heads of kings. Reverse lead-glazed. Reconstructed from fragments.
DIAM 33.5 cm
MLA 1913, 11–17, 1; bought from
C. Visconti

See p. 20. Thermoluminescence has confirmed this bowl to be a forgery. A similar bowl (Bode 1911, pl. 11) was destroyed in Berlin in the Second World War.

276

Fig. xxxii. Manuscript of the treatise *I Tre Libri dell'Arte del Vasaio*, written about 1557 by Cipriano Piccolpasso of Castel Durante at the request of Cardinal François de Tournon; it is a fair copy intended for publication, but remained unpublished until 1857. Its text and drawings are the basis of our knowledge of the techniques of Renaissance maiolica in the Urbino district and more widely. The manuscript was bought by the South Kensington Museum (now the Victoria & Albert Museum) in 1861.

The drawing illustrated shows Urbino, dominated by the ducal palace of Federigo da Montifeltro. Other drawings from the manuscript are illustrated on pp. 13, 14, 74, 75, 112.
Victoria & Albert Museum 7446–1861

Bibl. Piccolpasso 1980 (with full discussion and bibliography).

Glossary

Albarello
A cylindrical storage jar, usually slightly waisted and without handles, of Islamic origin, but much used in Renaissance pharmacies. The etymology is uncertain.

Alla porcellana
'In the porcelain manner': decoration in blue and white often found on Renaissance maiolica, usually with a rather distant relationship to Chinese porcelain.

Bacino
'Basin': specifically used of the pottery dishes ornamentally set into medieval buildings.

Bella
'Beautiful woman': the plural *belle* is used to describe the female 'portrait' dishes of the Renaissance; see p. 144.

Berettino
The Italian term for tin glazes stained blue or greyish blue.

Bianco sopra bianco
Decoration in opaque white on an off-white glaze.

Compendiario
'Summary': used to describe the rapid sketchy style of 'Faenza white'.

Delftware
The term (derived from the Dutch pottery town of Delft) used to describe English tin-glazed pottery in the seventeenth and eighteenth centuries. This is no more illogical than 'maiolica', 'faience', and 'china'.

Faience
In English this term, derived from the French name for Faenza, is used to describe the tin-glazed pottery made in Europe in the seventeenth and eighteenth centuries, owing more in style to Oriental and European porcelain than to Italian maiolica.

Grotesques
Painting in the fantastic style of Roman wall-paintings. The distinction made in modern Italian between *grottesche* and *raffaellesche* is not normally observed in English.

Hispano-Moresque
Pottery, often lustred, made originally by Islamic craftsmen in southern Spain: in the fifteenth century made mainly in Christian eastern Spain, especially around Valencia.

Impresa
A device, supplementary to and more personal than a coat-of-arms, usually with some ingenious and/or obscure point embodied in a motto; much used by noblemen in the Renaissance.

Istoriato
'Story-painted': pottery painted with narrative scenes or figure subjects.

Lustre
The application to ceramics of iridescent metallic decoration; see pp. 13–14.

Maiolica
For most of the Renaissance this word was used in Italian to describe Hispano-Moresque imports and other lustrewares. In modern Italian it is used to describe any tin-glazed earthenware. In English and French it is limited to work in the stylistic tradition of the Italian Renaissance. The spelling and pronunciation 'majolica' are now normally used in England to refer to Victorian and later wares more or less in Renaissance style.

Porcelain
A term originally used in medieval Europe to describe the high-fired, hard, white, translucent wares made in China. The term 'soft-paste porcelain', is usually applied to Medici porcelain and the porcelains made at Sèvres, Chelsea and elsewhere. The earliest European 'hard-paste' porcelain was made in Dresden from around 1708.

Putto
An Italian term for child, used loosely to describe the plump winged or unwinged boys who romp their way through Renaissance art.

Sgraffiato
Incised slipware; see p. 160.

Tin glaze
A lead-based glaze made opaque white by the addition of tin oxide.

Bibliography of works cited

Albarelli, G. 1986. *Ceramisti pesaresi nei documenti notarili dell'Archivio di Stato di Pesaro sec. XV–XVIII* (Biblioteca Servorum Romandiolae 9), Bologna.

Ainaud de Lasarte, J. 1952. *Ars Hispaniae*, 10: *Cerámica y vidrio*, Madrid.

Alinari, A. 1986. 'Cafaggiolo. Per un'indagine archeologica', *Faenza* 72, pp. 9–16.

Alverà Bortolotto, A. 1981. *Storia della ceramica a Venezia dagli albori alla fine della Repubblica*, Florence.

Amayden, T. 1910. *La storia delle famiglie romane*, Rome.

Antiche maioliche di Deruta 1980. Exhibition catalogue, Spoleto.

Argnani, F. 1898. *Il Rinascimento delle ceramiche maiolicate in Faenza*, Faenza.

Ballardini, G. 1916. 'Note intorno ai pittori di faenze della seconda metà del cinquecento', *Rassegna d'Arte*, N.S.3, pp. 59–72.

Ballardini, G. 1918. 'Note su Virgiliotto da Faenza', *Faenza* 6, pp. 34–40.

Ballardini, G. 1922. 'L'insigne "Piatto Leverton" con un episodio della spedizione di Carlo VIII in Italia', *Faenza* 10, pp. 132–43.

Ballardini, G. 1929. 'Alcuni aspetti della maiolica faentina nella seconda metà del cinquecento', *Faenza* 17, pp. 86–102.

Ballardini, G. 1932. 'Opere di maestri compendiari faentini al museo di Torino e loro rapporti con le ceramiche "habane"', *Torino*, April 1932, pp. 37–51.

Ballardini, G. 1933A. 'Francesco Mezzarisa alias Risino maiolicaro faentino del Cinquecento', *Miscellanea di Storia dell'arte in onore di Igino Benvenuto Supino*, Florence, pp. 519–51.

Ballardini, G. 1933B. 'Il monogramma B.T. nella maiolica faentina', *Faenza* 21, pp. 35–40.

Ballardini, G. 1933–8. *Corpus della maiolica italiana*, Rome.

Ballardini, G. 1938. *La maiolica italiana (dalle origini alla fine del cinquecento)*, Florence.

Ballardini, G. 1940. 'Un servizio di maiolica con lo stemma di Francesco Guicciardini', *Faenza* 28, pp. 3–9.

Ballardini, G. 1943–5. 'Giovanni Brame e Francesco Risino', *Faenza* 31, pp. 67–9.

Ballardini Napolitani, D. 1940. 'Ispirazione e fonti letterarie nell'opera di Francesco Xanto Avelli, pittore su maiolica in Urbino', *La Rinascita* 3, pp. 905–22.

Baroni, C. 1933. 'La disputa dei "latesini" nella storia della ceramica italiana', *Dedalo* 13, pp. 147–74.

Baroni, C. 1934. *Ceramiche italiane minori del Castello Sforzesco*, Milan.

Bascapè, G. C., & Del Piazzo, M. 1983. *Insegne e simboli*, Rome.

Beckerath Sale 1913. *Die Majolikasammlung Adolf von Beckerath*, Berlin (Lepke), 4–5 Nov. 1913.

Bellini, M., & Conti, G. 1964. *Maioliche italiane del Rinascimento*, Milan.

Berardi, P. 1984. *L'antica maiolica di Pesaro*, Florence.

Bernal Sale 1855. *Catalogue of the Celebrated Collection of Works of Art . . . of that Distinguished Collector, Ralph Bernal*, Christie's, 5 March – 30 April 1855 (cf. Bohn 1857).

Bernardi, C. (ed.) 1980. *Immagini architettoniche nella maiolica italiana del Cinquecento*, Exhibition catalogue, Bassano.

Berney Sale 1946. *Catalogue of Fine Italian Maiolica*, Sotheby's, 18 June 1946.

Berti, F. 1986. *La maiolica di Montelupo*, Florence.

Berti, F., & Pasquinelli, G. 1984. *Antiche maioliche di Montelupo, secoli XIV–XVIII*, Exhibition catalogue, Pontedera & Pisa.

Berti, G., & Tongiorgi, E. 1985. *Ceramiche importate dalla Spagna nell'area pisana dal XII al XV secolo* (Quaderni dell'insegnamento di archeologia medievale della facoltà di lettere e filosofia dell'Università di Siena 6), Florence.

Biavati, E. 1956. 'Un frammento di porcellana medicea', *Faenza* 42, pp. 61–2.

Biavati, E. 1979. 'Leonardo Bettisi fu Antonio ed il figlio Antonio junior detti ambedue "Don Pino"', *Faenza* 65, pp. 367–71.

Biscontini Ugolini, G. 1975. 'Un nuovo pezzo del celebre servizio nuziale di Alfonso II d'Este', *Rassegna di studi e di notizie* (Milan) 3, pp. 155–74.

Biscontini Ugolini, G. 1978. 'Di alcuni piatti pesaresi della bottega dei Lanfranco delle Gabicce', *Faenza* 64, pp. 27–33.

Biscontini Ugolini, G. 1979. 'Sforza di Marcantonio: figulo pesarese cinquecentesco', *Faenza* 65, pp. 7–10.

Biscontini Ugolini, G. 1980. 'La maiolica a Pesaro', in *Arte e immagine tra ottocento e novecento, Pesaro e provincia*, Exhibition catalogue, Pesaro, pp. 289–304.

Blake, H. 1972. 'La ceramica medievale spagnola e la Liguria', *Atti del V Convegno Internazionale della Ceramica*, Albisola, pp. 55–105.

Blake, H. 1978. 'Medieval pottery: technical innovation or economic change?', *Papers in Italian Archaeology I: the Lancaster Seminar* (BAR Supplementary Series 41), Oxford, pp. 435–72.

Blake H. 1980. 'The Archaic Maiolica of north-central Italy: Montalcino, Assisi and Tolentino', *Faenza* 66, pp. 91–152.

Blake, H. 1986. 'The medieval incised slipped pottery of north-west Italy', in *Siena/Faenza* 1986, pp. 317–52.

Bober, P. P., & Rubinstein, R. 1986. *Renaissance Artists and Antique Sculpture*, London & Oxford.

Bode, W. 1911. *Die Anfänge der Majolikakunst in Toskana*, Berlin.

Bohn, H. G. 1857. *A Guide to the Knowledge of Pottery, Porcelain and other objects of vertu comprising an illustrated Catalogue of the Bernal Collection*, London.

Bojani, G. C. et al. 1985. *Museo internazionale delle ceramiche in Faenza: La donazione Galeazzo Cora*, Milan.

Bonini, C. F. 1931. 'Maestro Giorgio da Ugubbio ed i lustri a reflessi metallici', *Faenza* 19, pp. 85–98, 137–50.

Borenius, T. 1928. *Catalogue of a Collection of Pottery belonging to W. H. Woodward*, London.

Borenius, T. 1930. *Catalogue of a Collection of Italian Maiolica belonging to Henry Harris*, London.

Borenius, T. 1931. *The Leverton Harris Collection*, London.

Boulay, R. 1960. 'L'apport des gravures flamands dans la décoration des faïences de Nevers', *Cahiers de la céramique* 17, pp. 46–54.

Boy Sale 1905. *Catalogue des Objets d'Art . . . de feu M. Boy*, Paris, 15–24 May 1905.

Britten, F. 1987. *London Delftware*, London.

Byrne, J. S. 1981. *Renaissance Ornament Prints and Drawings*, Metropolitan Museum of Art, New York.

Caiger-Smith, A. 1973. *Tin-Glaze Pottery in Europe and the Islamic World*, London.

Caiger-Smith, A. 1985. *Lustre Pottery*, London & Boston.

Caruso Sale 1973. *Catalogue of an Important Collection of Italian Renaissance Maiolica, the Property of Dr Giuseppe Caruso*, Sotheby's, 20 March 1973.

Castellani Sale 1871. *Catalogue of One Hundred and Fifty Choice Specimens of Majolica, Collected by . . . Signor Castellani of Rome and Naples*, Christie's, 12 May 1871.

Castelli, P. 1979. '"Atteon converso in cervo". Un episodio delle *Metamorfosi* di Ovidio nelle ceramiche cinquecentesche', *Faenza* 65, pp. 312–32.

La ceramica orvietana del medioevo 1983. Exhibition catalogue (1), Milan.

La ceramica orvietana del medioevo 1985. Exhibition catalogue (2), Orvieto.

Ceramiche medioevali dell'Umbria 1981. Exhibition catalogue, Spoleto.

Chambers, D., & Martineau, J. (ed.) 1981. *Splendours of the Gonzaga*, Exhibition catalogue, Victoria & Albert Museum, London.

Charleston, R. J. (ed.) 1968. *World Ceramics: An illustrated history*, London, etc.

Cherubini, G. 1865. *Dei Grue e della pittura ceramica in Castelli*, Naples.

Chompret, J. 1949. *Répertoire de la majolique italienne*, Paris.

Chompret, J. 1955. 'Les faïences françaises primitives', *Cahiers de la céramique* 1, pp. 18–22.

Cioci, F. 1979. 'La proposta per una ristampa: due sonetti inediti di Francesco Xanto Avelli', *Faenza* 65, pp. 297–301.

Clemente Sale 1931. *Italian Furniture of the Renaissance, Rare Maiolica . . . the Collection of Achille de Clemente*, American Art Association, Anderson Galleries, New York, 15–17 January 1931.

Clifford, T., & Mallet, J. V. G. 1976. 'Battista Franco as a Designer for Maiolica', *Burlington Magazine* 118, pp. 387–410.

Collina, L. 1973. 'Documenti (Maiolicari faentini)', *Faenza* 59, pp. 92–107.

Conti, G. 1971. *Museo Nazionale di Firenze, Palazzo del Bargello: Catalogo delle maioliche*, Florence.

Conti, G. 1974. *Mostra della maiolica toscana. Le imitazioni ottocentesche*, Exhibition catalogue, Monte San Savino.

Conti, G. 1980. *L'arte della maiolica in Italia* (2nd edn), Busto Arsizio.

Conton, L. 1940. *Le antiche ceramiche veneziane scoperte nella laguna*, Venice.

Cora, G. 1961. 'Nuovi compendiari toscani', *Faenza* 47, pp. 111–13.

Cora, G. 1973. *Storia della maiolica di Firenze e del contado: Secoli XIV e XV*, Florence.

Cora, G., & Fanfani, A. 1982. *La maiolica di Cafaggiolo*, Florence.

Cora, G., & Fanfani, A. 1986. *La porcellana dei Medici*, Milan.

Courtauld Galleries 1979. *General Catalogue of the Courtauld Institute Galleries*, London.

Courtauld Sale 1975. *Catalogue of Important Italian Renaissance Maiolica*, Sotheby's, 18 March 1975.

Cuppini, M. 1962. 'Alcune opere del Museo Miniscalchi Erizzo', in P. Gazzola (ed.), *La Fondazione Miniscalchi Erizzo*, Verona.

Dacos, N. 1969. *La découverte de la Domus Aurea et la formation des grotesques à la Renaissance* (Studies of the Warburg Institute 31), London & Leiden.

Dahlbäck Lutteman, H. 1981. *Majolika från Urbino och andra orter i Italien i Nationalmuseum Stockholm*, Stockholm.

Damiron, C. 1926. *La faïence de Lyon*, Paris.

Damiron Sale 1938. *Catalogue of the very choice Collection of Old Italian Majolica, the Property of Monsieur Damiron*, Sotheby's, 16 June 1938.

Darcel, A. 1864. *Musée de la Renaissance: Notice des fayences peintes italiennes, hispano-moresques et françaises etc.*, Paris.

Darcel, A., & Delange, H. 1869. *Recueil de faïences italiennes de XVe, XVIe et XVIIe siècles*, Paris.

Davies, I. 1969. 'Seventeenth-century delftware potters in St. Olave's Parish, Southwark', *Surrey Archaeological Collections* 66, pp. 11–31.

Davies, M. 1961. *National Gallery Catalogues: The Earlier Italian Schools* (2nd edn), London.

Davillier, J. C. 1882. *Les origines de la porcelaine en Europe*, Paris & London.

Delange, H. 1853. *Appendice*, in Passeri, G., *Histoire des peintures sur majoliques faites à Pesaro*, Paris.

Della Gherardesca, U. 1950. 'Una rara plastica maiolicata', *Faenza* 36, pp. 79–80.

De-Mauri, L. 1924. *Le Maioliche di Deruta*, Milan.

Dennistoun, J. 1909. *Memoirs of the Dukes of Urbino* (2nd edn), London & New York.

Donatone, G. 1970. *Maioliche napoletane della spezieria aragonese di Castelnuovo*, Naples.

Donatone, G. 1974A. 'La maiolica napoletana dalle origini al secolo XV', in *Storia di Napoli* IV, pt 1, Naples, pp. 579–625.

Donatone, G. 1974B. *La maiolica napoletana dell'età barocca*, Naples.

Donatone, G. 1980. *La maiolica napoletana del settecento*, Exhibition catalogue, Naples.

Donatone, G. 1981. *Pavimenti e rivestimenti maiolicati in Campania*, Cava dei Tirreni.

Donatone, G. 1983. 'La maiolica napoletana d'età aragonese. Storia critica e nuove scoperte', *Centro studi per la storia della ceramica meridionale, Quaderno* 2, pp. 11–33.

Donatone, G. 1984. *Maiolica napoletana del Seicento*, Cava dei Tirreni.

Douglas, R. L. 1902. *A History of Siena*, London.

Douglas, R. L. 1937. 'A Note on Maestro Benedetto and his Work at Siena', *Burlington Magazine* 71, pp. 89–90.

Drey, R. E. A. 1978. *Apothecary Jars: Pharmaceutical Pottery and Porcelain in Europe and the East 1150–1850*, London & Boston.

Drey, R. E. A. 1985. 'Pots de pharmacie du duché d'Urbino à décor dit "istoriato"', *Revue d'histoire de la pharmacie* 32, pp. 5–12.

Ericani, G. (ed.), 1986. *Il ritrovamento di Torretta*, Venice.

Faïences françaises 1980. *Faïences françaises XVI^e–XVIII^e siècles*, Exhibition catalogue, Paris.

Falke, O. von 1899. *Sammlung Richard Zschille: Katalog der italienischen Majoliken*, Leipzig.

Falke, O. von 1907. *Majolika* (Handbücher der Königlichen Museen zu Berlin), (2nd edn), Berlin.

Falke, O. von 1914–23. *Die Majolikasammlung Alfred Pringsheim in München*, The Hague.

Falke, O. von 1917. 'Majoliken von Nicola da Urbino', *Ämtliche Berichte aus den Königlichen Kunstsammlungen* 39, Berlin, cols 1–15.

Falke, O. von 1933. 'Der Majolikamaler Jacopo von Cafaggiolo', *Pantheon* 12, pp. 111–16.

Falke, O. von 1934. 'Der Majolikamaler Giorgio Andreoli von Gubbio', *Pantheon* 14, pp. 328–33.

Ferrari, O., & Scavizzi, G. 1981. *Maioliche italiane, seicento e settecento*, Milan.

Ferrari, V. 1960. *La ceramica graffita ferrarese nei secoli XV–XVI*, Ferrara.

Fiocco, C., & Gherardi, G. 1983. 'Contributo allo studio della ceramica derutese', *Faenza* 69, pp. 90–3.

Fiocco, C., & Gherardi, G. 1984. 'Una targa della collezione Cora attribuibile alla bottega del Frate da Deruta', *Faenza* 70, pp. 403–16.

Fiocco, C., & Gherardi, G. 1985A. 'Produzione istoriata nella bottega di Maestro Giorgio di Gubbio: un piatto del Maestro del Giudizio di Paride al Museo del Vino di Torgiano', *Faenza* 71, pp. 297–302.

Fiocco, C., & Gherardi G. 1985B. 'Il corredo "Colonna-Orsini" nella produzione cinquecentesca di Castelli: proposte per un'attribuzione', in *Antichi documenti sulla ceramica di Castelli* (Museo delle ceramiche di Castelli, Raccolta di studi ceramici dell'Abruzzo 1), pp. 67–104.

Förster, R. 1894. 'Die Verleumdung des Apelles in der Renaissance', pt III, *Jahrbuch der Königlichen Preussischen Kunstsammlungen* 15, pp. 27–40.

Fortnum, C. D. E. 1873. *A Descriptive Catalogue of the Maiolica . . . in the South Kensington Museum*, London.

Fortnum, C. D. E. 1896. *Maiolica: A Historical Treatise on the Glazed and Enamelled Earthenwares of Italy, With Marks and Monograms*, Oxford.

Fortnum, C. D. E. 1897. *A Descriptive Catalogue of the Maiolica . . . in the Ashmolean Museum, Oxford, Fortnum Collection*, Oxford.

Fould Sale 1860. *Catalogue de la précieuse collection d'objets d'art de feu M. Louis Fould*, Paris, 4–27 June 1860.

Fountaine Sale 1884. *Catalogue of the Celebrated Fountaine Collection* etc., Christie's, 16–19 June 1884.

Fourest, H.-P. 1983. *La céramique européenne*, Paris.

Fourest, H.-P., & Giacomotti, J. 1966. *L'œuvre des faïenciers français du XVI^e à la fin du XVIII^e siècle*, Paris.

Francovich, R. 1982. *La ceramica medievale a Siena e nella Toscana meridionale (secc. XIV–XV)*, Florence.

Francovich, R., et al. 1978. *I saggi archeologici nel Palazzo Pretorio in Prato 1976/77*, Florence.

Francovich, R., & Gelichi, S. 1984. *La ceramica spagnola in Toscana nel Bassomedioevo* (Quaderni dell'insegnamento di archeologia medievale della facoltà di lettere e filosofia dell'Università di Siena 3), Florence.

Franks, A. W. 1850. *Catalogue of Works of Ancient and Mediaeval Art, exhibited at the House of the Society of Arts*, London.

Frati, L. 1852. *Del Museo Pasolini in Faenza, Descrizione*, Bologna.

Frothingham, A. W. 1936. *Catalogue of Hispano-Moresque Pottery in the Collection of the Hispanic Society of America*, New York.

Frothingham, A. W. 1951. *Lusterware of Spain*, New York.

Frothingham, A. W. 1953. 'Valencian lusterware with Italian coats of arms in the collection of the Hispanic Society of America', *Faenza* 39, pp. 91–4.

Galbreath, D. L. 1972. *Papal Heraldry* (2nd edn), London.

Gardelli, G. 1982. *5 secoli di maiolica a Rimini*, Ferrara.

Garner, F. H., & Archer, M. 1972. *English Delftware*, London.

Gaude, W. 1986. *Die Alte Apotheke*, Stuttgart.

Gavet Sale 1897. *Catalogue des objets d'art . . . la collection de M. Émile Gavet*, Paris, 31 May–9 June 1897.

Gelichi, S. 1986. 'La ceramica ingubbiata medievale nell'Italia nord-orientale', in *Siena/Faenza* 1986, pp. 353–407.

Gennari, G. 1956. 'Virgiliotto Calamelli e la sua bottega', *Faenza* 42, pp. 57–60.

Gere, J. A. 1963. 'Taddeo Zuccaro as a designer for Maiolica', *Burlington Magazine* 105, pp. 306–15.

Gere, J. A., & Pouncey, P. 1983. *Italian Drawings in the Department of Prints and Drawings in the British Museum: Artists working in Rome c. 1550 – c. 1640*, London.

Getty 1985. 'Acquisitions/1984', *The J. Paul Getty Museum Journal* 13, pp. 239–44.

Giacomotti, J. 1956. 'Les collections de faïences blanches au Musée National de Céramique', *Cahiers de la céramique* 3, pp. 4–11.

Giacomotti, J. 1961. *La majolique de la Renaissance*, Paris.

Giacomotti, J. 1962. 'Les majoliques de la collection Paul Gillet au Musée Lyonnais des Arts Décoratifs', *Cahiers de la céramique* 25, pp. 21–45.

Giacomotti, J. 1974. *Catalogue des majoliques des musées nationaux*, Paris.

Gillet 1956. *112 pièces de la collection de faïences Paul Gillet*, Lyons.

Giovio, P. 1978. *Dialogo dell'imprese militari e amorose*, ed. M. L. Doglio, Rome.

Godman Collection 1901. *The Godman Collection of Oriental and Spanish Pottery and Glass 1865–1900*, London.

González Martí, M. 1944. *Cerámica del levante español: siglos medievales: Loza*, Barcelona, etc.

González Martí, M. 1948. 'Azulejos valencianos exportados a Italia', *Faenza* 34, pp. 91–2.

González Martí, M. 1952. *Cerámica del levante español: siglos medievales, II: Alicatados y Azulejos*, Barcelona, etc.

Gresta, R. 1983. 'Alcune "historie" della bottega di Girolamo Lanfranco dalle Gabicce', *Notizie da Palazzo Albani* 12, pp. 153–7.

Gresta, R. 1986. 'Girolamo e Giacomo Lanfranco dalle Gabicce: maiolicari a Pesaro nel secolo XVI', in N. Cecini (ed.), *Gabicce, un paese sull' Adriatico tra Marche e Romagna*, Gabicce.

Grigioni, C. 1932. 'Documenti relativi alla famiglia Manara', *Faenza* 20, pp. 152–80.

Grigioni, C. 1934. 'Documenti: serie faentina – I Calamelli maiolicari di Faenza', *Faenza* 22, pp. 50–4, 88–90, 143–53.

Grimaldi, F., & Bernini, D. 1979. *Le ceramiche da farmacia della Santa Casa di Loreto*, Rome.

Guasti, G. 1902. *Di Cafaggiolo e d'altre fabbriche di ceramiche in Toscana, secondo studi e documenti in parte raccolti dal Comm. Gaetano Milanesi*, Florence.

Hager L. 1939. 'Ein Majolika-Tafelgeschirr aus Faenza im Residenzmuseum München', *Pantheon* 23, pp. 135–9.

Harris, F. L. 1922. 'An Italian Maiolica Plate', *Burlington Magazine* 40, pp. 278–83.

Hartt, F. 1958. *Giulio Romano*, New Haven.

Haskell, F., & Penny, N. 1981. *Taste and the Antique: The Lure of Classical Sculpture 1500–1900*, New Haven & London.

Hausmann, T. 1972. *Majolika: Spanische und Italienische Keramik vom 14. bis zum 18. Jahrhundert* (Kataloge des Kunstgewerbemuseums Berlin VI), Berlin.

Henderson, J. 1868. *Works of Art in Pottery, Glass, and Metal, in the Collection of John Henderson*, London.

Heukensfeldt Jansen, M.-A. 1961. *Majolica* (Rijksmuseum. Facetten der verzameling 12), Amsterdam.

Hill, G. F. 1930. *A Corpus of Italian Medals of the Renaissance before Cellini*, London.

Hind, A. M. 1938–48. *Early Italian Engraving*, London.

Hobson, R. L. 1903. *Catalogue of the Collection of English Pottery in the Department of British and Mediaeval Antiquities and Ethnography of the British Museum*, London.

Hodgkin, J. E., & Hodgkin, E. 1891. *Examples of Early English Pottery, Named, Dated and Inscribed*, London.

Honey, W. B. 1928. 'Later Italian Maiolica', *Apollo* 8, pp. 119–26, 193–8.

Honey, W. B. 1952. *European Ceramic Art*, London.

Hume, I. N. 1977. *Early English Delftware from London and Virginia*, Colonial Williamsburg Occasional Papers in Archaeology 2, Williamsburg.

Hurst, J. G. 1977. 'Spanish Pottery Imported into Medieval Britain', *Medieval Archaeology* 21, pp. 68–105.

Hurst, J. G., & Neal, D. S. 1982. 'Late Medieval Iberian Pottery imported into the Low Countries', *Rotterdam Papers* IV, pp. 83–110.

Husband, T. 1970. 'Valencian Lusterware of the Fifteenth Century', *Metropolitan Museum of Art Bulletin*, Summer 1970, pp. 11–32.

Jestaz, B. 1972–3. 'Les Modèles de la Majolique Historiée, bilan d'une enquête', *Gazette des Beaux-Arts* 79, pp. 215–40; 81, pp. 109–128.

Join-Dieterle, C. 1984. *Musée du Petit Palais: Catalogue de Céramiques I*, Paris.

Kingery, W. D., & Vandiver, P. B. 1984. 'Medici porcelain', *Faenza* 70, pp. 441–53.

Knab, E., Mitsch, E., & Oberhuber, K. 1983. *Raphael: Die Zeichnungen* (Veröffentlichungen der Albertina Wien 19), Stuttgart.

Korf, D. 1968. 'Haarlemse majolica- en tegelbakkers', *Mededelingenblad Vrienden van de Nederlandse Ceramiek* 50.

Korf, D. 1981. *Nederlandse Majolica*, Haarlem.

Krahl, R., et al. 1986. *Chinese Ceramics in the Topkapi Saray Museum Istanbul: A complete catalogue*, II: *Yuan & Ming Dynasty Porcelains*, London.

Kube, A. N. 1976. *Italian Majolica XV–XVIII Centuries: State Hermitage Collection*, Moscow.

Kuyken, D. 1964. 'Enige opmerkingen bij twee fragmenten van Italiaanse tegelvloeren uit het einde van de vijftiende eeuw', *Bulletin Museum Boymans–van Beuningen* 15, pp. 53–62.

Lane, A. 1939. 'Mattonelle spagnole in Castel Sant' Angelo', *Faenza* 17, pp. 27–34.

Lane, A. 1947. 'The Baroque Faïence of Nevers', *Burlington Magazine* 89, pp. 37–42.

Lane, A. 1948. *French Faïence*, London.

Lane, A. 1960. *Victoria & Albert Museum: A Guide to the Collection of Tiles* (2nd edn), London.

Lawner, L. 1984. *I Modi*, Milan.

Lazzarini, L., & Canal, E. 1983. 'Ritrovamenti di ceramica graffita bizantina in laguna e la nascita del graffito veneziano', *Faenza* 69, pp. 19–59.

Leonardi, C. (ed.) 1982A. *La ceramica rinascimentale metaurense*, Exhibition catalogue, Urbania.

Leonardi, C. 1982B. 'Il pavimento in maiolica della cappella dei conti Oliva', *Studi Montefeltrani: Atti dei convegni II: Il convento di Montefiorentino*, San Leo, pp. 147–69.

Leonhardt, K. 1920. 'Italienische Majolikawerkstätten des 16. Jahrhunderts und die in ihnen benutzten vorlagen', *Der Cicerone* 12, pp. 243–52, 365–77.

Leonhardt, K. 1924. 'Gianbatista dale Pale, die Amazonenbotega, und Meister S', *Der Cicerone* 16, pp. 531–9.

Lerma, J. V., et al. 1986. 'Sistematización de la loza gótico-mudéjar de Paterna/Manises', in *Siena/Faenza* 1986, pp. 183–203.

Lessmann, J. 1976. 'Polychromes Medici-Porzellan', *Pantheon* 34, pp. 280–7.

Lessmann, J. 1979A. *Herzog Anton Ulrich-Museum Braunschweig: Italienische Majolika, Katalog der Sammlung*, Brunswick.

Lessmann, J. 1979B. 'Majoliken aus der Werkstatt der Fontana', *Faenza* 65, pp. 333–49.

Lessmann, J. 1980. 'Neue Untersuchungen zum Medici-Porzellan', *Faenza* 66, pp. 165–8, 170–3.

Lipski, L. L., & Archer, M. 1984. *Dated English Delftware*, London & Scranton.

Litta, P., et al. 1819–1923. *Celebri Famiglie Italiane*, Milan & Turin.

Liverani, F., 1985. 'Un piatto di Nicola e altro', *Faenza* 71, pp. 392–3.

Liverani, F., & Bosi, R. 1974. *Maioliche di Faenza*, Imola.

Liverani, G. 1936A. 'Introduzione ad un catalogo delle porcellane dei Medici – saggio di analisi cronologica', *Faenza* 24, pp. 6–39.

Liverani, G. 1936B. *Catalogo delle porcellane dei Medici* (Piccola Biblioteca del Museo delle Ceramiche in Faenza 2), Faenza.

Liverani, G. 1937A. 'Un nuovo piatto del servizio d'Isabella d'Este-Gonzaga', *Faenza* 25, pp. 89–93.

Liverani, G. 1937B. 'L'influsso della maiolica italiana su quella d'oltre alpe', *Rassegna dell'Istruzione Artistica* 8, pp. 3–23.

Liverani, G. 1938. 'Ancora nuovi piatti del servizio d'Isabella d'Este-Gonzaga', *Faenza* 26, pp. 90–2.

Liverani, G. 1939A. 'Fata in Faenza in la botega de Maestro Piere Bergantino', *Faenza* 17, pp. 3–9,

Liverani, G. 1939B. 'Le "Credenze" Maiolicate di Isabella d'Este Gonzaga e di Federico II Duca di Mantova', *Corriere dei Ceramisti* 17, pp. 1–17 (also in *Rassegna dell'Istruzione Artistica* 9).

Liverani, G. 1940. 'Sul disco di Baldassare Manara con l'effigie di Battistone Castellini', *Faenza* 28, pp. 78–82.

Liverani, G. 1941A. 'La tazza da impagliata', *Faenza* 29, pp. 11–16.

Liverani, G. 1941B. 'Un'incisione di Alberto Dürer e due maioliche faentine', *Faenza* 29, pp. 30–2.

Liverani, G. 1950. 'Un frammento di maiolica faentina del primo cinquecento', *Faenza* 36, pp. 104–7.

Liverani, G. 1955. 'Un piatto di Nicola Pellipario al Museo', *Faenza* 41, pp. 12–13.

Liverani, G. 1957. 'Un piatto a Montpellier marcato da Orazio Fontana ed altri ancora', *Faenza* 43, pp. 131–4.

Liverani, G. 1958A. *La maiolica italiana sino alla comparsa della porcellana europea*, Milan (also English-language edition, New York 1960).

Liverani, G. 1958B. 'La rivoluzione dei bianchi nella maiolica di Faenza', *Faenza* 44, pp. 27–32.

Liverani, G. 1959. 'Ampliamenti al catalogo delle porcellane medicee', *Faenza* 45, pp. 6–12.

Liverani, G. 1960. 'Un recente trovamento di ceramiche trecentesche a Faenza', *Faenza* 46, pp. 31–51.

Liverani, G. 1961. 'Trovamenti ceramici a Faenza: faenze graffite e maioliche del Tre e del Quattrocento', *Faenza* 47, pp. 99–108.

Liverani, G. 1967A. 'Un piatto di Giambattista Dalle Palle al Museo', *Faenza* 53, pp. 31–4.

Liverani, G. 1967B. 'Il corredo in maiolica di una farmacia cinquecentesca', *Faenza* 53, pp. 35–43.

Liverani, G. 1968. 'La fortuna di Raffaello nella maiolica', in M. Salmi (ed.), *Raffaello. L'opera, le fonti, la fortuna*, Novara, pp. 691–708.

Liverani, G. 1976. 'Per il "Pittore delle caricature"', *Faenza* 72, pp. 57–60.

Luccarelli, M. 1975. 'Contributo alla conoscenza della maiolica senese. Di un piatto nel Musée des Antiquitiés di Rouen', *Faenza* 61, pp. 83–5.

Luccarelli, M. 1983. 'Contributo alla conoscenza della maiolica senese. Il pavimento della Capella Bichi in S. Agostino', *Faenza* 69, pp. 197–201.

Luccarelli, M. 1984. 'Contributo alla conoscenza della maiolica senese. La "Maniera di Mastro Benedetto"', *Faenza* 70, pp. 302–4.

Magnani, R. 1981–2. *La ceramica ferrarese tra Medioevo e Rinascimento*, Ferrara.

Magniac Sale 1892. *Catalogue of the Renowned Collection of Works of Art chiefly formed by the late Hollingworth Magniac, Esq.*, Christie's, 2–15 July 1892.

Magnini, A. 1934. 'Elementi decorativi delle antiche maioliche di Deruta', *Faenza* 22, pp. 130–1.

Maioliche umbre decorate a lustro 1982. Exhibition catalogue, Spoleto.

Malagola, C. 1880. *Memorie storiche sulle maioliche di Faenza*, Bologna.

Mallé, L., n.d. *Maioliche italiane dalle origini al settecento*, Milan.

Mallet, J. V. G. 1967. 'Italian Maiolica in the Gambier-Parry Collection', *Burlington Magazine* 109, pp. 144–51.

Mallet, J. V. G. 1970–1. 'Maiolica at Polesden Lacey', *Apollo* 92, pp. 260–5, 340–5; 93, pp. 170–83.

Mallet, J. V. G. 1974. 'Alcune maioliche faentine in raccolte inglesi', *Faenza* 60, pp. 3–23.

Mallet, J. V. G. 1976. 'A maiolica plate signed "F.R."', *Art Bulletin of Victoria*, pp. 5–18.

Mallet, J. V. G. 1978. 'C. D. E. Fortnum and Italian Maiolica of the Renaissance', *Apollo* 108, pp. 396–404.

Mallet, J. V. G. 1979. 'Francesco Urbini in Gubbio and Deruta', *Faenza* 65, pp. 279–96.

Mallet, J. V. G. 1980. 'Istoriato-painting at Pesaro: I: The Argus Painter', *Faenza* 66, pp. 153–64.

Mallet, J. V. G. 1981. 'Mantua and Urbino: Gonzaga Patronage of Maiolica', *Apollo* 114, pp. 162–9.

Mallet, J. V. G. 1984. 'La biografia di Francesco Xanto Avelli alla luce dei suoi sonnetti', *Faenza* 70, pp. 398–402.

Mallet, J. V. G. 1985. 'Istoriato painting at Pesaro: II: An additional work by the Argus Painter', *Faenza* 71, pp. 293–6.

Mallet, J. V. G. 1986. Review of Berardi 1984, in *Burlington Magazine* 128, p. 424.

Mallet, J. V. G. 1987. 'In botega di Maestro Guido Durantino in Urbino', *Burlington Magazine*, May 1987.

Mallet, J. V. G., forthcoming. 'Xanto: i suoi compagni e seguaci', in Acts of the Conference on Francesco Xanto Avelli, Rovigo, 1980.

Manacorda, D., *et al.* 1980. 'La ceramica medioevale di Roma nella stratigrafia della Crypta Balbi', in *Siena/Faenza 1986*, pp. 511–44.

Mancini Della Chiara, M. 1979. *Maioliche del Museo Civico di Pesaro*, Pesaro.

Mannoni, T. 1969. 'Gli scarti di fornace e la cava del XVI secolo in via S. Vincenzo a Genova', *Atti della Società Ligure di Storia Patria*, N.S. 9, pp. 75–96.

Mannoni, T. 1975. *La ceramica medievale a Genova e nella Liguria* (Studi genuensi 7), Bordighera & Genoa.

Mannoni, L., & Mannoni, T. 1975. 'La ceramica dal medioevo all' età moderna nell' archeologia di superficie della Liguria centrale e orientale', *Atti del VII Convegno Internazionale della Ceramica*, Albisola, pp. 121–36.

Marquand, A. 1919. *Robbia Heraldry*, Princeton, etc.

Marquand, A. 1920. *Giovanni della Robbia*, Princeton, etc.

Marryat, J. 1850. *Collections towards a History of Pottery and Porcelain*, London.

Marryat, J. 1857. *A History of Pottery and Porcelain, Mediaeval and Modern*, London.

Marryat Sale 1867. *Catalogue of the . . . Collection of Works of Art formed . . . by Joseph Marryat, Esq.*, Christie's, 9–19 February 1867.

Massing, J. M., forthcoming. *Du texte à l'image. La Calomnie d'Apelle et son iconographie*.

Mazza, G. 1983. *La ceramica medioevale di Viterbo e dell' Alto Lazio*, Viterbo.

Mazzatinti, G. 1931. 'Mastro Giorgio', *Il Vasari* 4, pp. 1–16, 105–22.

Mazzucato, O. 1980. 'Il boccale romano del medioevo', in *Valbonne 1980*, pp. 155–65.

Mazzucato, O. 1981. 'La ceramica viterbese nel medioevo', *Tuscia* 25.

Mazzucato, O. 1976. *La ceramica laziale dei secoli XI—XIII* (Quaderni de 'la ricerca scientifica' 95, Consiglio Nazionale delle Ricerche), Rome.

Mazzucato, O. 1985. *I pavimenti pontifici di Castel Sant' Angelo* (2nd edn), Rome.

Middeldorf, U. 1938. Review of G. Liverani 1936B, *Art Bulletin* 20, pp. 117–22.

Middeldorf, U. 1980. 'Porcellana medicea', *Palazzo Vecchio: committenza e collezionismo medicei*, Exhibition catalogue, Florence, pp. 181–6.

Migliori Luccarelli, A. 1983. 'Documenti: Orciolai a Siena', *Faenza* 69, pp. 255–88.

Miller, E. 1973. *That Noble Cabinet: A History of the British Museum*, London.

Moccia, L. 1960. 'Francesco Grue da Castelli', *Faenza* 46, pp. 59–64.

Molinier, E. 1888. *La Céramique italienne au XVᵉ siècle*, Paris.

Molinier, E. 1889. *Collection É. Gavet. Catalogue raisonné*, Paris.

Molinier, E. 1892. 'Les faïences italiennes, hispano-moresques et orientales', *La collection Spitzer* IV, Paris.

De Monville Sale 1837. *Catalogue des objets d'art et de curiosité de la Renaissance*, Paris, 7–10 March 1837.

Moore A. W. 1985. *Norfolk and the Grand Tour*, Exhibition catalogue, Norwich.

Morazzoni, G. 1955. *La maiolica antica veneta*, Milan.

Morazzoni, G. 1960. *Le porcellane italiane*, Milan.

Moschetti, A. 1931. 'Delle maioliche dette "Candiane"', *Bollettino del Museo Civico di Padova* 24, pp. 1–58.

Mottola Molfino, A. 1976. *L'arte della porcellana in Italia*, Busto Arsizio.

Negroni, F. 1986. 'Nicolò Pellipario: ceramista fantasma', *Notizie da Palazzo Albani* 14, pp. 13–20.

Nepoti, S. 1975. 'La transizione medioevo-rinascimento nella ceramica dell'Emilia-Romagna: problemi aperti e prime informazioni dallo scavo bolognese in S. Giorgio', *Atti del VIII Convegno Internazionale della Ceramica*, Albisola, pp. 75–96.

Nepoti, S. 1978. 'Le ceramiche postmedievali rinvenute negli scavi nella Torre Civica di Pavia', *Archeologia medievale* 5, pp. 171–218.

Nepoti, S. 1981. 'Ceramiche a Pavia dal secolo XV al XVII', in *Pavia, Pinacoteca Malaspina*, Pavia, pp. 67–105.

New Gallery 1896. *Exhibition of Spanish Art*, London.

Nicaise, H. 1934. 'Les origines italiennes des faïenceries d'Anvers et des Pays-Bas au XVIᵉ siècle', *Bulletin de l'Institut historique belge de Rome* 14, pp. 109–29.

Norman, A. V. B. 1965. 'Sources for the design on a Majolica Dish', *Apollo* 81, pp. 460–3.

Norman, A. V. B. 1969. 'A note on the so-called Casa Pirota mark', *Burlington Magazine* 111, pp. 447–8.

Norman, A. V. B. 1976. *Wallace Collection: Catalogue of Ceramics* I, London.

Olding, S. 1982. *Glasgow Museums and Art Galleries: Italian Maiolica*, Glasgow.

Olivar, M. 1953. 'Su alcuni esemplari urbinati con iscrizioni spagnole, della bottega di Orazio Fontana'. *Faenza* 39, pp. 119–22.

Oppenheimer Sale 1936. *Catalogue of the highly important Collection . . . formed by the late Henry Oppenheimer, Esq.*, Christie's, 15–17 July 1936.

Ovid 1497. *Ovidio methamorphoseos vulgare*, Venice.

Papini, R. 1914. 'Gli antichi pavimenti di Castel Sant'Angelo', *Faenza* 2, pp. 65–71.

Parpart Sale 1884. *Catalogue des objets d'art . . . feu Monsieur Albert de Parpart*, Cologne (Heberle), 20–5 Oct. 1884.

Passavant, G. 1969. *Verrocchio*, London.

Passeri, G. B. 1758. *Istorie delle pitture in majolica fatte in Pesaro e ne' luoghi circonvicini*, Venice (also in Vanzolini 1879).

Pataky-Brestyánszky, I. 1967. *Italienische Majolikakunst: Italienische Majolika in ungarischen Sammlungen*, Budapest.

Pavone, M. P. 1985. 'Maestro Domenico da Venezia e la spezieria del grande ospedale di Messina', *Faenza* 71, pp. 49–67.

Pelizzoni, E., & Zanchi, G. 1982. *La maiolica dei Terchi*, Florence.

Pesce, G. 1971. 'Evoluzione dell'albarello dalla sua comparsa al XVIII secolo', *Atti del IV Convegno Internazionale della Ceramica*, Albisola, pp. 239–62.

Petruzzellis-Scherer, J. 1980. 'Le opere di Francesco Xanto Avelli al Castello Sforzesco', *Rassegna di studi e di notizie* (Milan) 8, pp. 321–71.

Petruzzellis-Scherer, J. 1982. 'Fonti iconografiche librarie per alcune maioliche del Castello Sforzesco', *Rassegna di studi e di notizie* (Milan) 10, pp. 373–88.

Piccolpasso, C. 1980. *The Three Books of the Potter's Art*, ed. R. Lightbown & A. Caiger-Smith, London.

Polidori, G. C. 1953. 'Nicolò Pellipario e le "Belle" di Pesaro e di altrove', *Studi artistici Urbinati* 2, pp. 57–70.

Polidori, G. C. 1962. 'Nicolò Pellipario, con particolare cenno ad una sua fase stilistica', *Pantheon* 20, pp. 348–55.

Pompeis, C. de, *et al.* 1985. 'Nuovi contributi per l'attribuzione a Castelli della tipologia Orsini-Colonna' (Museo delle Genti d'Abruzzo, Quaderno 13), Pescara.

Pourtalès Sale 1865. *Catalogue des Objets d'Art et de haute curiosité . . . de feu M. le Comte de Pourtalès-Gorgier*, Paris, 6 Feb. – 21 March 1865.

Prentice von Erdberg, J. 1950–1. 'Early Work by Fra Xanto Avelli da Rovigo in the Walters Art Gallery', *Journal of the Walters Art Gallery* 13–14, pp. 31–7, 75.

Prentice von Erdberg, J., & Ross, M. C. 1952. *Catalogue of the Italian Maiolica in the Walters Art Gallery*, Baltimore.

Pringle, D. 1977. 'La ceramica dell'area sud del convento di S. Silvestro a Genova', *Archeologia medievale* 4, pp. 100–60.

Pringsheim Sale 1939. *Catalogue of the Renowned Collection of Superb Italian Majolica . . . of Dr. Alfred Pringsheim of Munich*, Sotheby's, 7–8 June, 19–20 July 1939.

Rackham, B. 1904. 'Italian maiolica and other Pottery', in *Catalogue of the Art Collection* (Cook collection) I, London.

Rackham, B. 1913. 'The Sources of Design in Italian Maiolica', *Burlington Magazine* 23, pp. 193–203.

Rackham, B. 1915. 'A New Chapter in the History of Italian Maiolica', *Burlington Magazine* 27, pp. 28–35, 49–55.

Rackham, B. 1922. 'A New Work by Nicola Pellipario at South Kensington', *Burlington Magazine* 41, pp. 21–7, 127–33.

Rackham, B. 1926. *Early Netherlands Maiolica*, London.

Rackham, B. 1928. 'Some Unpublished Maiolica by Pellipario', *Burlington Magazine* 52, pp. 230–41.

Rackham, B. 1928–9. 'Der Majolikamaler Giovanni Maria von Castel Durante', *Pantheon* 2, pp. 435–45; 3, pp. 88–92.

Rackham, B. 1930A. 'Italian maiolica', *Faenza* 18, pp. 89–97, 141–53.

Rackham, B. 1930B. 'The "Master of the Resurrection Panel", an Italian Maiolica-Painter', *Anzeiger des Landesmuseums in Troppau* II (E. W. Braun Festschrift), Augsburg.

Rackham, B. 1932. 'The Berney Collection of Italian Maiolica', *Burlington Magazine* 61, pp. 208–19.

Rackham, B. 1933. *Victoria & Albert Museum: Guide to Italian Maiolica*, London.

Rackham, B. 1935. 'Some Maiolica Paintings by Nicola Pellipario', *Burlington Magazine* 66, pp. 104–9.

Rackham, B. 1937. 'The Damiron Collection of Italian Maiolica', *Apollo* 26, pp. 61–7, 251–7.

Rackham, B. 1940A. *Victoria & Albert Museum, Catalogue of Italian Maiolica*, London.

Rackham, B. 1940B. 'The Maiolica-Painter Guido Durantino', *Burlington Magazine* 77, pp. 182–8.

Rackham, B. 1945. 'Nicola Pellipario and Bramante', *Burlington Magazine* 86, pp. 144–9.

Rackham, B. 1948. 'The "Coriolanus" dish in the Museo Internazionale delle Ceramiche', *Faenza* 34, pp. 30–4.

Rackham, B. 1951. 'Italian Maiolica: Some Debated Attributions; a Follower of Signorelli', *Burlington Magazine* 93, pp. 106–11.

Rackham, B. 1955. '"Mazo", a sixteenth-century maiolica-painter', *Faenza* 41, pp. 14–17.

Rackham, B. 1957A. 'Xanto and ".F.R.": an insoluble problem', *Faenza* 43, pp. 99–113.

Rackham, B. 1957B. 'Further notes on "Mazo"', *Faenza* 43, pp. 32–4.

Rackham, B. 1958. 'The Ford Collection of Italian Maiolica', *The Connoisseur* 142, pp. 148–51.

Rackham, B. 1959. *Islamic Pottery and Italian Maiolica* (Adda collection), London.

Rackham, B. 1963. *Italian Maiolica*, 2nd ed., London.

Rackham, B., & Ballardini, G. 1933. 'Il pittore di maiolica ".F.R."', *Bollettino d'arte* 26, pp. 393–407.

Rackham, B., & Read, H. 1924. *English Pottery*, London.

Raffaelli, G. 1846. *Memorie istoriche delle maioliche lavorate in Castel Durante o sia Urbania*, Fermo (also in Vanzolini 1879).

Ragona, A. 1976. 'Maioliche casteldurantine del sec. XVI per un committente siculo-genovese', *Faenza* 62, pp. 106–9.

Rasmussen, J. 1972. 'Zum Werk des Majolikamalers Nicolo da Urbino', *Keramos* 58, pp. 51–64.

Rasmussen, J. 1980. 'Die Majoliken "in arimino"', *Jahrbuch der Hamburger Kunstsammlungen* 25, pp. 81–96.

Rasmussen, J. 1984. *Museum für Kunst und Gewerbe, Hamburg: Italienische Majolika*, Hamburg.

Rattier Sale 1859. *Catalogue des objets d'art et de haute curiosité composant la collection de feu M. Rattier*, Paris, 21–4 March 1859.

Ravanelli Guidotti, C. 1983A. 'Iconografia raffaellesca nella maiolica della prima metà del XVI secolo', in M. G. C. D. Dal Poggetto & P. Dal Poggetto (eds), *Urbino e le Marche prima e dopo Raffaello*, Exhibition catalogue, Urbino, pp. 448–73.

Ravanelli Guidotti, C. 1983B. 'Battista Franco disegnatore per la maiolica', in M. G. C. D. Dal Poggetto & P. Dal Poggetto (eds), *Urbino e le Marche prima e dopo Raffaello*, Exhibition catalogue, Urbino, pp. 474–7.

Ravanelli Guidotti, C. 1984. 'Aspetti della cultura maiolicara faentina all'epoca della stesura del manoscritto piccolpassiano', *Faenza* 70, pp. 189–97.

Ravanelli Guidotti, C. 1985A. *Ceramiche occidentali del Museo Civico Medievale di Bologna*, Bologna.

Ravanelli Guidotti, C. 1985B. 'Medaglie, placchette, incisioni e ceramiche: un itinerario iconografico attraverso materiali del Rinascimento', in *Piccoli bronzi e placchette del Museo Nazionale di Ravenna*, Exhibition catalogue, Ravenna, pp. LIII–LXV.

Ravanelli Guidotti, C., forthcoming. 'Osservazioni sul servizio di Alfonso II d'Este con il motto ARDET ÆTERNUM', in *Pennabilli nel Montefeltro, Annali di Studio*.

Read, C. H. 1902. *The Waddesdon Bequest*, London.

Reggi, G. L. 1971. *La ceramica graffita in Emilia-Romagna dal Secolo XIV al Secolo XIX*, Exhibition catalogue, Modena.

Reggi, G. L. 1972. *Comune di Ferrara: Ceramica nelle Civiche Collezioni*, Florence.

Reggi, G. L. 1984. *La ceramica graffita in Romagna*, Exhibition catalogue, Imola.

Ricci, C. 1888. 'Lorenzo da Viterbo', *Archivio storico dell'arte* 1, pp. 26–34, 60–7.

Ricci, S. de 1918. 'La porcelaine des Medicis', *Faenza*, Commemorative supplement 1908–18, pp. 26–32.

Ricci, S. de 1927. *A Catalogue of Early Italian Majolica in the Collection of Mortimer L. Schiff*, New York.

Riesebieter, O. 1927–8. 'Eine Gruppe Niederländischer Fayencen im Charakter von Urbino', *Altes Kunsthandwerk* 1, pp. 263–7.

Robinson, J. C. 1856. *Catalogue of the Soulages Collection*, London.

Robinson, J. C. 1862. 'Majolica Wares', in *Catalogue of the Special Exhibition of Works of Art . . . on loan at the South Kensington Museum*, London, pp. 399–444.

Rubinstein, R. 1984. 'The Renaissance discovery of antique river-god personifications', *Scritti di storia dell'arte in onore di Roberto Salvini*, Florence.

Ruscelli, G. 1566. *Le imprese illustri*, Venice.

Sauerlandt, M. 1929. 'Ceramiche italiane nei musei tedeschi', *Faenza* 17, pp. 71–85.

Scarrone, M. 1971. 'La fabbrica di ceramica Isola durante la gestione di Gio. Luigi Bosio (1703–1709)', *Atti del IV Convegno Internazionale della Ceramica*, Albisola, pp. 181–210.

Scatassa, E. 1904. 'Documenti: nomi e notizie di vasai che lavorarono in Urbino nel secolo XV e nel cinquecento', *Rassegna bibliografica dell'arte italiana* 7, pp. 24–7.

Scheidemantel, V. J. 1969. 'An Italian Maiolica Wine Cooler', *Art Institute of Chicago: Museum Studies* 3, pp. 42–62.

Scott-Taggart, J. 1972. *Italian Maiolica*, London.

Shaw, J. B. 1932. 'Iacopo Ripanda and Early Italian Maiolica', *Burlington Magazine* 61, pp. 19–25.

Shaw, J. B. 1933. 'Una composizione di Jacopo Ripanda e tre piatti faentini', *Faenza* 21, pp. 3–9.

Shinn, D. 1982. *Sixteenth-Century Italian Maiolica: Selections from the Arthur M. Sackler Collection and the National Gallery of Art's Widener Collection*, Exhibition catalogue, Washington, D.C.

Siena/Faenza 1986. *La ceramica medievale nel Mediterraneo occidentale* (Congress, Siena & Faenza, Oct. 1984), Florence.

Siviero, G. B. 1965. *Catalogo generale della mostra della ceramica graffita veneta del XIV–XV–XVI secolo*, Rovigo.

Siviero, G. B. 1981. *Ceramiche nel Palazzo Ducale di Mantova*, Exhibition catalogue, Mantua.

Siviero, G. B. 1983. 'Ceramica berettina veneta', *Atti del XIII Convegno Internazionale della Ceramica*, Albisola, pp. 311–18.

Solon, M. L. 1907. *A History and Description of Italian Majolica*, London, etc.

Spallanzani, M. 1978A. 'Un invio di maioliche ispano-moresche a Venezia negli anni 1401–1402', *Archeologia medievale* 5, pp. 529–41.

Spallanzani, M. 1978B. *Ceramiche orientali a Firenze nel Rinascimento*, Florence.

Spallanzani, M. 1979. 'Maioliche di Urbino nelle collezioni di Cosimo I, del Cardinale Ferdinando e di Francesco I de' Medici', *Faenza* 65, pp. 111–26.

Spallanzani, M. 1981. 'Maioliche veneziane per Cosimo I de' Medici ed Eleonora di Toledo', *Faenza* 67, pp. 71–7.

Stengel, W. 1908. 'Deutsche Keramik im Germanischen Nationalmuseum', *Mitteilungen aus dem germanischen Nationalmuseum*.

Stowe Sale 1848. *Catalogue of the contents of Stowe House, near Buckingham . . .*, Christie's, 15 Aug.–7 Oct. 1848.

Strauss Sale 1976. *The Robert Strauss Collection of Italian Maiolica*, Christie's, 21 June 1976.

Strawberry Hill Sale 1842. *A Catalogue of the Classic Contents of Strawberry Hill collected by Horace Walpole*, London (Robins), 25 April–21 May 1842.

Sutton, D. 1979. 'Robert Langton Douglas, II: Maiolica in Tuscany', *Apollo* 109, pp. 334–41.

Sutton, D. 1985. 'Aspects of British Collecting, IV', *Apollo* 122, pp. 84–129.

Taburet, M. 1981. *La Faïence de Nevers*, Paris.

Tait, G. H. 1960–1. 'Southwark (Alias Lambeth) Delftware and the Potter, Christian Wilhelm', *The Connoisseur* 146, pp. 36–42; 147, pp. 22–9.

Tait, G. H. 1962. *Porcelain*, London.

Tait, G. H. 1976. 'The Roman Lion-Hunt Dish, an early work by Xanto?', *British Museum Society Bulletin* 21, pp. 3–6.

Tait, G. H. 1981. *The Waddesdon Bequest: The Legacy of Baron Ferdinand Rothschild to the British Museum*, London.

Tátrai, V. 1978. 'Gli affreschi del Palazzo Petrucci a Siena', *Acta Historiae Artium Academiae Scientiarum Hungaricae* 24, pp. 177–83.

Tervarent, G. de 1950. 'Enquête sur le sujet des majoliques', *Kunstmuseets Årsskrift* 37, pp. 1–48.

Testart Sale 1924. *Catalogue des faïences italiennes . . . composant la Collection de Feu M. Charles Testart*, Paris, 24–5 June 1924.

Traldi, R. 1985. 'Un taccuino di disegni e alcune opere di Bernardino Pepi, ceramista senese del sec. XIX', *Faenza* 71, pp. 303–8.

Valbonne 1980. *La céramique médiévale en Méditerranée occidentale* (Congress, Valbonne, Sept. 1978), Paris.

van Dam, J. D. 1982–4. 'Geleyersgoet en Hollants Porceleyn', *Mededelingenblad Nederlandse Vereniging van Vrienden van de Ceramiek* 108.

Van de Put, A. 1904. *Hispano-Moresque Ware of the XV Century*, London.

Van de Put, A. 1905. 'The Lemos and Este Bottles in the Waddesdon Bequest', *Burlington Magazine* 7, pp. 467–9.

Van de Put, A. 1911. *Hispano-Moresque Ware of the Fifteenth Century: Supplementary Studies and some Later Examples*, London.

Van de Put, A. 1938. *The Valencian Styles of Hispano-Moresque Pottery*, New York.

Van de Put, A., & Rackham B. 1916. *Catalogue of the Collection of Pottery and Porcelain in the possession of Mr Otto Beit*, London.

Vannini, G. (ed.) 1977. *La maiolica di Montelupo: Scavo di uno scarico di fornace*, Exhibition catalogue, Montelupo.

Vannini, G. (ed.) 1981. *Una farmacia preindustriale in Valdelsa*, San Gimignano.

Vanzolini, G. (ed.) 1879. *Istorie delle fabbriche di majoliche metaurensi*, Pesaro.

Vasari, G. 1878–85. *Le opere*, ed. G. Milanesi, Florence.

Verlet, P. 1937. 'A Faenza Panel at the Victoria & Albert Museum', *Burlington Magazine* 71, pp. 183–4.

Viale, V. 1963. 'Maioliche', in *Mostra del Barocco Piemontese*, Exhibition catalogue, Turin, vol. 3.

Vignola, G. 1878. *Sulle maioliche e porcellane di Piemonte*, Turin, etc.

Vince, A. G. 1982. 'Medieval and post-medieval Spanish pottery from the City of London', in *Current research in ceramics: Thin-section studies* (British Museum Occasional Paper 32), pp. 135–44.

Vitaletti, G. 1918. 'Le rime di Francesco Xanto Avelli', *Faenza* 6, pp. 11–15, 41–4.

Vydrová J. 1973. *Italian majolica*, Prague.

Wallen, B. 1968. 'A Majolica Panel in the Widener Collection', *National Gallery of Art: Report and Studies in the History of Art*, Washington D.C., pp. 94–105.

Wallis, H. 1897. *Italian ceramic art: Examples of maiolica and mezza-maiolica fabricated before 1500*, London.

Wallis, H. 1901. *The Art of the Precursors: A study in the history of early Italian maiolica*, London.

Wallis, H. 1902. *Italian ceramic art: The maiolica pavement tiles of the fifteenth century*, London.

Wallis, H. 1903. *Oak-Leaf Jars: A fifteenth century Italian ware showing Moresco influence*, London.

Wallis, H. 1904. *Italian ceramic art: The Albarello: A study in Early Renaissance Maiolica*, London.

Wallis, H. 1905A. *Italian ceramic art: Figure design and other forms of ornamentation in XV^th century Italian maiolica*, London.

Wallis, H. 1905B. *XVII Plates by Nicola Fontana da Urbino at the Correr Museum Venice: A study in early XVI^th cent^y maiolica*, London.

Walpole, H. 1784. *A Description of the Villa . . . at Strawberry-Hill*, Strawberry Hill.

Ward-Jackson, P. 1967. 'Some Main Streams and Tributaries in European Ornament from 1500 to 1750', *Victoria & Albert Museum Bulletin* 3, pp. 58–71, 90–103, 121–34.

Watson, W. M. 1986. *Italian Renaissance Maiolica from the William A. Clark Collection*, London.

Weiss, R. 1966. *Pisanello's Medallion of the Emperor John VIII Palaeologus*, London.

Whitehouse, D. 1967. 'The medieval glazed pottery of Lazio', *Papers of the British School at Rome* 35, pp. 40–86.

Whitehouse, D. 1972. 'The medieval and Renaissance pottery', in J. Ward-Perkins *et al.*, 'Excavation and survey at Tuscania 1972', *Papers of the British School at Rome* 40, pp. 209–35.

Whitehouse, D. 1976. 'Ceramica Laziale', *Papers of the British School at Rome* 44, pp. 157–70.

Whitehouse, D. 1978. 'The medieval pottery of Rome', *Papers in Italian Archaeology I: the Lancaster Seminar* (BAR Supplementary Series 41), Oxford, pp. 475–92.

Whitehouse, D. 1980. 'Medieval pottery in Italy: the present state of research', in *Valbonne 1980*, pp. 65–82.

Wilson, D. M. 1984. *The Forgotten Collector: Augustus Wollaston Franks of the British Museum*, London.

Wilson, T. H. 1984. 'Some Medici devices on pottery', *Faenza* 70, pp. 433–40.

Wilson, T. H. 1985A. 'The Origins of the Maiolica Collections of the British Museum and the Victoria & Albert Museum 1851–55', *Faenza* 71, pp. 68–81.

Wilson, T. H. 1985B. Review of Ravanelli Guidotti 1985, in *Burlington Magazine* 127, pp. 907–8.

Wilson, T. H. 1986. 'The Cora Collection at the Museo Internazionale delle Ceramiche, Faenza', *Apollo* 123, pp. 86–9.

Wilson, T.H. 1987. 'Maiolica in Renaissance Venice', *Apollo* 125, pp. 184–9.

Wind, E. 1950. 'A Note on Bacchus and Ariadne', *Burlington Magazine* 92, pp. 82–5.

Winternitz, E. 1967. *Musical Instruments and their Symbolism in Western Art*, London.

D'Yvon Sale 1892. *Catalogue des Objets d'Art . . . de Mme d'Yvon*, Paris, 30 May – 4 June 1892.

Zauli Naldi, L. 1942. 'Una credenza di "Don Pino" per Alberto V di Bavaria', *Faenza* 30, pp. 79–89.

Zauli Naldi, L. 1958. 'Nuove accessioni al museo', *Faenza* 44, pp. 8–11.

Index

Numbers in bold type refer to catalogue entries, others to pages. Museums and buildings are listed under the town where they are situated.

Lenders to the exhibition

Mr William Beare **104**

Mr Bruno Schroder **100**

Ashmolean Museum, Oxford **49, 162, 193**

Courtauld Institute Galleries, London **105, 137**

The Fitzwilliam Museum, Cambridge **218**

Musée du Louvre, Paris **59**

Henry Reitlinger Bequest, Maidenhead **88, 183, 235, 236, 237, 264**

Rijksmuseum, Amsterdam **50**

Royal Museum of Scotland, Edinburgh **54–58**

Victoria & Albert Museum, London **67, 133, 178, 195**

Photographic acknowledgements

The photographs in this book are the work of Bill Lewis and his colleagues, past and present, in the British Museum Photographic Service, with the following exceptions: 49, 162, 193 (Ashmolean Museum, Oxford); 50 (Rijksmuseum-Stichting, Amsterdam); 54–58 (Trustees of the National Museums of Scotland); 59 (Musée du Louvre, Paris); 62 (Courtesy of Don Gino Andreoli, Novellara); 67, 133, 178, 195, fig. ii (Victoria & Albert Museum, London); 218 (Fitzwilliam Museum, Cambridge); fig. iv (Musei Civici, Pavia); fig. vi (Scala/Firenze); fig. vii (Biblioteca Universitaria, Bologna; photo Roncaglia, Modena); fig. viii (Mario Berardi, C.N.B. & C. Bologna); fig. xii (Kupferstichkabinett, West Berlin); figs xvi, xvii (Archivi Alinari, Florence); figs xxvi, xxvii, xxix (British Library); fig. xxxi (Musei Vaticani).